Forests
in Our
World

Gunther Willinger

Forests in Our World

How the Climate Affects Woodlands

Foreword by
Prof. Dr. Jürgen Bauhus

teNeues

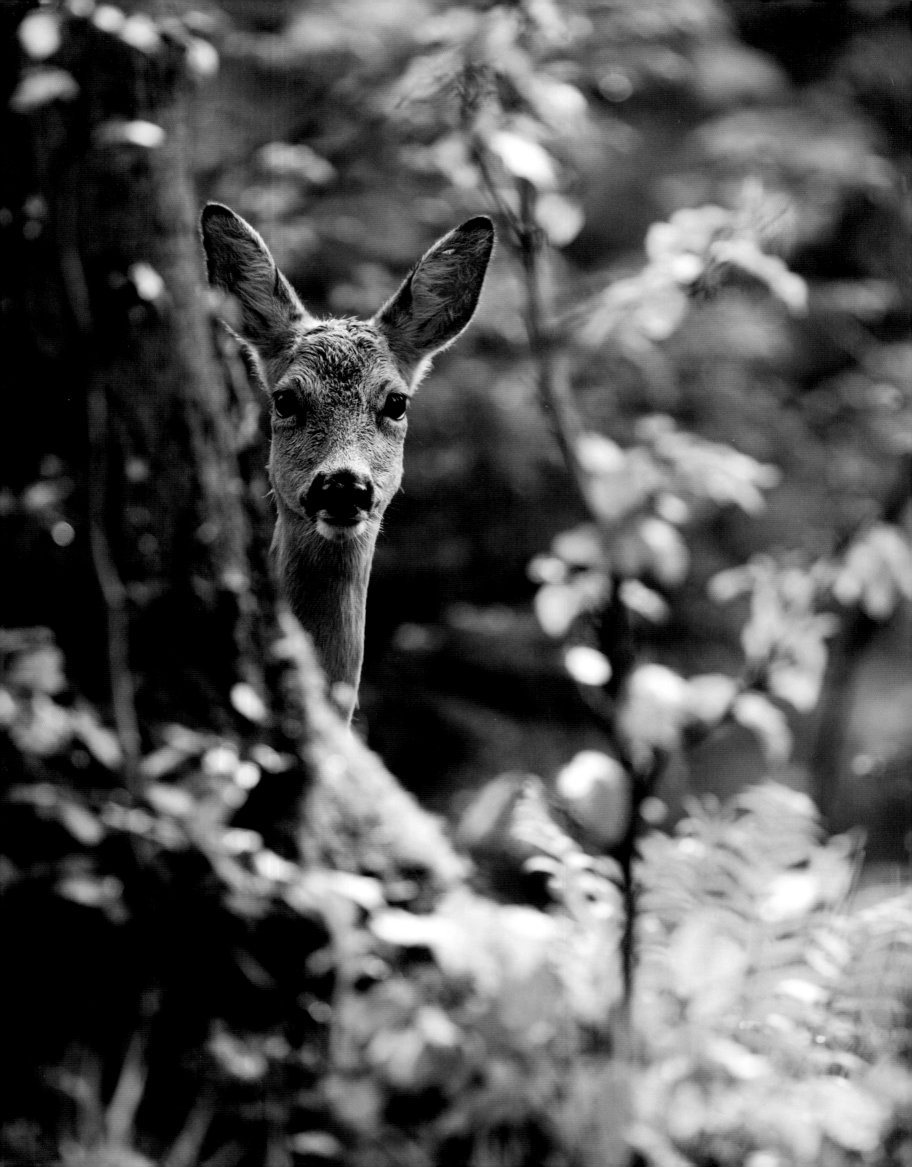

Contents

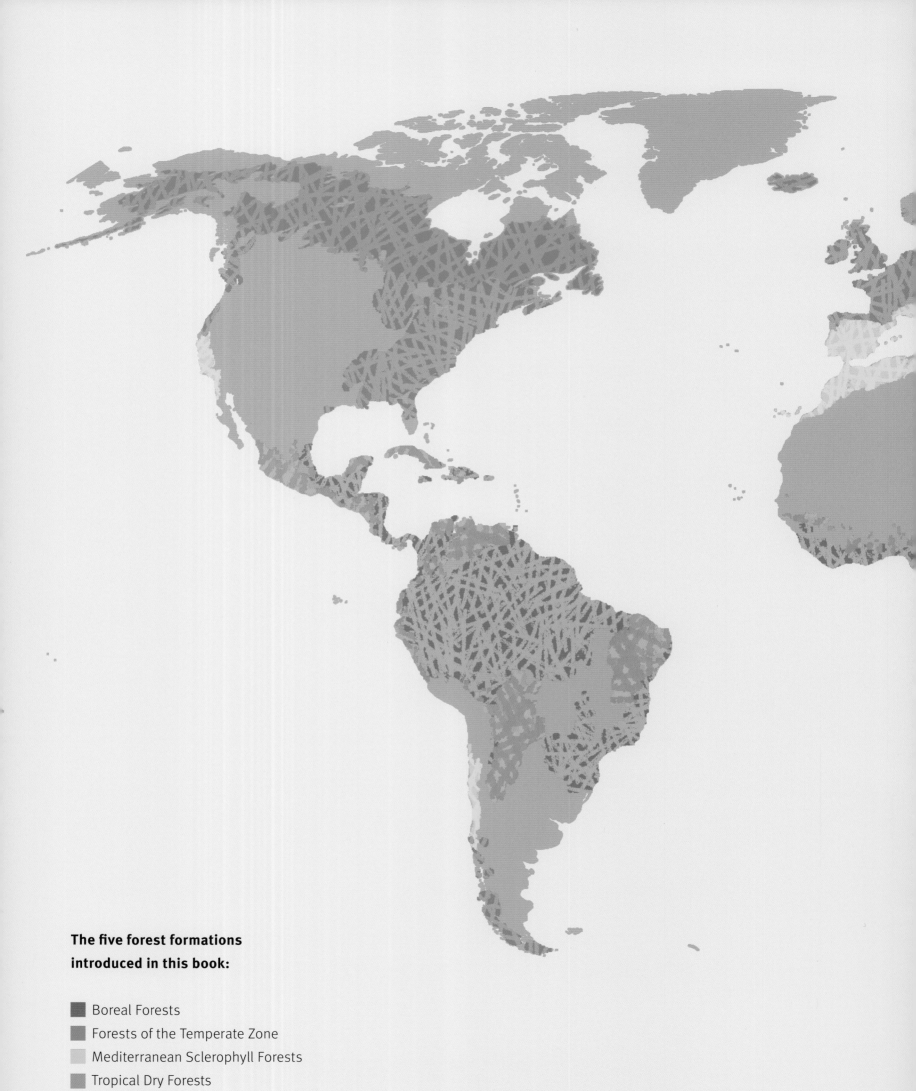

**The five forest formations
introduced in this book:**

Boreal Forests

Forests of the Temperate Zone

Mediterranean Sclerophyll Forests

Tropical Dry Forests

Tropical Rainforests

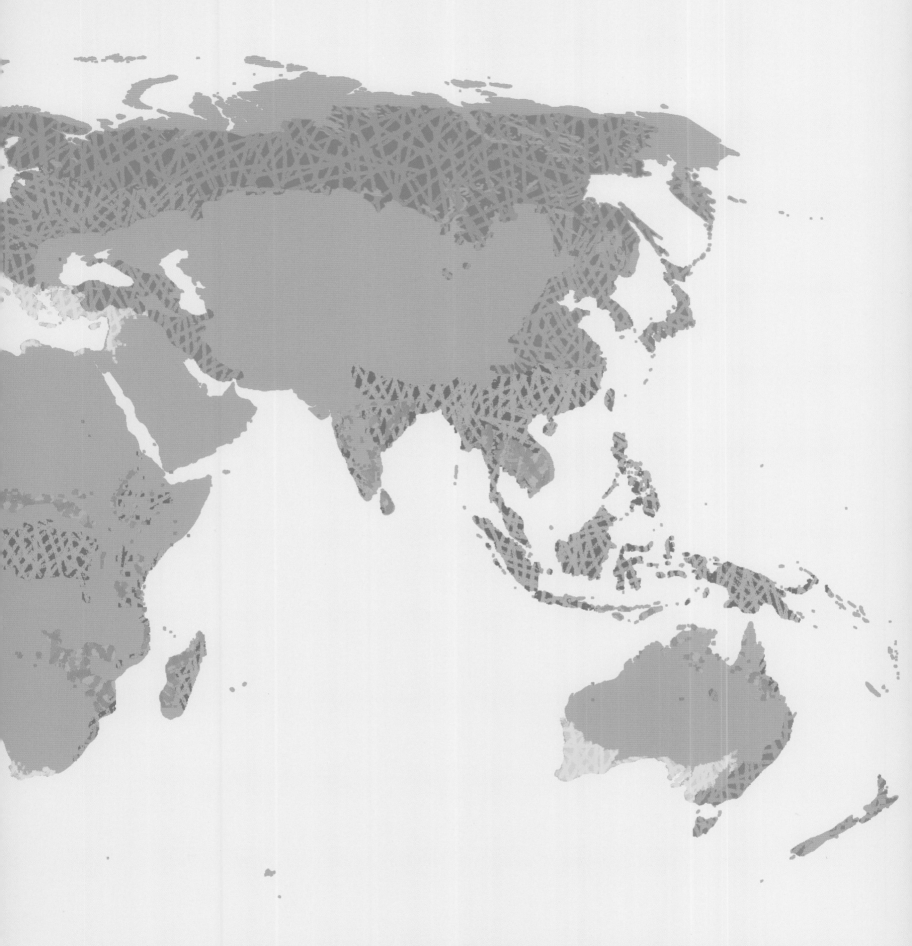

According to FAO data, 31 percent of the world's forests lie in Asia (including the Asian part of Russia); 21 percent in South America; 17 percent in North and Central America; 17 percent in Africa; 9 percent in Europe; and 5 percent in Oceania. Five percent of forests are plantations; and only five nations—namely: Brazil, China, Russia, Canada, and the United States—account for fifty-three percent of the global treed area.

Note: This overview map as well as the maps at the beginning of each chapter are for purposes of illustration and rough orientation, and do not claim to be exact depictions of the respective forest zones. More detailed maps can be found in the cited literature. The surface-area figures for each forest formation also vary significantly depending on the definition and survey method used, and should be understood only as rough approximations.

Foreword

by
Prof. Dr. Jürgen Bauhus

How the climate shapes forests is a very basic but at once highly current question. This year's celebration of the 250th anniversary of the birth of Alexander von Humboldt shows us it is an old question, for Humboldt was the scientific pioneer who first described the connection between climate and types of vegetation. Following Humboldt's classic descriptions, there has been a great deal of research on this topic, and we have a very good scientific foundation on the relationships involved in the climate shaping the forest on evolutionary time scales—on how all kinds of tree species, and the interlocking ecosystem, have become adapted not only to the climate per se but also to climate-driven soil conditions and disturbances. Conversely, the forest also influences the climate. It absorbs carbon dioxide from the atmosphere and contributes to cloud formation through evaporation and through its emission of natural aerosols, thus slowing global warming. Within this context, the original question of how climate shapes the forest takes on great importance. Because in many parts of the world, we are now observing how rapid climate change is stressing our forests. As immobile organisms with long lifespans, trees cannot escape the increasingly extreme effects of climate change. The adaptations they have developed in the past frequently no longer suffice to survive new pests or the extreme stresses of heat and drought. This book impressively articulates the delicate balance between the climate and the forests of the world's various climate zones, but moreover: It shows how easily humans can ruin that balance. This is a very timely book that should remind us that protecting our climate is the best way we can protect the world's forests.

Jürgen Bauhus
Professor of Silviculture, University of Freiburg
Freiburg, August 2019

The Fascination of the Forest

I went to the woods because I wished to live deliberately, to front only the essential facts of life, and see if I could not learn what it had to teach, and not, when I came to die, discover that I had not lived.

Henry David Thoreau (1817–1862)

From time immemorial, the earth's forests have provided us with wood, foodstuffs, and medicinal plants. They offer us shelter, economies are based on them, and many in today's world long to spend time in them. Depending on how the term is defined, forests cover between thirty-three and forty million square kilometers, or roughly a quarter of the planet's total landmass.[1][2] Forests comprise a mosaic of the most diverse habitats, usually with smooth transitions from one to the next. This makes blurry distinctions and inconsistencies unavoidable when designating forests as belonging to one formation or the other. For nature is loath to be squeezed into a prearranged system; and yet doing so makes sense in order to provide a certain structure for the abundance of tree-covered landscapes. Following the climate zones, one may distinguish among boreal forests, temperate-zone forests, and tropical forests. For this book, we have sub-divided tropical forests further into dry, seasonal, and year-round wet tropical forests; and with the Mediterranean forests, we have described a special transitional type between the temperate and subtropical climate zones.

Boundaries of the Forest

Forests represent the final stage of natural succession, that is: the form of vegetation that comes to exist in a particular place as a result of the climate and the environmental conditions. The overall ecology of a place is determined by fire, floods, storms, seasons, temperature, topography, soil characteristics, the doings of animals, incident solar energy, and the amount of precipitation. Humans, whose activities have led to the disappearance of many a forest, also play a significant role, of course (more on this in the chapter on "Changing Forests").

The timberline in polar regions and in alpine environments is determined primarily by temperature. If there are fewer than thirty frost-free days a year, the growing season is too short to support any more than scattered trees, as is the case in subarctic tree tundra. High-altitude conditions are similar: Montane forests in the Alps, for example, grow to elevations of about 1,900 meters (6,234 feet) on the northern slopes, whereas one finds larch-stone pine forests still growing at up to 2,400 meters (7,874 feet) in sunnier locations in the southern and central Alps.[3] Where water from precipitation has nowhere to go, bogs and swamps arise that hinder forest growth; and, by the same token, no forest can grow in rocky areas because of the lack of a sufficient humus layer. Too little precipitation gives rise to deserts, or to grass-dominated landscapes such as prairies, steppes and savannahs, the latter often in tandem with recurring fires.

What Is A Forest?

As defined by the Food and Agriculture Organization of the United Nations (the FAO), a forest is land spanning more than half of one hectare with trees higher than five meters and canopy cover greater than 10 percent. When one hears or reads official figures on how forests are trending globally, and these hold that the rate of deforestation worldwide is slowing, and that woodlands in some parts of the world are even recovering,

one should always bear in mind the very significant role of the way such reports define the term "forest." According to the frequently used FAO definition, a forest is a forest even if it has been completely cleared, but it is expected that forest will regrow in the same place. Tree plantations and species-poor reforested areas therefore count just as much as "forest" as untouched, primeval forests do.

What a forest is, and how to recognize and classify forests as they appear on satellite and aerial images, are complex matters. Tropical dry forests, for example, which shed their foliage almost completely at certain times of year, had long been overlooked. Distinguishing primary, i.e., largely untouched, forests from secondary, i.e., regenerated woodland or plantations, presents even greater difficulties for remote sensing. But new technologies, such as drones or laser-supported aerial imaging (LIDAR), are continually increasing the accuracy of forest monitoring.

It is certainly easier for people to agree about the ways forests benefit humans. Ecosystem services of forests are many: Forests provide us with fruits, leaves, tubers, nuts, game, and other foodstuffs; animals find nourishment and shelter from the sun in them; they keep us supplied with fuel, medicinals, and building materials; and they grant us protection from flooding,

high winds, landslides, and avalanches. Forests generate fertile soil and prevent soil erosion; they filter the air, purify the water we drink, and serve us with recreation and inspiration. Forests store large quantities of water and carbon, produce oxygen, generate evaporative cooling, and have a significant effect on weather and climate; and, last but not least, the earth's forests are home to millions of animal and plant species.

The Diversity of Trees

Worldwide, botanists recognize about 50,000 species of trees alone.[4] A rule of thumb holds that the diversity of trees among the earth's three forested climate zones increases by a factor of ten from the poles towards the equator. In boreal forest, tree species are still tallied in intervals of ten (160 known species); in the temperate forests, it goes up to hundreds (1500); and in the tropical and subtropical forests, thousands (43,000).[5] But it does not mean that all of those species occur in every forest in the respective climate zone. Tropical tree species in particular often grow only one here, one there, and are restricted to small areas. How many different tree species occur in a particular woodland depends, for example, on the complexity of the landscape and on the historical as well as the present climate. Ecologists measure the number of tree species per hectare (which

is about the size of a football field). This value, for forests in the part of Amazonia with the highest biodiversity, is over three hundred tree species per hectare; in the temperate forests of Europe, fifteen; and in the boreal forests, rarely more than five species per hectare.

Every Tree Is an Individual

But one must not reduce biodiversity to sheer numbers of species. It also includes genetic diversity within a species as well as the characteristics of the individuals within a population. This is particularly true for trees, which—due to their long lifespans, often many hundred to several thousand years, combined with their lack of mobility—depend on their populations being highly adaptable on the whole. Each tree pursues its own strategy. There are, for example, risk-averse as well as risk-tolerant deciduous trees of the same species. The one sheds its leaves too early in order to minimize the risk of desiccation, thereby forgoing valuable photosynthesis time. Others put more on the line and postpone shedding their leaves. They can produce energy longer, but assume the risk of coming to harm in a drought.

What is true for the diversity of tree species is also true for the diversity of other life forms. For the forest is much more than a collection of trees. It is a complex habitat, with thousands of species existing in a dense web of relationships. Trees and fungi mutually supply one another with nutrients; untold small organisms process leaves and wood into fertile earth; plants nourish animals, and animals assume the role of pollinating or of dispersing plant seeds in return. In an intact forest ecosystem, every organism, from slime molds to giant trees, is valuable. Even the tiny bark beetle, so feared by the commercial timber industry, fulfills an important function in a species- and structure-rich primeval forest: It removes old, diseased trees, and creates space and light for new ones.

Man-Made Forests

Humans have been using forests for thousands of years and forming new landscapes in the process. That humans are consciously creating forests by planting large areas with trees, or by promoting the natural regrowth of forests, is a more recent development. The spectrum ranges from timber plantations with fast-growing tree species such as pine, spruce, acacia or eucalyptus, to species-rich, secondary-growth forests. The thing is, more and more people are beginning to understand that forests are a valuable treasure which we ought to protect, and to use with care, for ourselves as well as for future generations.

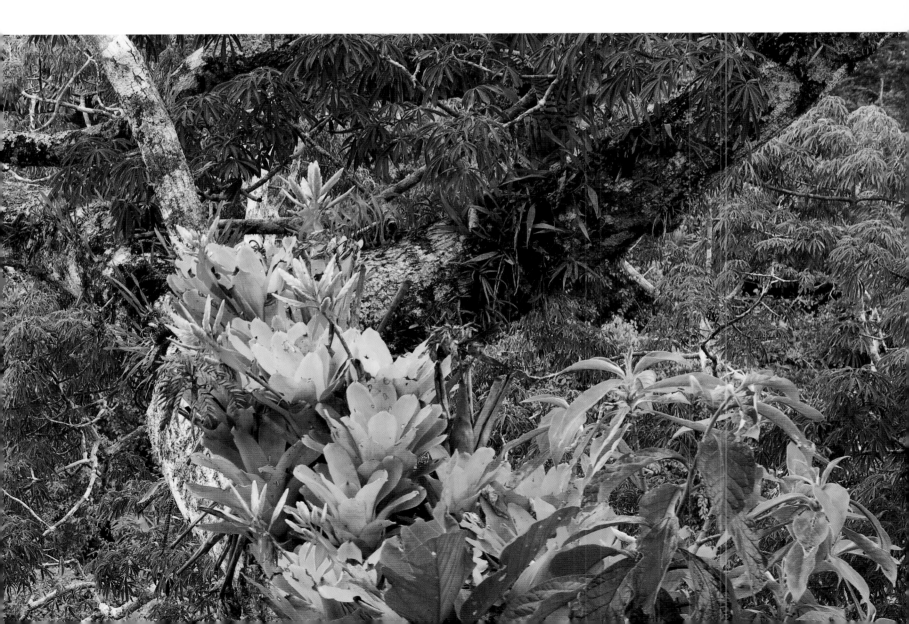

This book aims to convey the fascination of forests and to give an overview of their diversity, beauty, and importance, in the hope of expanding the circle of those who are committed to the concerns of the woods.

[1] Hansen 2010
[2] FAO 2010
[3] Jaun/Joss 2011
[4] Qian 2019
[5] Leuschner 2014
[6] Whittaker 1975

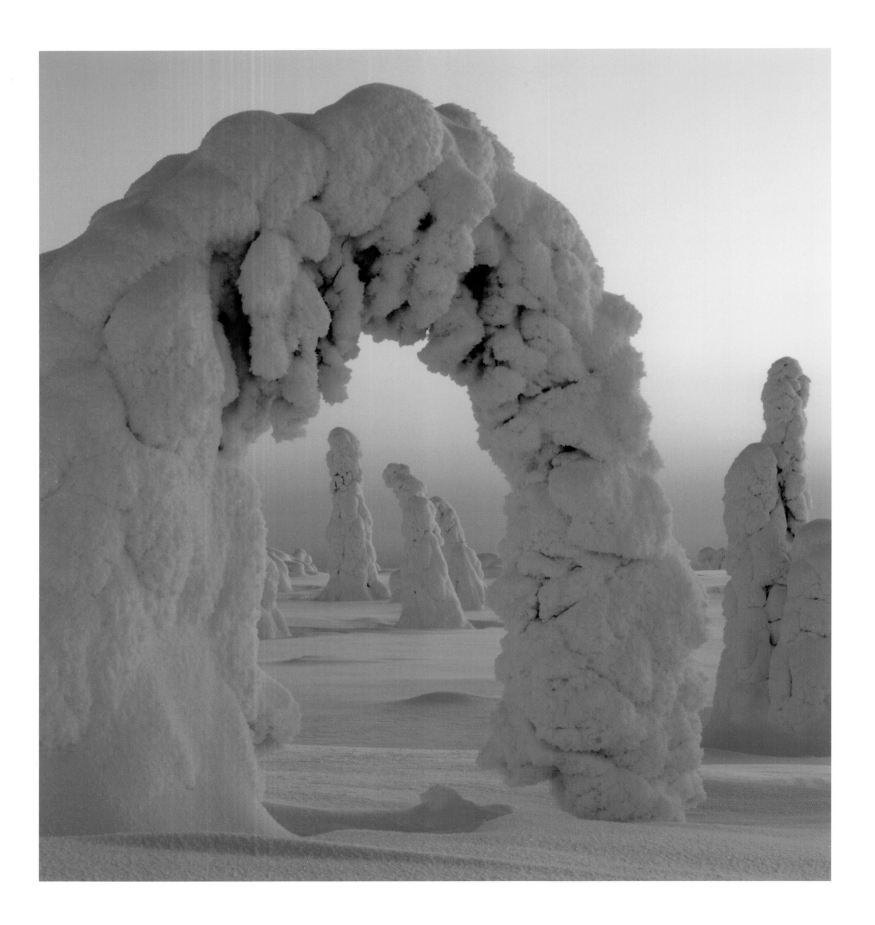

The climate forms the forest:

This diagram shows the relationship between temperature, precipitation and forest type.[6]
The transitions from one forest formation to the next are usually fluid.

Figure adopted from Fahey 2013, based on Whittaker 1975.

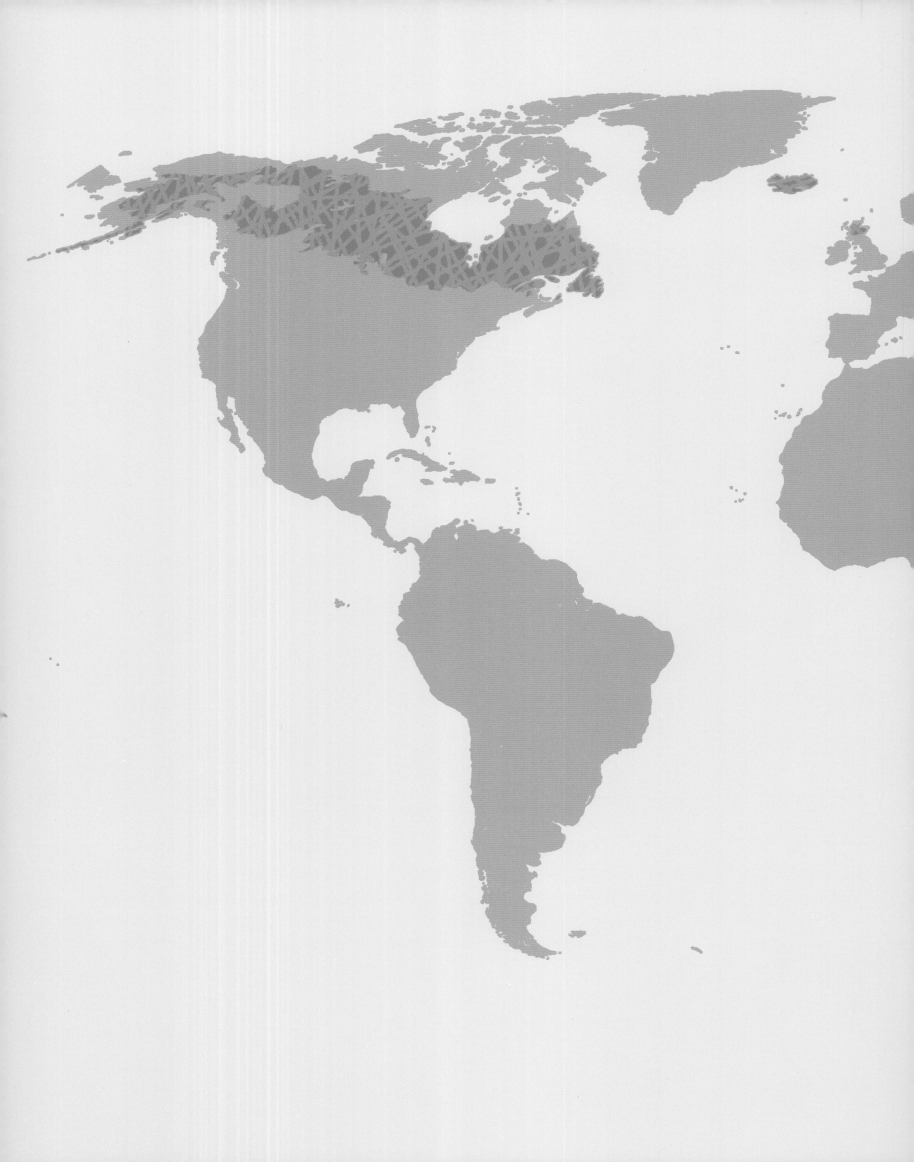

Boreal Forests
Land of Trees and Water

The northern coniferous forests withstand long,
hard winters and are home to moose, wolves and
snowshoe hares. Countless lakes, rivers and bogs punctuate
these vast forests which are regarded by many
as the purest form of wilderness.

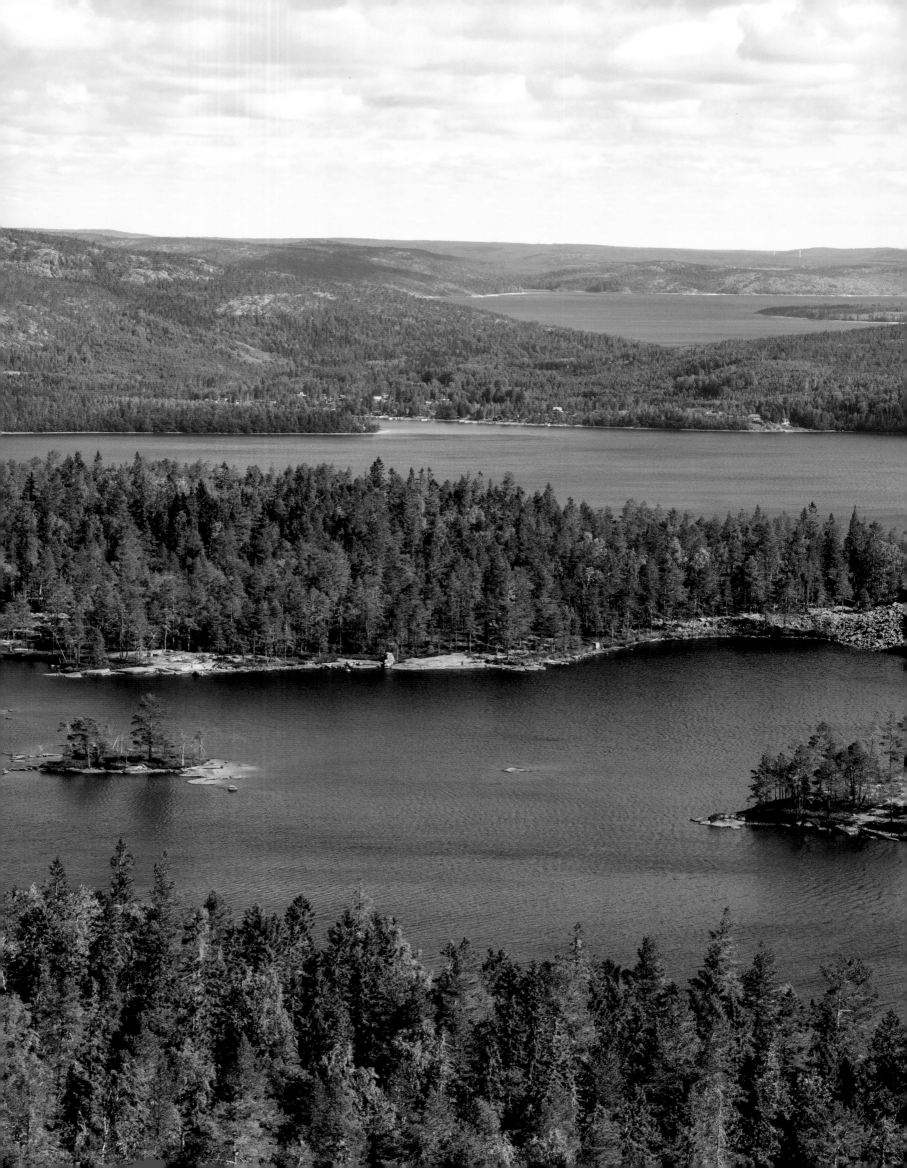

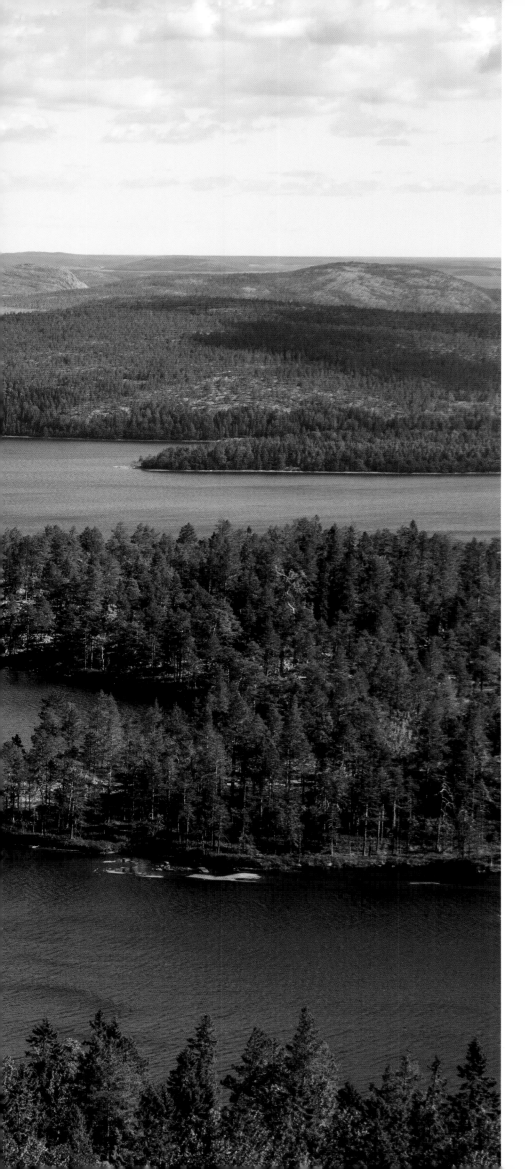

Characteristics evergreen; dominated by needle-leafed conifers; only a few widely-occurring tree species on the whole; long, cold and snowy winters

Distribution found in a broad belt across North America, Europe and Asia between the treeless arctic tundra to the north and the warmer, temperate latitudes to the south; similar to the forests of alpine mountainous regions in temperate latitudes

Typical tree species spruces, firs, larches, pines

Animals caribou, moose, wolf, brown bear, wolverine, snow hare, flying squirrel, migratory birds (in summer months)

Status threatened by climate change, mining and logging

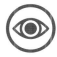

Special features the boreal forests contain a third of the living terrestrial biomass and thus store large amounts of carbon

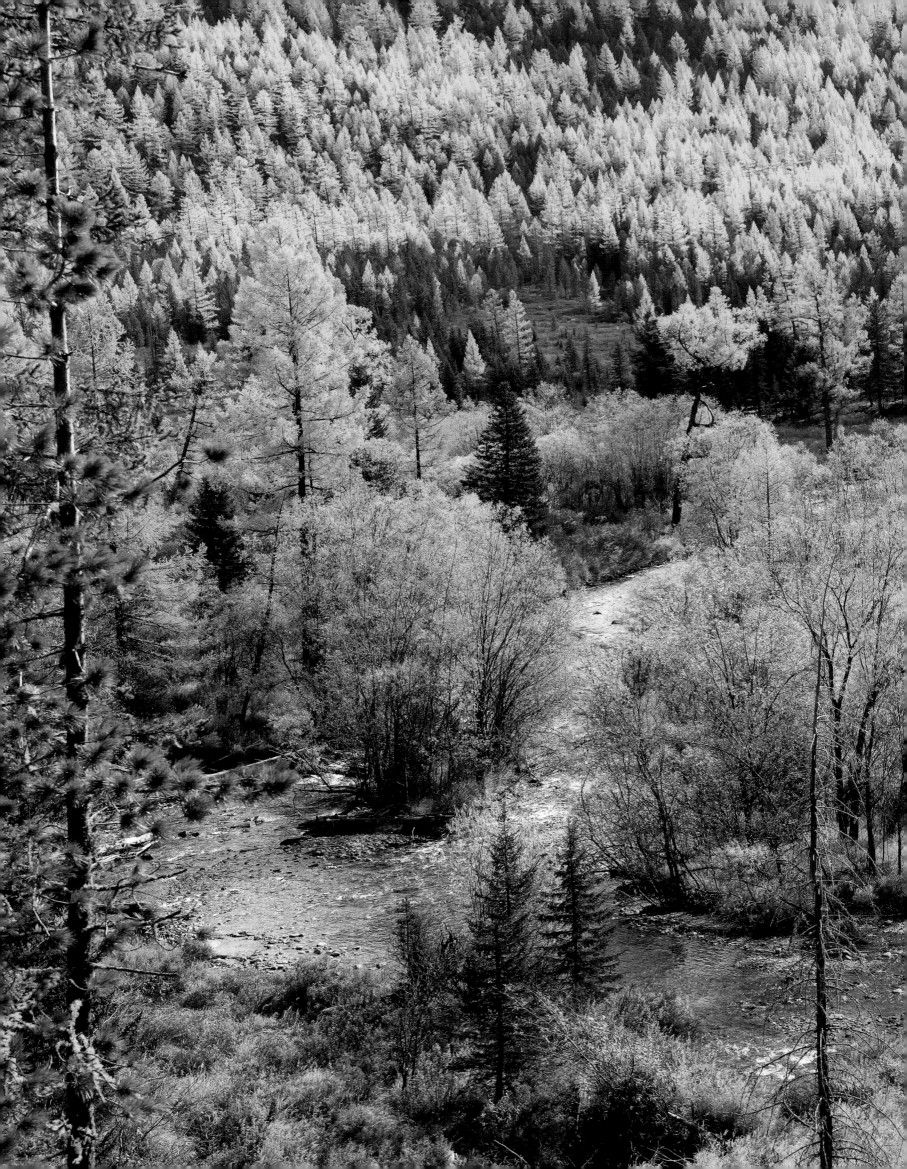

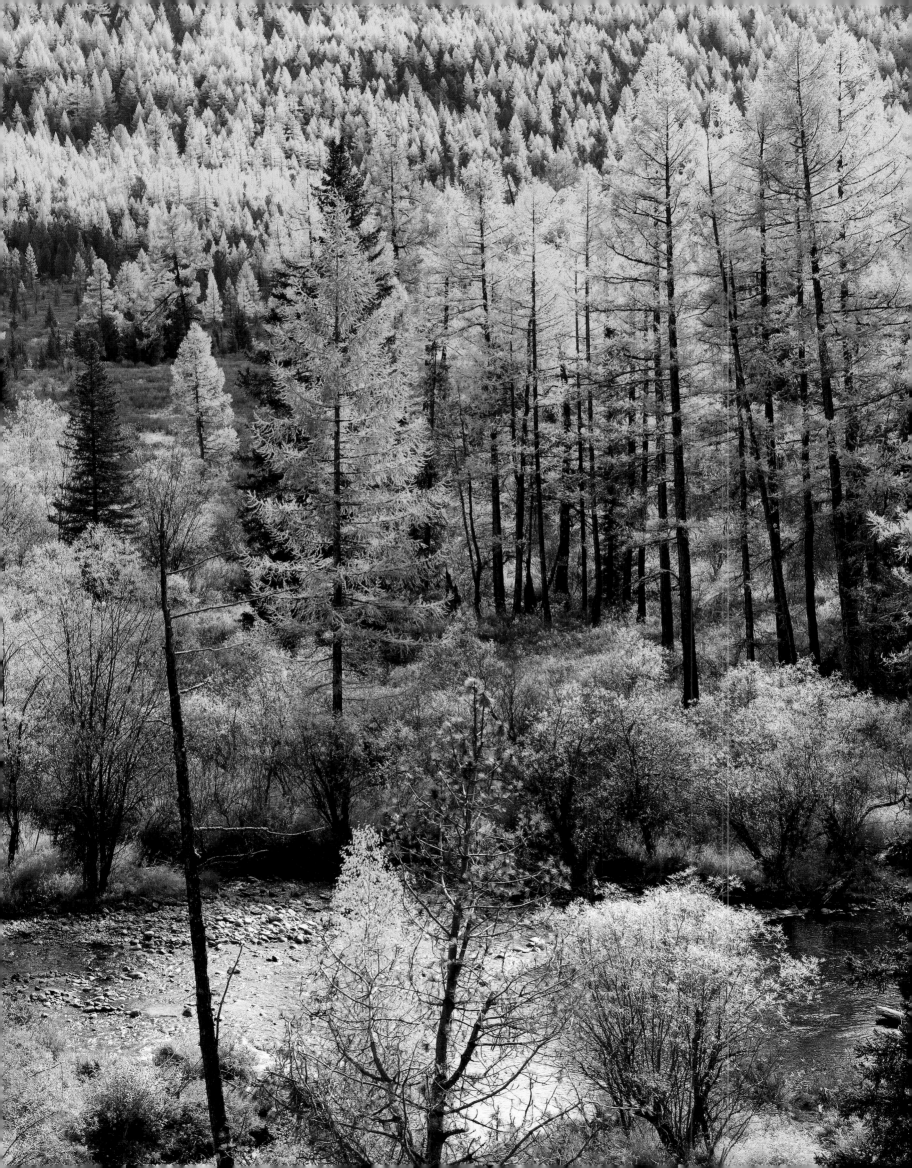

The Boreal Forest—Land of Trees and Water

The boreal[1] forest encircles the earth like a broad, green belt mostly between the 60th and 70th northern parallels. It borders on the treeless tundra to the north and transitions into mixed forests in the warmer regions at its southern boundary.

that include long, cold winters (with six to eight months of frost) and temperatures below −25°C (−13°F).[3] In its northernmost third,[4] the forest grows atop permafrost which remains frozen year-round below one-and-a-half to three meters (five to ten feet). Average annual precipitation rates are relatively low, ranging from 250 to 600 mm (10 to 24 in.); but due to

Previous page: **Siberian larches** (*Larix sibirica*) and Siberian stone pines (*Pinus sibirica*) line a river in the Altai Mountains of southwestern Siberia. Larches do what deciduous trees do: They shed their needles every year. The needles are also more simply constructed for this purpose, with a thinner epidermis and not much wax coating. // Above: **Bogland lakes** in a boreal forest in the Yamalo-Nenets area of western Siberia, Russia. Since huge tracts of the boreal zone are utterly flat, the permafrost is impervious to precipitation, and there is little evaporation, the rule in boreal forests is superabundant water. Depending on the degree of saturation and other soil characteristics, peat mosses thrive, and bogs form. Especially in the northern boreal zone, the resulting landscape is defined by a mosaic of woods, lakes and bogs.

"Boreal islands" are found in the mid-latitudes, at high elevations, where climatic conditions mirror those of the farther-northern latitudes; an example of boreal islands are the mountain forests of larch in the Alps. With a surface area of around fifteen million square kilometers,[2] the boreal forest is one-and-a-half times the size of Europe and accounts for one-third of the forested landmass on earth. Most of the boreal forest is found in Russia and Canada in rough climatic conditions

the short, cool summers, evaporation rates are low as well. Not only is the boreal forest the largest contiguous forested expanse on the planet, but it is also a water-rich terrain that hosts some of the biggest lakes, bogs, and free-flowing rivers on earth. It is for this reason that taiga, loaned from the Russian word for the swampy coniferous forest area of Siberia, is generally synonymous with "boreal forest."

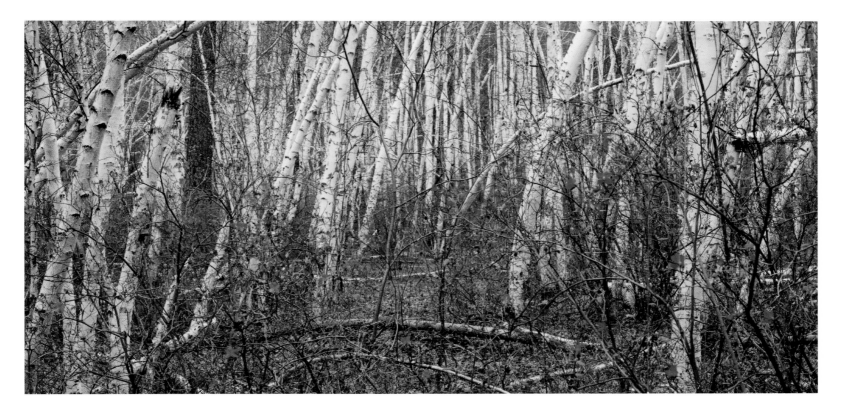

Blossoming birch forest. Near the banks of a river in Siberia, Daurian rhododendrons (*Rhododendron dauricum*) bloom among luminous white birch trunks. Birches are one of the few deciduous trees that grow all throughout the boreal forests.

Trees of the Boreal Forest

Boreal forest consists mainly of conifers, because conifers are better adapted than deciduous trees to low temperatures, drought and short growing seasons. Their wax-coated needles protect against transpiration and frost, and the trees conserve energy by not shedding their needles from year to year. Nonetheless, although there are only a few species of conifer that can survive in the harsh climatic conditions—spruces (*Picea*), pines (*Pinus*), firs (*Abies*) and larches (*Larix*)—these few are highly specialized. Larches are common foremost in the boreal forests of Siberia and are exceptional among needle-leafed trees in that they shed their needles in the winter. They obtain the benefits both of having needles and as well as of shedding leaves, thereby optimizing their protection from drought and frost. They are thus able to colonize even more unforgiving habitats than their evergreen needle-leafed relatives.[5] The Lukunsky grove in central Siberia—which, at 72° N, is the northernmost known forest—is composed mainly of Dahurian larch (*Larix gmelinii*). Despite extreme conditions, the trees reach heights of five to seven meters (sixteen to twenty-three feet) and can withstand winter temperatures of −70°C (−94°F).

The number of species declines as one moves farther north; there are forty different tree species along the southern boundary of the Canadian taiga but only about ten growing at its northern edges.[6] As the boreal forest gives way to tundra in a transitional zone called tree-line, timberline or krummholz tundra, tree density drops until the forest consists solely of small, isolated trees. Any farther north and it is too cold for trees; the vegetation transitions into low shrubs, grasses, mosses and lichens.

Black spruce (*Picea mariana*) and white spruce (*Picea glauca*) dominate across large expanses of North America's boreal forest; another common species there is the ponderosa pine (*Pinus ponderosa*). The Norway spruce (*Picea abies*) grows in Europe and the Siberian spruce (*Picea obovata*) in Asia, while Scots pine (*Pinus sylvestris*) is common across both continents. Approximately one-fifth of the boreal forest is occupied by more openly spaced larch forests.[7] Deciduous trees such as poplars, alders, birches and willows colonize gaps in the dense coniferous forests that come about as a result of fire, high winds, poor drainage, or insect infestations. Because of the climatic conditions, the trees in a boreal forest grow so slowly that the trunk of many a two-hundred-year-old tree is barely as thick as a person's arm. Some trees, such as the Siberian pine (*Pinus sibirica*), nevertheless reach impressive proportions: The tallest specimens of this species reach heights of up to forty meters (130 feet) high and are more than six hundred years old. To the Evenks, an indigenous people of the boreal zone of Siberia, these trees are holy beings whose magical energy—in the form of seeds from their cones—is supposed to guard against heart attacks and high blood pressure. These pine nuts are a favorite food of nutcrackers (*Nucifraga caryocatactes*), which store them in hidden winter caches in the ground. The caches, in turn, are plundered by Siberian chipmunks (*Eutamias sibiricus*).

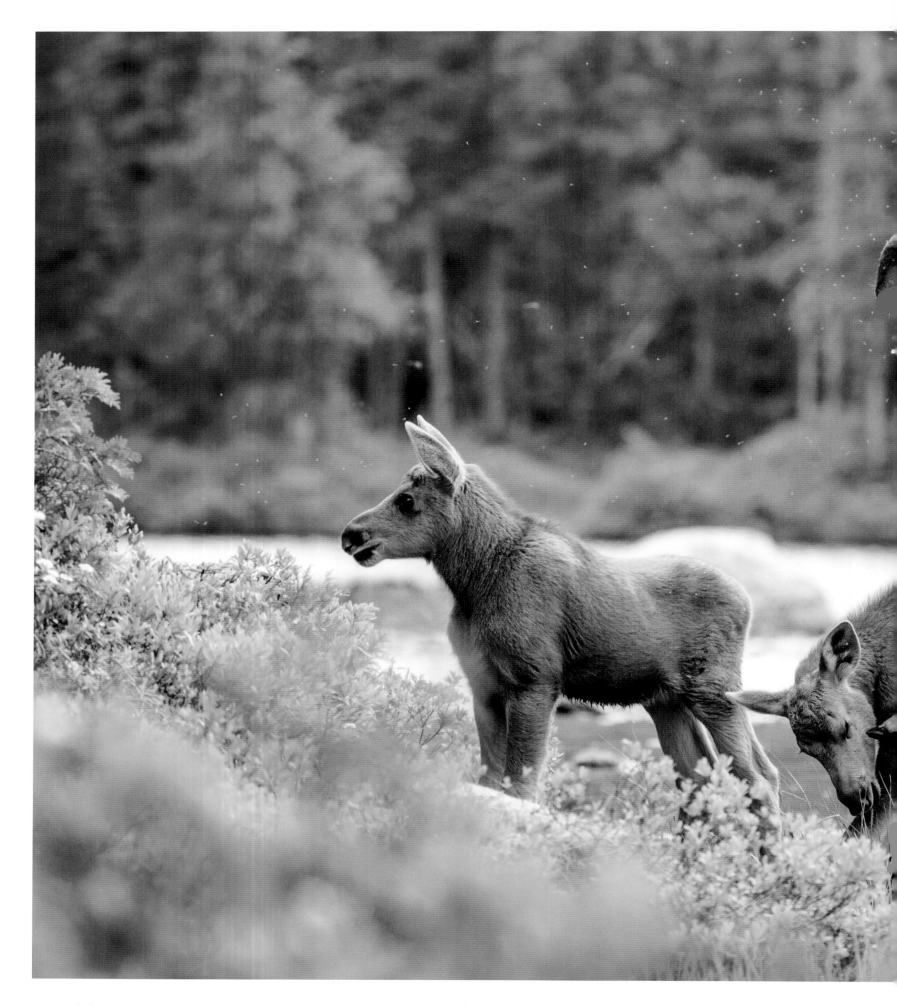

Moose (*Alces alces*) are quintessential inhabitants of boreal bog, swamp, and forest landscapes. They feed on buds, leaves, and young tree shoots and thereby have a considerable effect on the structure and the extent of forests. Shortly after birth, moose calves can already keep up with their mother. They arrive in the spring, when food is particularly plentiful.

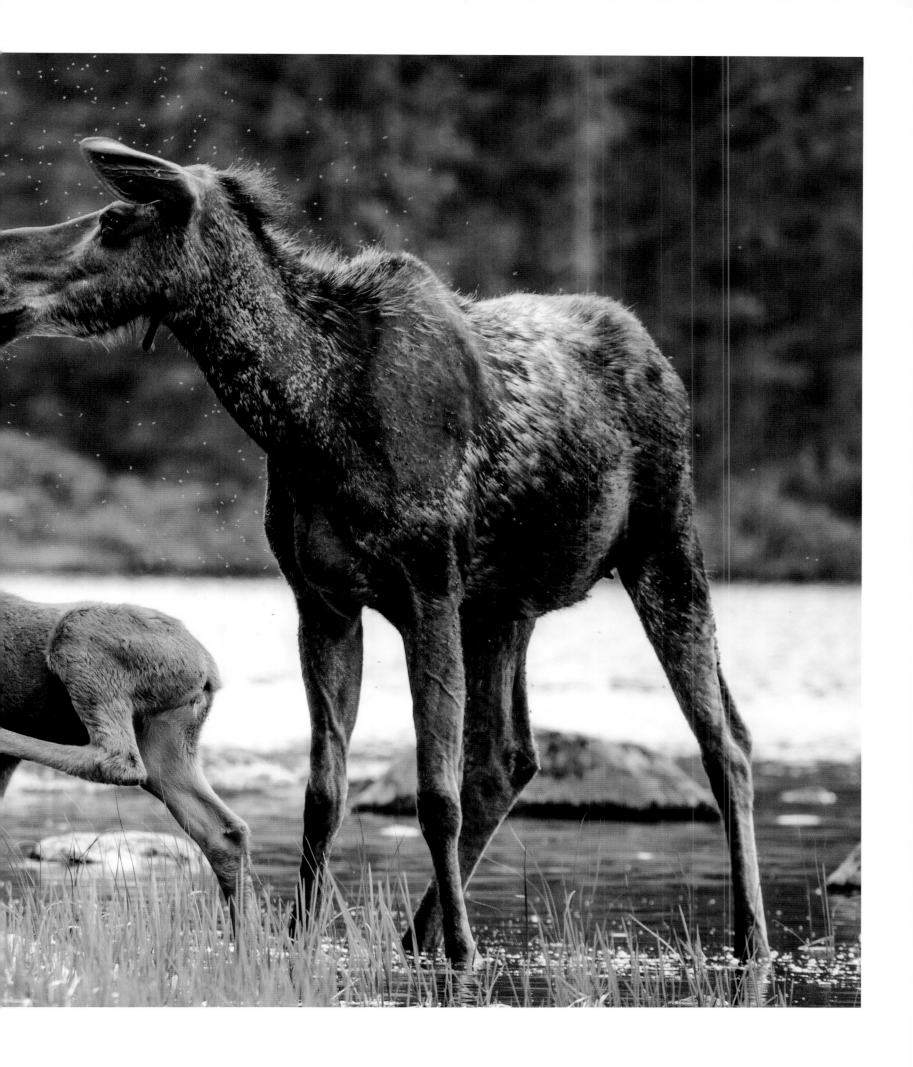

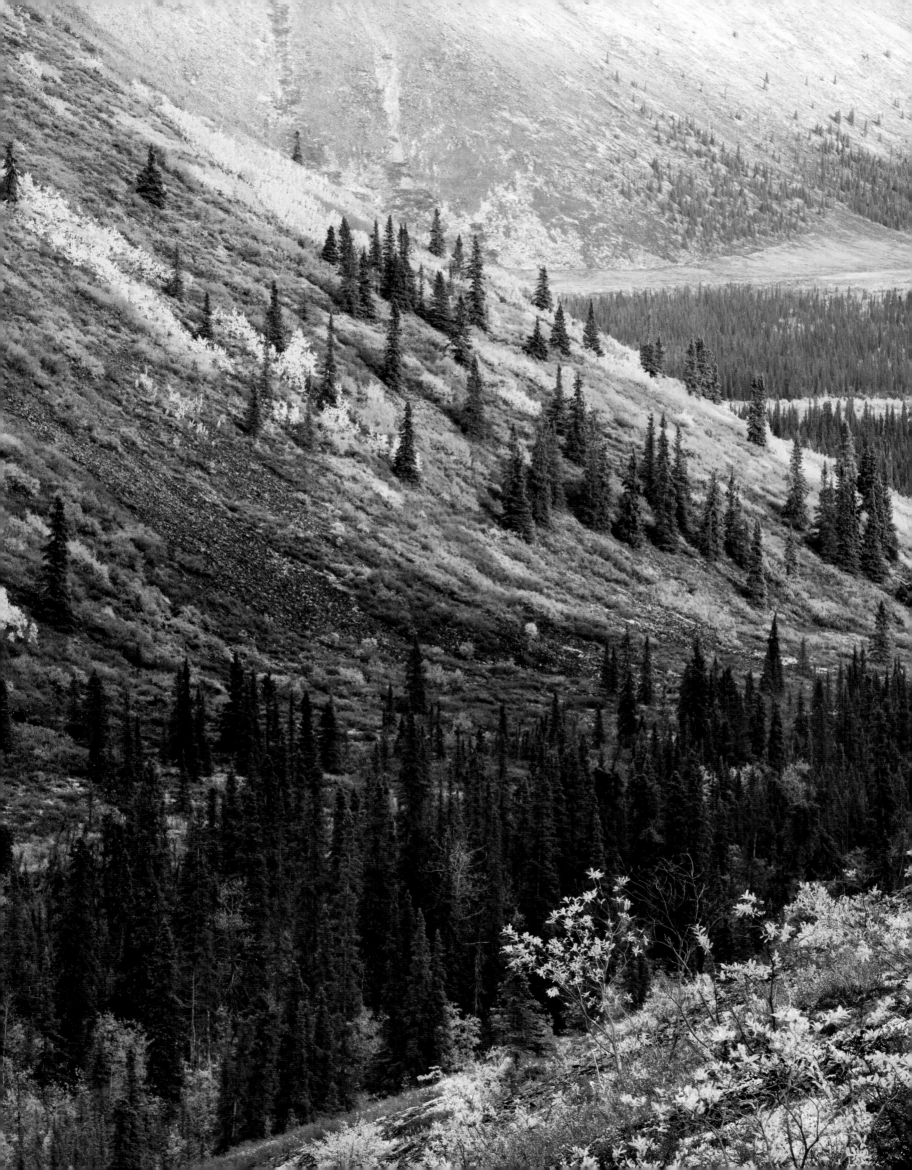

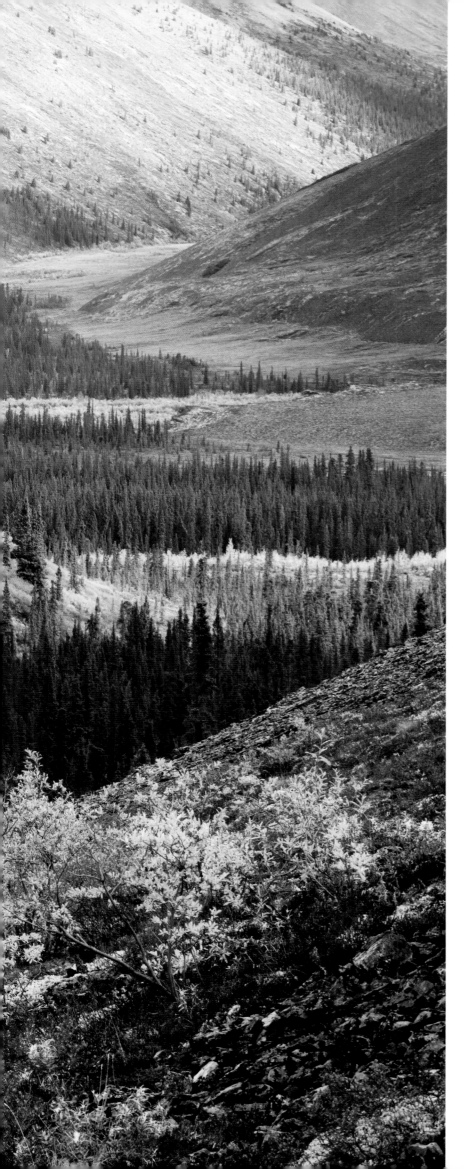

At present, the disappearance of boreal forests is proceeding at speeds second only to tropical forests, not just in absolute terms but also in proportion to their total area. Across Fennoscandia the loss of boreal forest is due mainly to clear-cutting by the timber industry, while forest fires are the reason for much of the losses in North America and in parts of Eurasia.

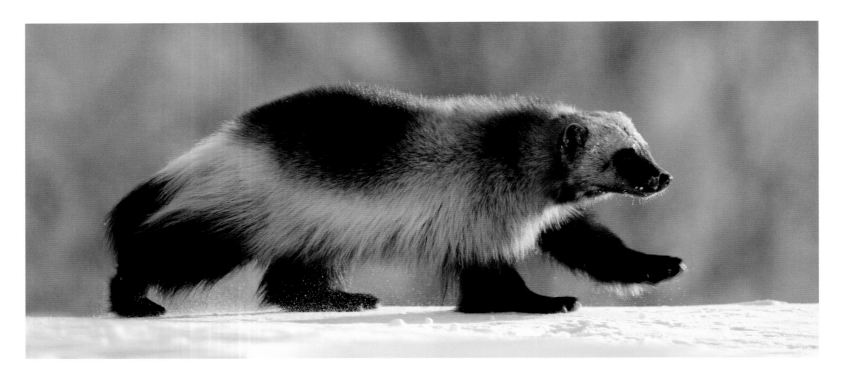

Boreal hunter. The wolverine (*Gulo gulo*) forays far out onto the treeless tundra. The wolverine's range once extended further south, but hunting by humans forced it to retreat.

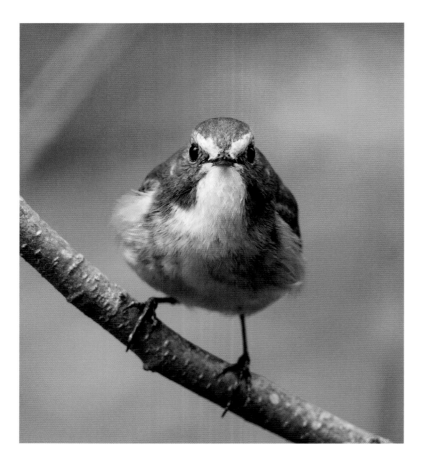

Widely traveled summer guest. The red-flanked bluetail (*Tarsiger cyanurus*) breeds in the boreal forests of Eurasia from Finland to Japan, and winters in southern China. This shy bird is slightly smaller than a European robin and feeds on insects that it nimbly picks out of the air.

The following spring, lost or forgotten seeds are in an excellent position to germinate—and so both animal species make a contribution to the spread of the tree.

Ice Frogs and Frozen Foods: Animals in the Boreal Forest

Just a few animals have learned to survive year round in the harsh climate. Among the year-round-resident birds of the boreal forests are Siberian jays (*Perisoreus infaustus*) and Canada jays (*Perisoreus canadensis*) as well as several species of owls and woodpeckers, like the great gray owl (*Strix nebulosa*) and the three-toed woodpecker (*Picoides tridactylus*). In defiance of winter, when the forest gets buried in ice and snow for months on end, many birds have developed amazing strategies. Canada jays, for example, cement caches of food to tree trunks using special salivary glands and already lay their eggs in late winter, in ice and snow and temperatures that can fall to −30°C (−22°F). Since the eggs also tend to hatch before it warms, the parents often feed reserves of frozen food to their young.

In summer, however, the extensive forests are an important habitat for billions of migrating birds, where they either breed or stop over to rest on their way to the tundra. About half of the bird species that occur in the temperate latitudes of the Northern Hemisphere spend part of their lives in the boreal forests. Among them are the yellow-bellied sapsucker (*Sphyrapicus varius*), a type of woodpecker; or the dainty Canada warbler (*Cardellina canadensis*), which fledges its young in the taiga of North America but overwinters in northern South America.

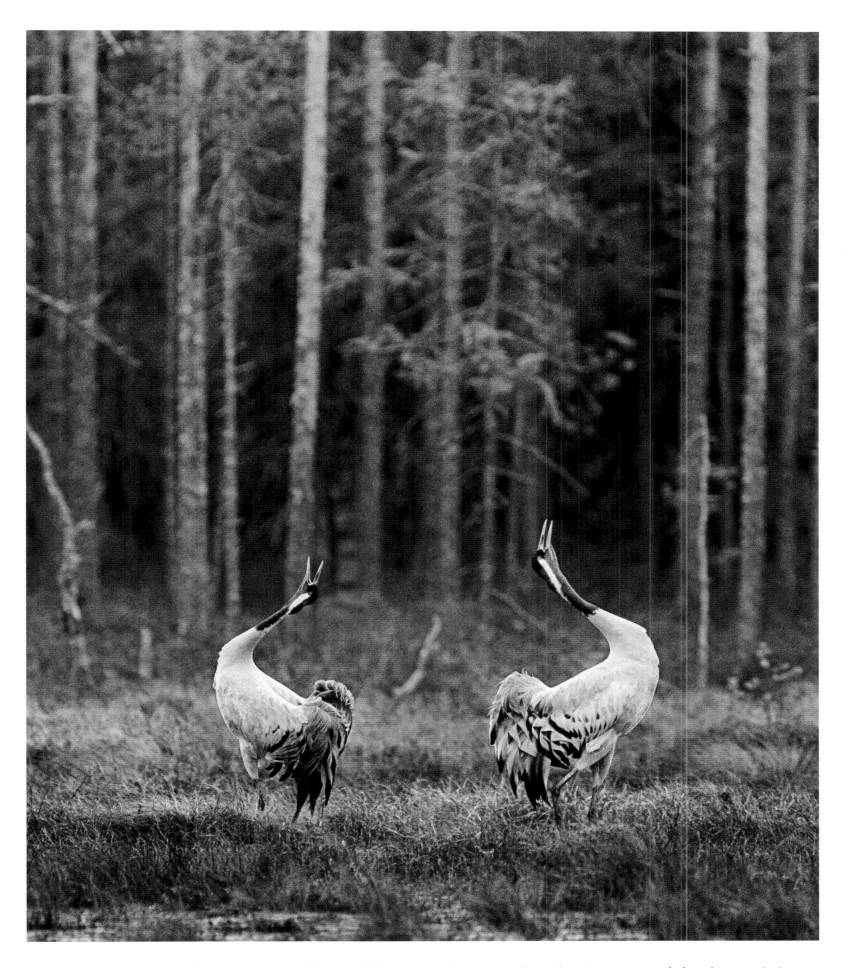

Cranes in a courtship display. The common crane (*Grus grus*) likes to nest in bogs or marshes, where its eggs are safe from foxes and other adversaries. This pair, in Finland, has evidently already found a suitable place to brood and begun the courtship ritual.

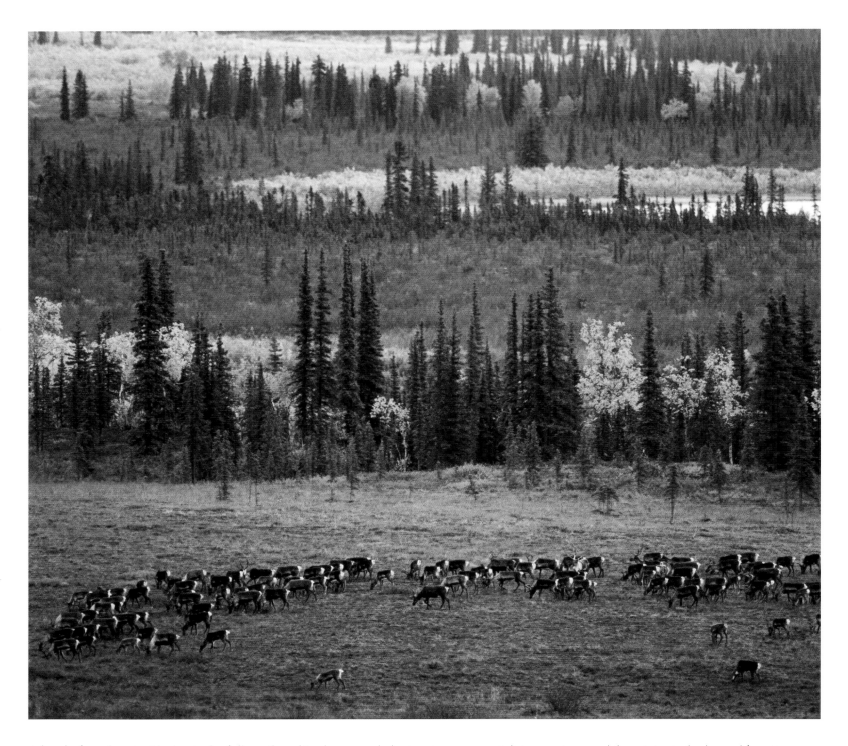

A herd of caribou in Alaska. In the fall, caribou (*Ranker tarandus*) migrate over great distances to spend the winter in the boreal forest (the taiga). Then they return for the short arctic summer, in order to calve on the tundra.

The red-flanked bluetail (*Tarsiger cyanurus*), an Old World fly-catcher, breeds in northern Eurasia but migrates into southern China, Japan and Korea for the winter. Ruffs (*Philomachus pugnax*), common cranes (*Grus grus*), whooper swans (*Cygnus cygnus*) and wood sandpipers (*Tringa glareola*) are also found across much of the boreal forests.

The numbers of reptiles and amphibians to be found in boreal forests are, at best, sparing. Exceptions to this are the vivipa-rous lizard (*Zootoca vivipara*) and the North American wood frog (*Rana sylvatica*). The latter's range extends into northern Alaska, and it enters a state of deep-freeze in the winter during which it can survive up to seven months on ice thanks to its body's own antifreeze agent.

Reindeer—Nomads of the North

Reindeer (*Rangifer tarandus*, known in North America as caribou) are members of the deer family. Much like migratory birds, rein-deer likewise undertake long migrations into the boreal forests. But they spend not the summer, but rather the winter in the safety of the forest, where they rely on reindeer lichen as well as on

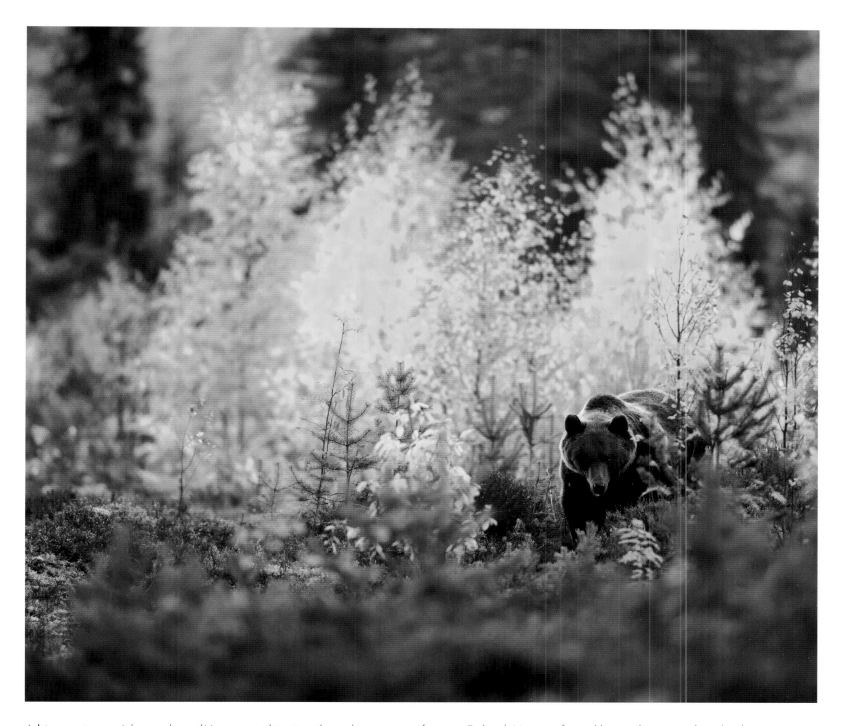

A big omnivore. A brown bear (*Ursus arctos*) trotting through an autumn forest in Finland. Humans forced brown bears to abandon large parts of their former ranges. But boreal forests today still offer brown bears undisturbed habitats. A brown bear's diet is highly varied, with lots of vegetarian fare such as fruits, mushrooms and leaves, supplemented by ants, eggs, fish, carrion, and small mammals.

their bodies' fat reserves for survival. In the springtime, when temperatures rise and the days begin to lengthen again, the reindeer migrate north toward the tundra, where they spend the Arctic summer birthing their calves and replenishing their fat reserves as they feed on leaves, shoots, herbs and grasses. Reindeer are particularly vulnerable if—as is happening more and more with climate change—precipitation falls as rain and then freezes when temperatures suddenly drop. Then the plants the animals depend on for food (which would otherwise be protected by a blanket of snow) become inaccessible, and the reindeer starve. If the thaw sets in too early at the end of winter,

then the rivers the herds of reindeer cross on their long migrations become insurmountable obstacles. Few other mammals live in the boreal forests year round. Those that do include rodents such as mice and flying squirrels, frugal herbivores such as bison and moose, and carnivores such as fox, bears, wolves and lynx. The wolverine, a member of the mustelid family, can weigh up to thirty kilograms (sixty-six pounds) and is excellently adapted to its northern habitat. Its summer diet consists of berries, insects, fish, eggs, birds, lemmings and carrion. In the winter, wolverines shift to larger prey such as snow hare, black grouse, and, occasionally, a reindeer or a young or sick moose.

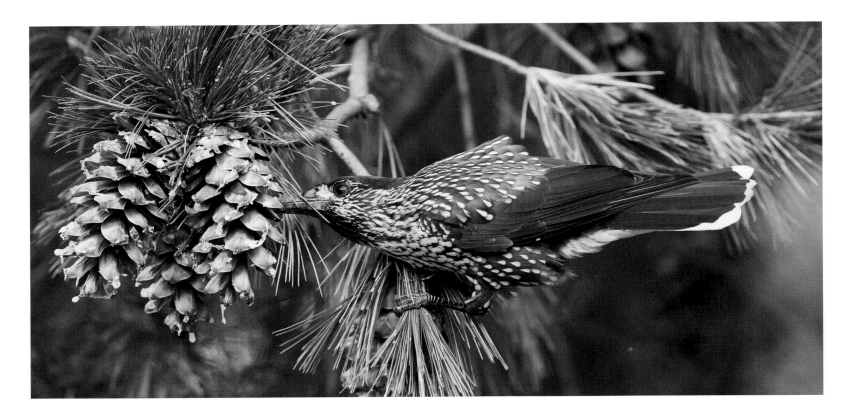

A nutcracker at harvest. A nutcracker (*Nucifraga caryocatactes*) skillfully teases the tasty seeds out of pine cones. These large birds with powerful beaks are specialized dwellers in coniferous forests, and the counterparts of the Eurasian jay, which lives farther south. Just as jays in the winter feed on stores of acorns, nutcrackers in the winter feed on hazel- and Siberian pine-nuts. During late summer and fall, they have laid their winter reserves in thousands of locations in the ground—making them, along with chipmunks, important seed-dispersers of the boreal forest.

Cheeks stuffed with nuts. Like nutcrackers, Siberian chipmunks (*Eutamias sibiricus*) lay winter reserves of nuts—the seeds of trees—all across the forest floor. Many are never again found by the animals, remain in the ground uneaten and, being seeds, thus find themselves very well situated to germinate the following spring.

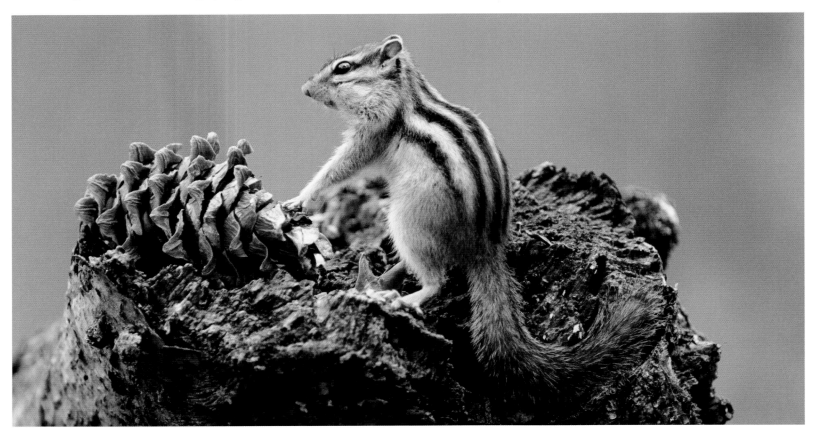

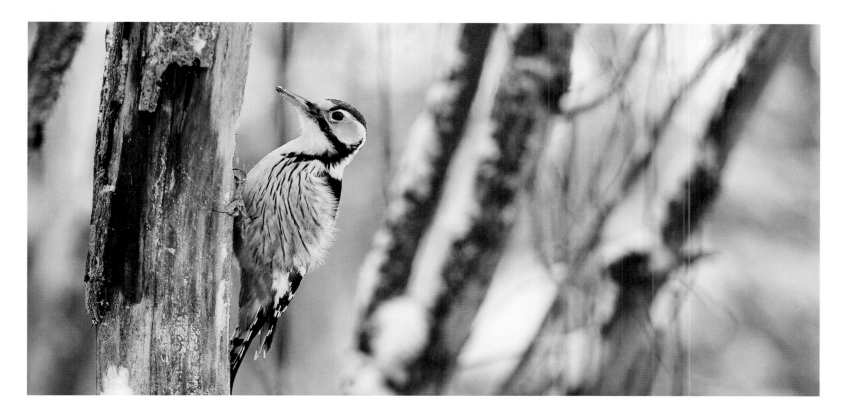

Hunting insects in deadwood. The white-backed woodpecker (*Dendrocopos leucotos*) loves woods that open up with a high proportion of dead and dying trees; for it is in rotten, decomposing wood and beneath flaking bark that it finds its favorite food: plump grubs and caterpillars. In summer and fall, it also likes to feed on berries and nuts. White-backed woodpeckers are not migratory and overwinter in the boreal forests of Eurasia as well.

A blot of color in the woods. The common redpoll (*Carduelis flammea*) breeds all around the Arctic in openings in the boreal forest. It feeds mainly on seeds, which it finds in the winter primarily on birches and alders.

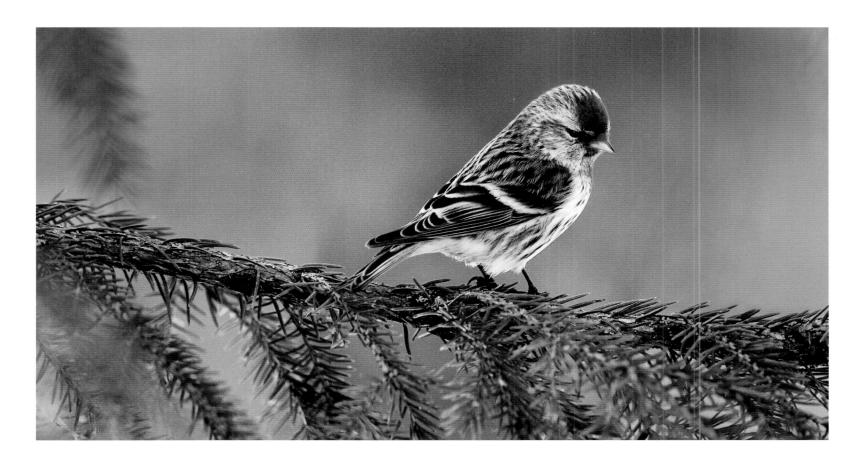

Great grey owl in driving snow. The great grey owl (Strix nebulosa) is a specialized hunter of mice and lemmings. Like all owls, the great grey's specially shaped feathers and wings let it fly almost without a sound, leaving unsuspecting mice with little opportunity to escape. It uses its keen sense of hearing to precisely locate prey, even beneath the snow. Great grey owls brood in nests abandoned by hawks, or in stumps in stands of old spruces and pines in the mid-boreal zone.

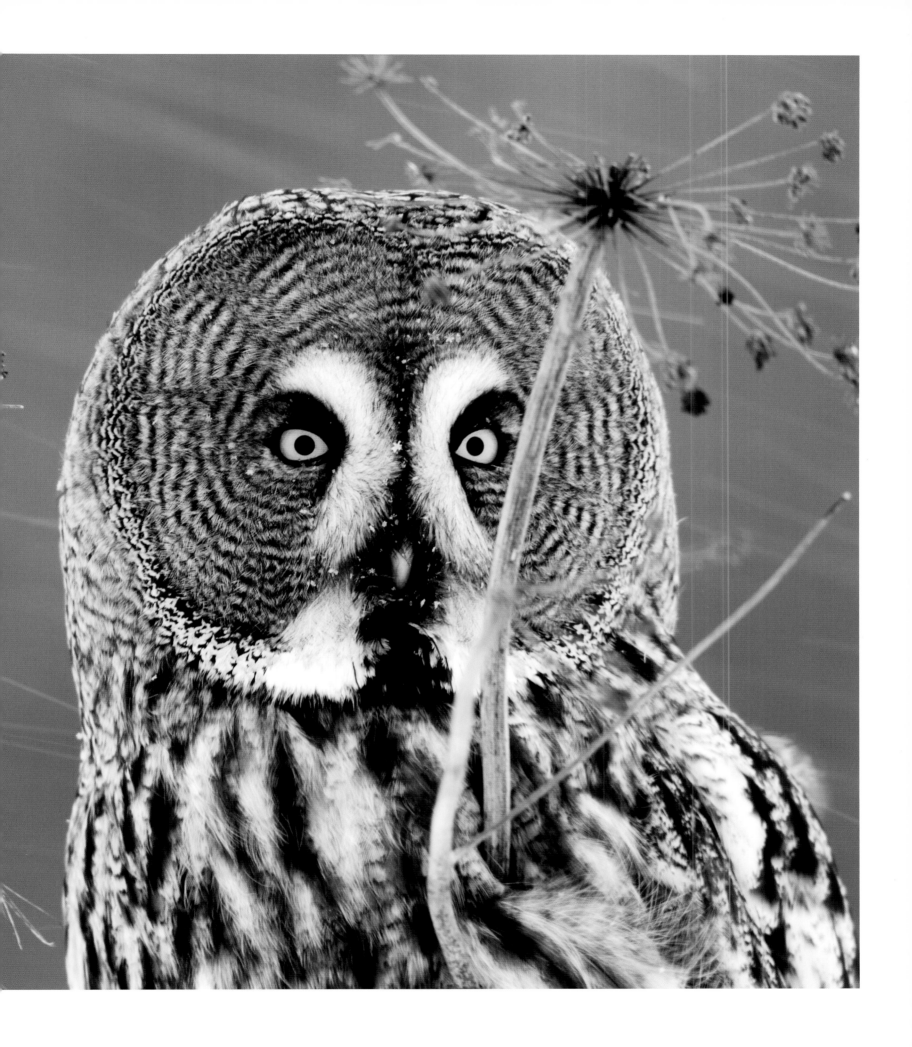

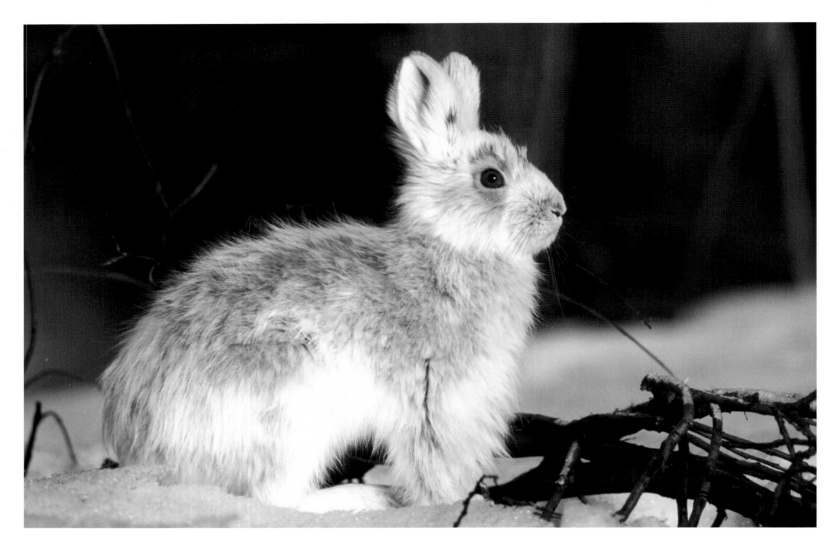

Above: **Molting snowshoe hare.** Snowshoe hares (*Lepus americanus*) inhabit the boreal forests of North America. They have dense fur on their hind paws, and their fur goes from being brown in the summer to being thick and white in the winter. They prefer varied habitats at the edges of woods and clearings. // Right: **A fairytale forest.** A boreal forest in deep snow in Lapland, Sweden.

The wolverine is a runner with great stamina and dense fur on the undersides of its paws that prevent it from breaking through the snow.

Snowshoe Hares Need Fire

Wild forest fires, caused by lightning strikes, play an important role in the ecology of boreal forests. Fires burn through dry regions at intervals of twenty to one hundred years; in wetter areas such as river valleys, fire comes more like every two hundred years.[8] An old tree can thus have survived several fires over its lifespan. For this reason, many plants have adapted to periodically recurring fires and have even come to depend on them—only after a fire will a cone of some pine species release its seeds. The most important effect of fire is that sunlight can penetrate to the forest floor, where it used to get filtered out by the tree-crowns; this allows an interesting mix of vegetation to flourish for a few years before the conifers dominate once more. Many animals also depend on fire. If it were not for fire, snowshoe hares (*Lepus americanus*)—typical dwellers of the North

American boreal forest zone—would starve to death. The sap of the dominant black and white spruces contains camphor, which protects them from browsing herbivores. It is only in more open areas that the hares can find enough food, where herbaceous plants, shrubs, and deciduous trees receive enough light to grow. But the hares also need the dense spruce forest—for protection against predators like the lynx. This is precisely the kind of landscape mosaic that regular forest fires create.[9] Grouse—like the wood grouse (*Tetrao urogallus*), the black grouse (*Tetrao tetrix*) or the willow ptarmigan (*Lagopus lagopus*)—likewise rely on this mixture of woods and clearings to assemble their varied diet of fresh sprouts, berries, seeds and insects. Besides high winds and fire, insects play an important role in regulating light and thus in letting new life take hold in the boreal forest: Bark beetles damage growing tissue on the trees, and an infestation can result in a die-off of many acres of forest. The larvae of the spruce budworm (*Genus Choristoneura*) can have similar effects, eating the needles and buds off the trees. The latter often occur in large numbers in North America.

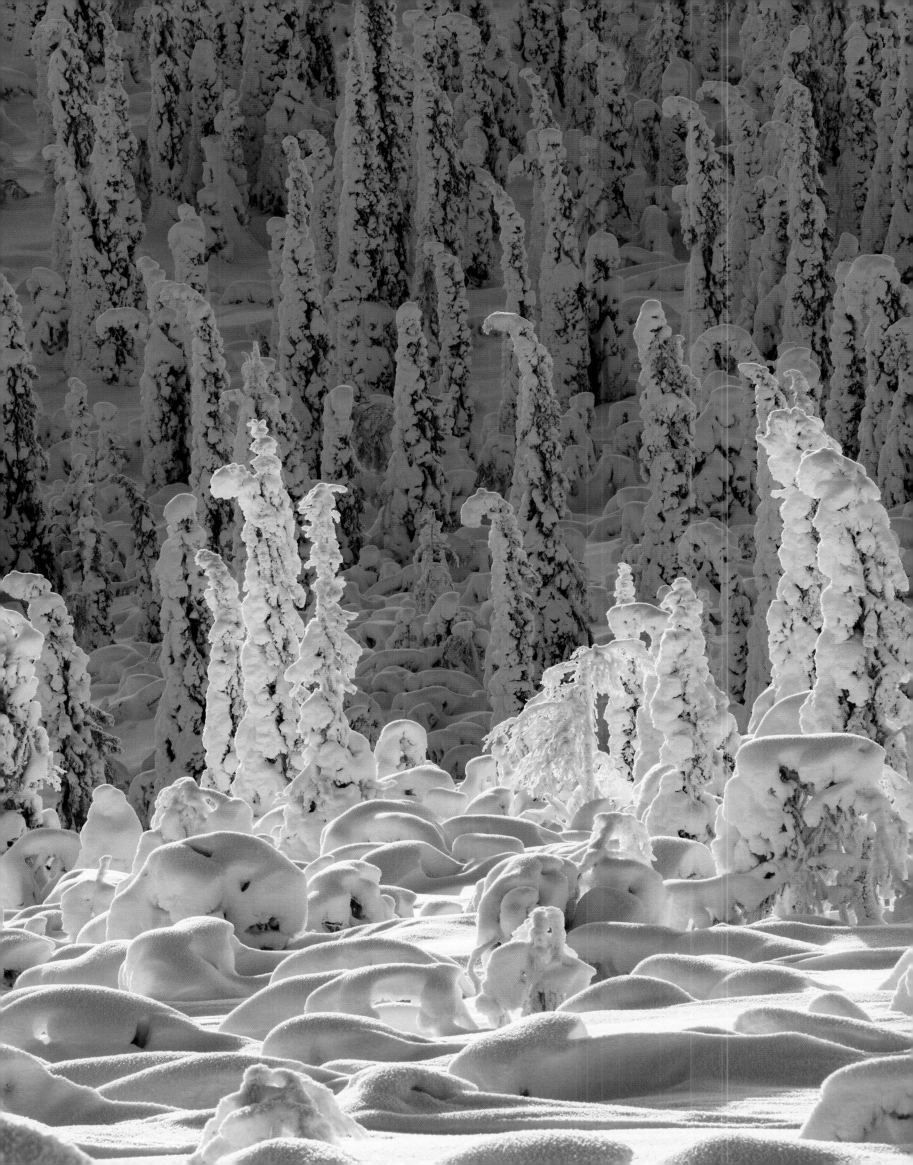

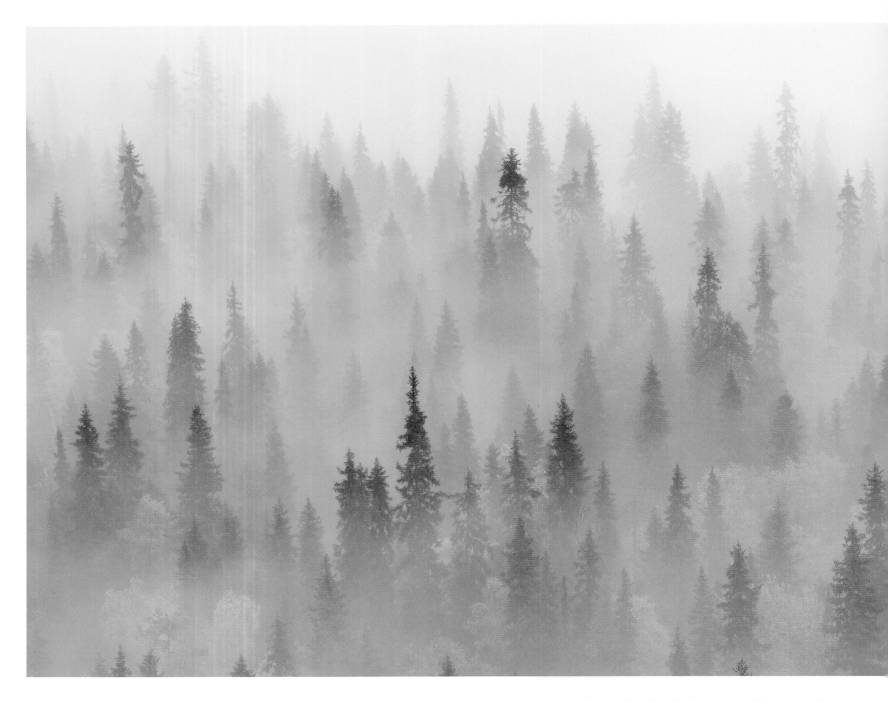

Threatened Guardians of the Climate

Because the boreal forest covers such a large area, and because biological processes in it are so slow due to low temperatures, boreal forest is an important carbon sink. Huge quantities of carbon have been stored here over the millennia, most of it in the forest soil. The boreal forests thus easily compete with tropical rain forests as far as their significance for the global climate is concerned. And for now, the boreal forests are taking up more greenhouse gases than they are releasing. Climate models, however, assume that this relationship could soon reverse.[10] Current warming of the earth's atmosphere is making itself particularly felt near the poles. Shorter cold spells, thawing permafrost, increased insect damage, and more frequent forest fires are only a few of the consequences. Even many animal species such as reindeer or migratory birds are having trouble with their seasonal patterns because they cannot adapt quickly enough to the new conditions.

Although satellite data show that the belt occupied by boreal forest is gradually expanding farther north and that the surface area of boreal forests around the world is relatively stable,[11] these immature forests lack the numerous ecological niches of a centuries-old forest. Especially at the southern edges of the boreal forest, humans are a direct threat as woodlands are vanishing in favor of mining activity, tar-sand extraction,[12] hydro-electric power, and clear-cutting for timber. On the other hand, there may be reason for optimism, in that Canada has stepped up protections for boreal forests, and environmental initiatives in many places have been advocating for more sustainable use of this valuable resource.

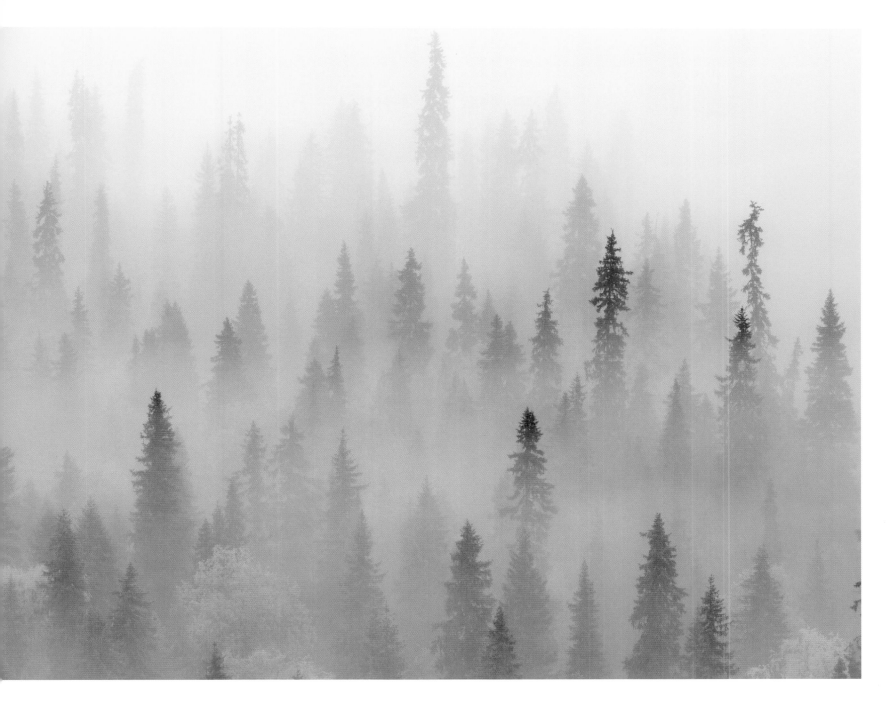

Fog in the autumn forest, Oulanka National Park, northern Finland, on the Russian border. Boreal tree species such as spruces grow across huge areas and exhibit high intraspecific genetic variability. This genetic diversity lets species survive even such disturbances as major forest fires, blowdowns, and insect outbreaks. However, it can take a long time for the forest to reestablish itself in areas that become deforested in the harsh conditions of the far north.

1 Boreal: From Latin Boreas; ultimately from the Greek name for the north wind; belonging to the northern climates of Europe, Asia and North America
2 DeAngelis 2019
3 Gauthier 2015
4 Gauthier 2015
5 Gower 1990
6 DeAngelis 2019
7 Gauthier 2015
8 DeAngelis 2019
9 DeAngelis 2019
10 DeAngelis 2019
11 FAO2018, https://psmag.com/environment/the-planet-now-has-more-trees-than-it-did-35-years-ago
12 https://blog.globalforestwatch.org/commodities/tar-sands-threaten-worlds-largest-boreal-forest
13 Schmitz 2014

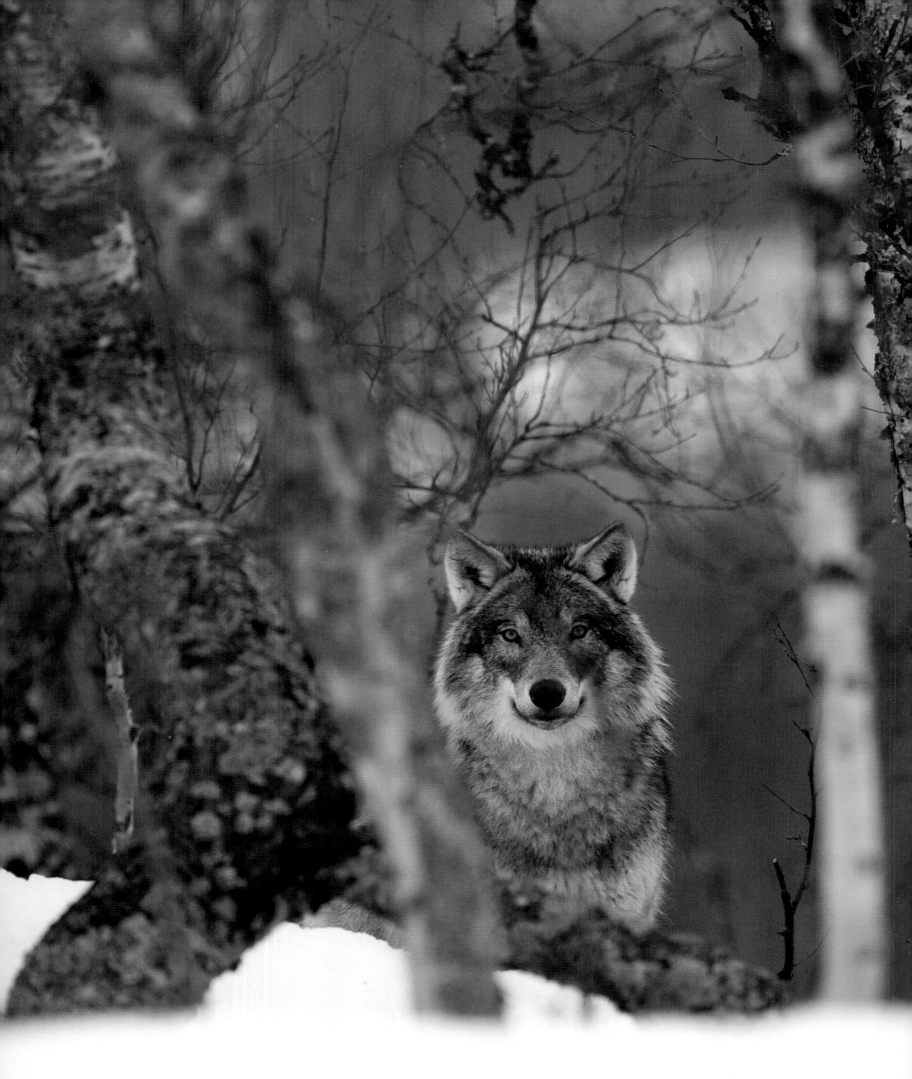

Wolves as Climate Guardians

Ecologists from Yale University[13] in the United States have studied the interplay of moose and wolves in the boreal forests of North America and discovered how complex the web of life in the boreal forest is: Moose (*Alces alces*) are big herbivores with considerable appetites, and the wolf (*Canis lupus*) is its greatest adversary. Because the predators were heavily decimated by humans, moose could reproduce rapidly; but more moose consume more plants, which are then no longer available to trap carbon. According to the scientists' calculations, a natural relationship between wolves and moose would substantially favor plant growth, and the added vegetation could take up nearly the same amount of carbon as Canada emits annually through the burning of fossil fuels. Thus, one effective measure against climate change would be to have a healthy population of wolves controlling the moose population.

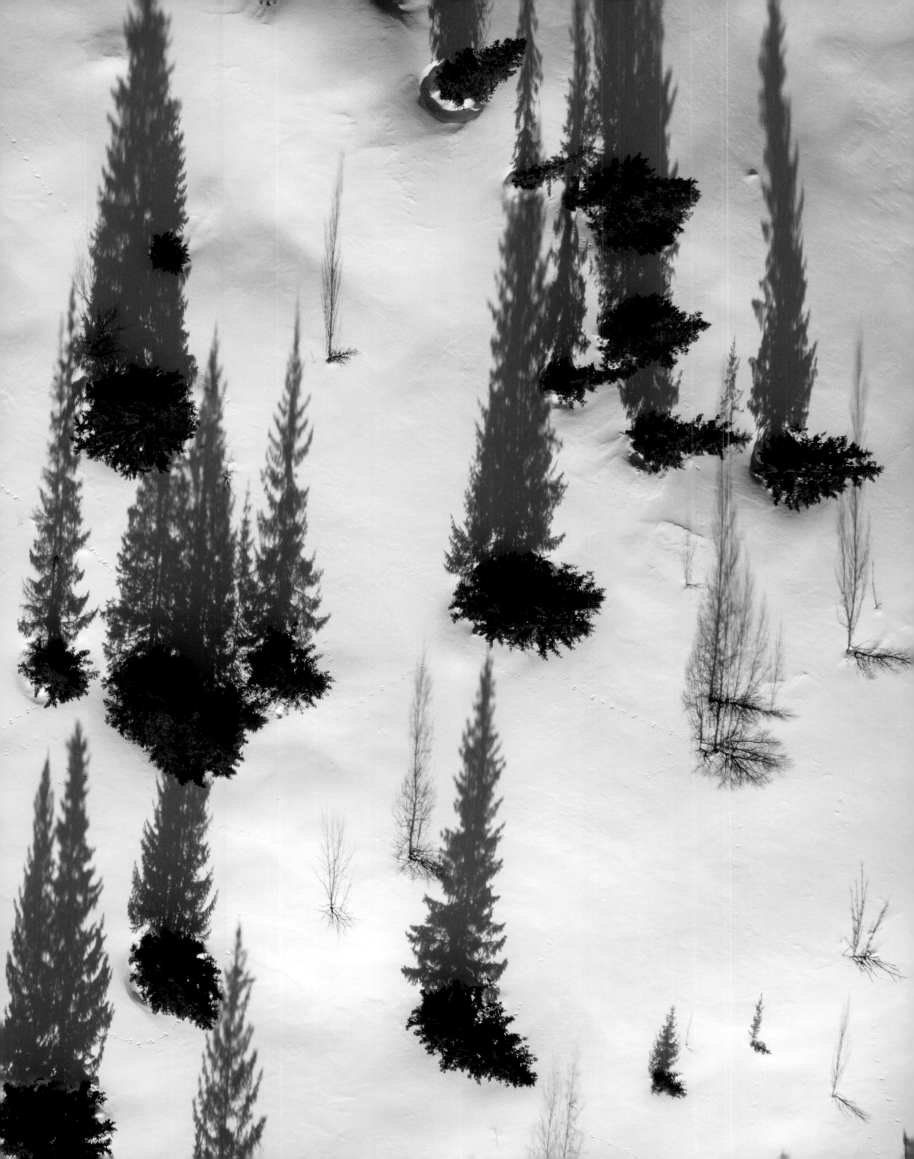

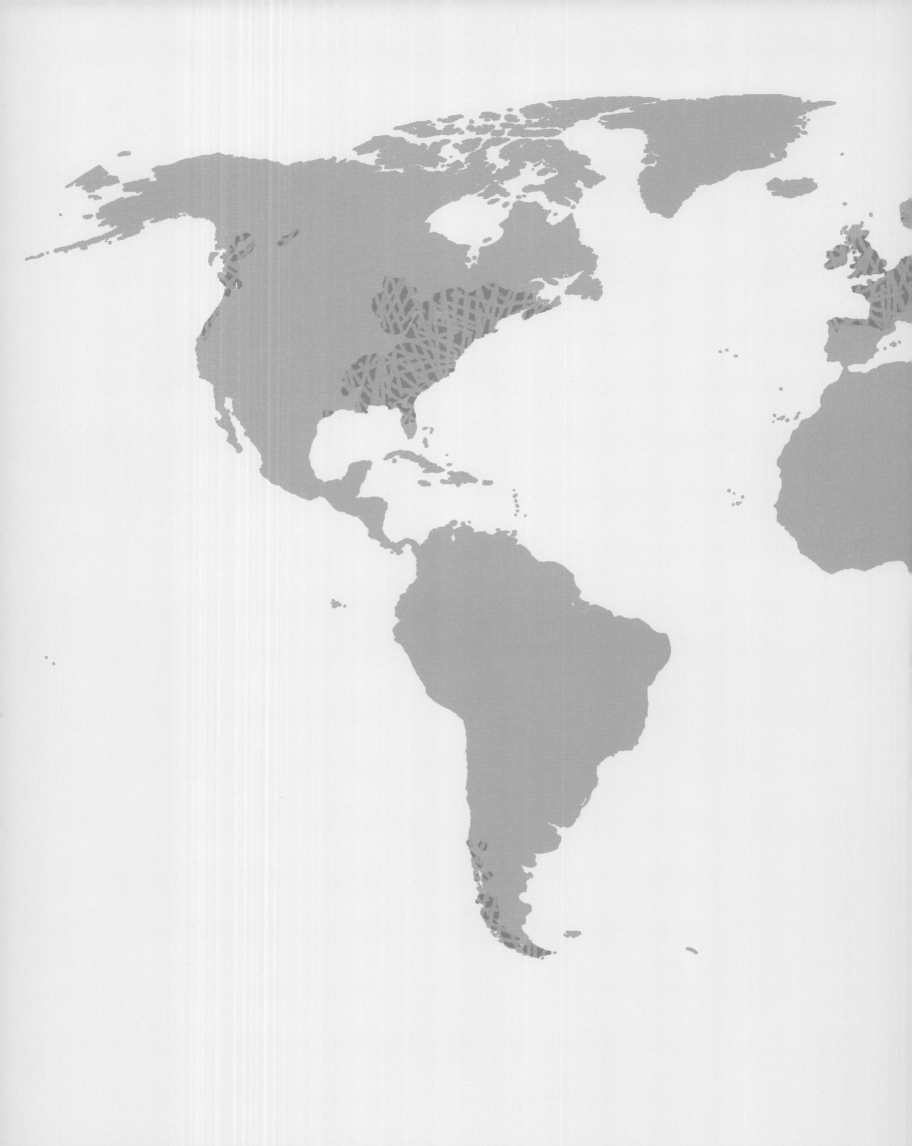

Forests of the Temperate Zone
The Four-Season Forest

The fresh greens of spring, the saturated greens of summer, colorful fall foliage, bare in winter: Pronounced seasonal changes affect the rhythm of temperate zone forests.

Characteristics deciduous hardwood forests with long growing seasons and short winters; distinct seasons; dense stands of trees that shed their leaves; lots of undergrowth

Distribution mainly in the mid-latitudes of the Northern Hemisphere where there is sufficient moisture for large broadleaf trees to grow, as in all of central Europe, eastern North America, eastern China, Korea and Japan as well as, in the Southern Hemisphere, in southeastern Australia, Tasmania, New Zealand, and southern Chile

Typical tree species beeches (*Fagus sylvatica, F. grandifolia*), oaks (*Quercus robur, Q. petraea*), maples (*Acer*), basswood (*Tilia, lime or linden*), elms (*Ulmus*), ashes (*Fraxinus*), hickories (*Carya*), and tulip trees (*Liriodendron*)

Animals red deer, badger, lynx, dormice, tawny owl, fire salamander, caraboid beetles, alpine longhorn beetle

Status used extensively, converted into timber-lands or cleared for agriculture over the course of human history; remaining old-growth forests often poorly protected

Special features especially fertile soils that can take up and store large amounts of water

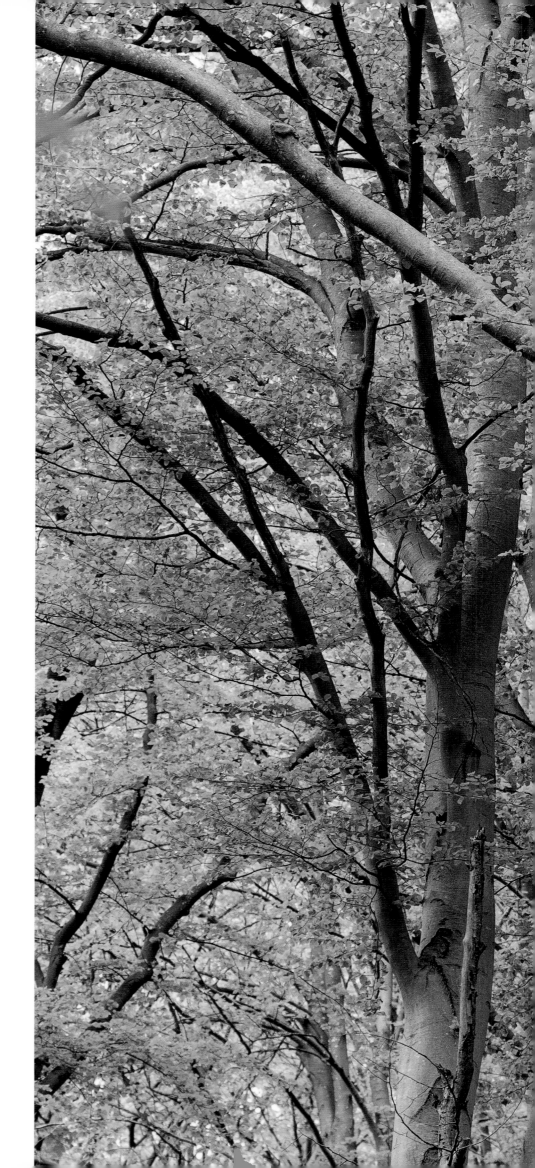

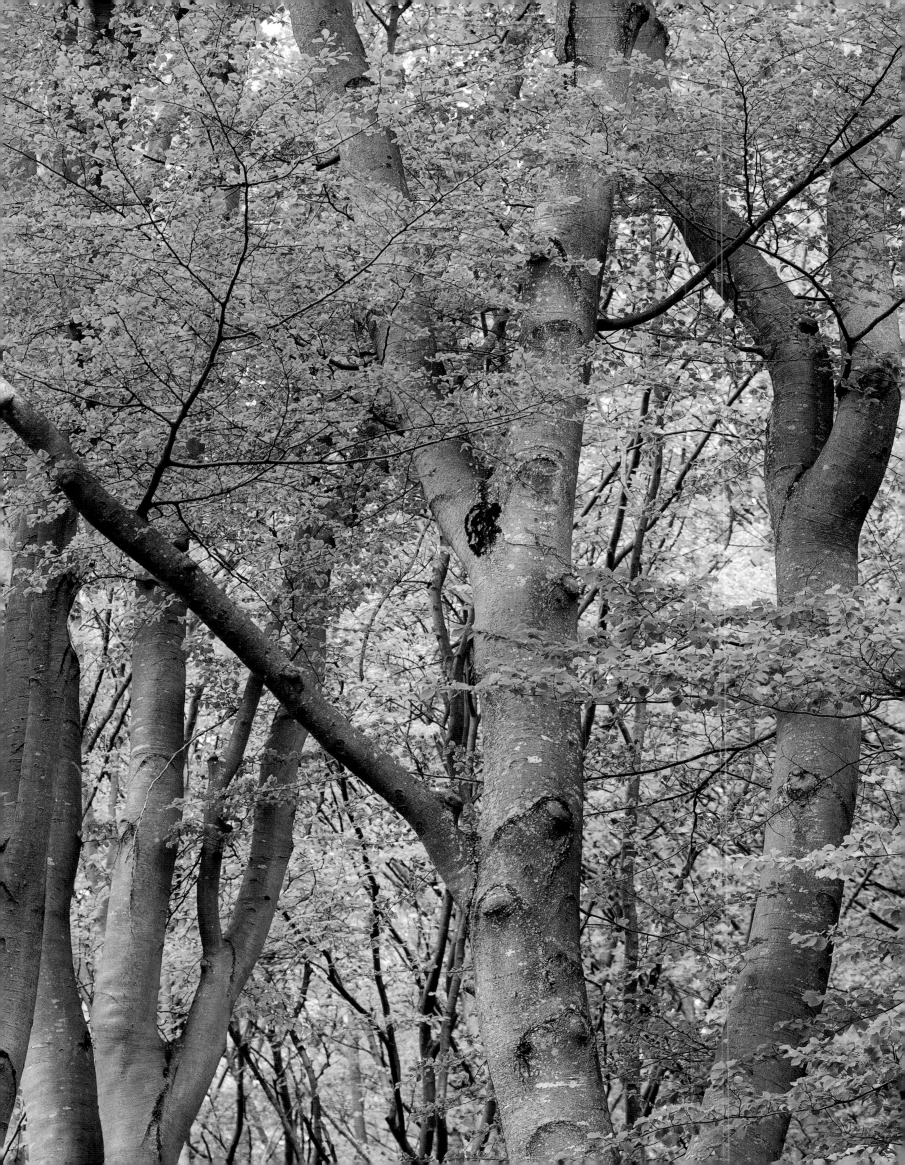

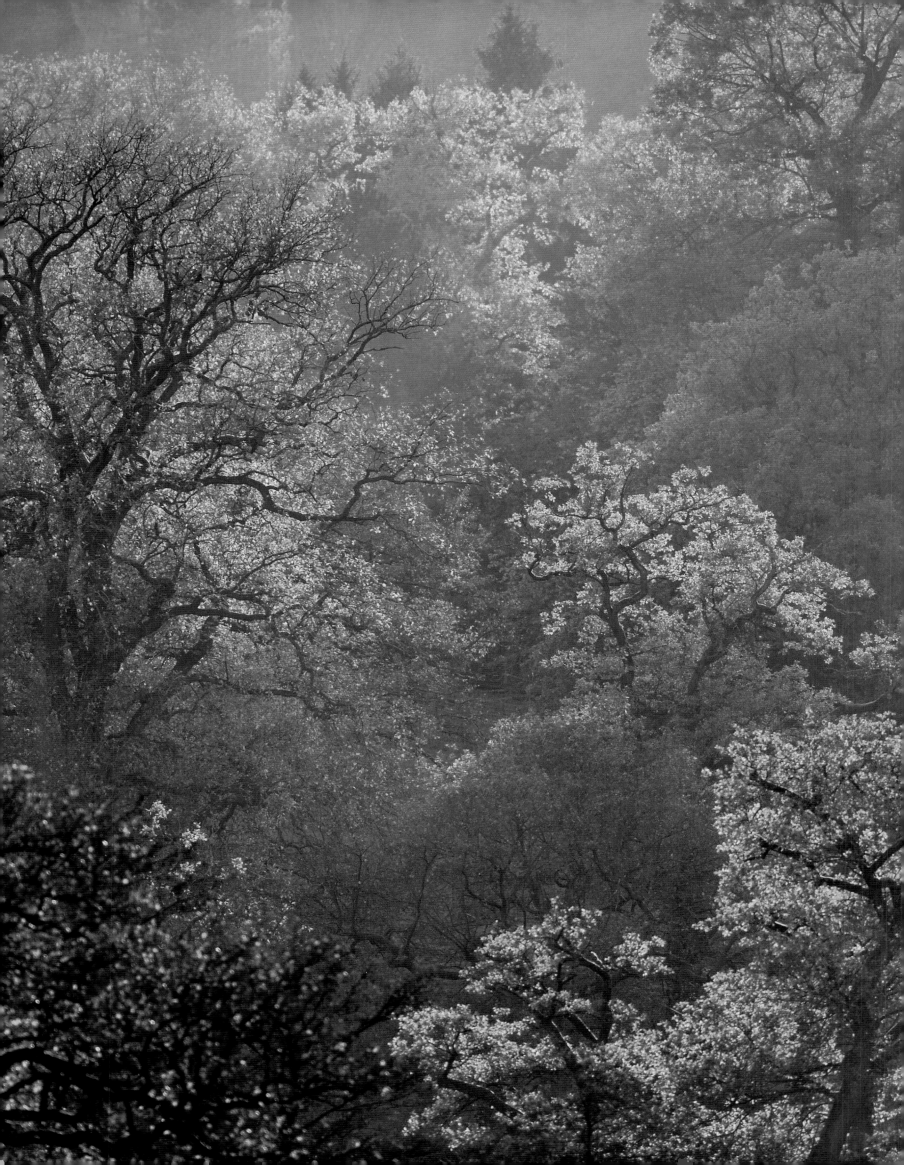

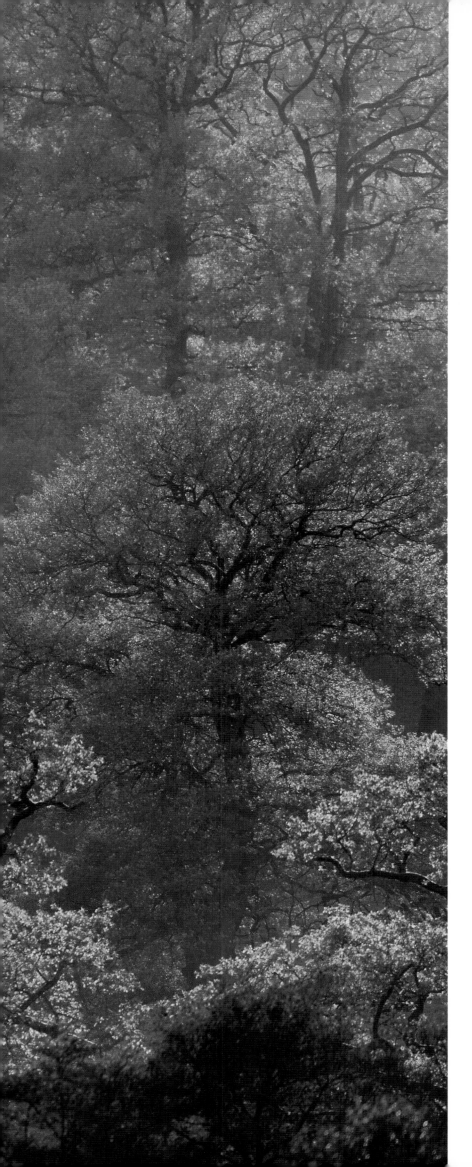

An oak forest in the fall, Kellerwald, Germany. Many of the world's six hundred oak species grow in the deciduous and mixed forests of the temperate latitudes. In Europe, pedunculate oak (*Quercus robur*) and European white oak (*Quercus petraea*) are very common. They do not blossom until they are fifty or sixty years old and have lifespans of between six hundred and a thousand years. Oaks in forestry production are usually felled at between 160 and 200 years. The wood, leaves, fruits and flowers in particular of old oaks provide habitat or food for many birds, beetles, mammals, butterflies, and other organisms.

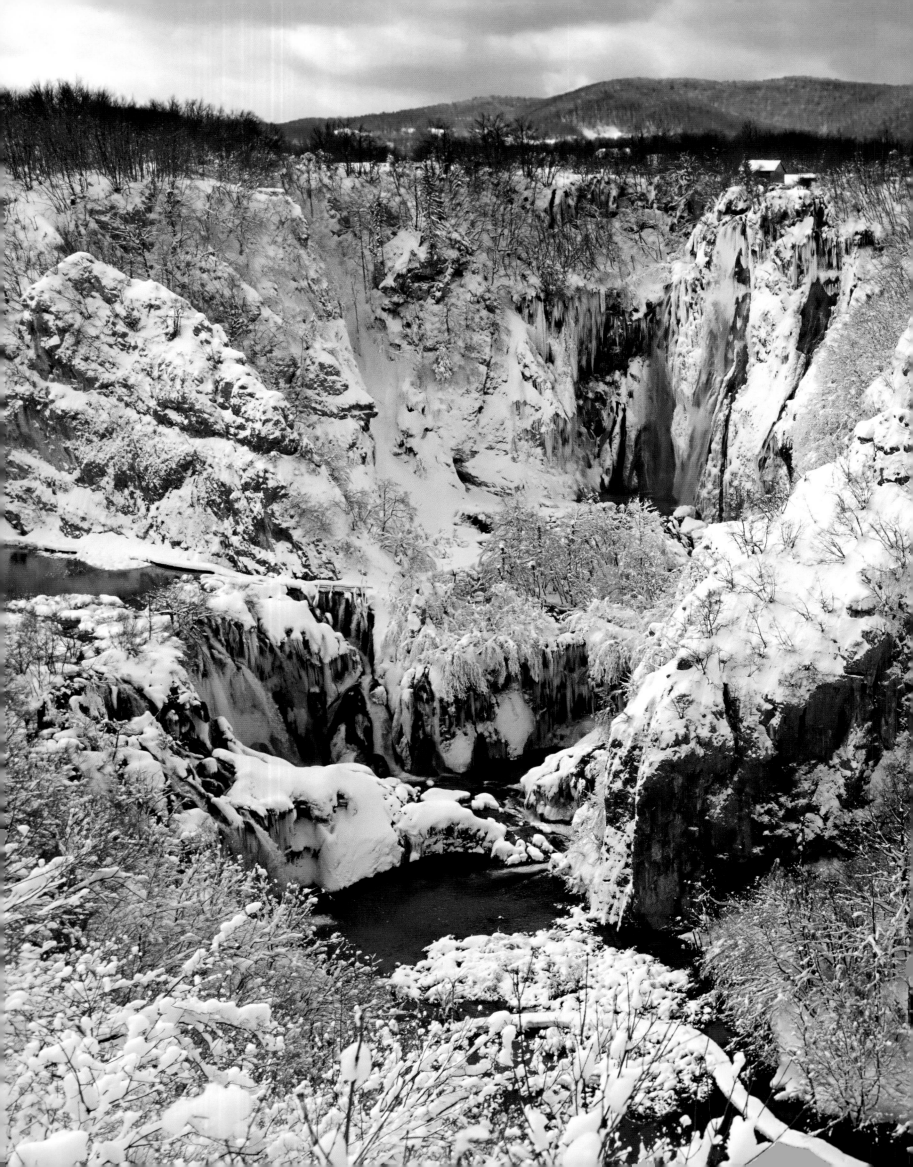

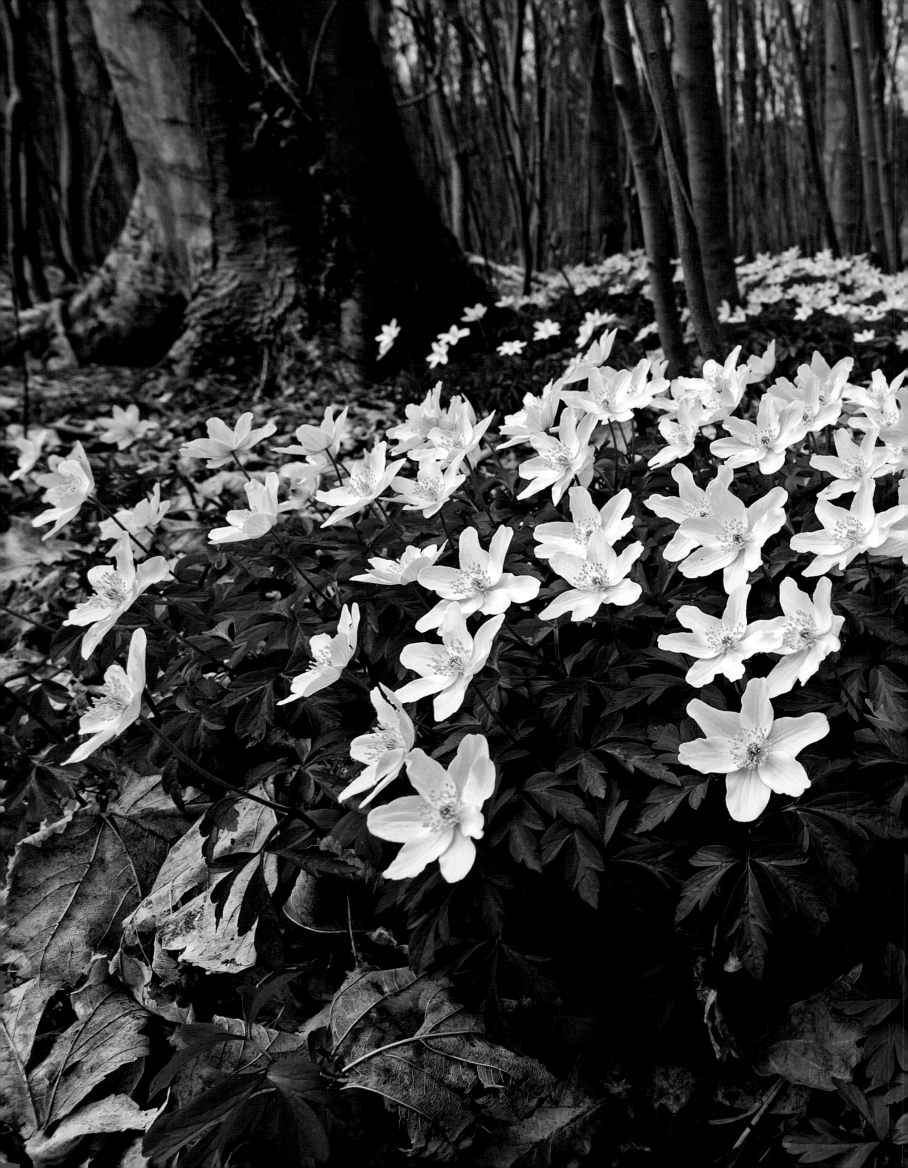

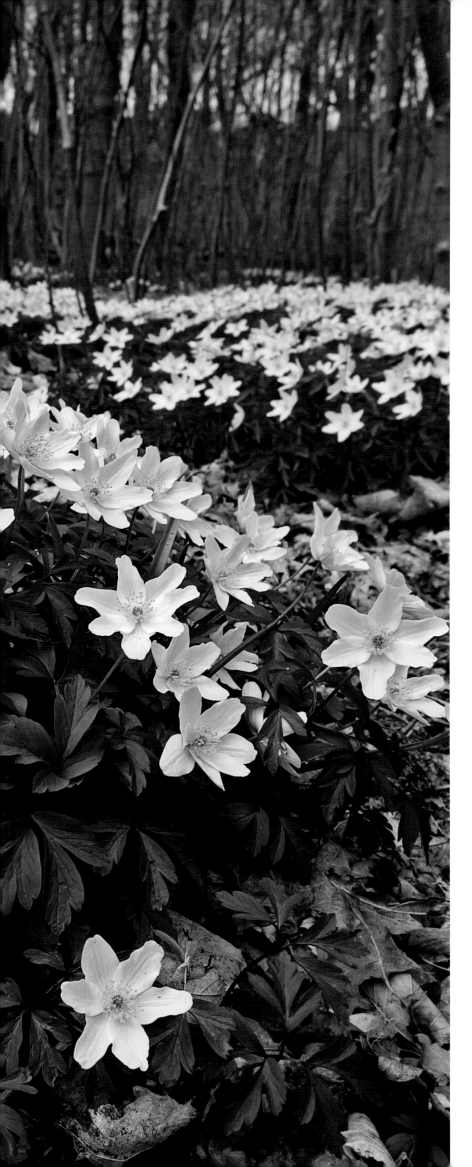

Early bloomers on the forest floor. As soon as the first warming rays of the sun hit the forest floor early in the spring, life begins to stir. At this time of year in temperate-zone hardwood forests, the treetops are still bare to allow light and heat to come through uninhibited. These wood anemones (*Anemone nemorosa*) and other early bloomers—plants such as winter aconite, bluebells, and liverwort— do not let it go to waste. They have amassed energy in below-ground tubers and bulbs so they can get a jump on all the other plants and start the new year with flowers and green foliage.

The Four-Season Forest

The forests of the temperate zone spread out across the Northern Hemisphere between the 40th and 60th parallels, but unlike the needle-leafed boreal forests, they do not form a continuous, globe-spanning band of forest. Temperate forests are found in eastern North America and across central Europe into Russia, as well as in Turkey, the Caucasus, northwestern Iran, northeastern China, Korea, and Japan. All told, temperate-zone forests cover an area of somewhere between eight and ten million square kilometers (3 to 3.8 million sq. mi.) and thus account for approximately one-fifth of all forested landmass globally.[1] The growing season the period each year during which the trees grow, blossom and bear fruit-lasts four to eight months. Precipitation varies from five hundred to fifteen hundred millimeters (about

araucarias) or the eucalyptus forests of southeastern Australia, exist in various places in the Southern Hemisphere.

A Colorful Variety of Trees

The hardwood trees of temperate zone forests are adapted to a climate regime that must be neither too cold nor too dry. Species of beech, oak, maple, ash, elm and basswood are widespread, and birches (*Betula*), willows (*Salix*), alders (*Alnus*) and poplars or aspens (*Populus*) grow in places that are wetter or more open. These are joined by hornbeam or musclewood (*Carpinus*), cherry (*Prunus*), hazel (*Corylus*), rowans (*Sorbus*, also called wild service tree or mountain-ash), and many others. The variety of tree species is even greater in North America, the Caucasus, and East Asia, because species there were able to

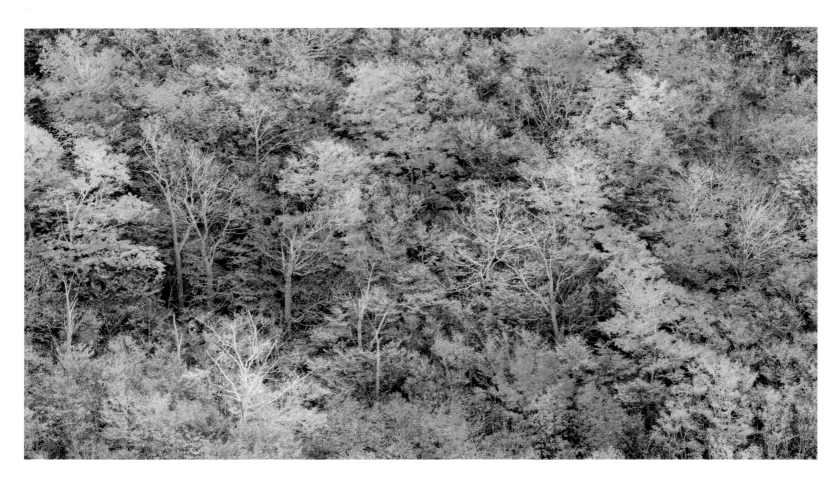

Bright fall foliage in the eastern United States. The temperate forests put all their magnificent colors on display twice each year: once in the spring, when bright wildflowers blanket the forest floor; and again in the fall, when the hardwood foliage turns colors in every hue from green and yellow to fire-red to brown.

twenty to sixty inches) and is relatively evenly distributed throughout the year. Toward the south, as conditions become too dry for growth, the trees give way to the grasses of steppes and prairies. Comparable forests, such as the southern beech forests of southwestern South America (with *Nothofagus* and

retreat southward during the most recent glaciation, whereas in Europe, the east-to-west-running Alps presented an insurmountable barrier. Additional species such as hickory (*Carya*), sugar maple (*Acer saccharum*), tulip trees (*Liriodendron*: yellow poplar), and sweetgum (*Liquidambar*) are thus found outside of

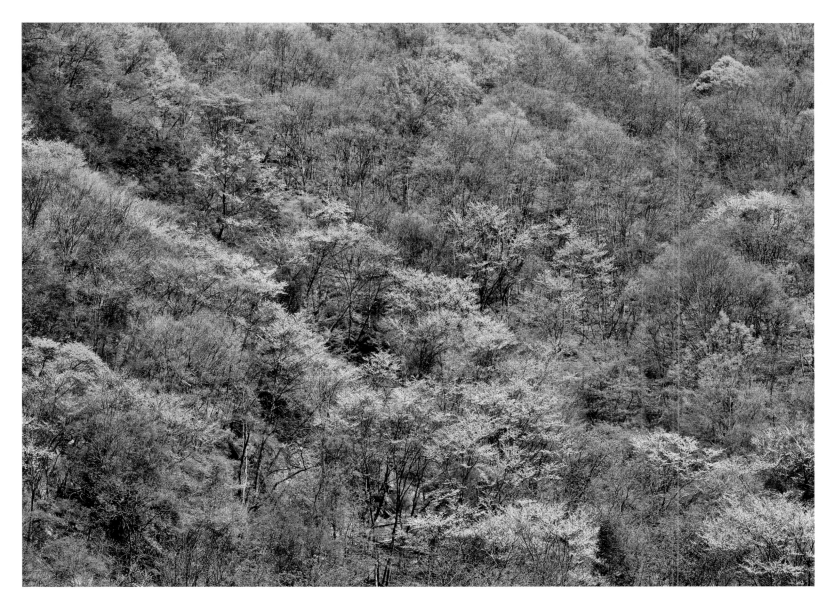

Cherry blossoms. In the province of Sichuan in southwestern China, the deciduous forest is graced with the tender pinks of blossoming cherry trees.

Europe. In dry or nutrient-poor environments, needle-leafed trees such as pines are more likely to thrive, and in mid- to high-elevation mountainous areas, spruces and firs. All told, botanists have registered around 1,500 different tree species in the forests of the temperate zone.

Layers of the Forest

A typical mid-latitude hardwood forest is organized in four stories or layers. The bottom layer—the forest floor—consists of leaf litter made up of leaves and twigs that numerous fungi, microbes, and animals break down into new, nutrient-rich earth. Above the forest floor, low-growing plants such as ferns, mosses, and wildflowers make up the herbaceous layer. The plants in this layer come into their own in early spring, before the hardwoods expand their foliage: Winter aconite, snowdrops, corydalis, snowflake, wood anemone, primula, liverleaf, and bluebell (or wild hyacinth) shoot up out of tubers and bulbs, blanketing the forest floor with a brightly-colored carpet of blossoms that provide wild bees and bumblebees with their first pollen-and-nectar meal of the year. Above the herbaceous layer comes the two-to-five-meter-high shrub layer. What thrives here are generally shade-adapted trees and shrubs, including a few evergreens; examples include rhododendrons, mountain laurel (*Kalmia*) and buckthorn (*Rhamnus*) as well as honeysuckle (*Lonicera*), sumac (*Rhus*) and dogwood (*Cornus*). Above that, uppermost, held aloft by thick tree-trunks and frequently at least twenty meters above the forest floor, comes the tree layer. With its thick leaf cover, the tree layer filters out more than 90 percent of the sunlight in summer, and also diverts a good deal of the rain. It is not until leaf abscission takes place in the fall that this dual parasol-and-umbrella collapses, whereupon the forest floor beneath the bare treetops soaks up precipitation like a sponge.

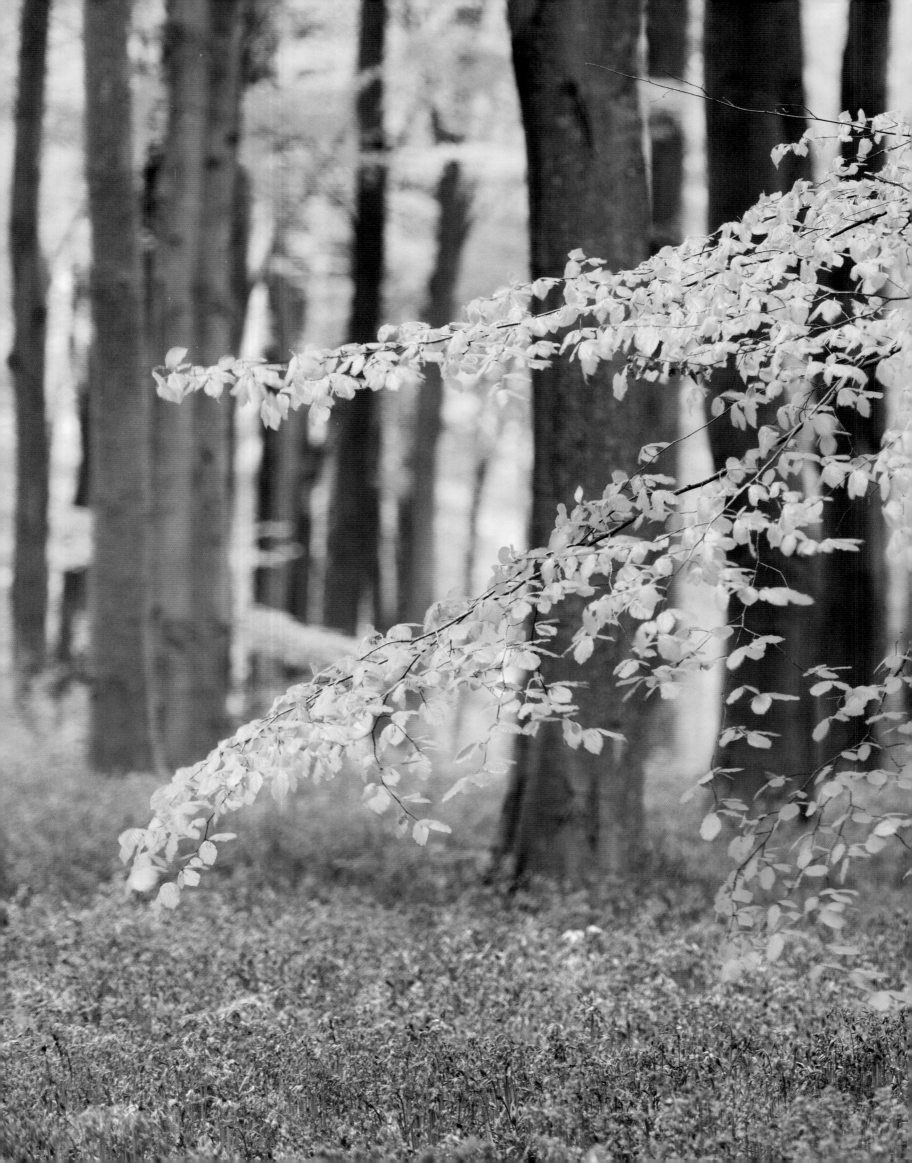

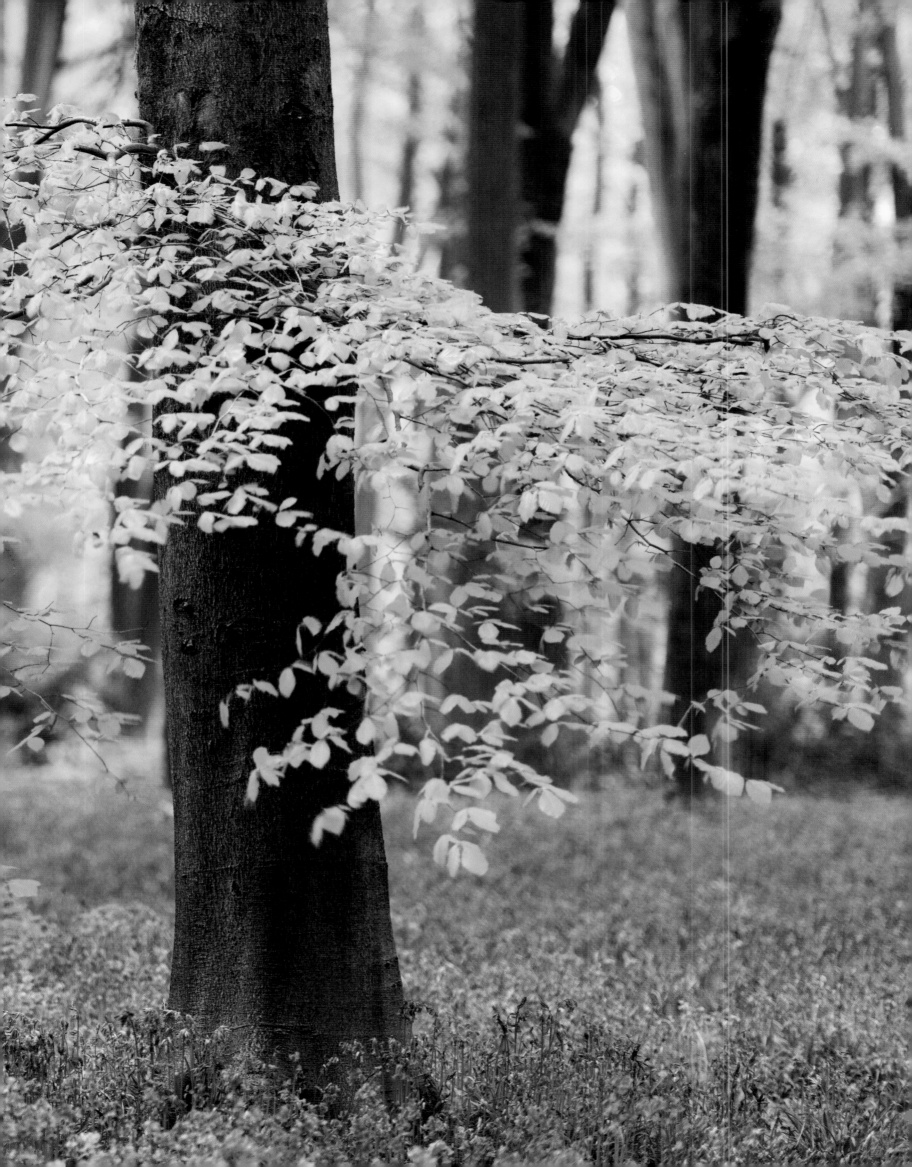

Deciduous Forests: A Spectacle of Color

In spring, as the buds on the deciduous trees break and the leaves expand and fill up with chlorophyll, the leaves go from bright to dark green. The trees are now generating energy at full capacity. As temperatures drop in the fall, the chlorophyll in the leaves degrades, and the residue is deposited in the trunks, roots, and limbs of the trees together with other nutrients such as nitrogen, phosphorus and iron. This lets yellow, orange and red pigments such as carotenoids and xanthophylls shine through, and the forest turns bright colors. Dying leaves turn brown, and a separation zone forms at the base of petioles all over the tree. Worms, mites, springtails, fungi and bacteria decompose the fallen leaves, transforming them into new, fertile forest floor—the cycle is complete.

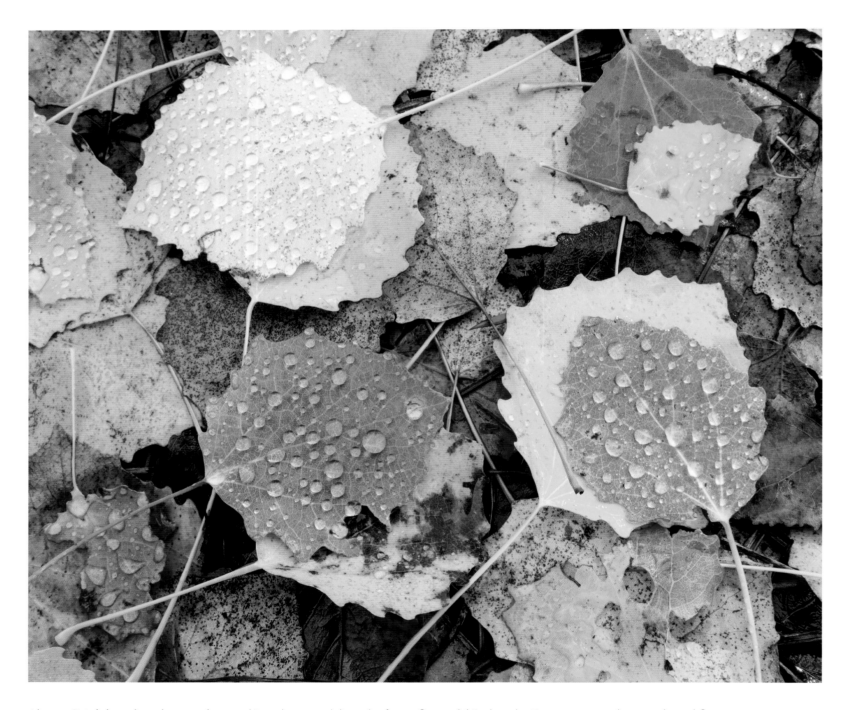

Above: **Brightly colored aspen leaves** (*Populus tremula*) on the forest floor. // Right side: **Ferns, mosses, horsetail, and flowering rhododendrons** in a swampy wooded area in Ithaca, New York, USA. In winter and spring, the forest floor absorbs water until sopping like a sponge. Plants, animals, and funguses take up a lot of additional water from the precipitation in a forest. The greater the amount of biomass in a forest, the more water the forest is able to retain. All that water is the reason there is hardly ever a major forest fire in undisturbed hardwood forests in the temperate zone.

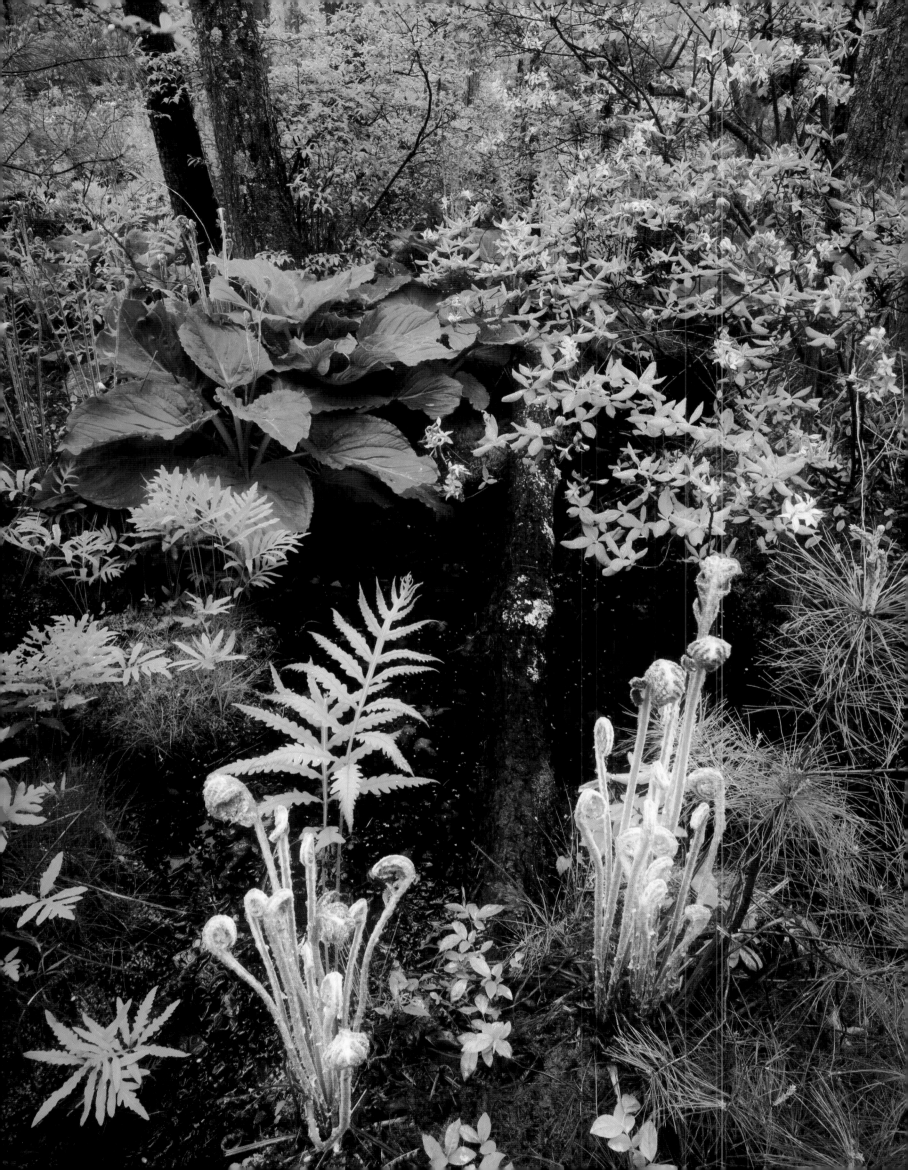

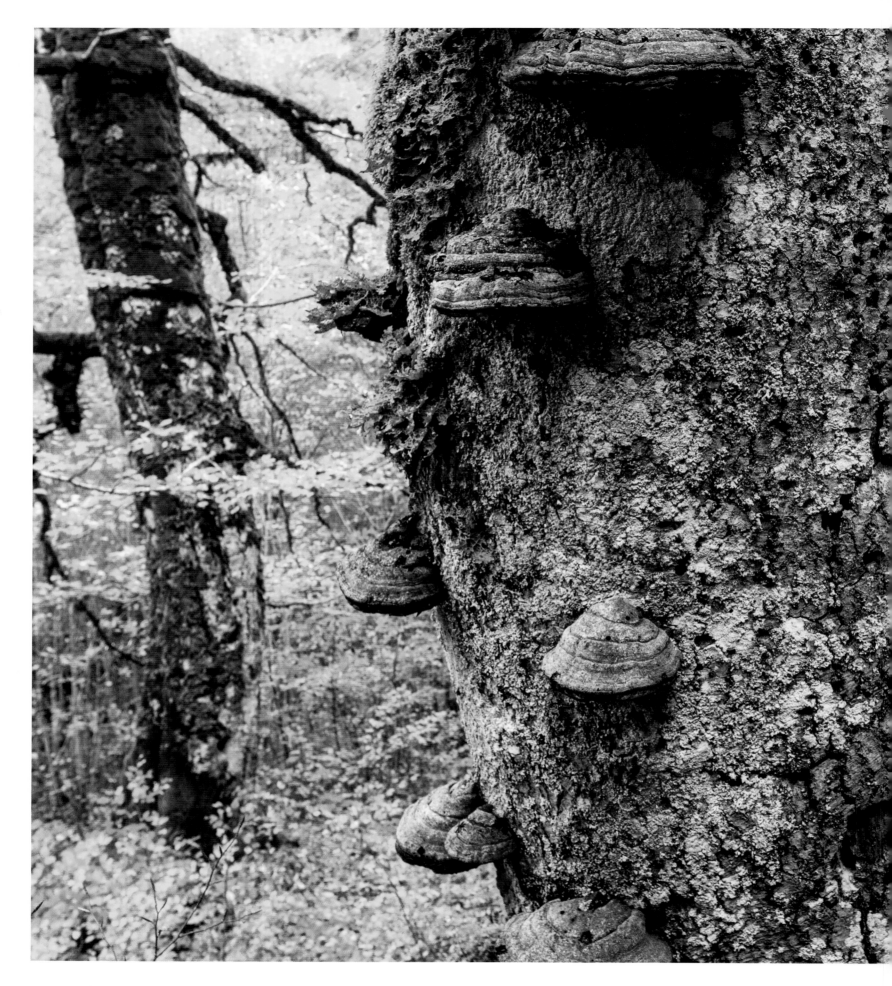

Funguses that grow on trees. Tinder fungus on the trunk of a beech in Abruzzi, Italy. Despite being dominated by the European beech (*Fagus sylvatica*), beech forests are a diverse habitat for several thousand species of animals, plants and funguses.

Leaves or Needles?

Why do deciduous trees undertake this immense effort of putting out thousands of new leaves every year? The answer is simple: They can produce a huge amount of energy through their leaves during the summer and do not dry out in the winter. A large beech tree transpires up to four hundred liters of water on a summer day, a process it controls (to a certain degree) through gas-exchanging pores called stomata positioned on the underside of its leaves. But freezing soil during winter would prevent fresh influxes of water, without which the tree would die of thirst even with maximally restricted stomata. This leaf senescence and loss by the trees every fall serves moreover to dispose of toxins, and it makes the trees less vulnerable to winter storms. Where summertime photosynthesis is concerned, evergreen conifers cannot keep up with hardwoods because (among other

things) the surface area of conifer needles is significantly smaller than that of hardwood leaves. Yet because conifer needles have a leathery exterior, a thick wax layer and narrow stomata, conifers can withstand low temperatures and drought better than hardwoods. Another advantage of needles is that they survive the winter, so the tree can resume photosynthesis earlier in the season than a hardwood.

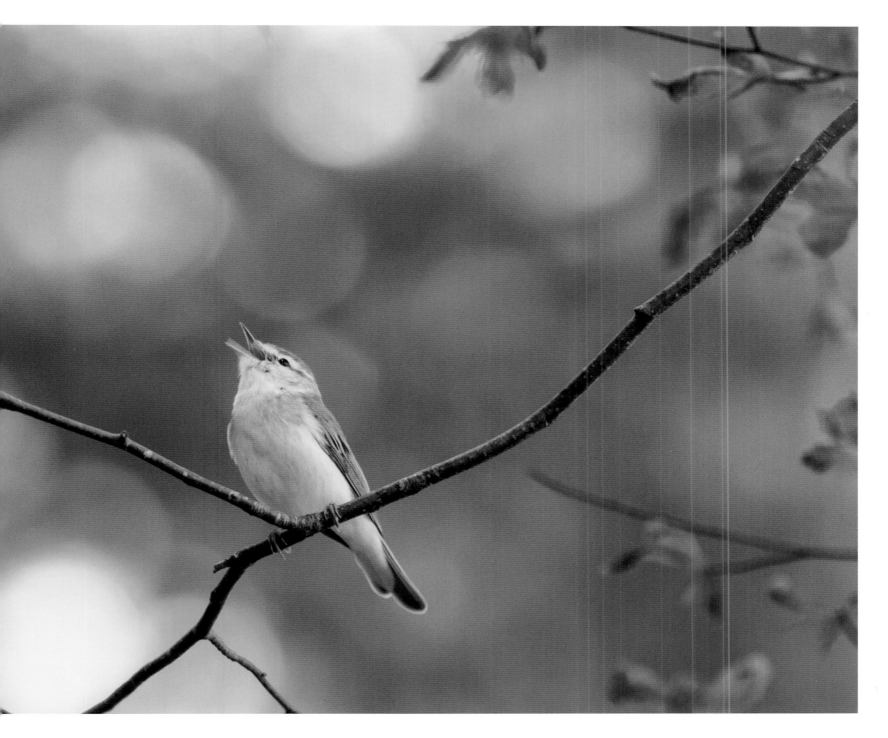

A prodigal voice. The wood warbler (*Phylloscopus sibilatrix*) is one of many migratory bird species that winter in warmer climes but make use of the abundant summer food supply of temperate-zone forests to raise their young.

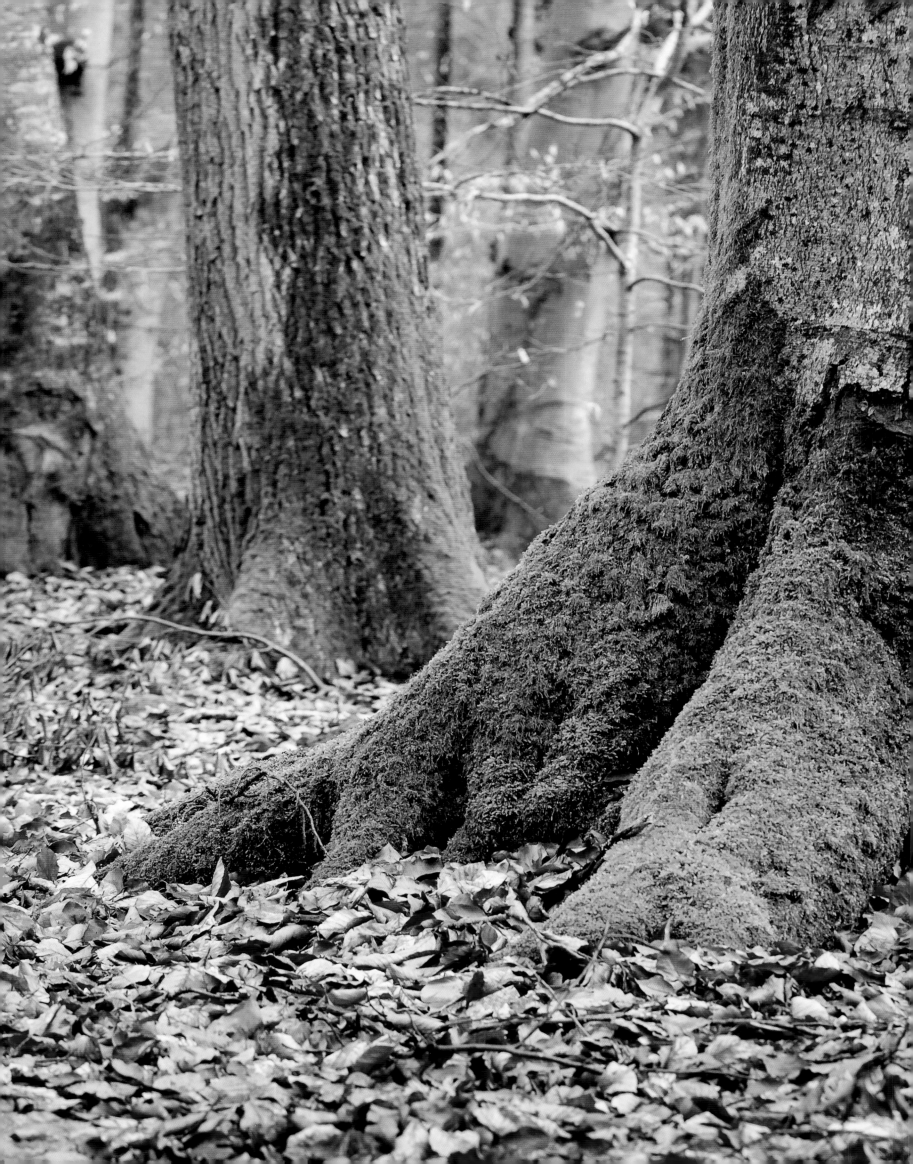

Built to last. Many deciduous trees, like oaks or beeches, if left alone, may grow to be several hundred years old; for forestry purposes, however, they are only useful for the first 150 or so of those years. And they are usually harvested much earlier than that, so hardly any woodlands in active forestry production will contain many trees that have exhausted their natural lifespans.

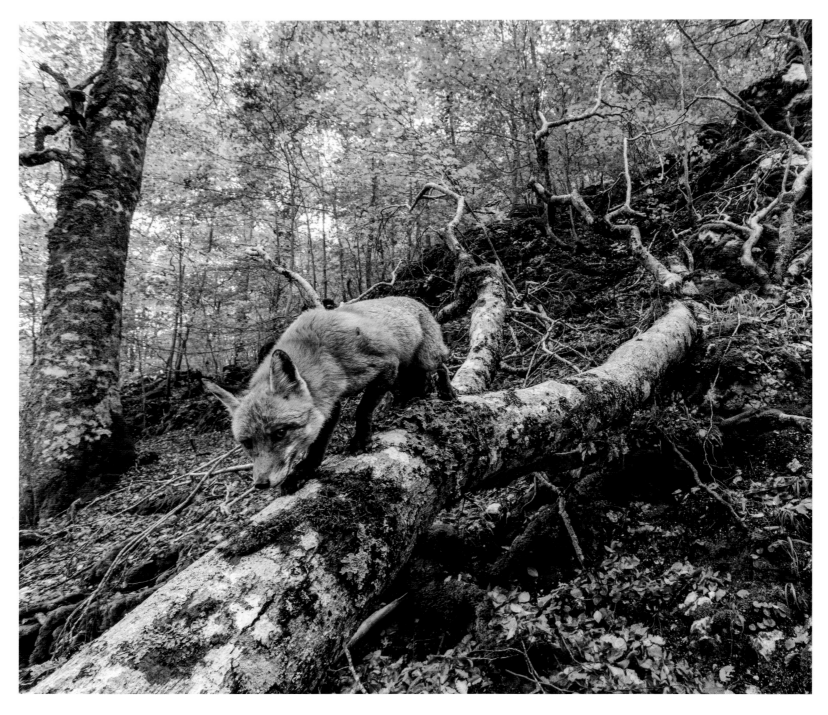

A fox in an autumn wood. The red fox (*Vulpes vulpes*) is very intelligent and extremely resourceful. It can get by in forests, in cultural landscapes, and even in the middle of a metropolis like Berlin or Vienna.

Animals in the Forests of the Temperate Zone

Most animal activity in the forest happens on and beneath the forest floor. The number of insect species is particularly high; in European forests alone, there are around thirty thousand different species,[3] mostly beetles, flies, bees, wasps and ants. They pollinate trees (including maple, cherry, willow, basswood and mountain-ash), form the basis of the food chain for other animals, and help to break down deadwood and leaf litter. Because little sunlight reaches the forest floor in summer and the forest floor stores moisture well, amphibians such as frogs, toads,

newts and salamanders feel right at home in the forest. Widespread mammal species include wild boar, squirrels, and other rodents such as dormice; in North America, these are joined by opossums, raccoons, and skunks and in Eurasia by hedgehogs and raccoon dogs. These animals benefit from the microclimate of the forest, which offers them shelter against both heat and cold. They also play an important role in dispersing plant seeds. When seeds get snared in an animal's fur, carried off by ants or mice, or buried by squirrels or jays or the like, the seeds can travel significant distances and colonize new habitats. A single squirrel buries thousands of nuts throughout the year, most of

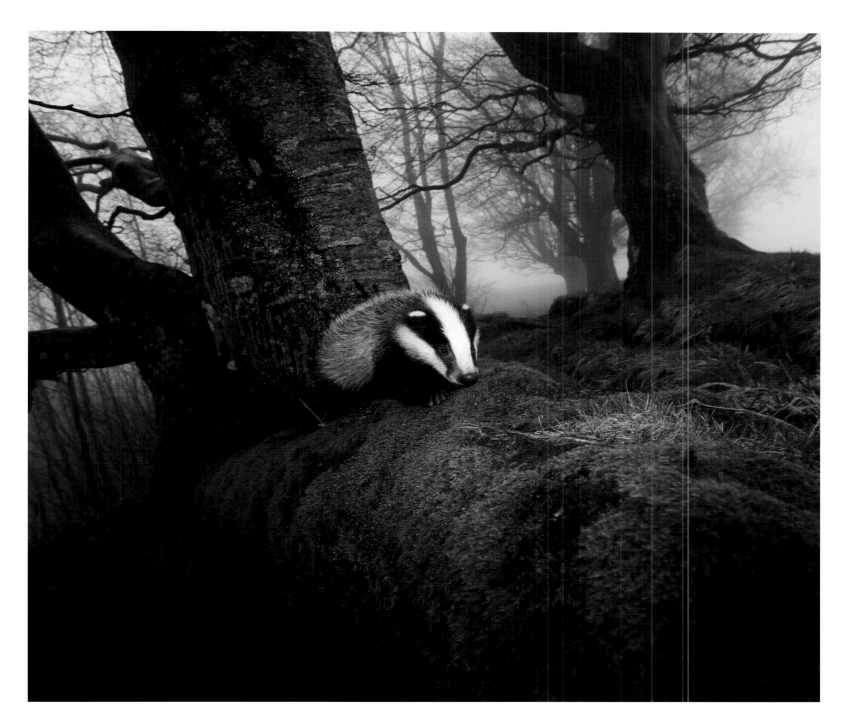

A badger on the prowl. The nocturnal and crepuscular badgers (*Meles meles*) excavate sprawling underground dens, with multiple entrances and exits, where they live together in family communities. They are omnivores that feed on bark, tubers, funguses, earthworms, snails and slugs, and small mammals.

which it will never find again—leaving the rest to germinate into a new generation of trees. Lesser predators such as pine martens, foxes, and wildcats still roam the forests where in earlier times bears, wolves, lynx, and mountain lions were also widespread—in Asian hardwood forests, there were even tigers and leopards[4] hunting deer and bovines up until the beginning of the 20th century. Before being driven to extinction in the 17th century,[5] aurochs roamed the forests of Europe, as did bison. Through selective breeding, some of the latter have now been reintroduced into the wild in Poland, Romania and Germany. Bats and birds share control of the airspace of the forest. They find the food and

shelter they need to raise their young there. Whereas owls and bats are nocturnal, woodpeckers and tree-creepers inspect wood for insect larvae; flycatchers, leaf warblers, and titmice pluck insects off of leaves or out of the air; and woodcocks and wood-thrushes search for food on the ground. Great birds like black storks, red kites or eagles breed in the protection of the forest, where they build their aeries in the crowns of the trees.

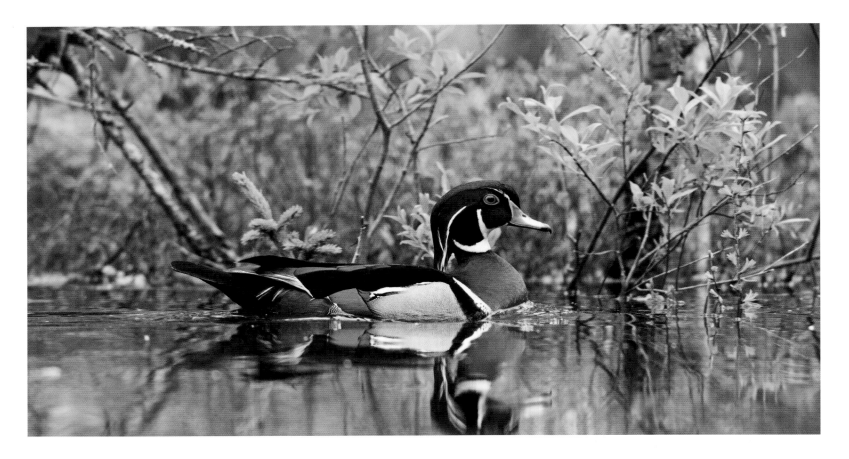

Wood duck. The North American wood duck (*Aix sponsa*), like the mandarin duck (*Aix galericulata*) of Eurasia, likes to brood in abandoned woodpecker hollows. Once hatched, the ducklings have to jump down from the nest-hollow (which is often several meters high), whereupon their mother escorts them to the nearest body of water.

Furry; sleeps a lot. The dormouse (*Glis glis*) spends two-thirds of the year hibernating in the shelter of a hollow in a tree. Skilled climbers, they collect nuts, seeds, fruits, mushrooms, and even, on occasion, animal things to eat.

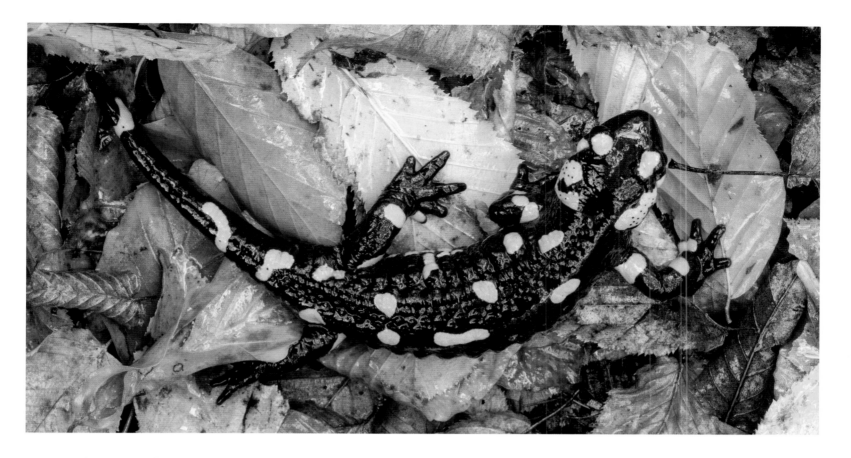

In its wet element. The fire salamander inhabits the cool, climate-controlled basement of Europe's hardwood forests. It lays its eggs in forest streams, in the vicinity of springs where its offspring are safe from fish. Fire salamanders are threatened by a fungus introduced from Asia.

Sawflies on high alert. The larvae of the birch sawfly (*Craesus septentrionalis*) are strongly reminiscent of butterfly caterpillars. The larvae of these sawflies have only a single legless segment between thorax and prolegs—unlike caterpillar butterflies, which have two.

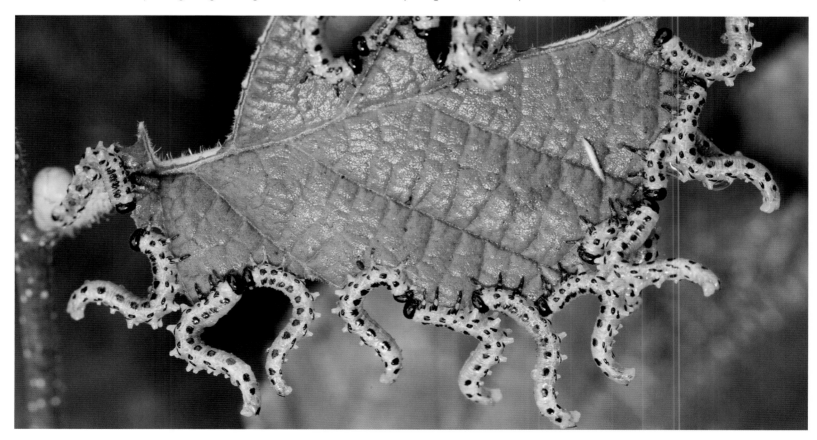

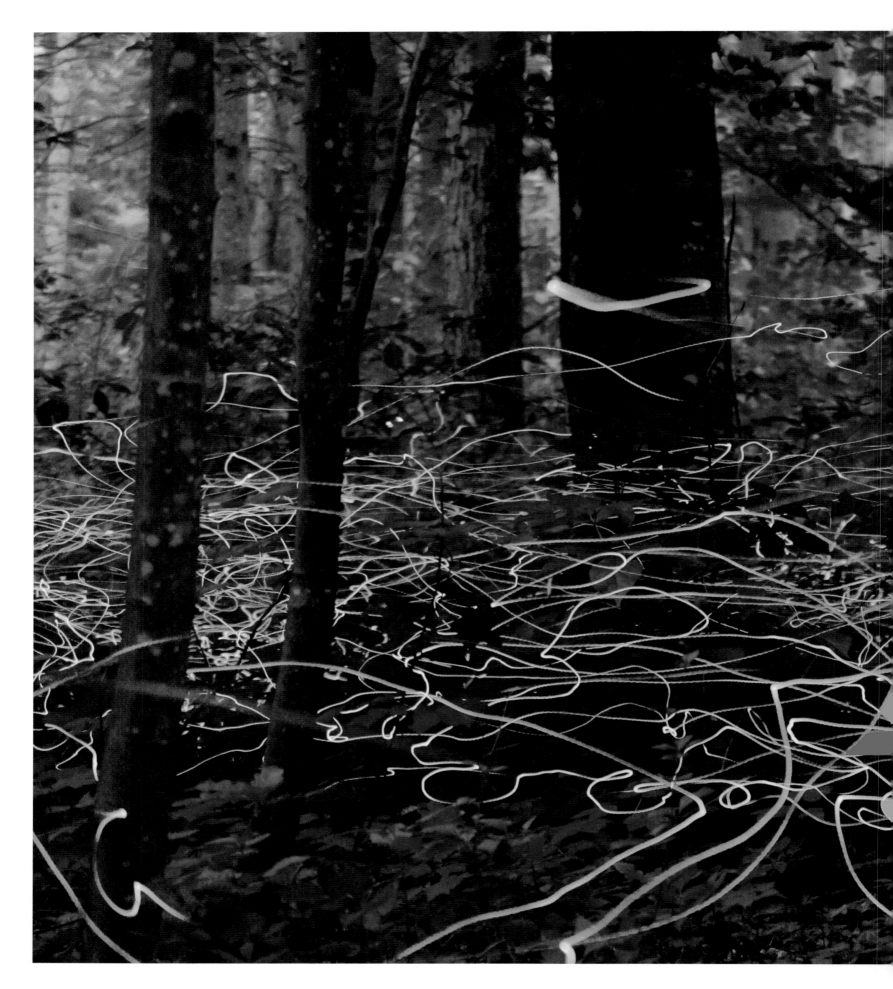

Apparitions in the forest. The approximately one-centimeter-long firefly (*Lamprohiza splendidula*) lives in the moist hardwood forests of the temperate latitudes of Europe. On warm nights in June, the males fly around the forest emitting light signals. On the ground, females light up in response. This picture shows the trajectories of the males during a long exposure.

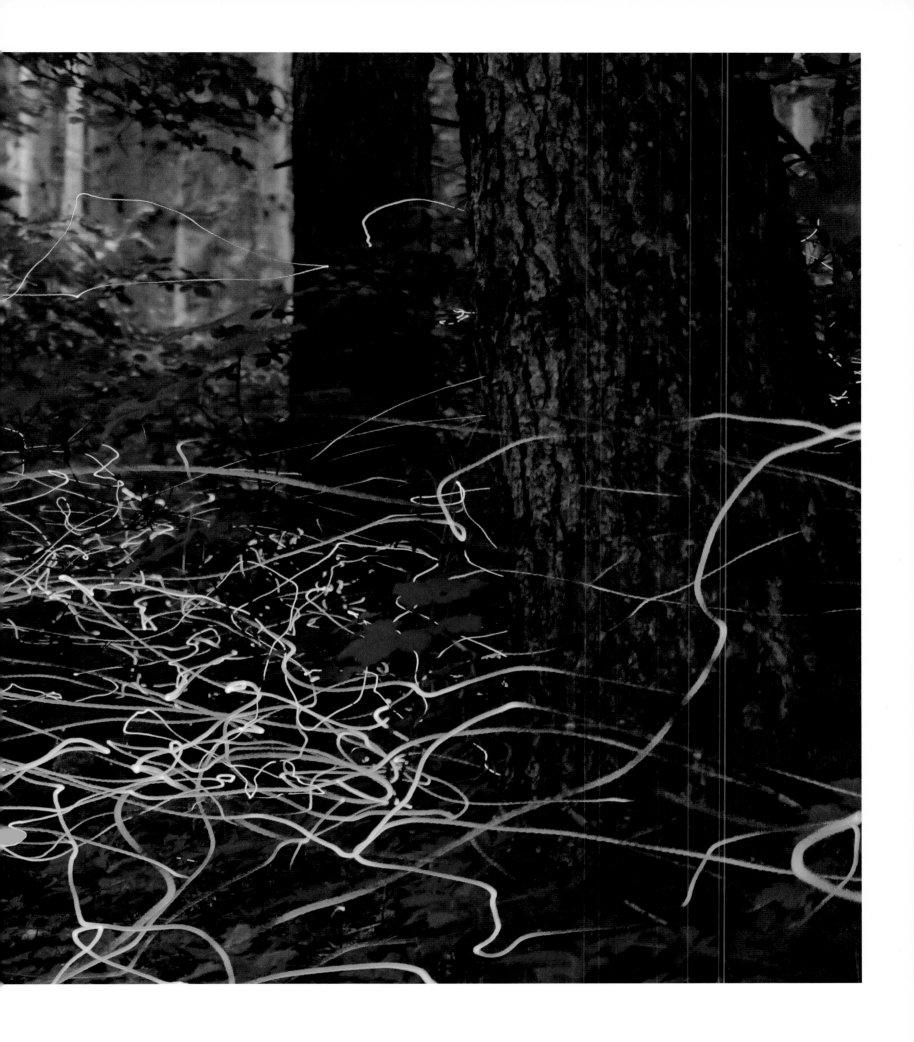

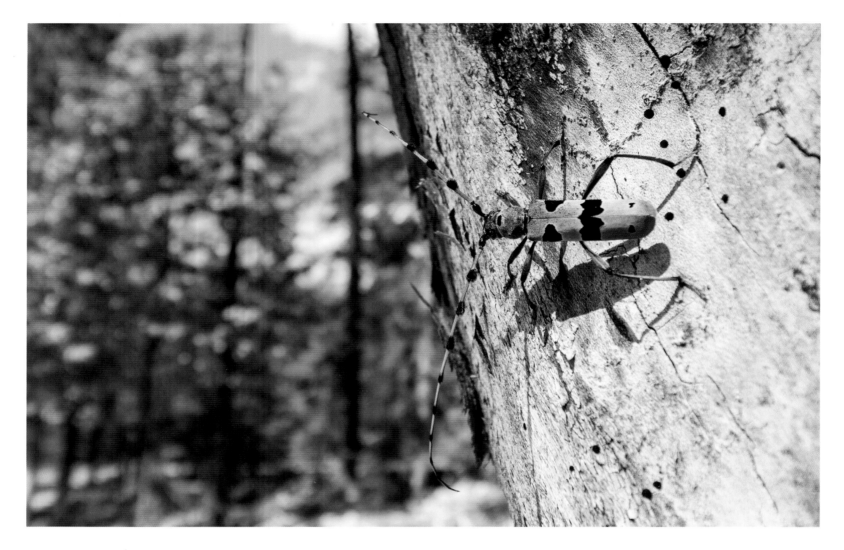

Above: **Living deadwood.** The Alpine longhorn beetle (*Rosalia alpina*), with its striking blue-and-black coloring, lays its eggs in the trunks of dead hardwood trees, like beeches or elms. This puts it in the same category as numerous other beetle species of temperate-zone forests whose survival depends on the existence of disorderly wild forests. // Right: **Nature's carpenter.** The black woodpecker (*Dryocopus martius*) drills holes in the trunks of old beech trees to sleep and raise its young in. Abandoned holes are appealing homes for bats, owls, stock doves, dormice, and hornets.

Tiny forest denizen. A springtail (*Dicyrtomina ornata*) on an oak leaf, only a few millimeters long. Innumerable springtails (*Collembola*) live in and on the forest floor and join the funguses, snails, woodlice, spiders, beetles, worms, mites and millipedes turn leaves, wood and other plant matter into fertile soil.

Dead Wood Makes New Life

Dying or dead tree limbs and trunks are an important component of the forest ecosystem. This so-called deadwood quickly awakes with new life. Fungi, algae, lichens and mosses grow on it, and deadwood provides food and shelter for numerous animals. Twenty to fifty percent of all species that live in the forest depend on deadwood.[6] The deadwood of the European beech alone, which grows across central Europe, is known to be home to more than two hundred beetle species—and the number for oak deadwood is more than six hundred. From what remains of the old-growth forests of the temperate latitudes, we know that a fallen tree continues to provide habitat for about as long again as the tree's entire lifespan—which can be anywhere from decades to centuries. In timberlands, however, deadwood is often in short supply, and so many animals adapted to live in this habitat are on the IUCN Red List of threatened species.

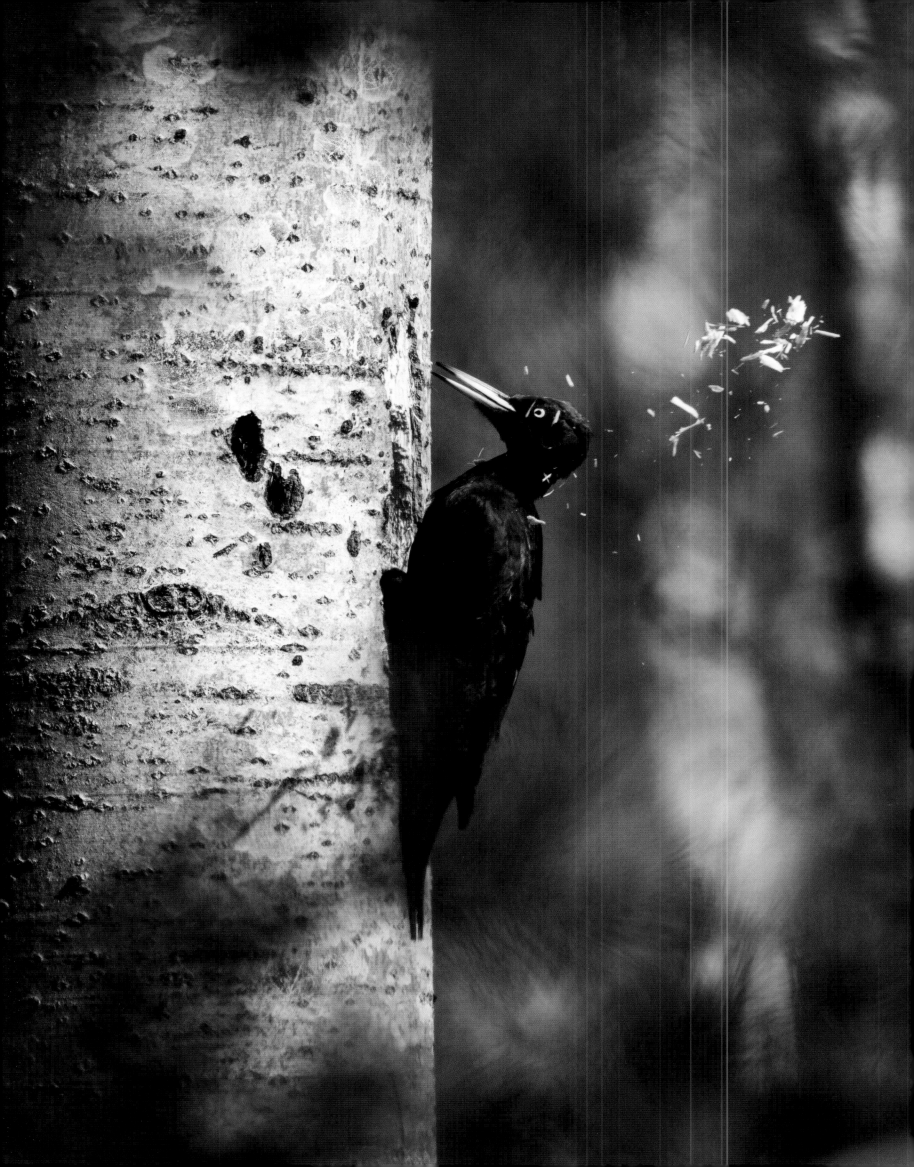

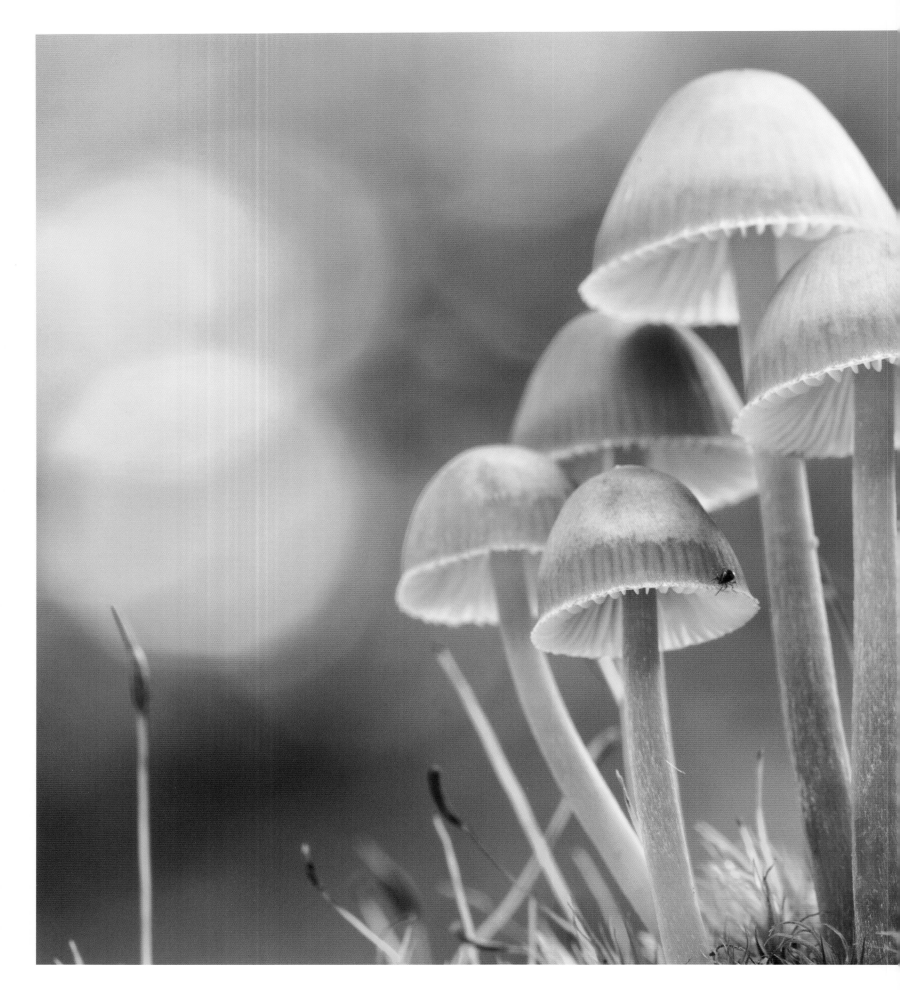

Symbiosis on the forest floor. Funguses and trees work together. A mat of fungal filaments, called mycelium, becomes braided together with delicate tree roots to form a huge underground mesh that serves (among other things) to exchange nutrients and information. The attractive caps of these Mycenas (*Mycena sp.*) disperse fungal spores.

Humans and the Forest

Humans have settled in the forest landscapes of the temperate zone for ages owing to the pleasant climate and fertile soils of these places. At the time of the Germanic tribes, there were still vast expanses of old-growth forest in central Europe. The forests came into more and more intensive use during the Middle Ages. People drove their livestock into the forest (*silvopasture*), cut timber and firewood, and cleared trees to create farmland. Twigs and branches were gathered for fuel; dead leaves were raked out of the woods in the fall and used to line the stalls or as fodder for the livestock (leaf fodder). Big trees—preferably oak as well as softwoods—were used for shipbuilding and other construction. But wood was also highly sought-after as fuel for metalworking, and it was not until wood was replaced by coal and petroleum with the advent of industrialization in the 19th century that many forests could recover or were replanted. However, this led to yet another change in the forests: More economically appealing conifer species such as spruces, pines and larches were frequently planted instead of native hardwoods; the former are less susceptible to browsing, and they grow faster and have straighter stems as well as more durable, resin-protected wood. Where coppicing was the dominant practice (in which new shoots are regularly cut for firewood), species such as hornbeam, hazel and basswood were preferred.

Up until the time the earliest European settlers arrived in North America, the American Indians had cleared only small parcels of forest for agriculture. Large-scale exploitation of the forests of North America did not begin until the late 17th century as more

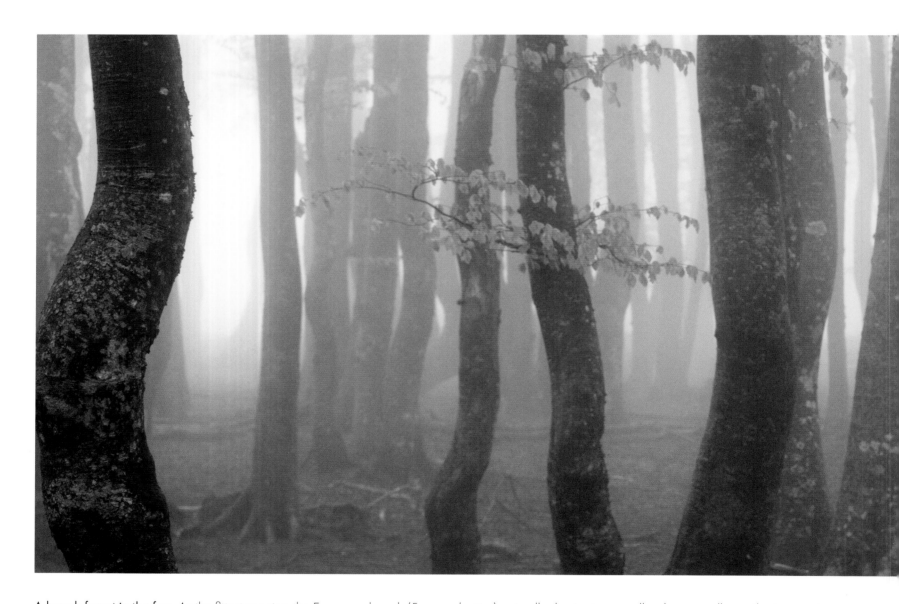

A beech forest in the fog. As the fittest species, the European beech (*Fagus sylvatica*) naturally dominates woodland scenes all over the temperate-latitude forests of central Europe. With increasing heat and dryness, European beech yields to forests of hornbeam and oak, and these eventually give way to subtropical or Mediterranean hardwood forests.

and more European settlers arrived; but it proceeded all the more quickly from then on. Once it became clear in the 19th century that the plains of the Midwest were better suited to farming, most of the forests in the eastern United States had already been cleared. Thus the large areas of hardwood forest across New England, New York or Virginia are not old-growth, but rather for the most part secondary growth forests.

Today, the exploitation of wood as a renewable resource is relevant once more as climate change mitigation efforts advance. The chief criticism of this trend is that monoculture plantings of non-native conifers are no compensation for the loss of old, natural, species-rich forests.[7] It has been estimated that today, barely one-to-two percent of the original forests of the temperate zones are still left in much their natural condition. And yet

these forests—such as the old-growth beech forests in the Carpathian Mountains of Romania—are in many cases so poorly protected that forestry activity in them is on the rise. But there is reason for hope in the fact that wherever the ground remains fertile, the forest can recover, and biologically diverse secondary forests can grow there.

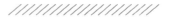

[1] Pravalie 2018
[2] Leuschner 2014
[3] https://naturwald-akademie.org/waldwissen/waldtiere-und-pflanzen/bedeutung-von-insekten-im-wald/
[4] Jacobson 2016
[5] The last of these aurochs was shot in Poland in 1627.
[6] https://www.waldwissen.net/wald/naturschutz/arten/fval_totholzmenge/index_DE
[7] Kuhlmann 2018
[8] Kohnle 2009

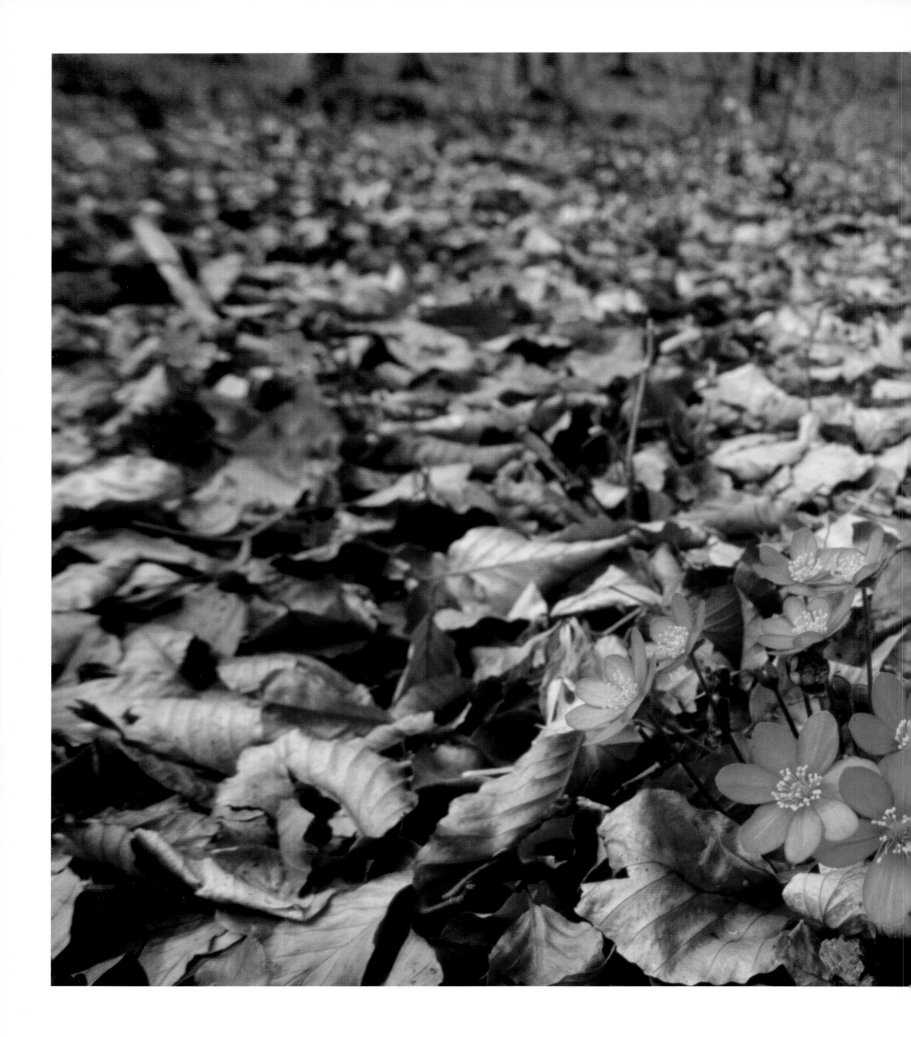

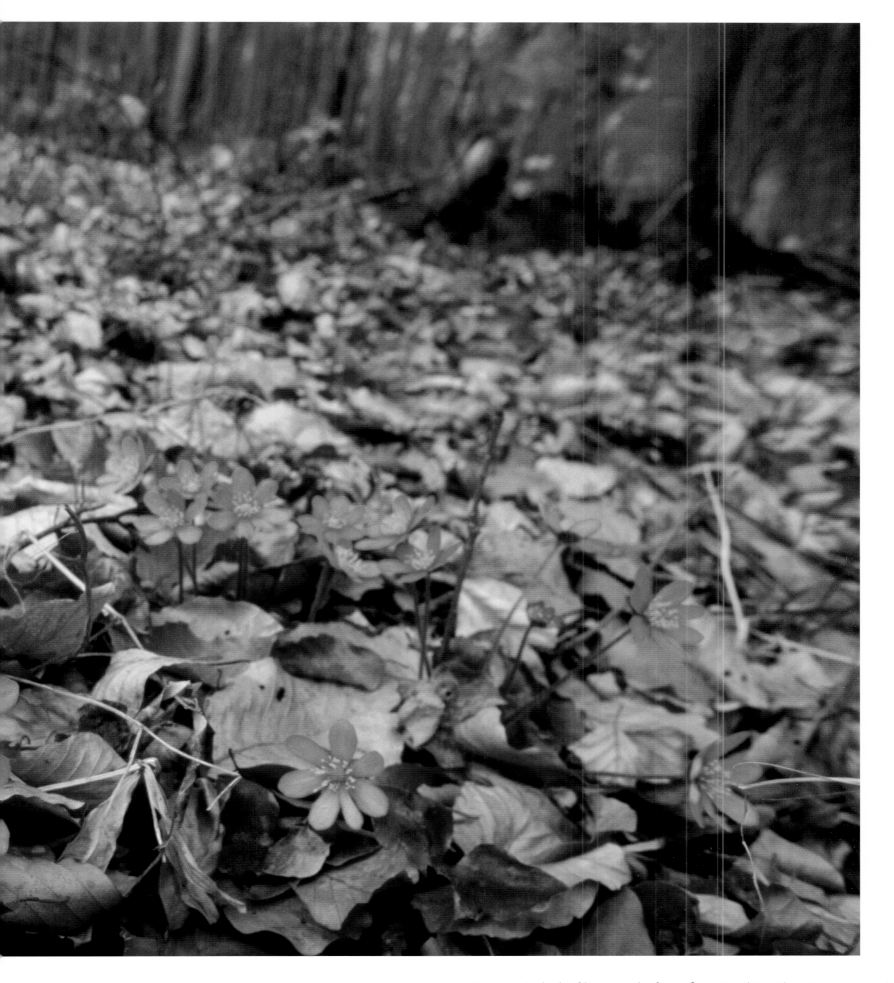

Liverwort in the leaf layer on the forest floor. Swabian Alps, Germany.

Evergreen Coastal Rainforests of the Temperate Zone

The cool rainforests found in North America along the coasts of California, the Pacific Northwest and Canada up into Alaska are of a special type and are similar to forests found in parts of Chile, Japan and New Zealand. They account for only a very small part of the forested landmass of the temperate zone but are among the most productive ecosystems on earth. Not only do they hold the world record for the tallest tree on earth—a nearly 116 meter (380 feet) high, six-to-eight-hundred-year-old California coast Redwood is the tallest known tree in the world—but they also generate the most biomass per hectare, up to two thousand metric tons (809 tons per acre).[8] This is aided by extremely high precipitation amounts of more than three meters (ten feet) per year, as rain clouds coming off the ocean get trapped against inland mountain ranges and deposit all their moisture in the form of rain. Moreover the winters are milder, and the summers cooler, in the heavily ocean-influenced forest climate than farther inland; temperatures in the forests hover between 10 and 24°C (50 and 75°F), and summer fogs often supply the forests with additional moisture.

Typical tree species of temperate rainforests: Coast redwood (*Sequoia sempervirens*), coast Douglas fir (*Pseudotsuga menziesii var. menziesii*), Sitka spruce (*Picea sitchensis*), western hemlock (*Tsuga heterophylla*), western red cedar (*Thuja plicata*), alerce (*Fitzroya cupressoides*), monkey puzzle or Chilean pine (*Araucaria araucana*), kauri (*Agathis australis*), sugi or Japanese cedar (*Cryptomeria japonica*).

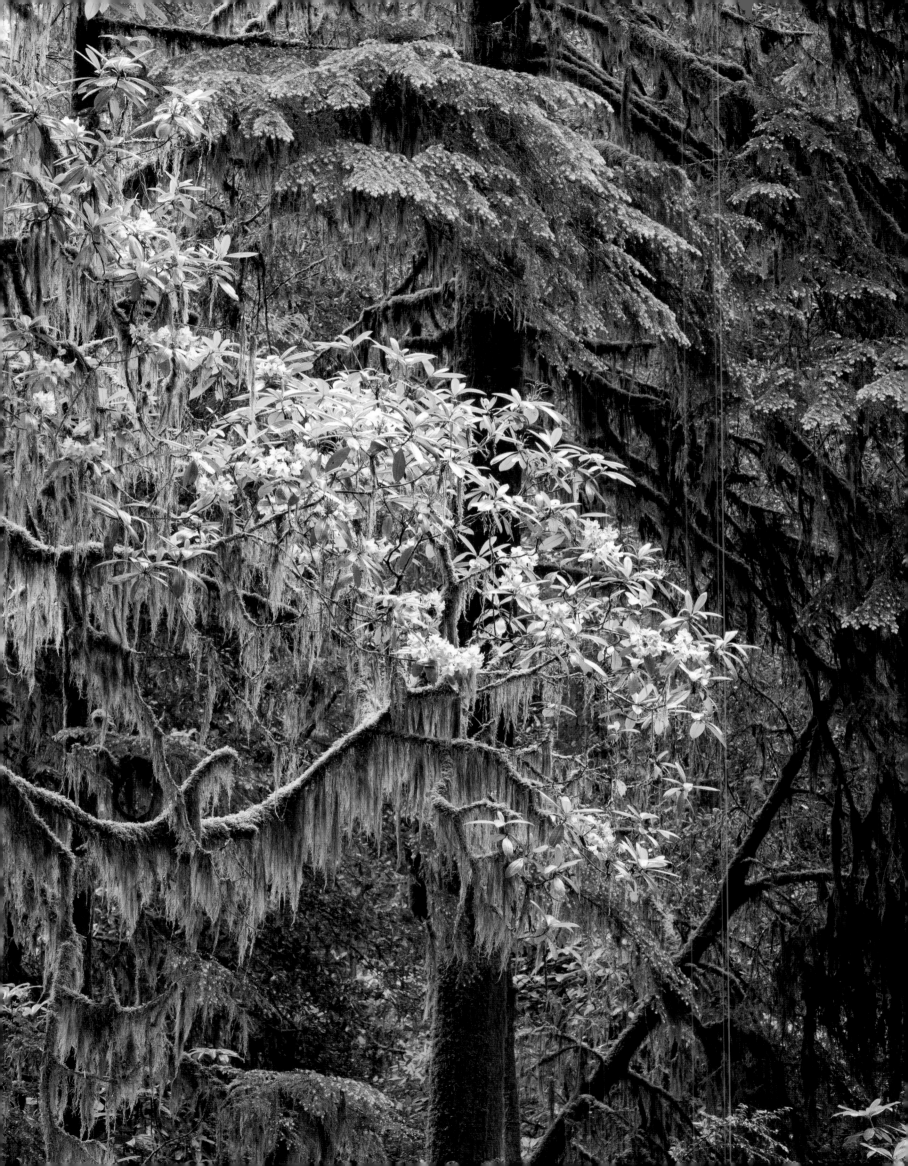

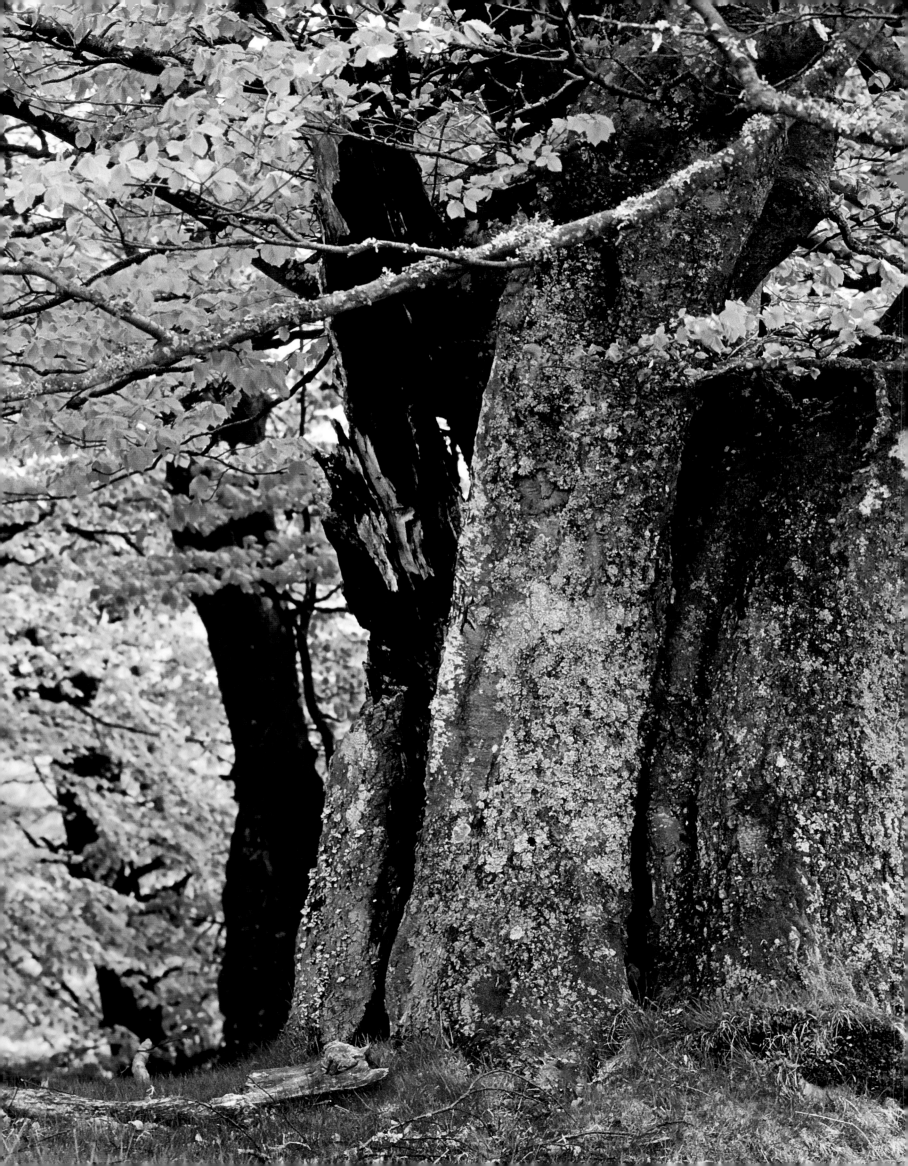

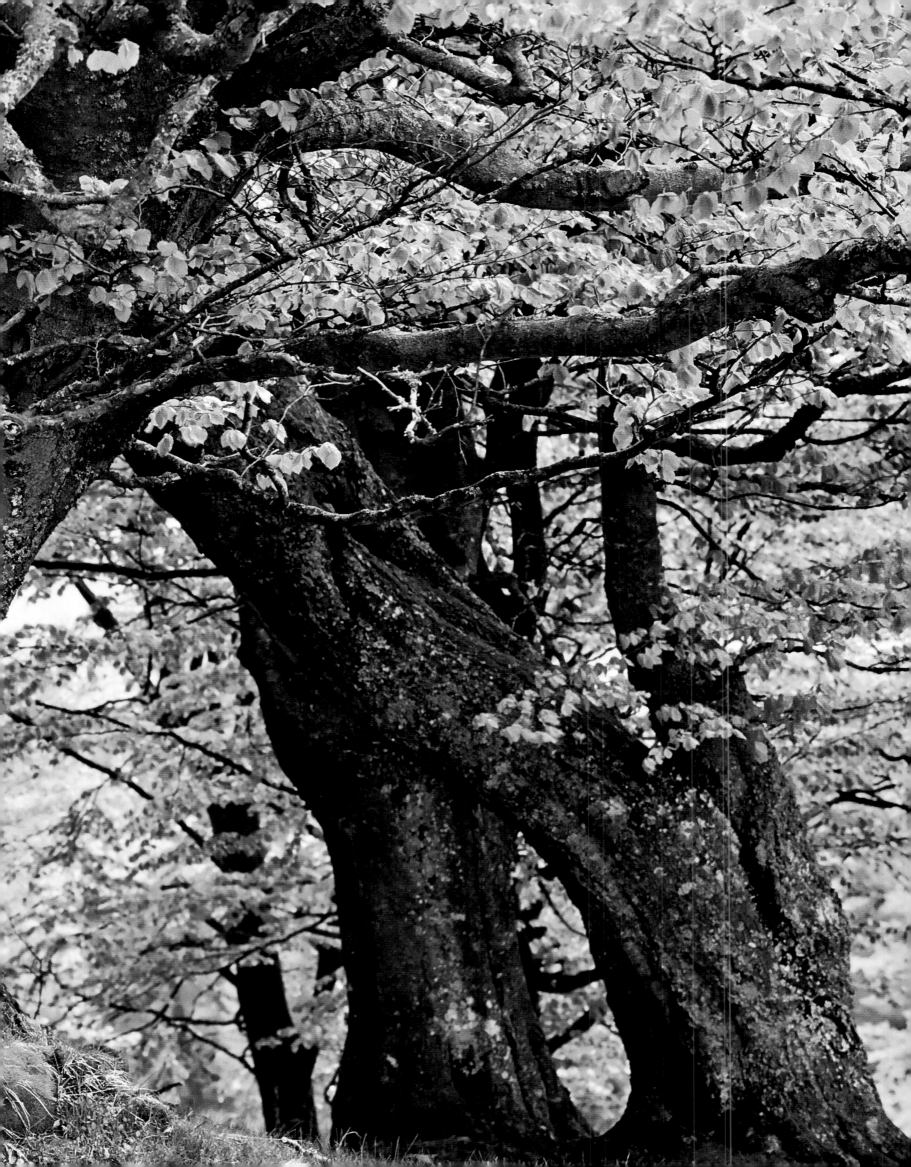

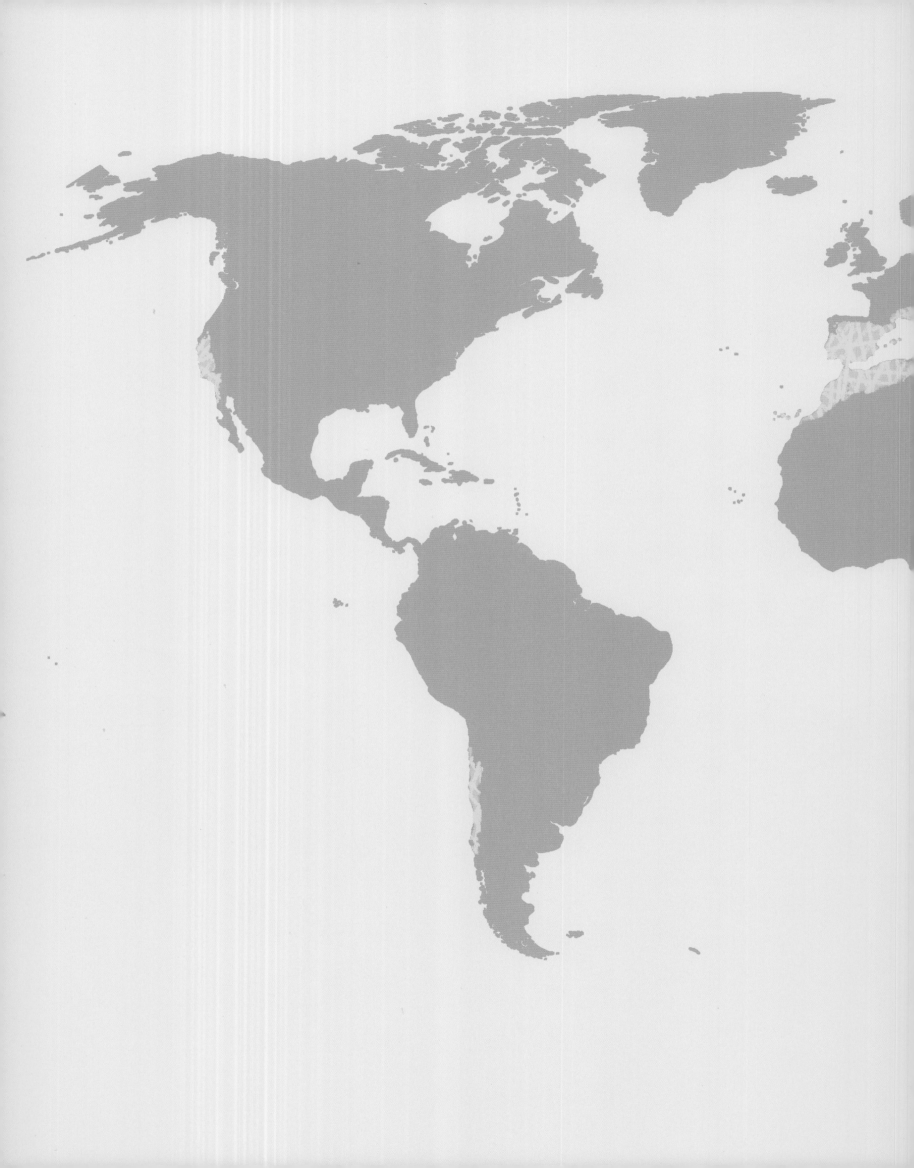

Mediterranean Sclerophyll Forests

Forests That Stand Up to Fire

Each of the five Mediterranean-type regions of the world has its own character. But all of them stand out for their high biodiversity and special adaptations to drought and fire.

Characteristics hot, dry summers and mild, humid winters; trees and shrubs often have thick bark and narrow, leathery-hard foliage; recurring wildfires

Distribution the Mediterranean, California, central Chile, southwestern and southern Australia, the Western Cape region of South Africa

Tree species oaks such as holm oak (*Quercus ilex*) and cork oak (*Quercus suber*); pines (*Pinus spp.*); olive (*Olea europaea*); and in the Southern Hemisphere, eucalyptus and podocarps (*Podocarpus spp.*)

Animals genet, Sardinian warbler, black racer, green lizard, two-tailed pasha (*Charaxes jasius*)

Status impacted by humans for millennia; threatened today by development, agriculture, and forestry involving eucalyptus and pine plantations

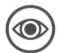

Special features high biodiversity with many endemics (species that only occur in one region); favorable climate for cultivation of grapes and olives

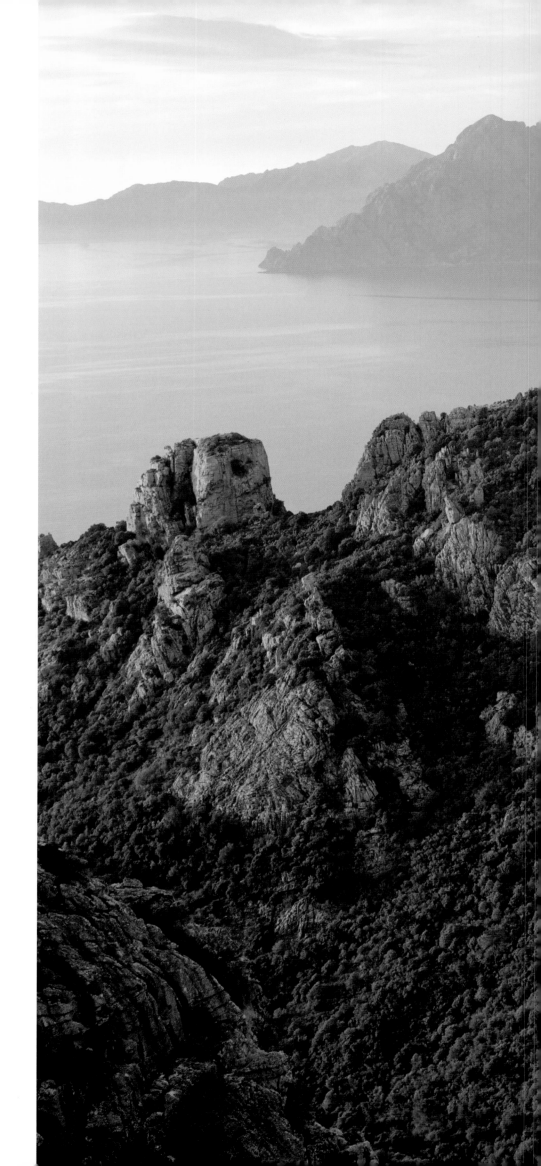

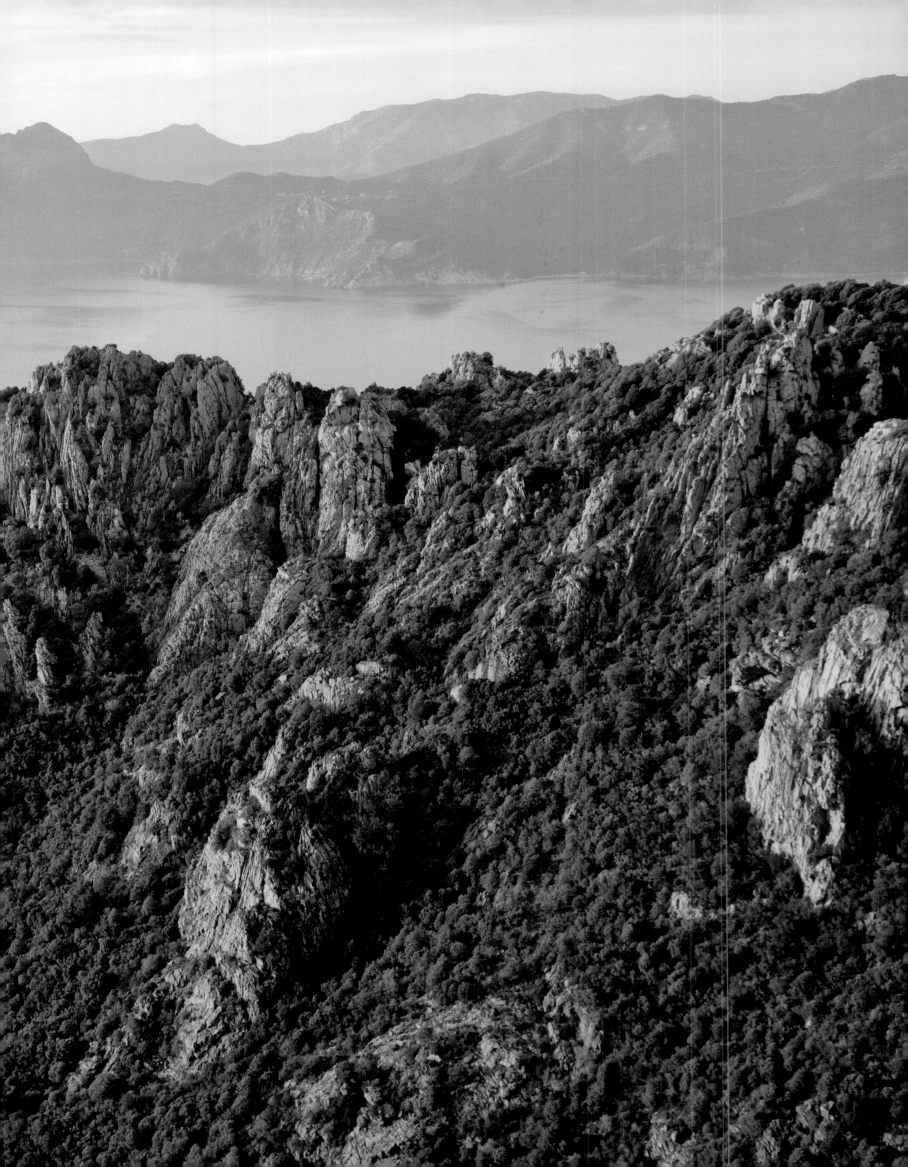

Above: **Forest dominated by pine** on the coast of the Pelješac peninsula, Dalmatia, Croatia. Mediterranean forests are always near the coasts, because the waters of the sea store up the heat of the summer and so take the bite off the winter cold. // Right side: **A holm-oak forest in the fog.** If nature had its way, large areas of the western Mediterranean region would be covered in holm-oak upland forests (*Quercus ilex*), such as this one in the French Pyrenees. Because little light filters through the dense canopy, only very modest undergrowth emerges; the lower layers of the forest remain relatively cool and humid.

The Forest and the Sea

The Mediterranean climate zone is clearly influenced by the sea, which stores heat during summer and releases it again slowly during winter. The resulting mild and damp winters, rich spring blooms, and long, dry summers shape the lives of the people as well as the plants and animals. Almost all the precipitation falls during the winter months; annual precipitation rates run between 150 and 900 millimeters (6–35 inches). Snow and freezing temperatures are rare near the coast and occur no more than a few days each year.

Worldwide, there are only five relatively small regions that have this special climate: the Mediterranean region, California, central Chile, southern and southwestern Australia, and the Western Cape region of South Africa. These all lie between 30° and 40° N or S latitude and together occupy 3.2 million square kilometers of land (about 1.2 million square miles), the largest by far being the Mediterranean with an area of 2.3 million square kilometers (around 888,000 square miles).[1] Occasionally, the Mediterranean zone is also called the "warm-temperate zone" because it occupies a categorical position between the moderately cool hardwood and the tropical dry forest zones.

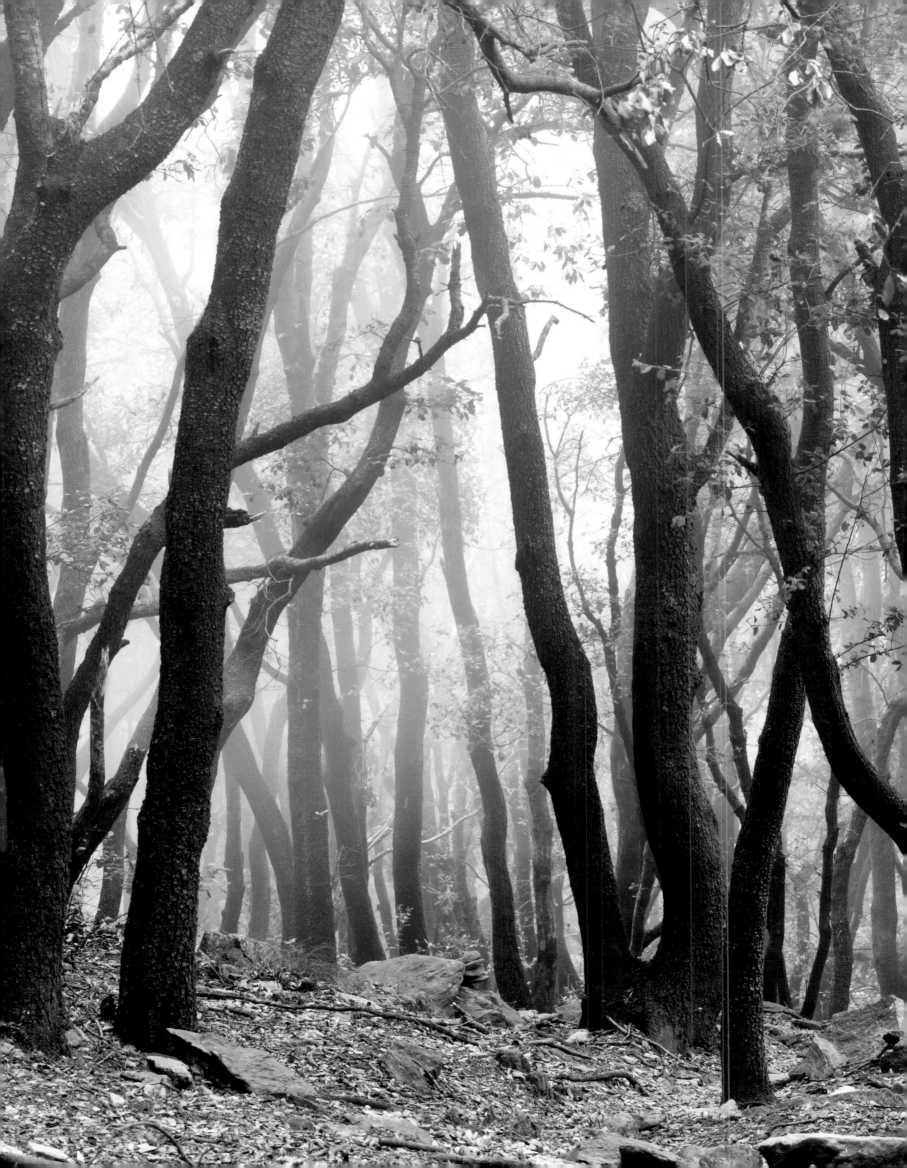

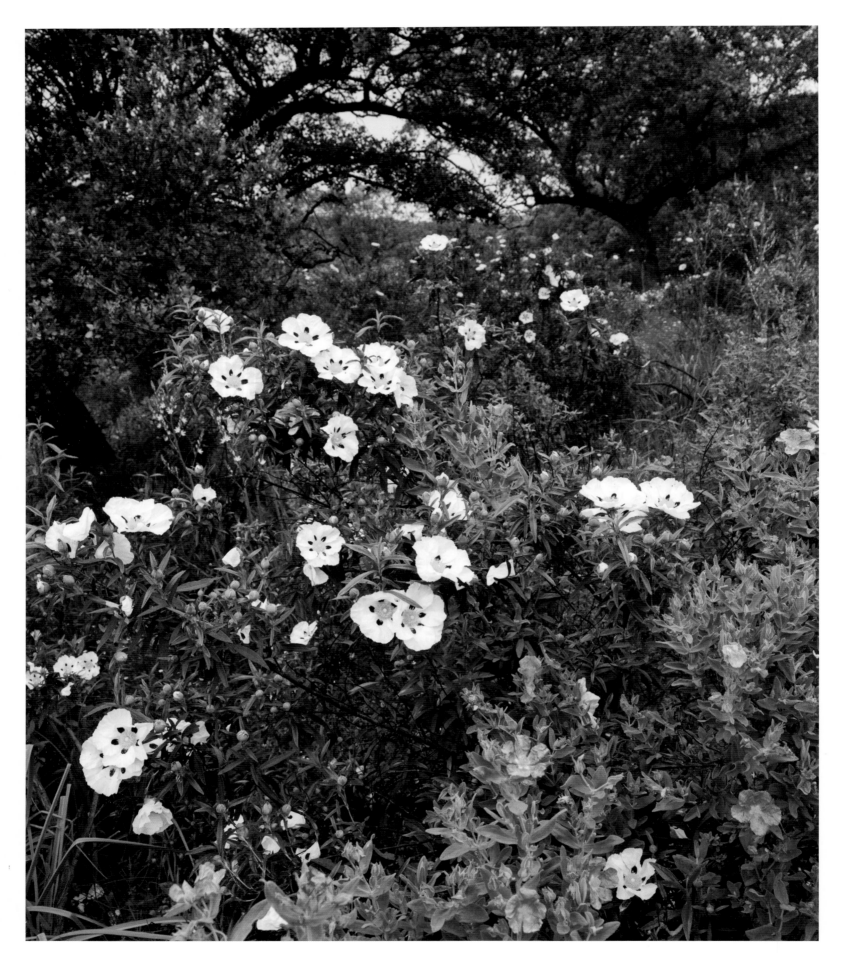

Rockroses and oaks. The leaves of the white-flowering gum rockrose (*Cistus ladanifer*) are protected from the sun by a sticky wax that exudes an intense, bitter scent. Another species of rockrose (*Cistus sp.*) is growing next to it. Sierra de Andújar, Andalusia, Spain.

High Plant Biodiversity in a Small Area

While in terms of surface area the Mediterranean zone accounts for only two percent of the earth's total landmass, it is home to one-fifth of the world's 250,000 known plant species.[2] The vegetation consists of forests, grasslands and shrubs, with ecosystems that depend on fires burning through every few decades.[3] The cones of some pine species as well as the floral clusters of the silk- or silver-oak, which grows in South Africa and Australia (family *Proteaceae*), actually need a wildfire's heat to release their seeds or to enable the seeds to germinate.

Macchia in bloom. The Italian gladiolus or common sword-lilly (*Gladiolus italicus*), which is graceful and petite compared to our garden-variety gladioluses, grows in the Tuscan macchia alongside Spanish broom (*Spartium junceum*) and orchids such as tongue Serapias and Ophrys.

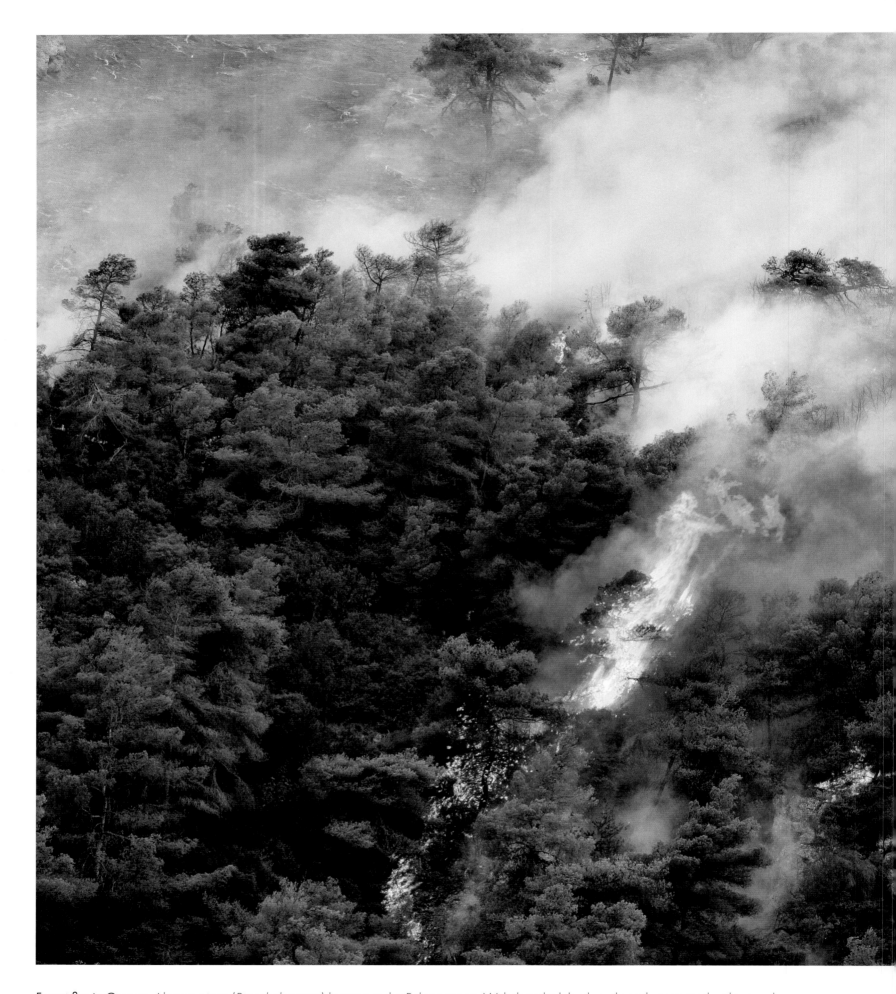

Forest fire in Greece. Aleppo pines (*Pinus halepensis*) burning in the Peloponnese. With their thick bark and seeds protected within tough cones, pines are adapted to forest wildfires. But with climate change and human acts of arson, the frequency of summer fires is rising.

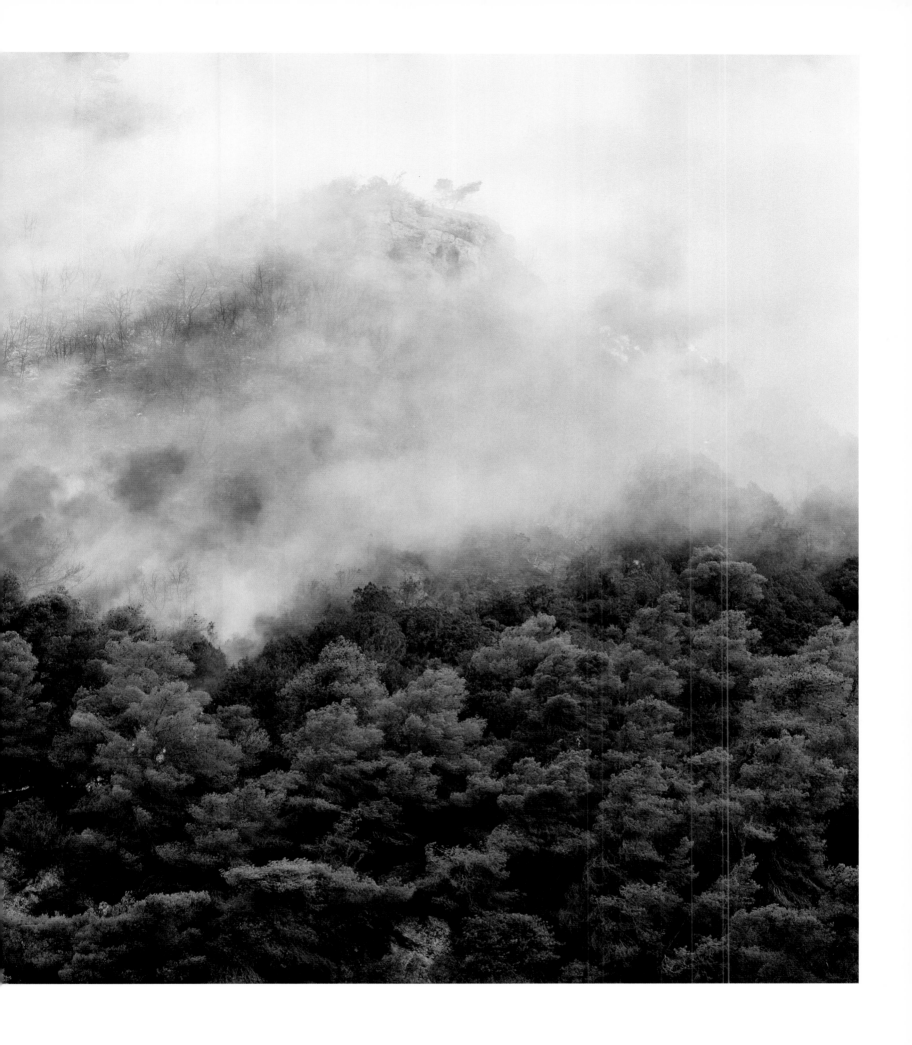

Sclerophyll and Evergreen

The trees of the Mediterranean forests guard against fire, summer drought, and intense sunlight with thick bark and relatively small, leathery leaves that have a shiny surface or a dull wax layer. Since the winters are largely frost-free, the trees hold on to their leaves all year round, gradually cycling through them over the course of several years.

Oaks are quite common: A great many of the world's approximately six hundred species of oak (*Quercus*) grow in Mediterranean landscapes. A typical lower-elevation evergreen sclerophyll forest up to around five hundred meters (1,640 feet) consists of holm oaks (Quercus ilex) and cork oaks (Quercus suber). Holm-oak forests with trees as tall as twenty-five meters (eighty-two feet) once extended all across the western and central Mediterranean region. Other common tree species include laurels (*Lauraceae*), hollies (*Ilex*), and Olea species such as true olive (*O. europaea*).

Pines (*Pinus*) are another of the region's typical tree species. Pines are pioneers: They grow fast, are well adapted to drought and barren soils, and their seeds are dispersed by the wind. The Italian stone pine (*Pinus pinea*), a native of the southern Mediterranean region, has been cultivated since before the Roman

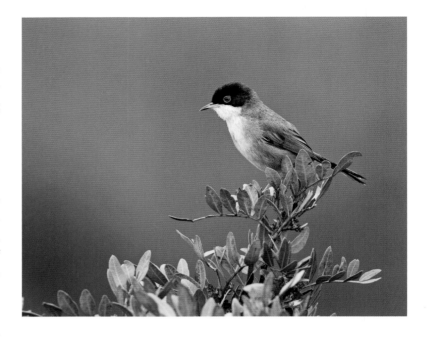

A Sardinian warbler. The male Sardinian warbler (*Sylvia melanocephala*), with its black head and red eye ring, is handsomely colored. The species hunts insects and inhabits the Mediterranean coasts year-round. It is quite trusting and is found in macchias and open forests with lush undergrowth.

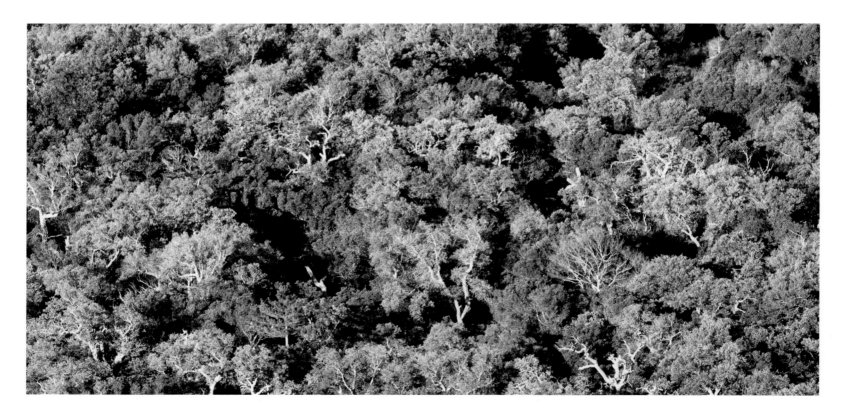

Cork-oak forest. The Mediterranean sclerophyllous trees, with their leathery leaves and thick bark, are adapted not only to the dry summers but also to regularly occurring wildfires. The most impressive example of this is the cork oak (*Quercus suber*), with its several-centimeters-thick, fire-retardant bark that protects it effectively against the flames. While the surface of the soil with grass, foliage and low shrubbery burns beneath the trees, the tree crowns are left unscathed.

period for its tasty seeds: pine nuts. People would establish plantations of stone pine, for example, as a buffer between the sea and agricultural areas farther inland. Pine and oak often occur together in mixed stands, since oak can grow in the shade of the pines and, conversely, pine will grow in less favorable spots within oak forests. Across the western and into the central Mediterranean region, a mix of holm oak and Aleppo pine (*Pinus halepensis*) often forms; in the eastern Mediterranean, the mix will be of Palestine oak (*Quercus calliprinos*) and Calabrian pine (*Pinus brutia*).[4] Pure stands of pine in the present-day Mediterranean region are the result of plantations going back to the 18th century.

At higher elevations between five hundred and a thousand meters (1,640 to 3,280 feet)—or eight hundred to fourteen hundred meters (2,625 to 4,593 feet) in the southern Mediterranean region—we find a sub-Mediterranean hardwood forest stage. Here, summer drought is less pronounced, winter frosts are more common, and more and more species of deciduous trees appear. Depending on the region, downy oak (*Quercus pubescens*), Pyrenean oak (*Quercus pyrenaica*), Turkey oak (*Quercus cerris*) or Hungarian oak (Quercus frainetto) is dominant. Other tree species in this zone include flowering ash (*Fraxinus ornus*), Montpellier maple (*Acer monspessulanum*), and European hophornbeam (*Ostrya carpinifolia*) as well as—via propagation by humans—the sweet chestnut (*Castanea sativa*). At still higher elevations, the forests in montane locations, up to tree-line, are made up of beeches and firs and resemble the hardwood forests of the temperate zone.

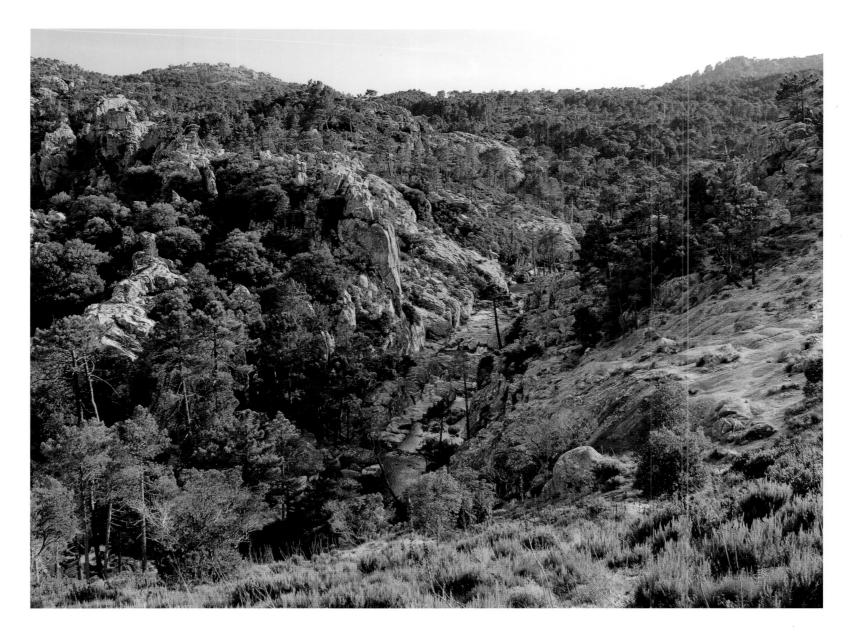

Rockland forest. In the mountains of southeastern Corsica, a stream has carved a channel through the landscape. These pines are clinging to the rocky slopes. Oaks can be found as well, in nooks where a little more soil has collected.

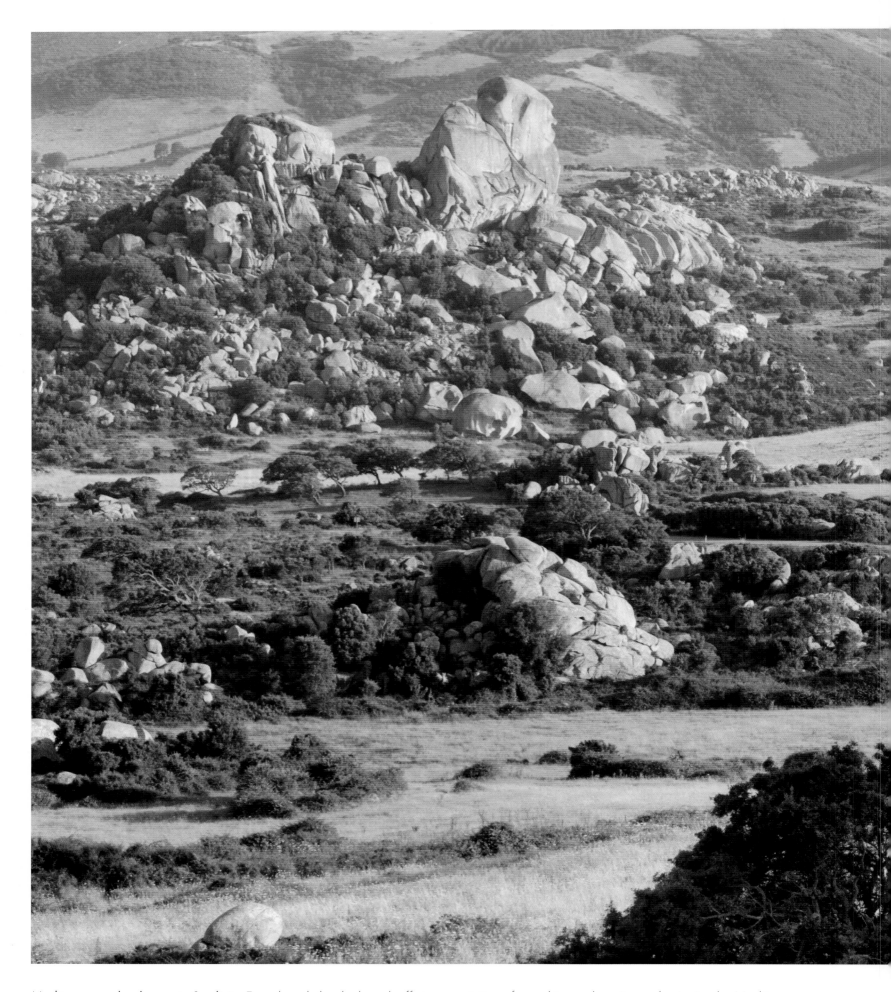

Mediterranean landscape in Sardinia. Even though the shrub and suffrutex vegetation of macchias and garrigues dominates the Mediterranean zone nowadays, forests can still be found in many places, especially in more fertile locations with deeper soil, or in river valleys, or as gallery forests along river courses.

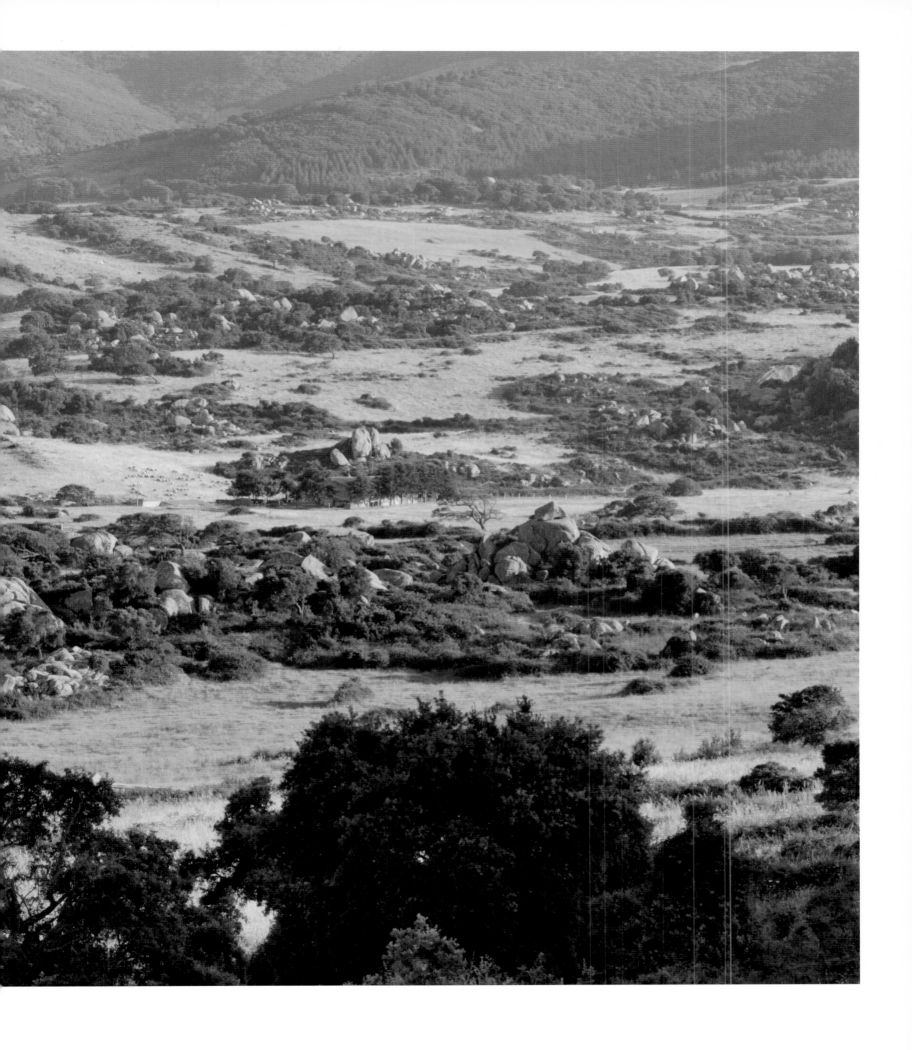

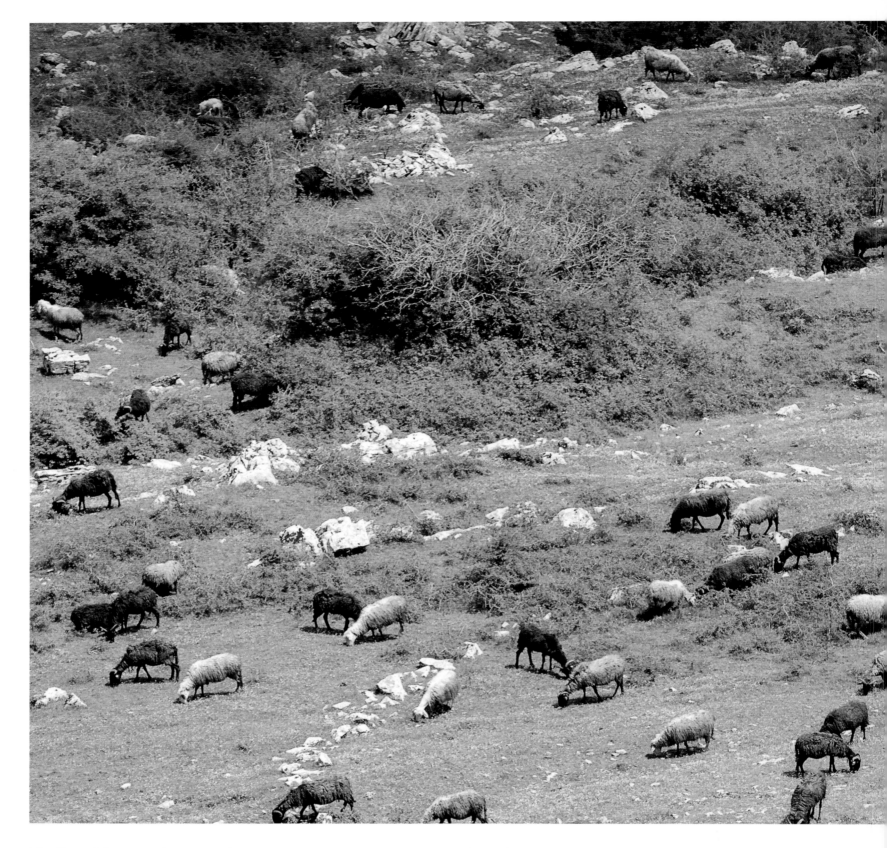

The Transition to Cultural Landscape

The great structural diversity of the Mediterranean ecosystems over a small area[5] is the result of the ever-changing topography, variations in the soil and, not least, the influence, over thousands of years, of human activity on the appearance of the landscape. Already in antiquity, the primeval forests of holm oak were cleared to make room for cultivation of wheat, olives and wine-grapes as well as for timber to be used in construction and shipbuilding. Later, with the development of coppicing, people would cut oaks "down to the stock" regularly, meaning they would cut the shoots for firewood or for the charcoal needed to smelt iron ore (among other uses). Intensive grazing of sheep and goats did the rest, preventing natural reforestation and leading, particularly on hillsides or steep slopes, to erosion of the fertile soil. But because of the dry summers, Mediterranean-type forests grow back much more slowly than the hardwood forests of central Europe, even without excessive grazing. That is why only a few patches of natural holm-oak forest remains today in such places as Tuscany, Corsica, and Catalonia.[6]

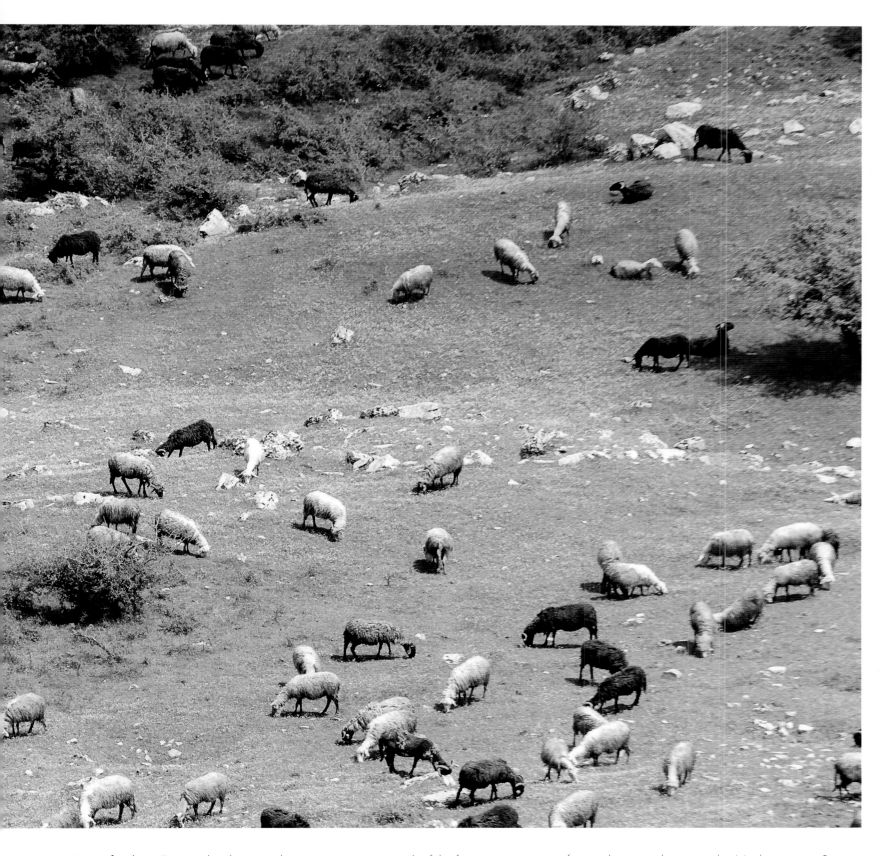

Forest–feeders. Grazing by sheep and goats prevents regrowth of the forest in many once-forested areas adjacent to the Mediterranean Sea. For especially in steep terrain, neither water nor soil can hold on for long, and erosion leaves large swathes of infertile land behind.

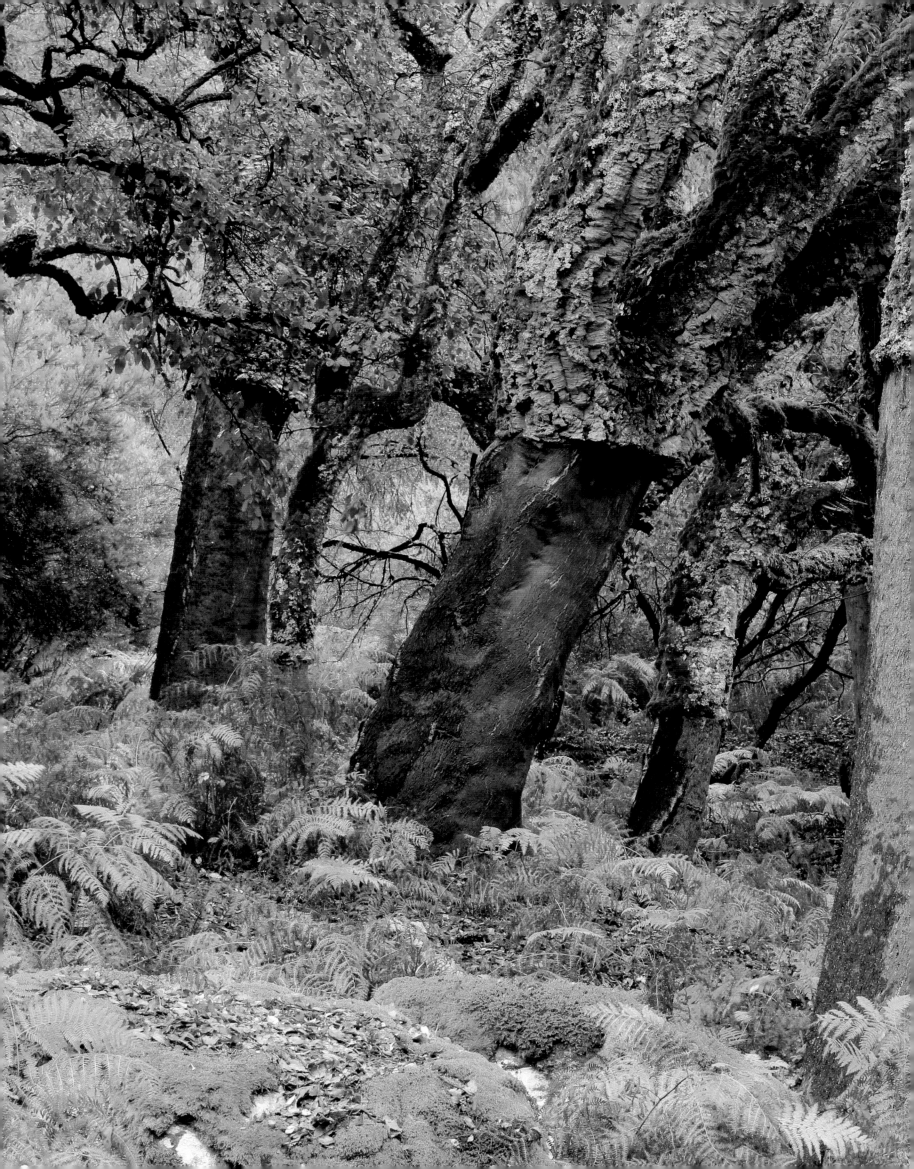

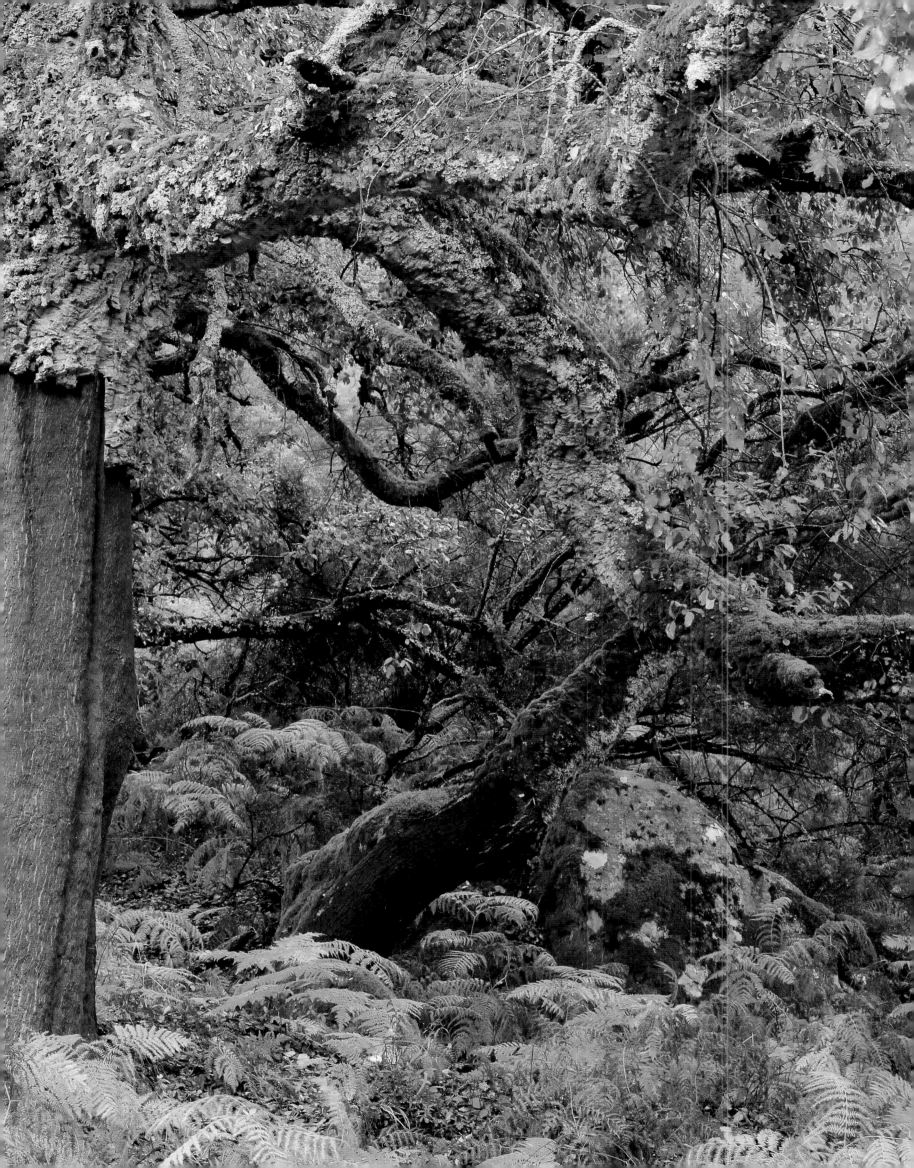

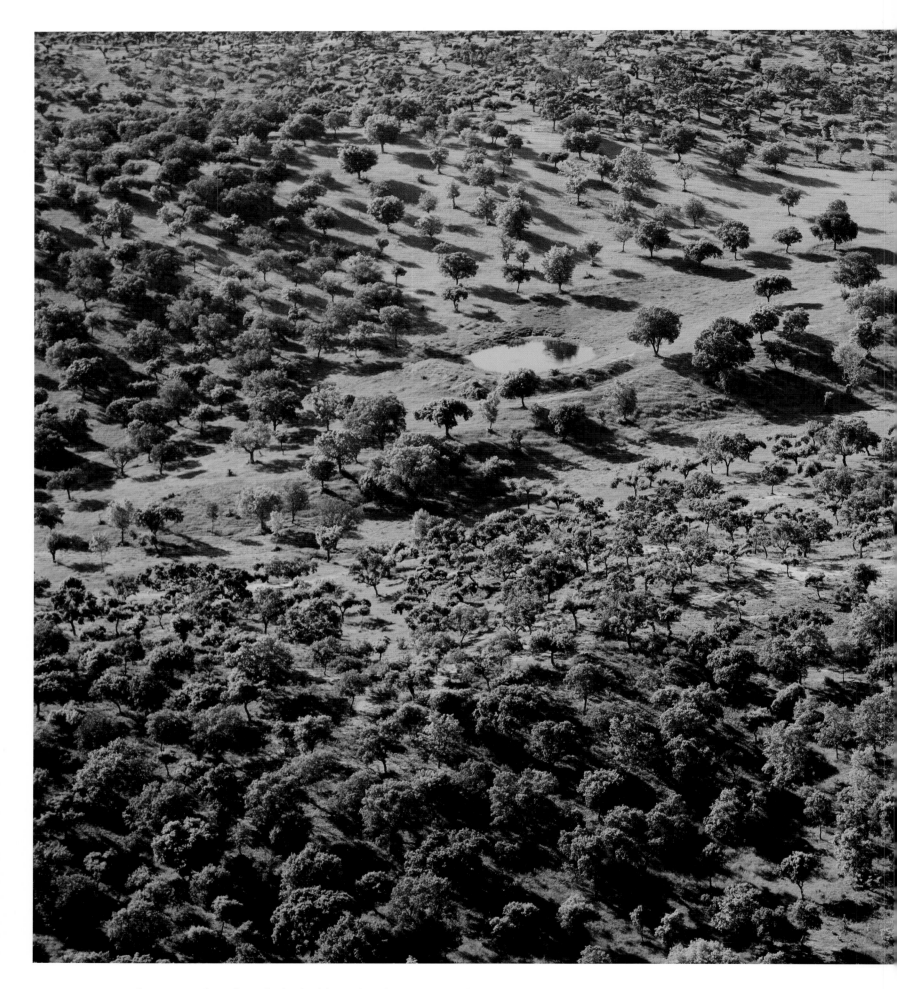

Previous page: **Cork is a natural product.** The bark of the cork oak gets extracted every ten or so years; it takes that long for the tree's cork layer to grow back. // Above: **Silvopasture.** Called dehesa in Spain and montado in Portugal, these parkland-like holm- and cork-oak forests are a particular formation of Mediterranean forest on the Iberian Peninsula, developed by humans for grazing livestock on.

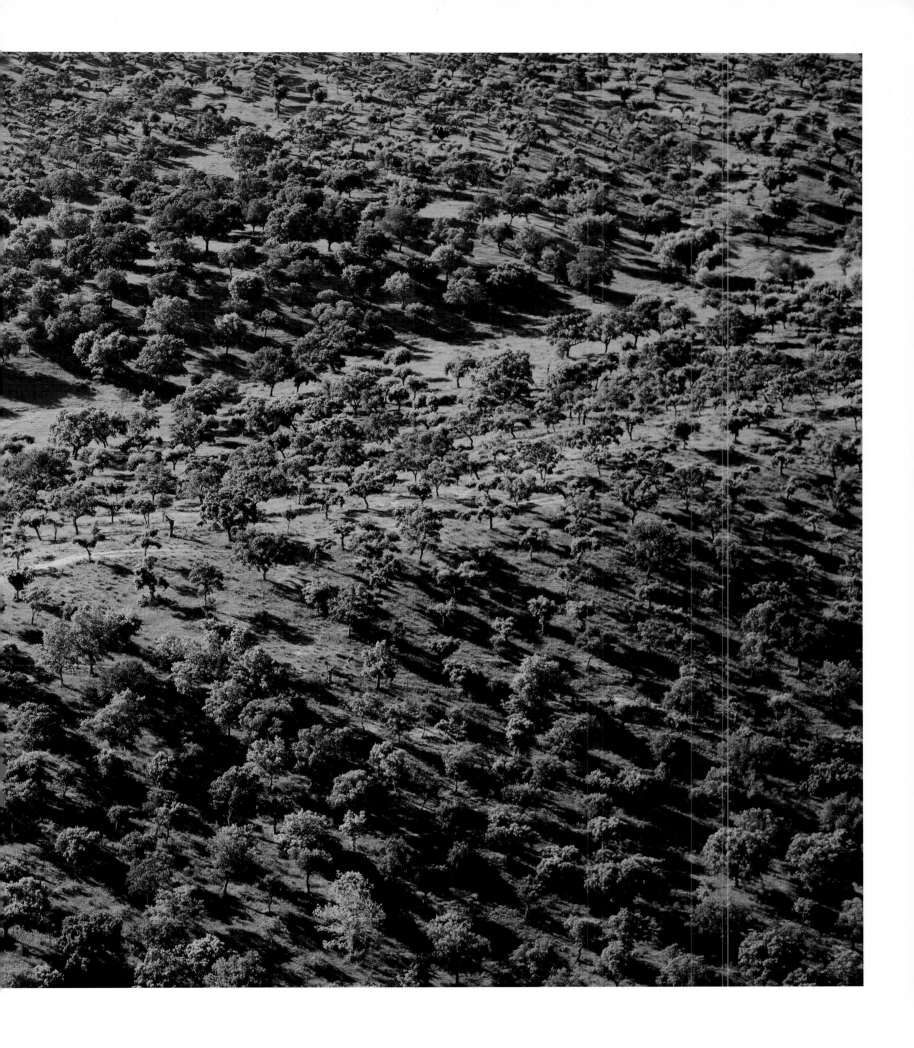

California and the Southern Hemisphere

Different oak species dominate the Mediterranean forests of California, where a distinction lies between the coast live oak (*Quercus agrifolia*) forests of coastal areas and the blue oak forests farther inland and up to the foothills of the Sierra Nevada. Mediterranean-type sclerophyll forests once existed all over central Chile until humans cleared great expanses of them. Typical tree species in the stands that remain there are peumo or Chilean acorn (*Cryptocarya alba*), boldo (*Peumus boldus*), and manio (*Podocarpus nubigenus*). In the Western Cape region of South Africa little forest remains, because of human use, frequent fires and summer drought. Nonetheless, there are small remnants of southern Afromontane forests of yellowwood (*Podocarpus sp.*), wild almond (*Brabejum stellatifolium*), Cape holly (*Ilex mitis*) and many other sclerophyllous trees; these are found predominantly in wetter, fire-protected locations like canyons or along the beds of rivers, for instance near Knysna or by Cape Town on the eastern flank of Table Mountain. In southern and southwestern Australia, the Mediterranean-type forests are dominated by various eucalyptus species such as karri (*Eucalyptus diversicolor*), which can grow up to seventy meters (230 feet) tall.

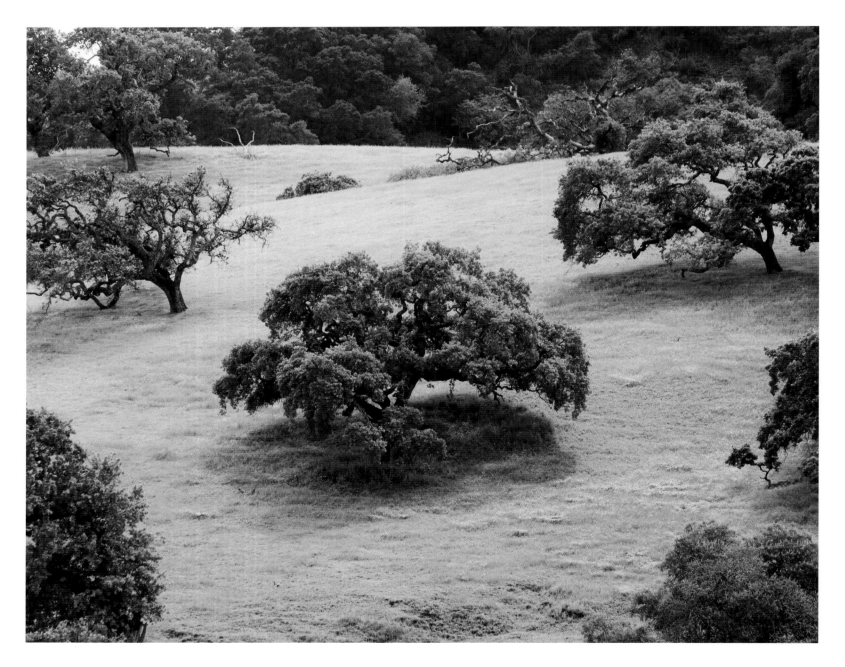

A park-like oak grove in central California, with dense forest in the background. The California live oak (*Quercus agrifolia*) has leathery evergreen leaves with a thorny border. It and other oak species dominate the Mediterannean sclerophyll forests between California's Pacific coast and the Sierra Nevada mountains. However, only tiny portions of the original vast forests remain.

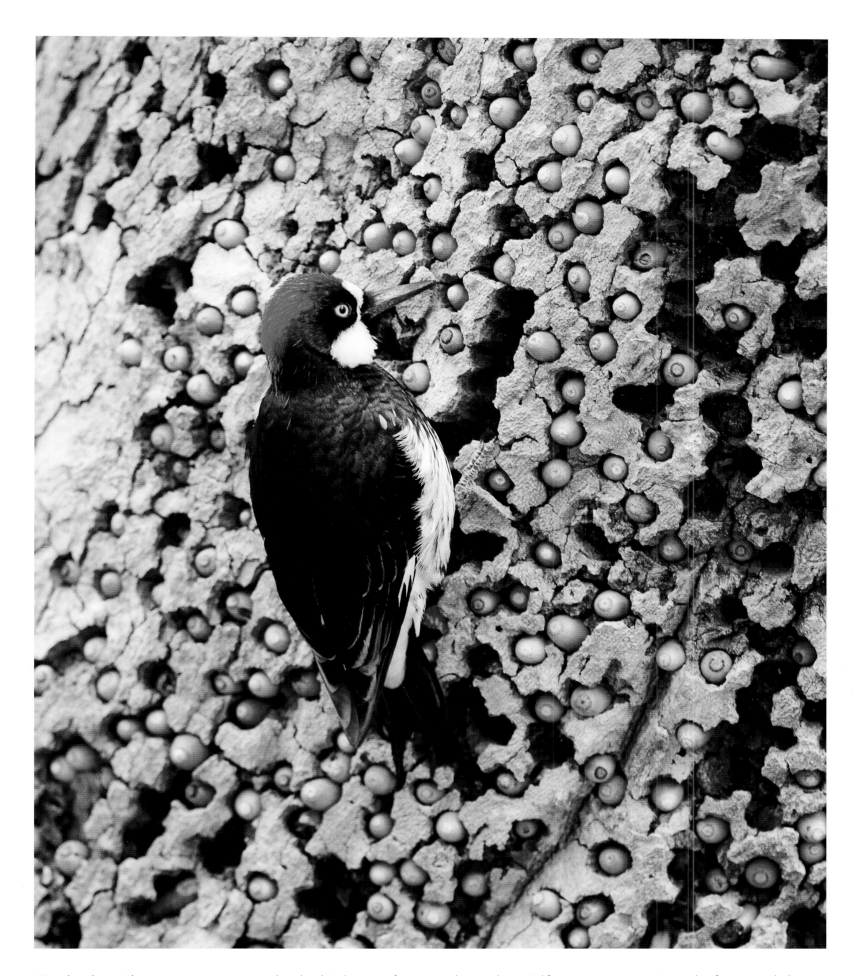

Woodpecker, with granary. An acorn woodpecker (*Melanerpes formicivorus*) in southern California stows a winter's supply of acorns in holes it has chiseled into the tree-bark with its beak solely for this purpose. In doing so, the gregarious woodpeckers cooperate in groups and defend their granary-tree against other woodpeckers. The granaries, maintained over many generations of woodpeckers, are perforated through-and-through.

Macchia & Co.: Shrubs, Not Trees

The forests of the Mediterranean region range from closed-canopy forests where little light penetrates to the forest floor, to loose stands with a pronounced shrub layer, to parklands with scattered tree-cover. The boundaries are fluid and depend on the intensity of grazing, the frequency of forest fires, and the local relationships of climate and soil. Anywhere sclerophyll forests have been cleared by humans, a relatively dense, shrubby vegetation grows to heights anywhere between one and five meters (three to sixteen feet). Depending on the region and on certain specific characteristics, this growth is called: macchia (in the Mediterranean region); chaparral (in California); matorral (in Chile); fynbos (in South Africa); or kwongan (in Australia). Trees that originally would have preferred the understory of intact forests stand sporadically—and, frequently, disfigured-looking—among the vegetation in these landscapes. In the western Mediterranean, for example, these species might be tree heath (*Erica arborea*), strawberry tree or strawberry bush (*Arbutus unedo*), mastic tree or lentisco (*Pistacia lentiscus*), or laurel of antiquity (*Laurus nobilis*). Another forest type, known as garrigue, develops anywhere with heavier grazing or where the local climate is drier and more barren. Garrigue is short, open, shrubby heath that occurs naturally mostly at the transition between the forest and coastal zones. The same type is called "phrygana" in the eastern Mediterranean region and "batha" in Israel. Low shrubs grow there that are adapted to summer drought: rockroses (*Cistus sp.*), rosemary, lavender, Spanish broom (*Spartium junceum*) and true myrtle (*Myrtus communis*), as well as tough, herbaceous plants like thyme, sage, thistles and grasses. Many of these plants have developed spines or prickles or accumulate ethereal oils in their leaves to protect themselves against grazing. And there is a particular richness of species representing the geophytes—plants that survive droughts with the help of underground storage organs—such as alliums (*Allioideae*), cyclamen, and members of the orchid family.

Left side: **A landscape dominated by tall shrubs and dense bushes** (*macchia*) has supplanted the original forests in many Mediterranean areas. In the foreground: Spanish broom (*Spartium junceum*); in the background: wooded slopes in the south of Tuscany, Italy. // Above: **The strawberry tree** (*Arbutus unedo*), which is a relative of the genus *Erica*, bears its small white flowers and striking red, bitter-tasting fruits at the same time.

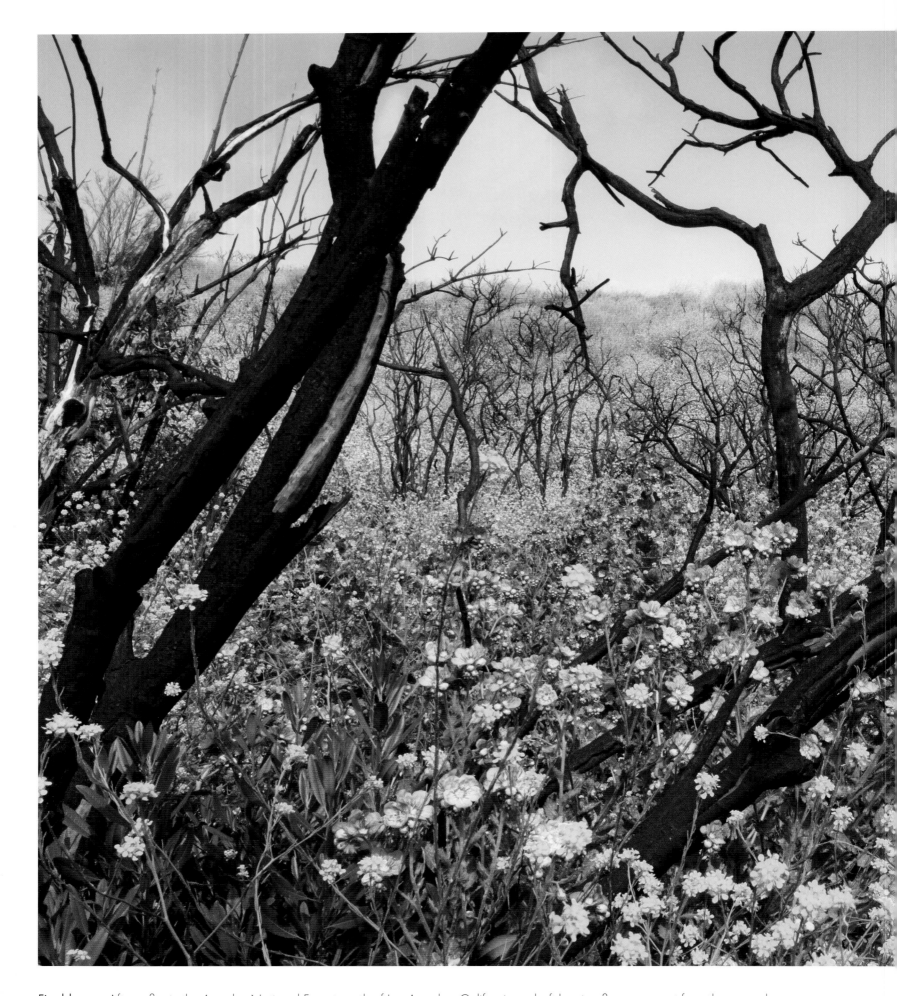

Fire blooms. After a fire in the Angeles National Forest, north of Los Angeles, California, colorful spring flowers sprout from the ground.

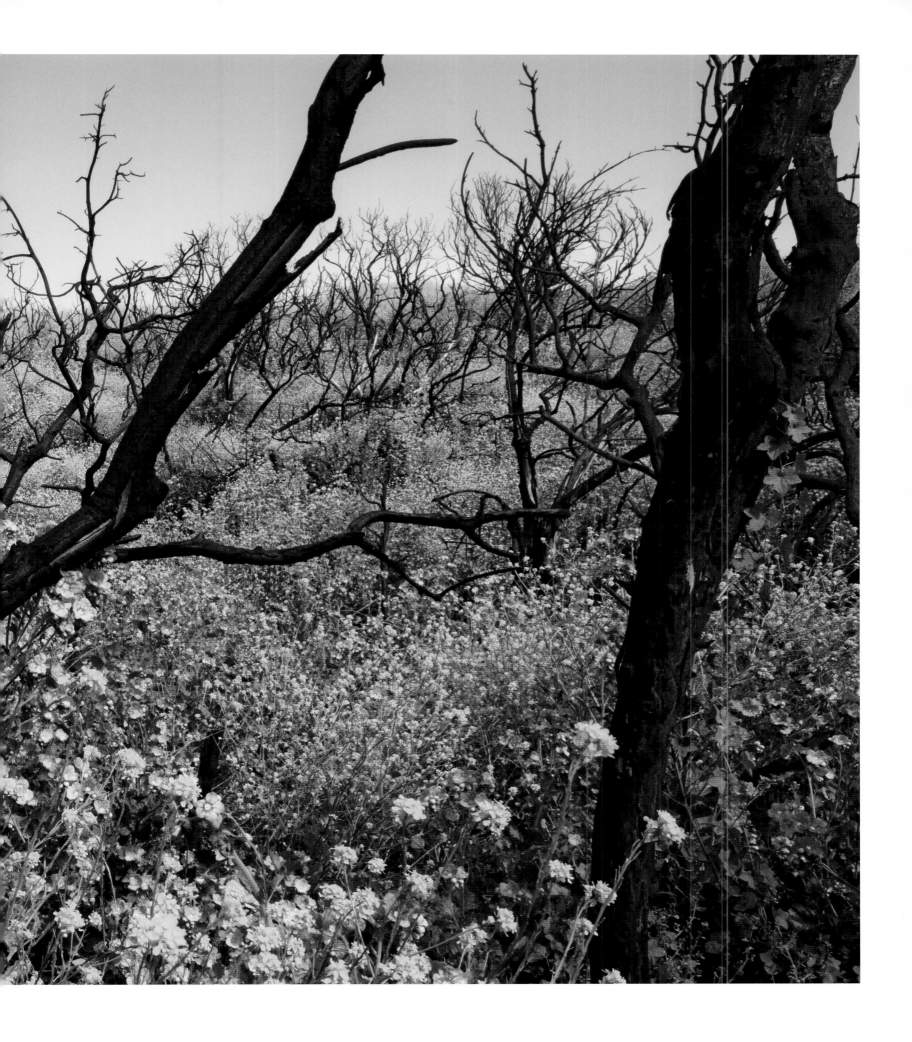

The Realm of Insects, Reptiles, and Birds

The hot, dry Mediterranean climate guarantees an extreme diversity of insect, spider and reptile fauna. Lizards, like the western green lizard and the ocellated lizard, sun themselves on rocks; and black racers, Dahl's whip snakes and asp vipers hunt along the ground. Praying mantises and crab spiders lay in wait for incautious flower-visitors such as bees or butterflies. Numerous bird species, such as sylvian warblers (*Sylvia spp.*), tree warblers (*Hippolais spp.*), the European bee-eater (*Merops apiaster*), shrikes (*Lanius spp.*), the European roller (*Coracias garrulus*), the Eurasian hoopoe (*Upupa epops*), or the short-toed snake eagle (*Circaetus gallicus*) profit, in turn, from the plethora of reptiles and insects. In summer, the familiar monotone call of the Eurasian scops owl (*Otus scops*) heralds nightfall in the forests of the Mediterranean region. This small owl, which spends the winter in Africa south of the Sahara, hunts large insects such as cicadas, tree- and leafhoppers, grasshoppers, crickets, locusts and beetles. Eurasian jays (*Garrulus glandarius*), western scrub-jays (*Aphelocoma californica*) and acorn woodpeckers (*Melanerpes formicivorus*) feed on a plentiful supply of acorns. In evening twilight, when the heat of the day relents, rodents such as the garden dormouse (*Eliomys quercinus*) or insectivores like the Etruscan (or white-toothed)

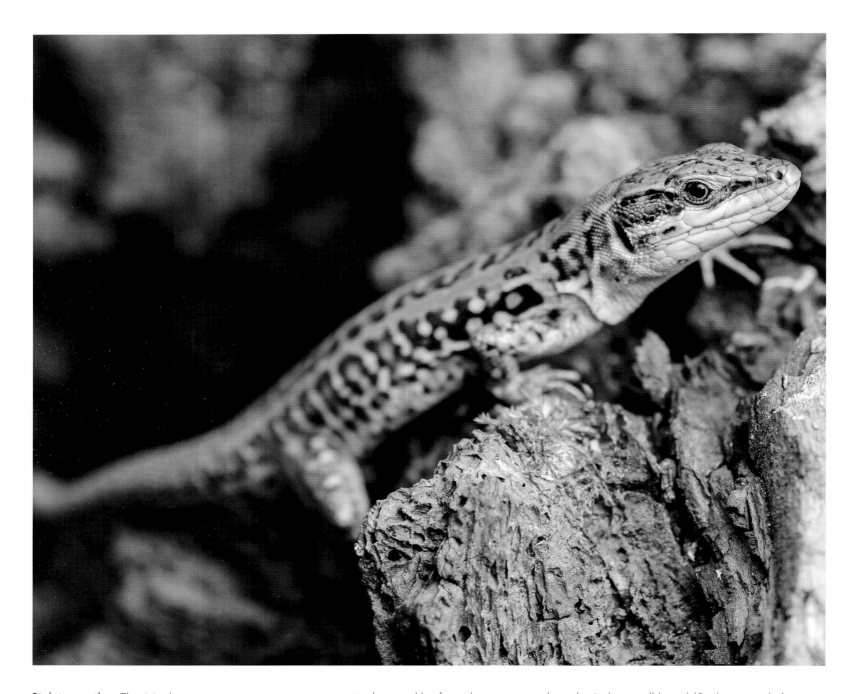

Rich in reptiles. The Mediterranean zone possesses a particular wealth of reptile species such as the Italian wall lizard (*Podarcis siculus*), where—being cold-blooded—they are accommodated by plenty of sunshine, mild winters, and an abundant food supply in the form of tasty insects.

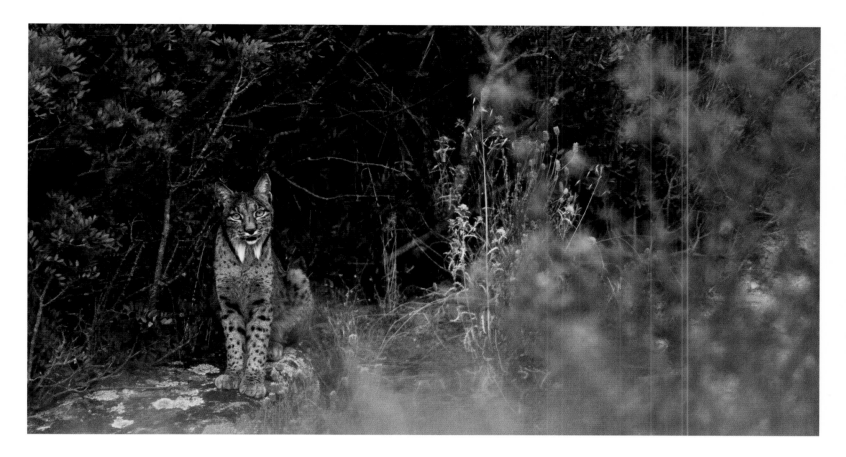

Rare cat. The Iberian lynx (*Lynx pardinus*) is one of the rarest cats in the world. It feeds practically exclusively on rabbits and lives only in the oak forests and macchias of western Spain and Portugal. Destruction of its habitat, roadkill, and its prey being decimated by myxomatosis had brought the elegant cat to the brink of extinction. But the population has meanwhile been stabilized again through intensive conservation and breeding programs.

pygmy shrew (*Suncus etruscus*) venture out of their hiding-places. Bat species are especially well represented among the small mammals. They feed mostly on flying insects, which they track down at night using echolocation. Larger mammals, however, tend to be rare. Ones that do exist include the Iberian lynx (*Lynx pardinus*), which feeds almost exclusively on rabbits; the common genet (*Genetta genetta*), which hunts birds and mice at night; and the fallow deer (*Dama dama*),[7] which is native to the southeastern Mediterranean region and has a tell-tale, white-spotted coat and shovel-like antlers. The fact that large mammals are generally absent from such areas is related to the presence of humans. Before the Europeans arrived in California, there used to be grizzly bears, wolves, bison and jaguars in the oak forests near the coast;[8] today, only a few pumas still roam the area.

/////////////////////

[1] Medail 2008
[2] Rundel 2013
[3] Rundel 2013
[4] Sheffer 2012
[5] Medail 2008
[6] deRigo 2016
[7] Baker 2017
[8] Rundel 2013
[9] Tagawa 1997
[10] Ashton 2003

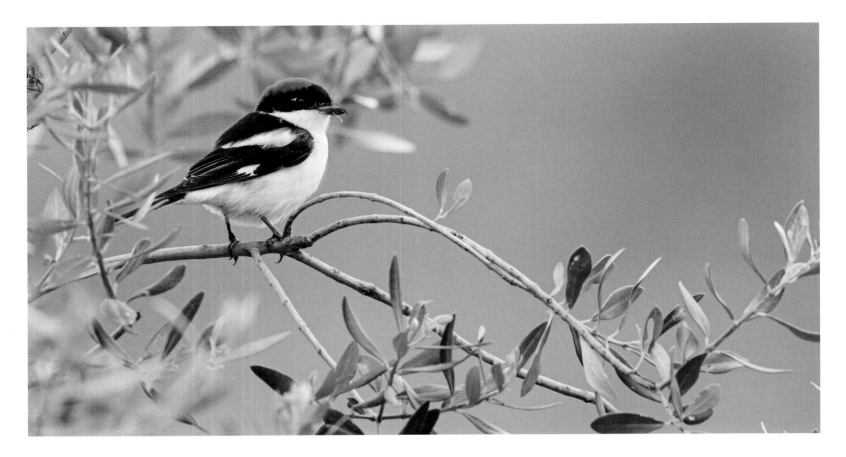

Insect hunters. The woodchat-shrike (*Lanius senator*) breeds in the Mediterranean region, in particular on the Iberian peninsula, and winters in sub-Saharan Africa. It preys mainly on large insects such as beetles, crickets, locusts, grasshoppers, and cicadas.

A quail stands sentry. The California or valley quail (*Callipepla californica*) spends most of its time on the ground. This male has taken up a lookout in the bushes so he can provide advance warning of danger.

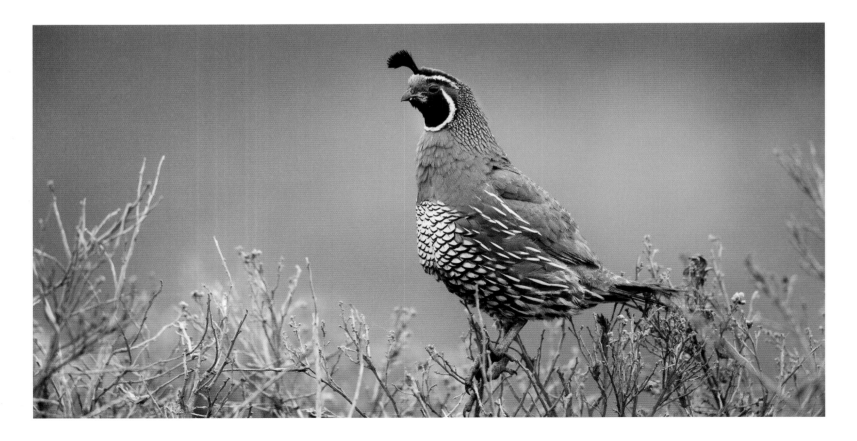

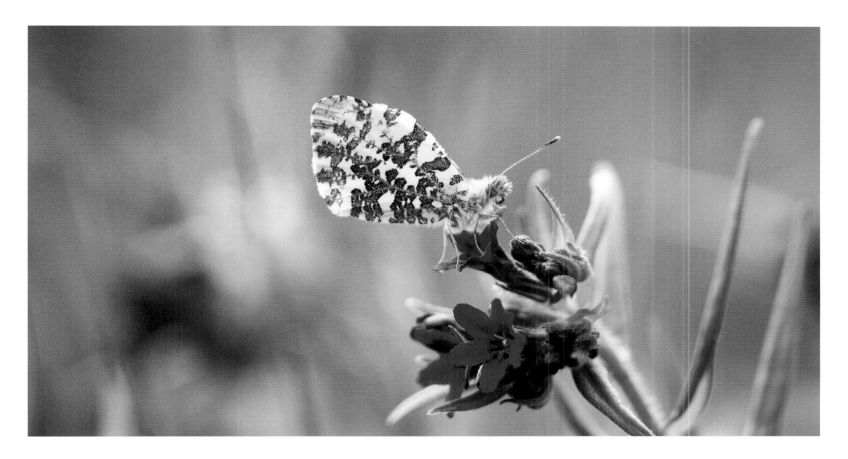

Flower visitation. An orange tip (*Anthocharis cardamines*) has alighted upon the brilliant flower of a purple gromwell (*Buglossoides purpurocaerulea*). This flower, a relative of the borage plant and of Echium, grows in the Mediterranean region, especially in somewhat upland oak forests.

Wild hens. The red-legged partridge (*Alectoris rufa*) is a gamebird and relative of the pheasant that occurs in the western Mediterranean region. Given sufficient cover of grass and shrubbery, it goes foraging in macchias, but also happily in open holm- and cork-oak forests. Around evening, the sociable animals jointly make their way to roost trees, where they will spend the night. The very similar chukar (*Alectoris chukar*) inhabits the eastern Mediterranean region.

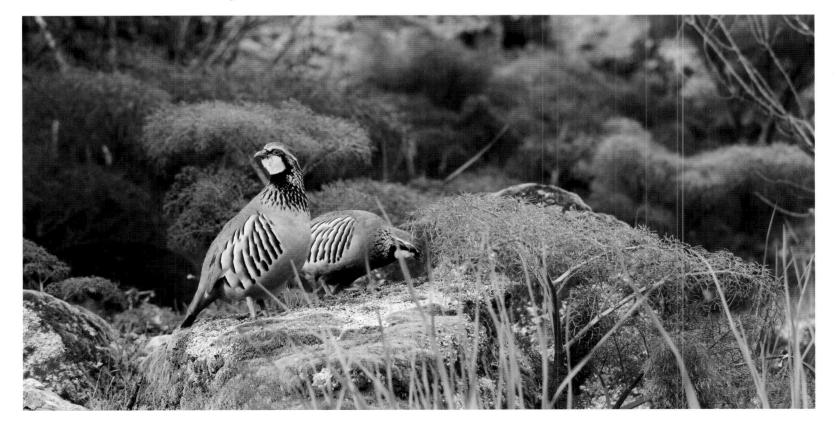

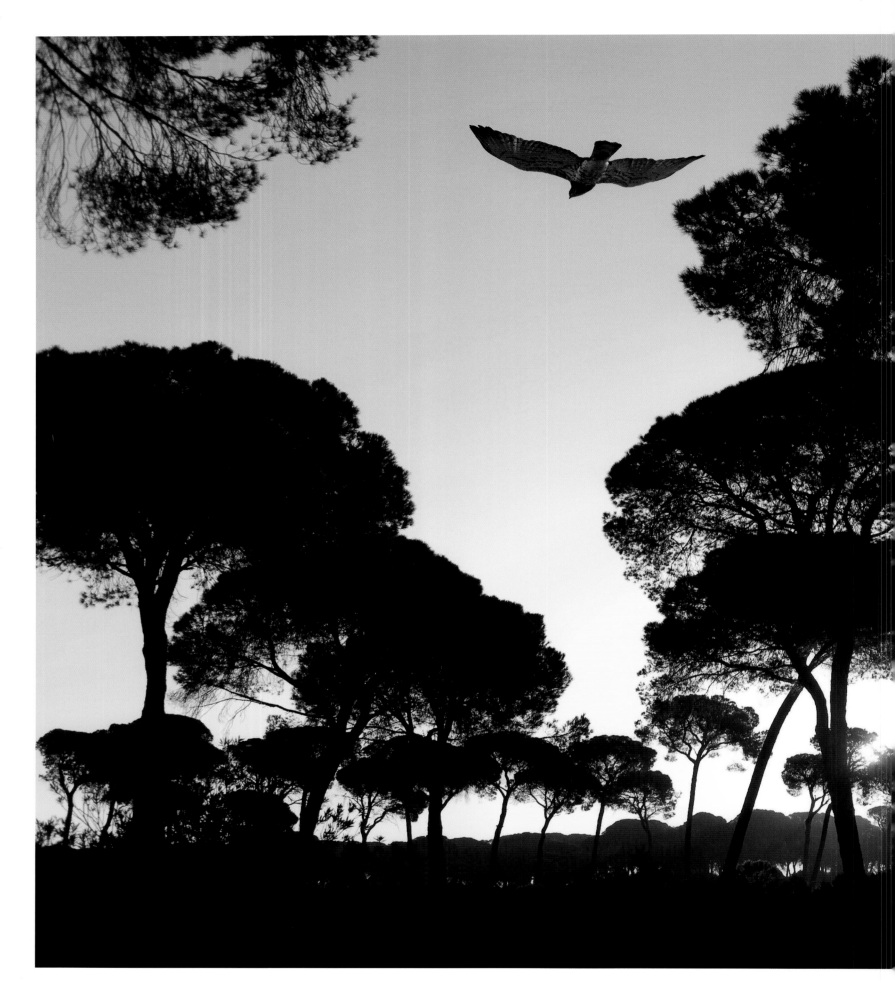

Short-toed snake eagle and stone pines just before sunset. Many birds of prey, like this short-toed snake eagle (*Circaetus gallicus*), live in the Mediterranean zone. The open landscapes and an abundance of reptiles, insects and small mammals make rich hunting grounds for them.

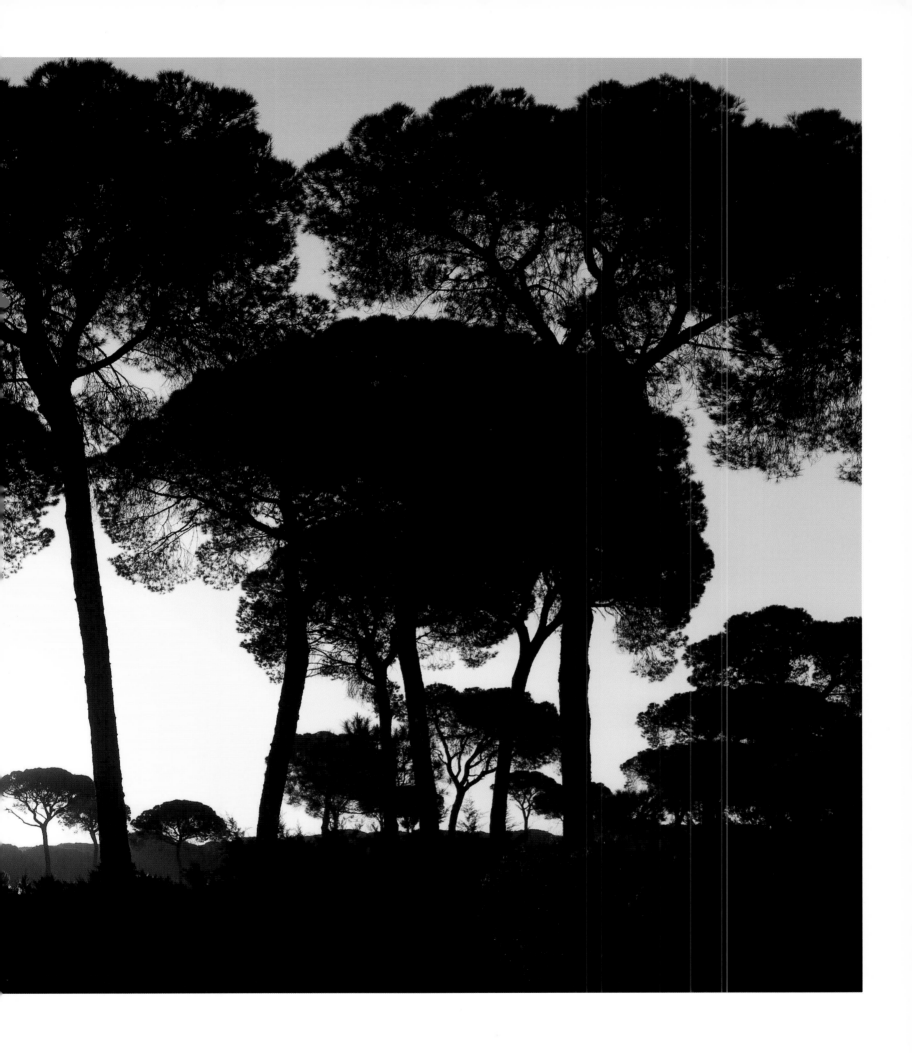

Laurel Forests

In the Atlantic Ocean archipelagos of Madeira, the Azores, and the Canary Islands, the climate conditions are similar to those of the Mediterranean zone except without the dry summers. This allows a lusher vegetation thrive there, with broader-leaved species than those of Mediterranean-type climates. Characteristic of this vegetation are tree species with shiny-leathery leaves[9] such as laurel (family *Laureaceae*: *Laurus*, *Cryptocarya*)—of which there are whole forests called the "Laurisilva"—as well as hollies (*Ilex*), the Chinese guger tree (*Schima*, of the tea family *Theaceae*), and oaks, tanoaks and chinkapins (*Quercoideae*: *Quercus*, *Lithocarpus*, *Castanopsis*). Because forests like these are isolated on oceanic islands or on mountains, they exhibit high biodiversity as well as a high incidence of endemics, species that occur only there. As a result, there is great variation among the different laurel forests.[10]

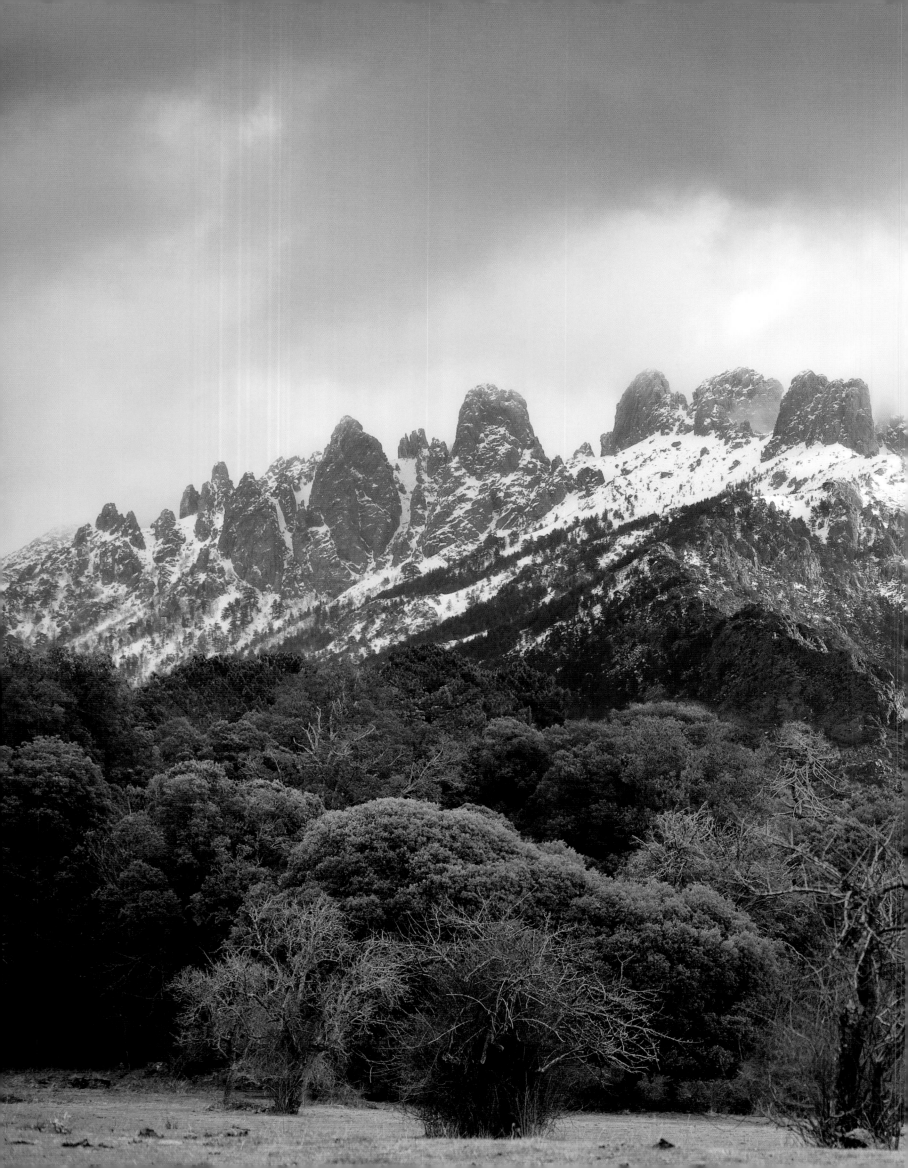

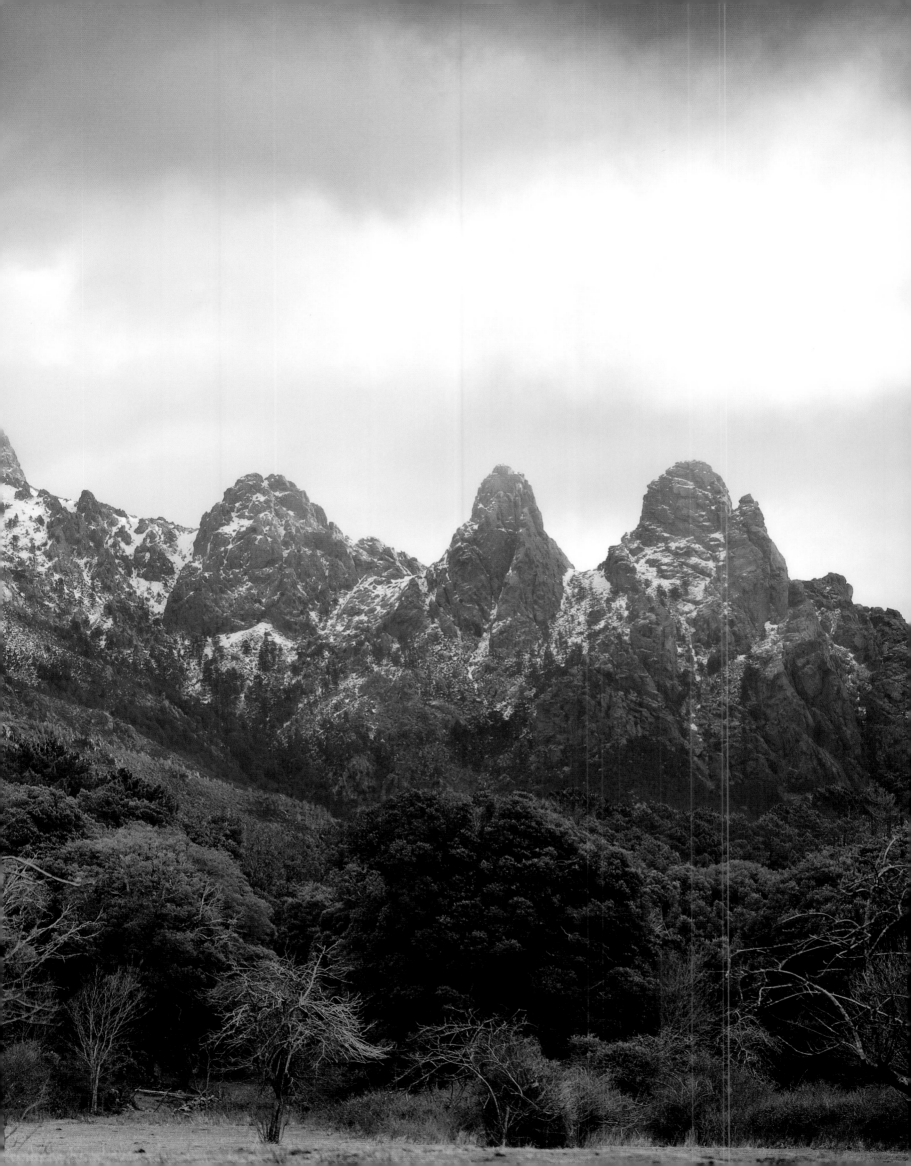

Tropical
Dry Forests

Forests between bare and lush green

Tropical dry forests survive long annual dry seasons
and are home to many domestic animals and
cultivated plants.

Characteristics open, mostly low hardwood forests in tropical and subtropical lowlands, with robust undergrowth consisting of shrubs and vines; pronounced shifts between dry and rainy seasons; often complete loss of foliage during the dry season

Distribution South and Central America (southern Mexico, Cuba and the Caribbean; Colombia, Venezuela, the caatinga and cerrado of Brazil, the chiquitania of Bolivia, the chaco of Bolivia, Paraguay, and Argentina); sub-Saharan Africa, western Madagascar, India and Sri Lanka, continental Southeast Asia (Myanmar, Thailand, Laos, Cambodia, and Vietnam); Little Sunda Islands (Indonesia), northeastern Australia, South Pacific

Tree species rain tree (*Albizia saman*), jacaranda (*Jacaranda mimosifolia*), silk floss tree (*Ceiba speciosa*), teak (*Tectona grandis*), dark red meranti (*Shorea siamensis*), red sandalwood (*Pterocarpus santalinus*), baobabs or monkey bread trees (*Adansonia sp.*), marula tree (*Sclerocarya birrea*), gum arabic trees (*Acacia senegal, A. raddiana*), Darwin stringybark and woollybutt (*Eucalyptus tetrodonta, E. miniata*)

Animals chital, Bengal tiger, Hanuman langur, sloth bear, Komodo dragon, tamandua, armadillo, giraffe, tree kingfisher

Status if not gone altogether, then highly fragmented in many places; remaining stands heavily strained by human settlement; much of what remains is unprotected

Special features less well known and less studied than savannahs or rainforests; source of important basic natural resources for the rural population of the tropics

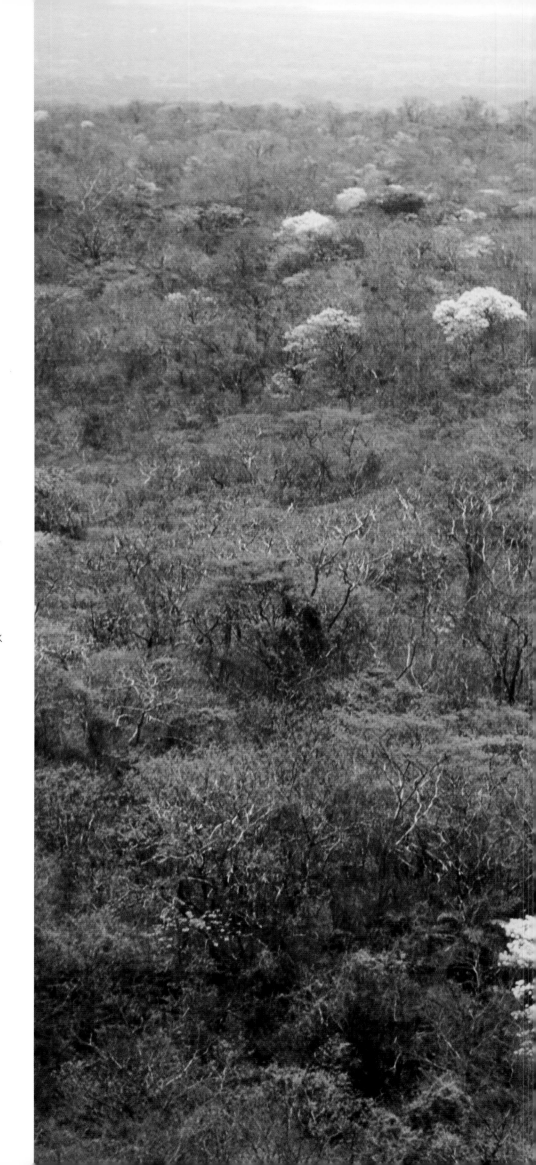

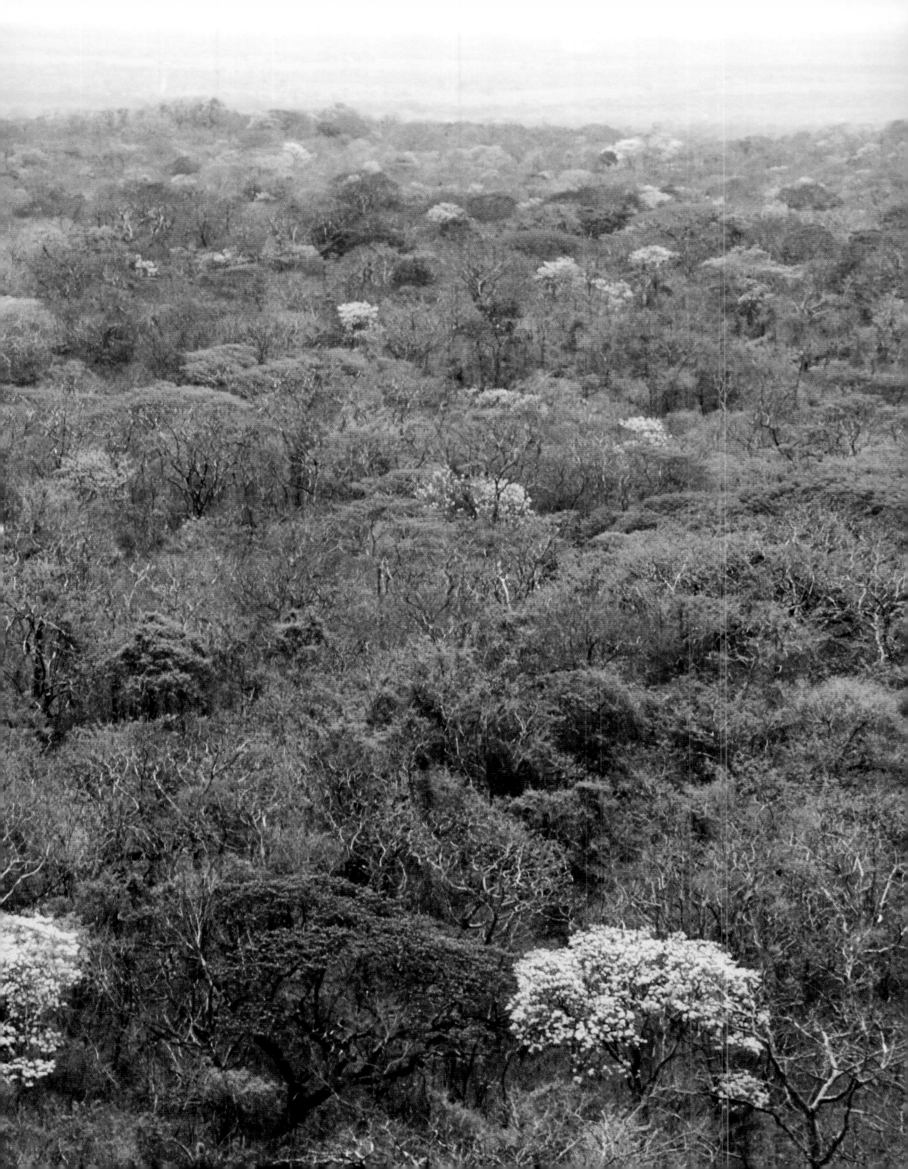

Tropical and Subtropical Dry Forests, Monsoon Forests and Tree Savannahs

Dry forests are also called tropical seasonal dry forests because the climate vacillates between a three-to-eight-month-long dry season in which there is almost no rainfall and a rainy period in which precipitation ranges from 500 to 3,000 millimeters per year.[1] The trees of a typical dry forest grow to maximum heights of between ten and forty meters,[2] and the ceiling the forest crown forms is, structurally, simpler and more open than that of the rain forests.[3] Because a lot of light penetrates down to the lower layers of the forest, a thick undergrowth of shrubs and vines flourishes there. During the dry season, most of the trees and many of the other plants lose their leaves to protect themselves against evaporation.[4]

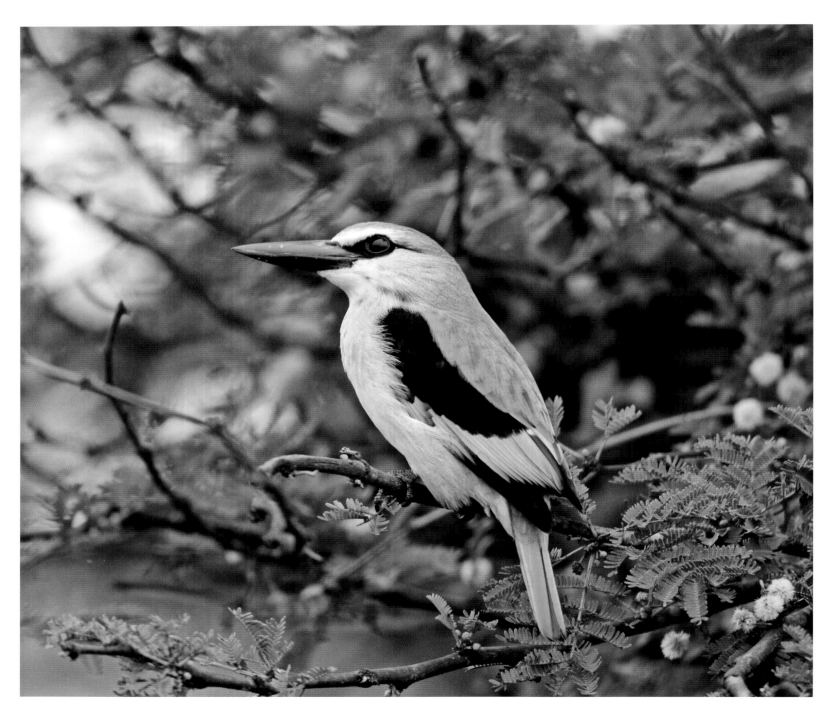

Previous page: **Yellow-flowering golden trumpet trees** (*Tabebuia ochracea*) during the dry season, Guanacaste dry forest, Santa Rosa National Park, Costa Rica. // Above: **Woodland kingfisher in an acacia tree.** Kingfishers like this woodland kingfisher are colorful inhabitants of the tropical dry forests of Africa, Asia, and Australia. They do not need to live near water and snap up large insects and small vertebrates with their powerful beaks.

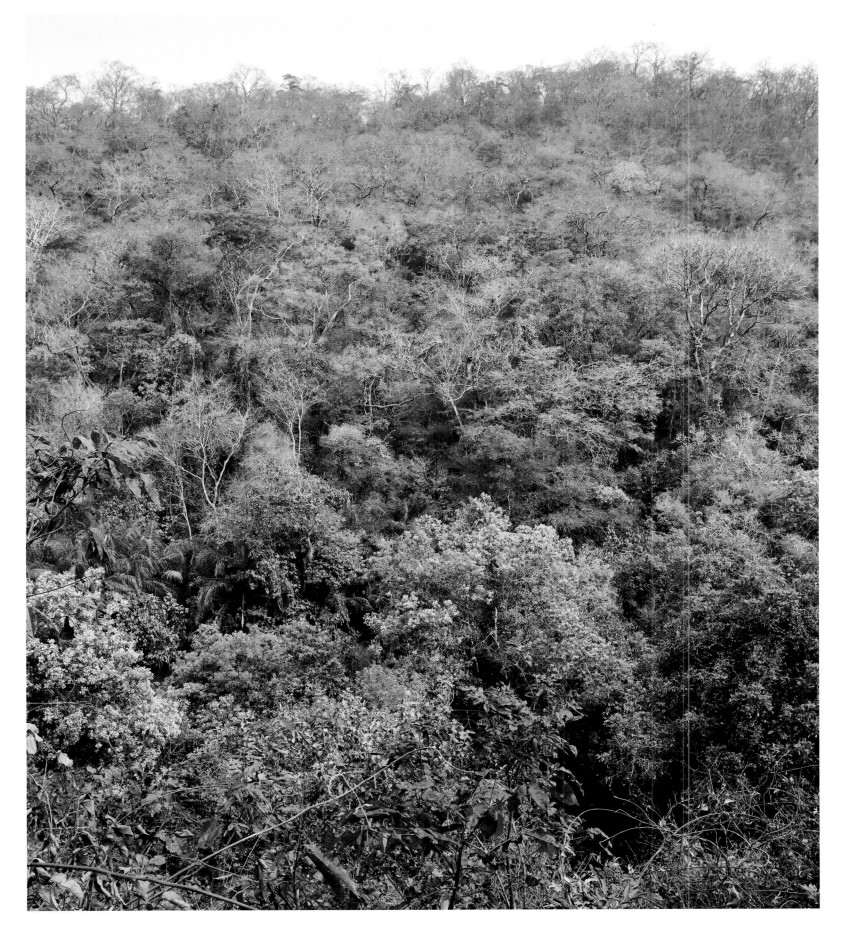

Above: **Multicolor leaf canopy** in the Cerrado of Brazil. // Next Page: **Baobabs** (*Adansonia rubrostipa*) in the Kirindy dry forest of Madagascar. The baobab or monkey bread tree, with its thick stem that bunkers water and its broad, finely branching crown, is one of the most striking trees in the tropical dry forest. It can live to be more than 1,500 years old. Six of the nine known baobab species occur exclusively in Madagascar.

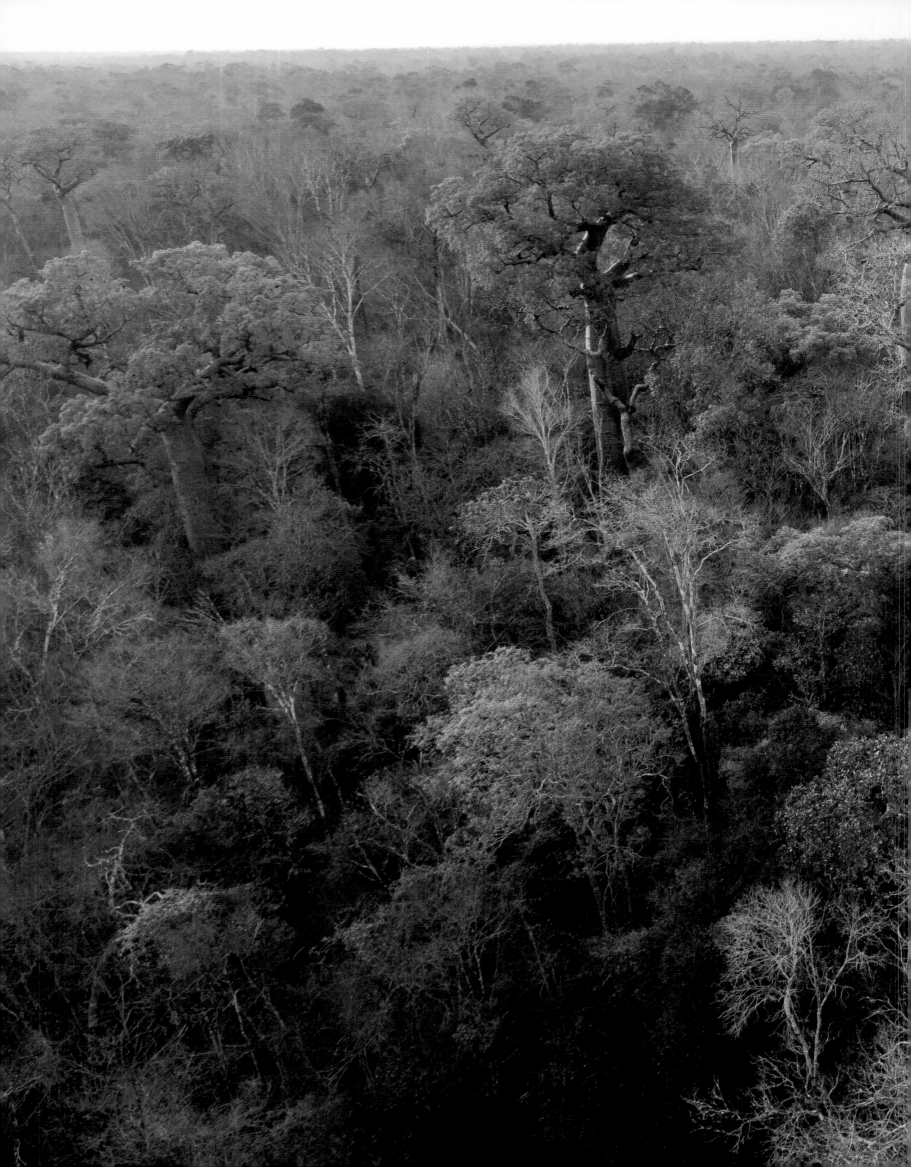

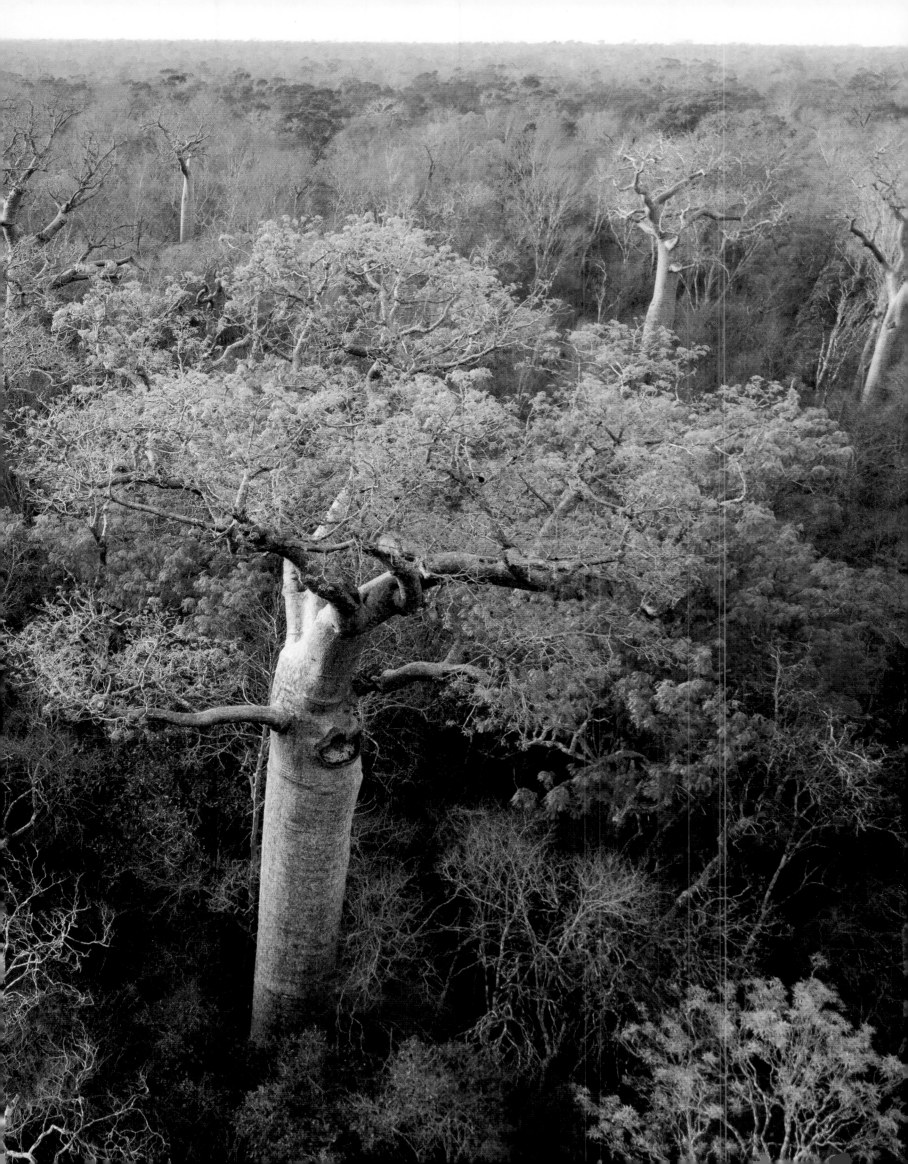

Forest Ecological Communities

During the dry season, low humidity prevails in the forest, and most of the rivers and streams run dry.[5] The tropical sun blazes unchecked through the bare tree crowns, dries out the leaf litter that covers the forest floor and thereby prevents the litter from decomposing quickly. When the last remaining puddles and ponds vanish, a complex mosaic of different dry microclimates arises in the forest. Many forest animals flee to habitats that have higher residual moisture, such as hollow tree stumps, rocky caves, river valleys, shady mountainsides out of the wind, or higher elevations that receive more rain. Other forest dwellers enter estivation (the summer equivalent of hibernation) during the dry season, or they at least reduce their activity, as for example the tree-dwelling lesser hedgehog or tenrec (*Echinops telfairi*) and the fat-tailed dwarf lemur (*Cheirogaleus medius*) of the dry forests of Madagascar do.[6] Some trees are able to store water in their stems, such as the baobab (*Adansonia sp.*) in Africa, or the silk floss tree (*Ceiba speciosa*, *Ceiba trischistandra*) in Latin America.

Magnificent Colors in the Bare Forest

While most of the plants undergo no or only very limited photosynthesis during the dry season, many trees form buds at the beginning of the dry season, during which the buds then speckle the foliage-bare forest with luminous bright colors. In Latin America, such trees include the golden-yellow-flowering golden trumpet tree (*Tabebuia ochracea*), the pink-blossoming pink trumpet tree (*Tabebuia impetiginosa*), the blue-violet black poui (*Jacaranda mimosifolia*), or the bright-red coral tree (*Erythrina smithiana*).[7] The blossoms attract numerous species of bats, wild bees, butterflies, and other nectar-gathering animals that take care of pollination on behalf of the trees. In time, the fruits and seeds of these trees will make for a welcome diversion on many an animal's menu during this otherwise nutrition-poor time of year.

The Rainy Season Makes the Leaves Unfold

The dry season ends with violent cloudbursts that replenish the waterways, and the forest turns green for a few months. For animals, this is the beginning of the season of plenty: They find plenty of water, leaves, and other nourishment everywhere in the forest. In the dry forests of Central and South America, spider monkeys (*Ateles spp.*), howler monkeys (*Alouatta spp.*) and capuchin monkeys (*Cebus spp.*) swing through the trees in search of tasty leaves, fruits, and flowers. Below, white-tailed deer (*Odocoileus virginianus*) or peccaries (or javelinas: *Tayassuidae*) are often already on the lookout for fruits and leaves the monkeys drop from the trees. In the monsoon forests of India, there are similar ecological communities involving chitals (*Axis axis*) and Hanuman langurs (*Semnopithecus spp.*); these animals also warn one another when predators such as tigers are present.

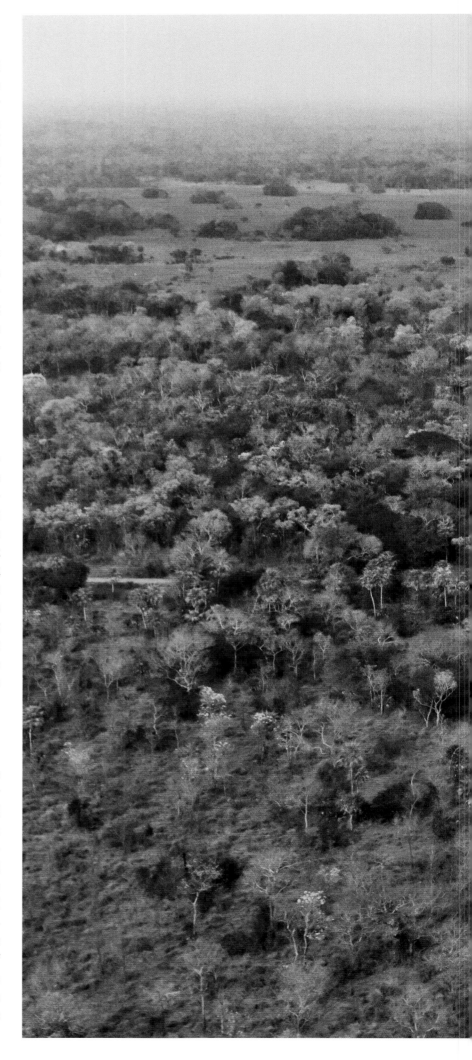

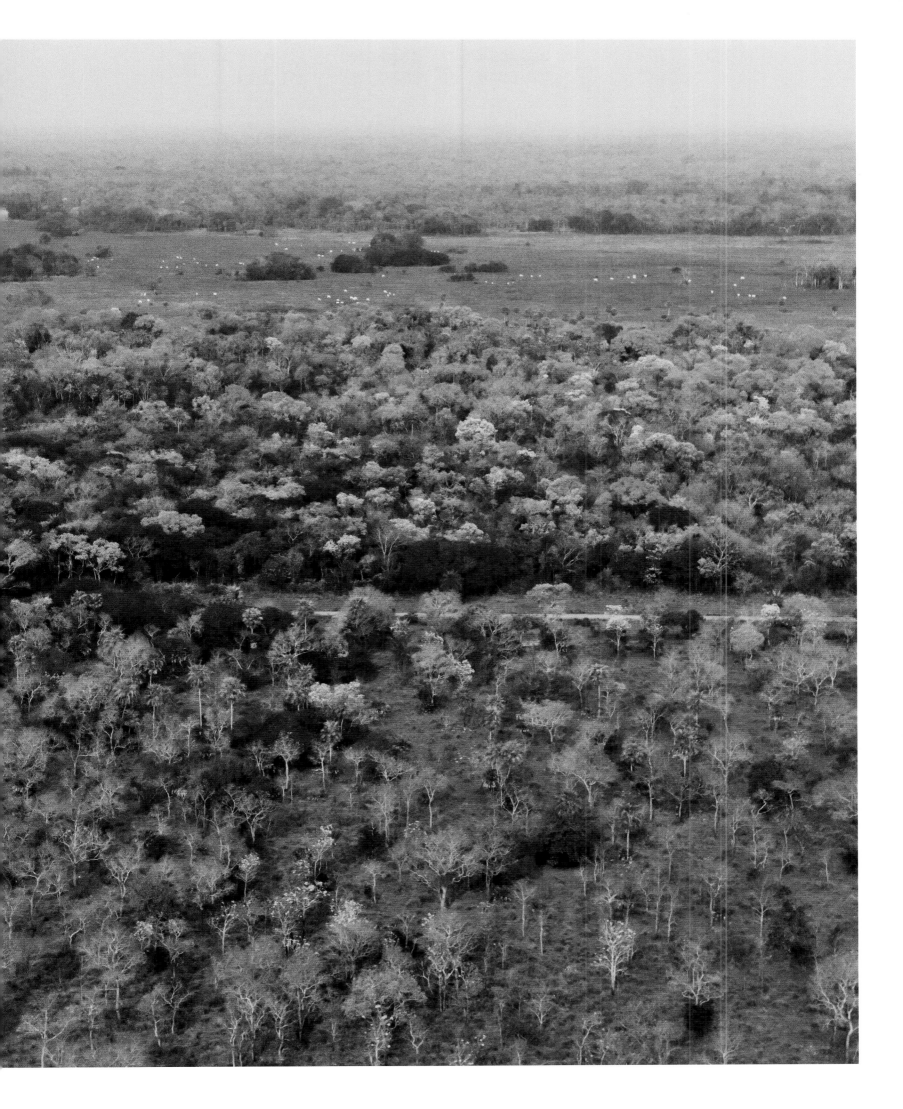

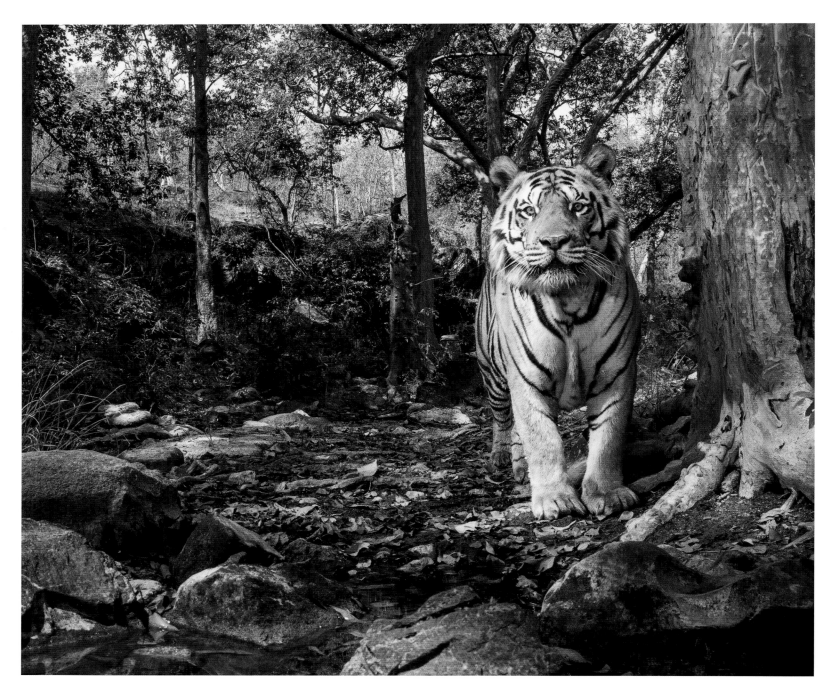

Previous page: **Pink-flowering pink trumpet or lapacho trees** (*Tabebuia impetiginosa*) in the Cerrado of Brazil. // Above: **A camera trap** in Pench National Park in India photographed a king tiger (*Panthera tigris tigris*). This male paused at a tree that was marked earlier by a female. // Right side: **Hanuman langurs** (*Semnopithecus entellus*) and chitals (*Axis axis*) mutually warn one another about tigers and other hazards.

Dry Forests are Gravely Threatened

Surveys on the extent of the earth's forests conducted by organizations like the Food and Agriculture Organization of the United Nations (FAO) frequently distinguish among only three climate zones (boreal, temperate and tropical) so that there is no data specifically about tropical dry forests (as opposed to the rain forests).[8] However, according to some estimates, tropical dry forests used to occupy more than 40 percent of the total forest area of the tropics;[9] today, they still cover an area of around one million square kilometers (386,000 sq. mi.).[10] More than half of this is located in Latin

America, and most of the rest is in southeastern Africa, India and Sri Lanka as well as in continental Southeast Asia.[11] Practically all of the remaining forests are threatened by human activity.[12] In the Philippines, in Madagascar, or on the major South Sea islands such as Fiji or New Caledonia, large areas of the original dry forests have already been destroyed;[13] along the Pacific coast of Central America, the forests have already dwindled down to less than one-tenth of one percent of their original size.[14] In addition to protecting the remaining forests, the goal today in many places is to restore the forests to their natural condition and to manage them as a sustainable resource.

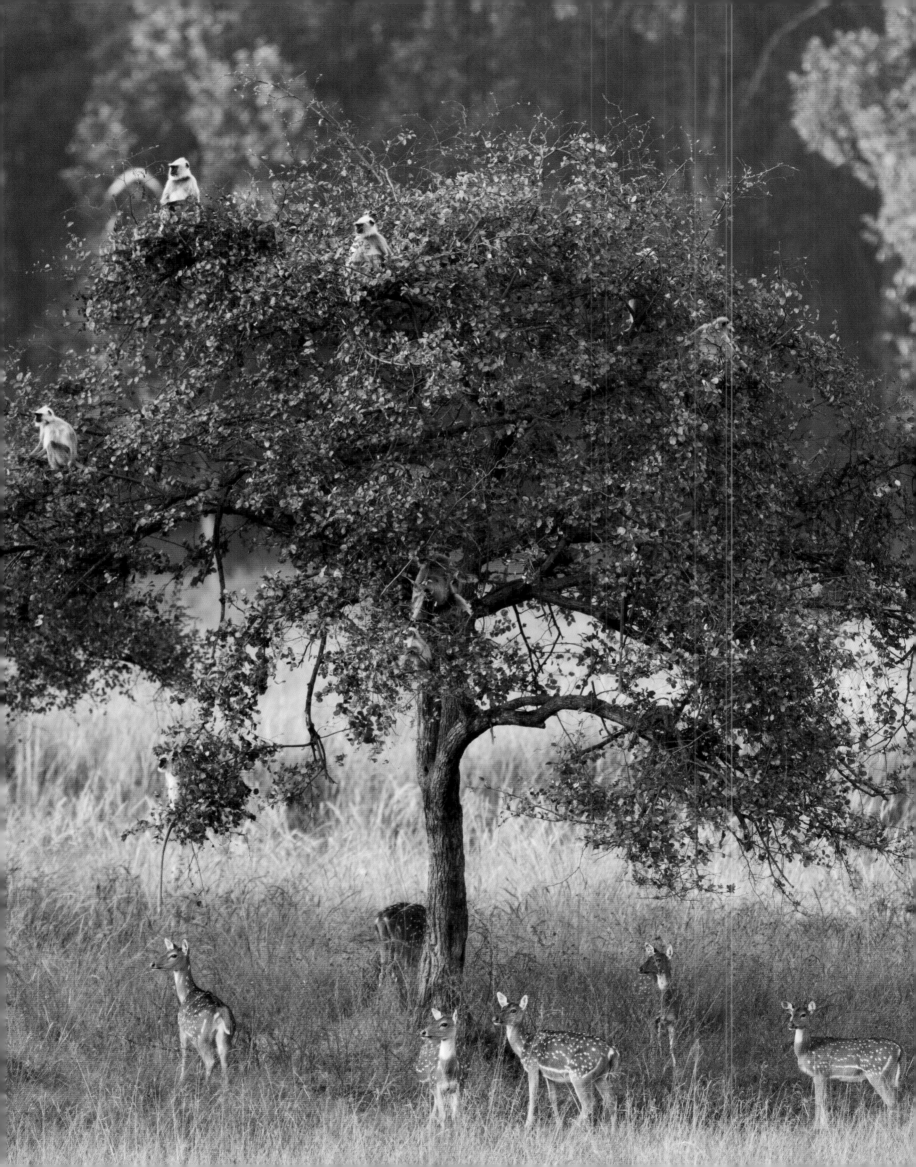

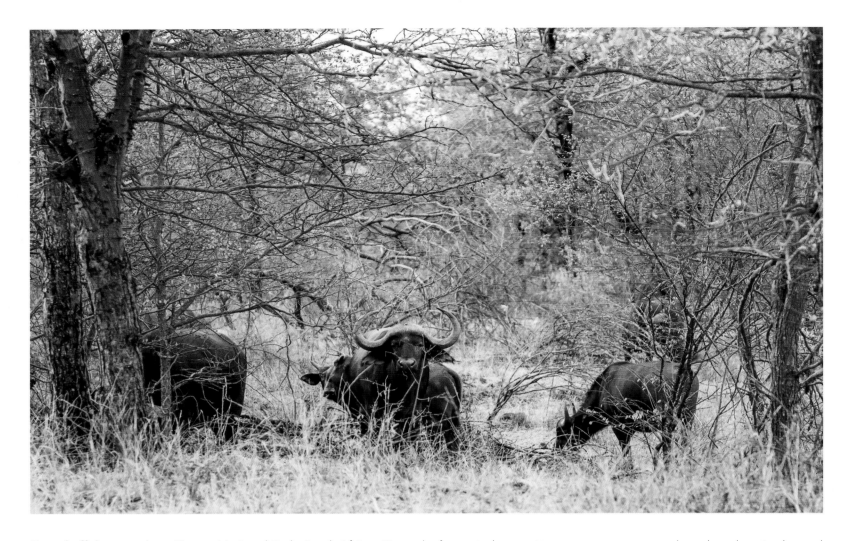

Cape buffalo in northern Kruger National Park, South Africa. Open dry forests in the transition zone to tree savannah, such as the miombo and mopane woodland landscapes of southeastern Africa, are characterized by dense grass cover, which, together with the trees, nourishes many large herbivores such as elephants, giraffes, and Cape buffalo.

Dry Forest and Humans

The dry forest regions have always been a coveted place for human habitation as they offer a more agreeable climate than the wet-all-year rainforests, and the conditions are better for agriculture and animal husbandry. Another factor is that the soils in many places are fertile and the forests are easily cleared for agriculture by burning them off during the dry season. Although dry forests as a rule have not been as much of a focus for the media as the rainforests have,[15] they are by no means less significant in terms of their ecological and economic value. The diversity of the dry forests makes them very productive, and they play an important role in supplying local populations with food. In these forests, people gather root vegetables, honey, beeswax and such insects as grasshoppers and butterfly caterpillars. Many of the trees found in the dry forests of Africa—such as the baobab (*Adansonia sp.*), the marula tree (*Sclerocarya birrea*), kei apple (*Dovyalis caffra*), the Natal orange (*Strychnos cocculoides*), or the medlar tree (*Vangueria infausta*)—deliver vitamin-rich fruits, leaves, and nuts as well as medicinal compounds. And not just that: They also provide shade, for humans and animals alike, during the heat of the day.[16] The miombo woodland in southeastern Africa alone provides sustenance and firewood for over one hundred million people.[17] Also, tropical dry forests are the ancestral home of important domestic animals such as cattle and chicken, as well as of numerous agricultural staples including rice, maize, beans, sweet potato, sorghum, cotton and various grains. Chewing gum also has its origins in the tropical dry forest: both the Maya and the Aztecs were already cutting the bark of the chicle tree (*Manilkara chicle*) of Latin America and chewing on the sticky sap that trickles out of it.

Wooden Treasures

Teak (*Tectona grandis*), one of the best-known tropical woods, is native to the dry forests of Southeast Asia. These days, however, this warmth-loving tree is also cultivated on plantations in other tropical regions; and for many countries, teak wood is an important export. Teak is very weather resistant and a favorite material for outdoor furniture or decks. Other precious woods, like cocobolo (*Dalbergia retusa*), bigleaf mahogany (*Swietenia macrophylla*), and what in Mexico is called "palo de culebra" (*Astronium graveolens*) come from the tropical dry forests of Latin America, just as quebracho (*Schinopsis brasiliensis*) or the wood of the lignum vitae (*Guaiacum sp.*, also called *palo santo*) are products of the caatinga region of northern Brazil. Palo santo has been an export from Latin America to Europe—where it is was used for mechanical parts that were subject to especially rough treatment, like the bearings in windmills—since the beginning of the 16th century. All of these tree species grow very slowly, and their wood is extremely hard and so dense that it does not float in water.

The pod mahogany (*Afzelia quanzensis*) grows in sandy soils in southeastern Africa and sheds its foliage during the dry season. People appreciate it for its valuable reddish-brown wood, which is used in furniture-making and wood-carving.

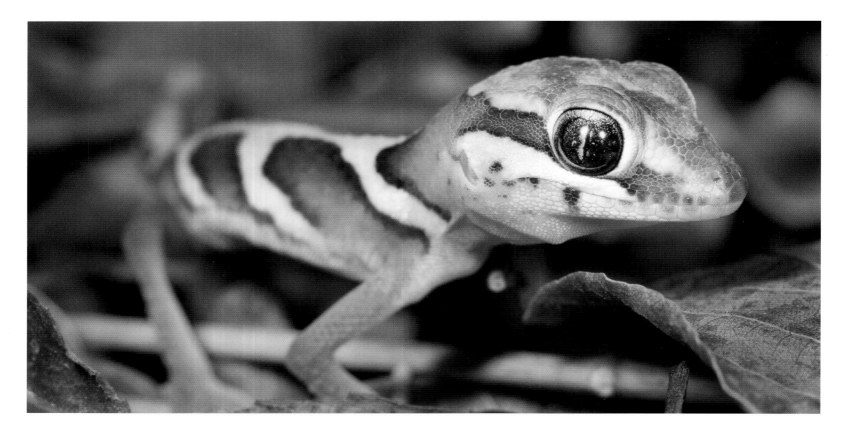

Previous page: **The last retreats of the threatened hyacinth macaw** (*Anodorhynchus hyacinthinus*) are located in the dry forest regions of southwestern Brazil near the borders with Bolivia and Paraguay. // Above: **The ocelot gecko** (*Paroedura pictus*) inhabits the dry forests of western Madagascar and grows to a length of around fourteen centimeters. // Right side: **The tree-dwelling fossa** (*Cryptoprocta ferox*) is a cat-like predator endemic to Madagascar that preys on, among other things, lemurs.

Temminck's pangolin (*Smutsia temminckii*) of Africa is hunted for its meat and scales. The latter trade expensively as a medicinal in Asia. Like all pangolins, it is threatened with extinction as a result. Rangers managed to rescue this young female in Gorongosa National Park in Mozambique from poachers and release her into the wild.

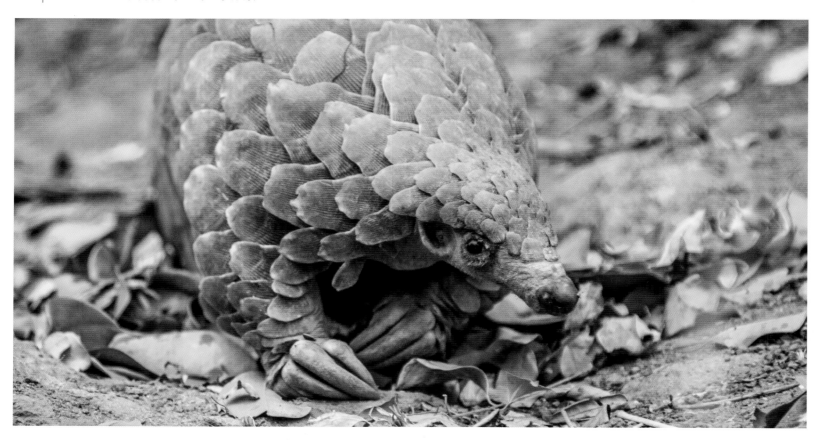

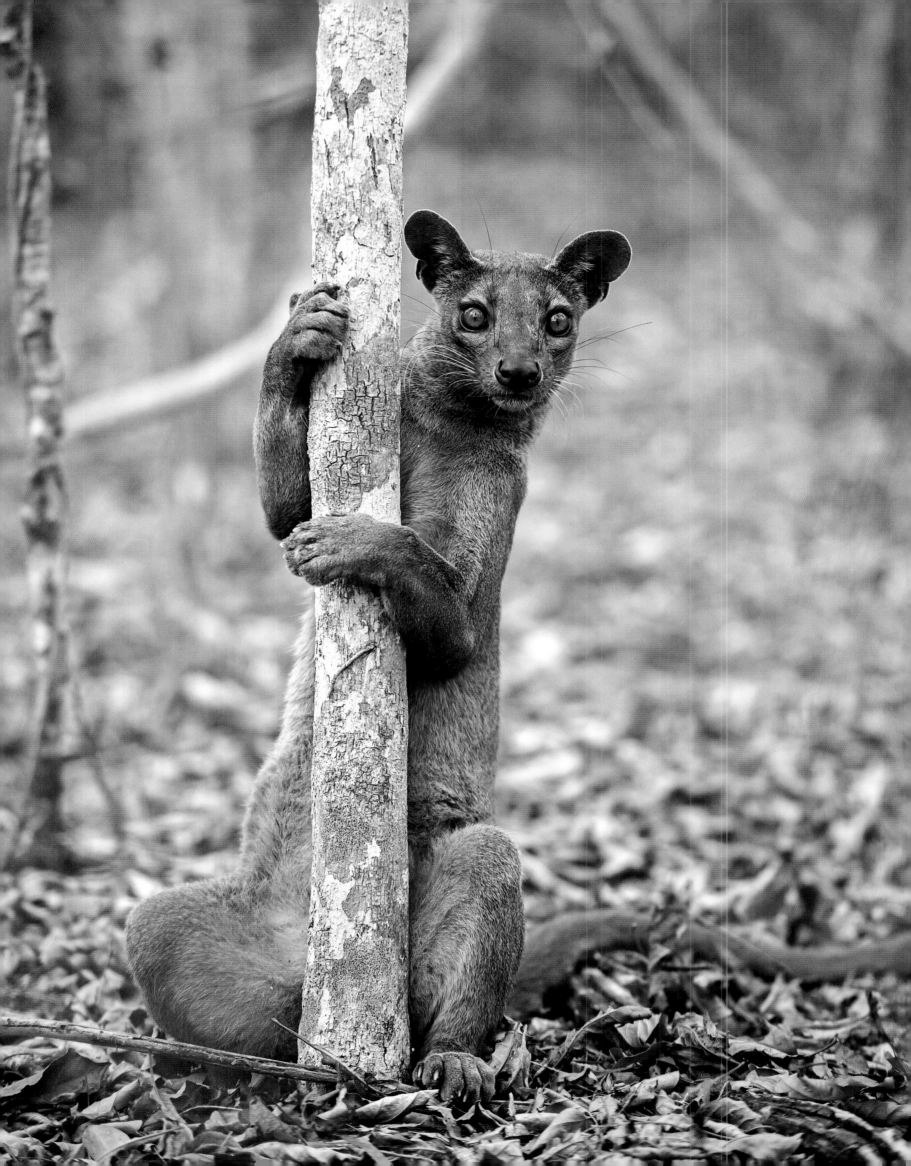

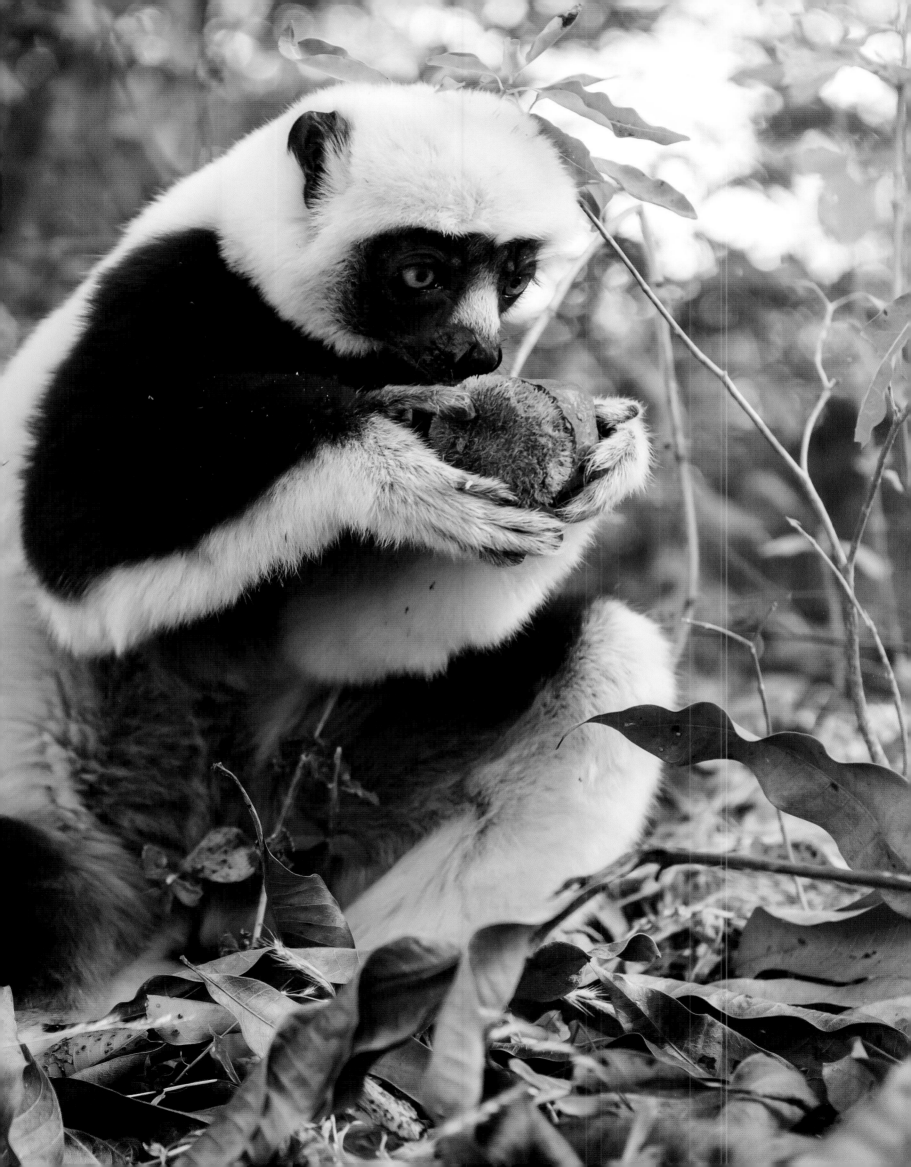

Previous page: **A Coquerel´s sifaka** (*Propithecus coquereli*) has found a fruit lying on the forest floor. This lemur species lives exclusively in the dry forests of northwestern Madagascar and feeds mainly on fruits, leaves, and buds.

Right: **The peafowl** (*Pavo cristatus*), a familiar pet and zoo animal, is native to the dry forests of India. The birds head for their roost-trees at dusk.

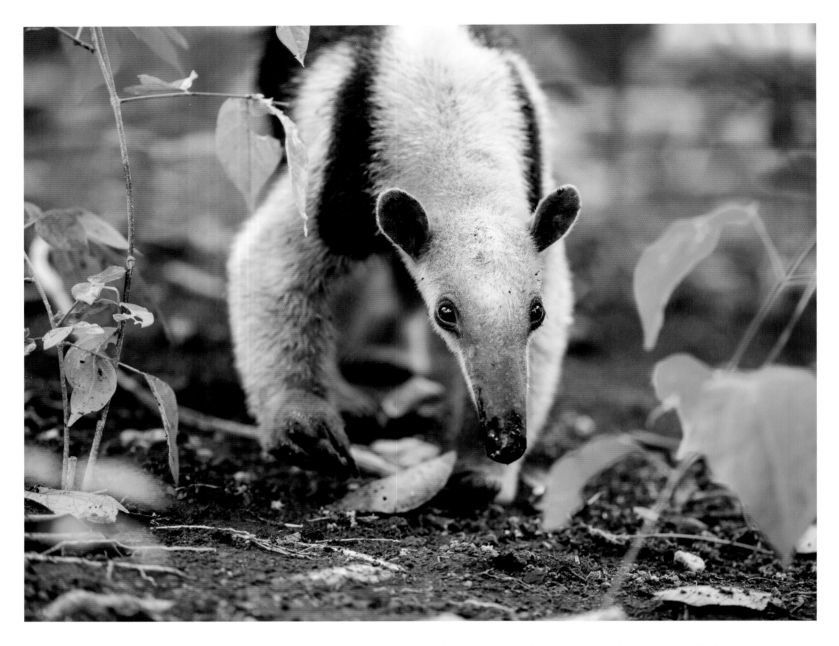

Above: **A lesser anteater or tamandua** (*Tamandua mexicana*) roams the dry forest on the lookout for ants and termites. Usually, however, it moves by climbing through the trees. // Right side: **Epiphytic cacti grow on the outspreading branches of a rain-tree** or monkeypod (*Albizia saman*) in a dry forest in Costa Rica. Known locally also as cenízaro, it has the name "rain-tree" on account of the honeydew produced by cicadas, aphids, and other sap-sucking insects that "rains" down from it at certain times of year.

Bushland and Winged Fruit Forests

The miombo woodland—which extends across southern and eastern Africa and is home to trees of the genus Brachystegia—is often counted as a form of tropical dry forest.[21] But grasses dominate the undergrowth in these ecosystems, and wildfires are a regular occurrence; both features are rather typical of savannah. While these forests—called "woodlands" by English speakers, specifically to emphasize how un-forest-like they are—are not dry forests in the classic sense, they do sometimes produce forest-like stands. Some of the typical tree species here are mopane (*Colophospermum mopane*) as well as combretums such as leadwood (*Combretum imberbe*), which has extremely hard wood and can live to be more than a thousand years old.[22] This landscape mosaic consisting of forest, river-runs through gallery forests, tree savannah, and grass- and bushland, is especially species-rich. It is home to many big mammals such as elephants, giraffes, buffalos, zebras and antelopes.

The deciduous dipterocarp forests of mainland Southeast Asia occupy a similar position between savannah and forest—for example in Myanmar, where members of this "two-winged fruit" family of trees (family *Dipterocarpaceae*) are widely distributed. The open forest and the grasses covering the ground provide a suitable habitat for many large mammals including Asian elephants (*Elephas maximus*), Eld's deer (*Panolia sp.*), and wild oxen such as the gaur (*Bos gaurus*) and the banteng (*Bos javanicus*).

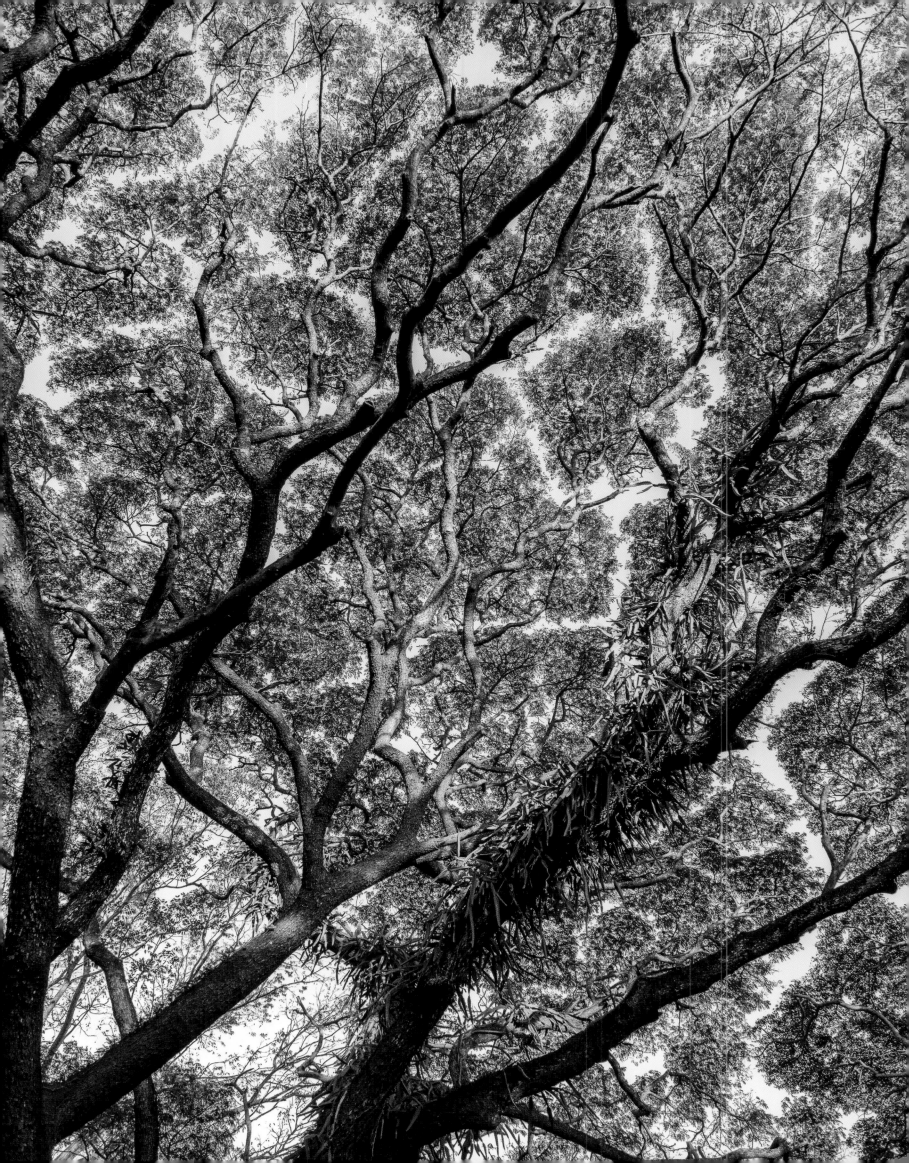

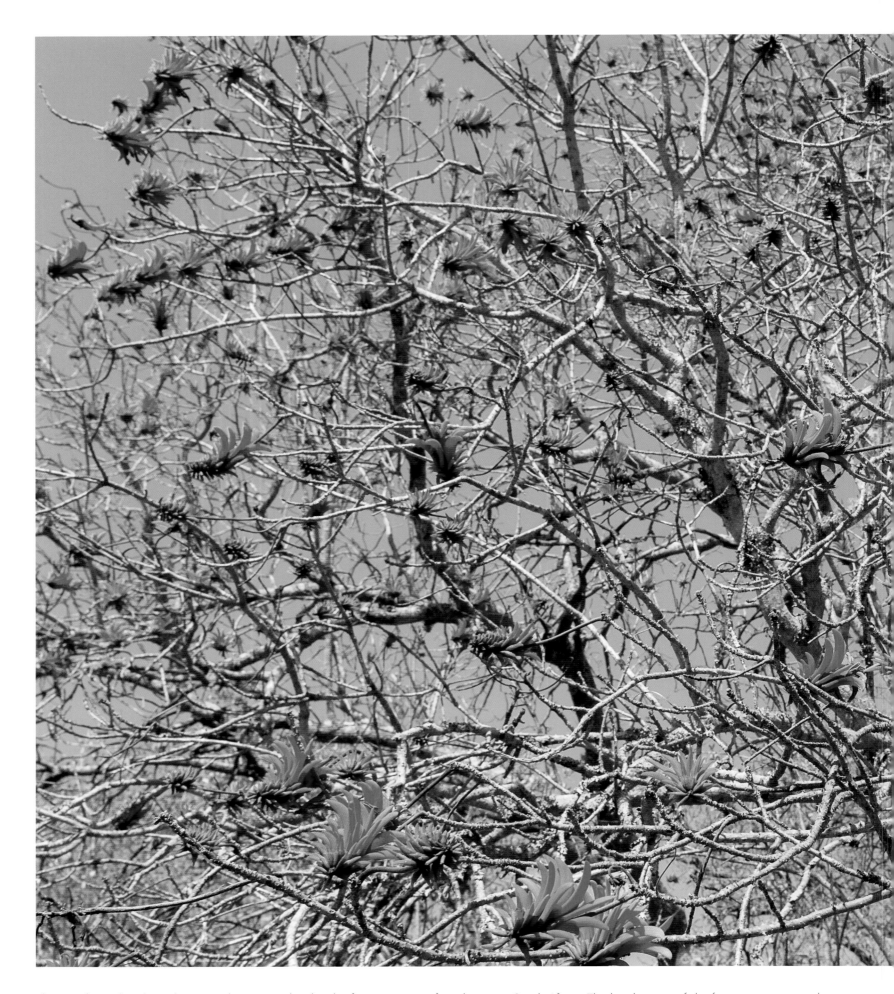

The coral tree (*Erythrina lysistemon*) originated in the dry-forest regions of northeastern South Africa. The biodiversity of dry forests cannot match that of tropical rainforests; but with many specially adapted species occurring only in these forests, biodiversity here is nonetheless high compared to the forests of the cooler latitudes.

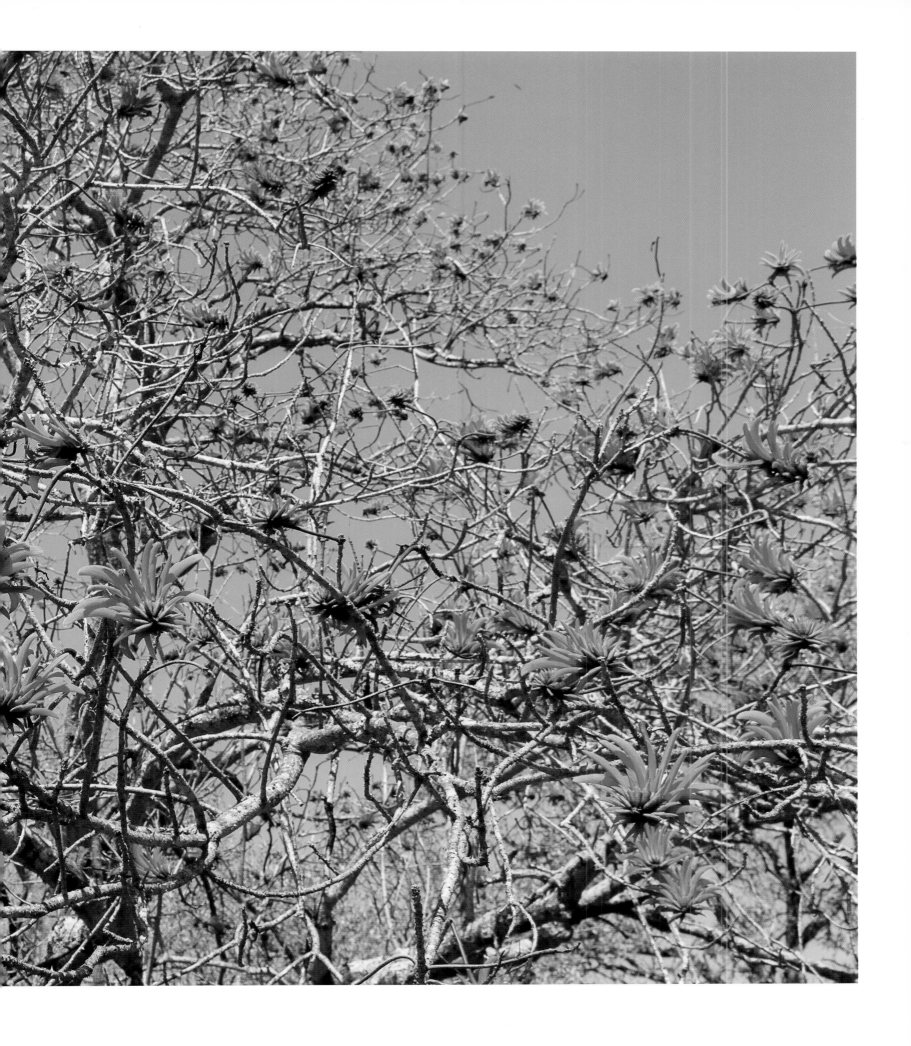

Diversity Despite Extreme Weather

Tropical dry forests are a hard-to-define, heterogeneous forest type, but it is worthwhile to distinguish them from tropical rainforests, which are characterized by year-round moisture. For tropical dry forests are unique, species-rich, and of great economic importance; and they are home to numerous specialized animal and plant species that, in the course of evolution, have adapted to a life of exposure to extreme weather, between long dry periods and short intervals of torrential rain. In times of rapidly advancing climate change, this adaptation in particular could make tropical dry forests even more valuable to humans.

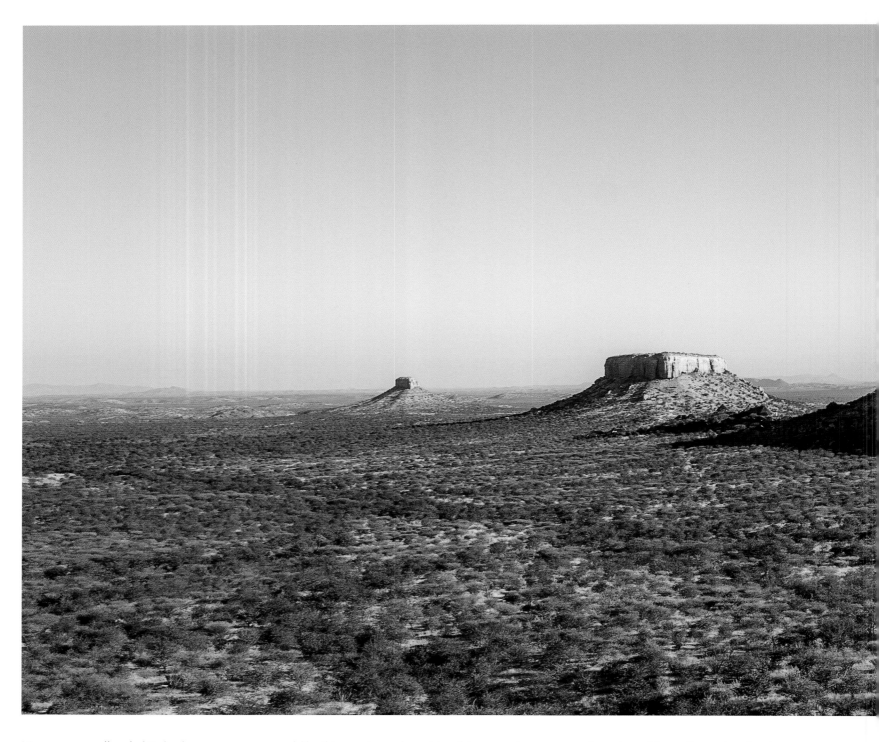

Mopane woodlands (*Colophospermum mopane*) like this one in northern Namibia cover large areas of southern Africa. Specialized in the leaves of the mopane tree is a caterpillar—the larvae of the emperor moth Gonimbrasia belina—which appears in droves at certain times of year and is much valued by the local people as an important protein source.

[1] Janzen 1988 und Blackie 2014
[2] Murphy 1986
[3] Murphy 1986
[4] Murphy 1986
[5] Janzen 1988
[6] Bittner 1992
[7] Lauerer 2008
[8] Sunderland 2015
[9] Waeber 2015
[10] Miles 2006
[11] Miles 2006
[12] Miles 2006
[13] https://www.worldwildlife.org/ecoregions/oc0201, Waeber 2015, Lasco 2008
[14] Gillespie 2000
[15] Blackie 2014
[16] National Research Council 2008
[17] CIFOR 2014
[18] CIFOR 2014
[19] https://en.wikipedia.org/wiki/Combretum_imberbe
[20] Starr 2015
[21] Dexter 2018
[22] Lasco 2008

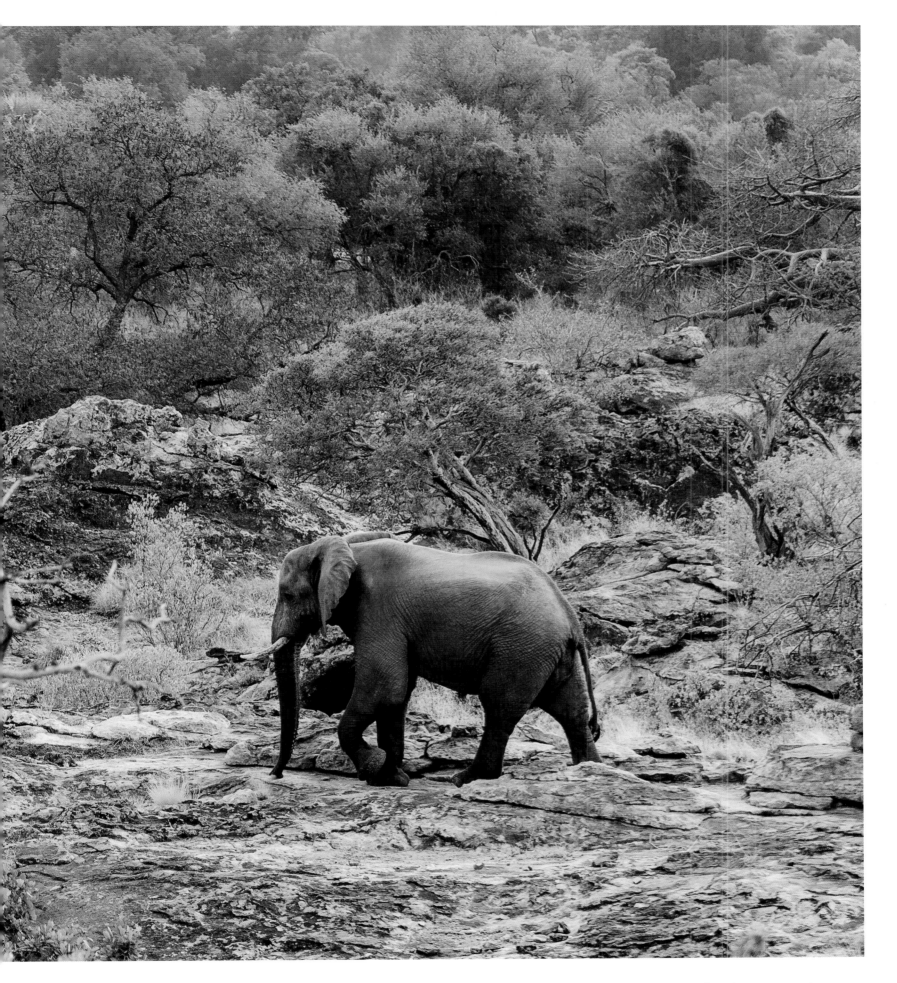

An African elephant in the dry border-region between South Africa and Zimbabwe, near the Limpopo River. Gallery forests arise along major rivers with tall evergreen trees that benefit from the year-round supply of water and nutrients at the river; they are thus a distinct type of forest. At left about halfway up is a continental African monkey-bread tree (a baobab: *Adansonia digitata*), which is found in dry regions throughout Africa.

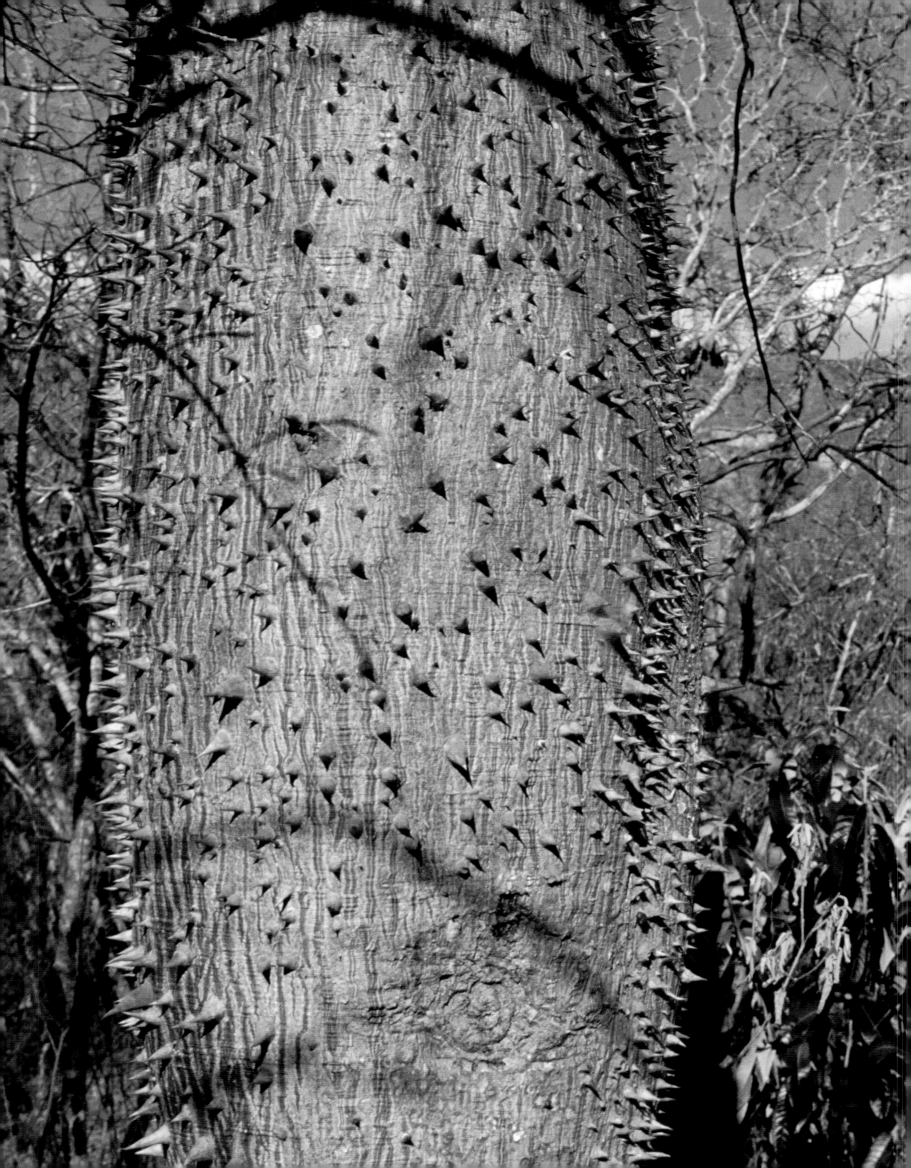

Forest or savannah?

Transitional zones between forest, tree savannah and savannah characterize landscapes such as the cerrado of Brazil, the bushland of the South Sahel zone of Sudan,[20] or the bushveld of southern Africa. Though dense forest will still inhabit river valleys or mountain slopes, tree coverage across the plains gradually thins out into savannah, which is dominated by grassland and only scattered trees. Savannahs differ from dry forests in that their undergrowth consists mainly of grasses, and they are marked by recurring wildfires and poor soils.[21]

Fire, livestock grazing, and clearing of the forest can transform a dry forest into a savannah land-scape. Because of the influence of people over millennia, that transformation makes it hard to determine when a savannah has developed naturally or arose through human activity. Climate change is also affecting the forests, through changes in precipitation patterns and amounts. As a result of increasingly hot, dry conditions, dry-seasonal forests may transform into savannahs, and rain forests into dry forests. By the same token, however, dry forests can transition into wetter forest types through increasing rainfall in certain regions such as the Philippines.[22]

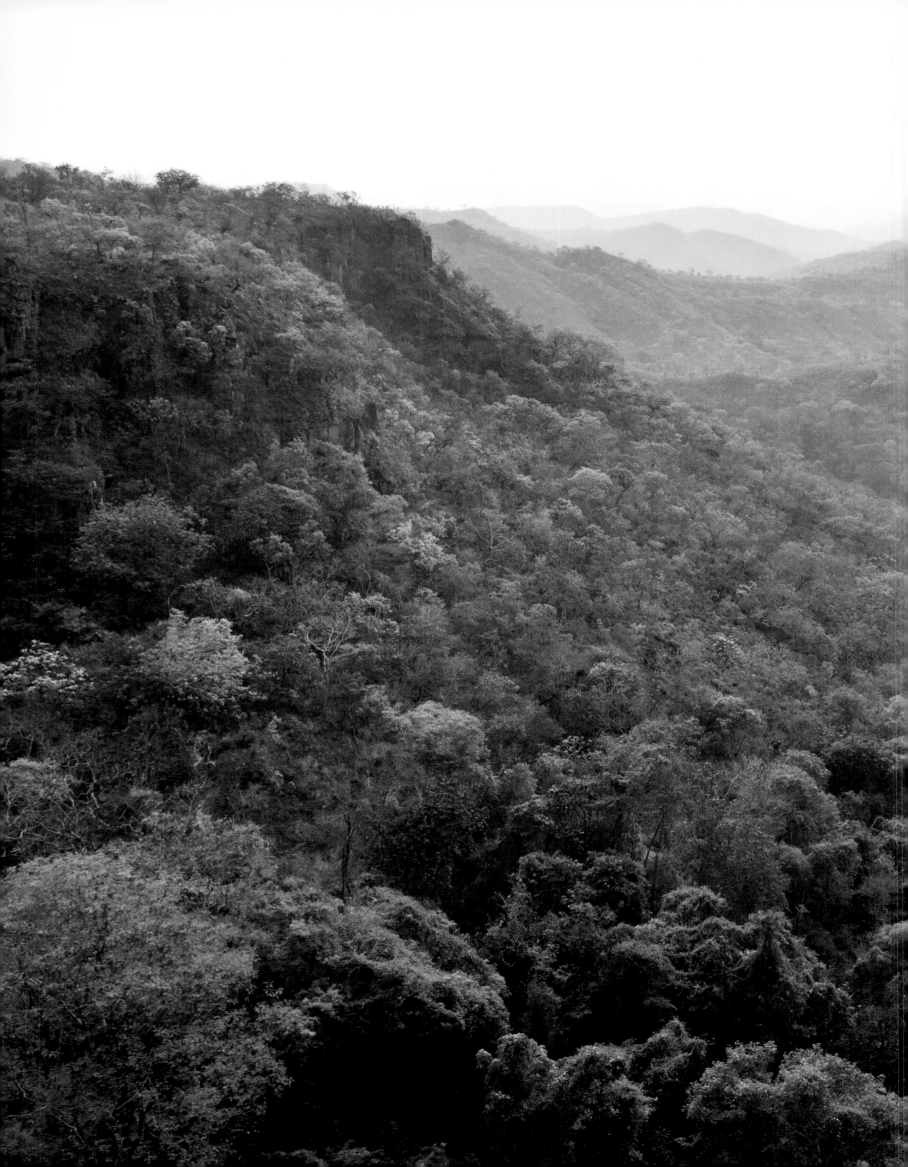

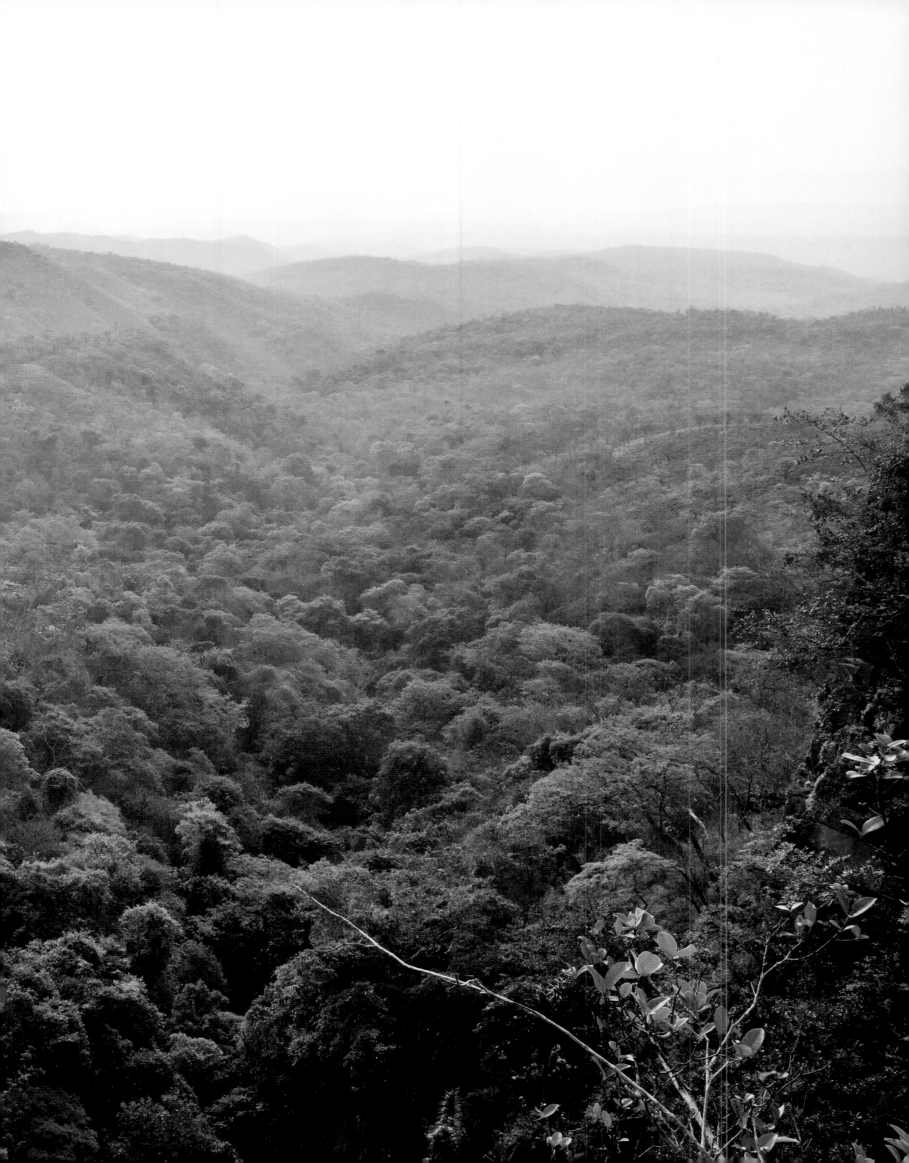

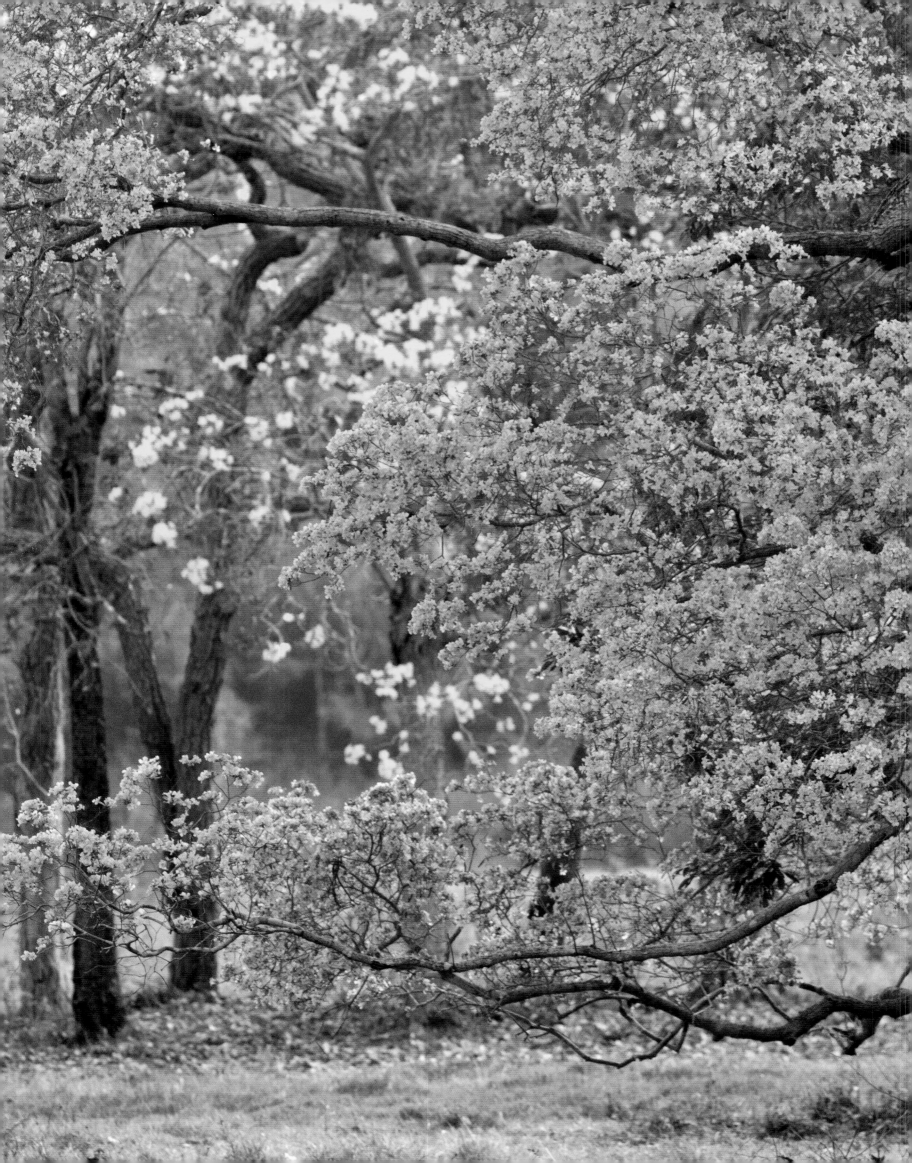

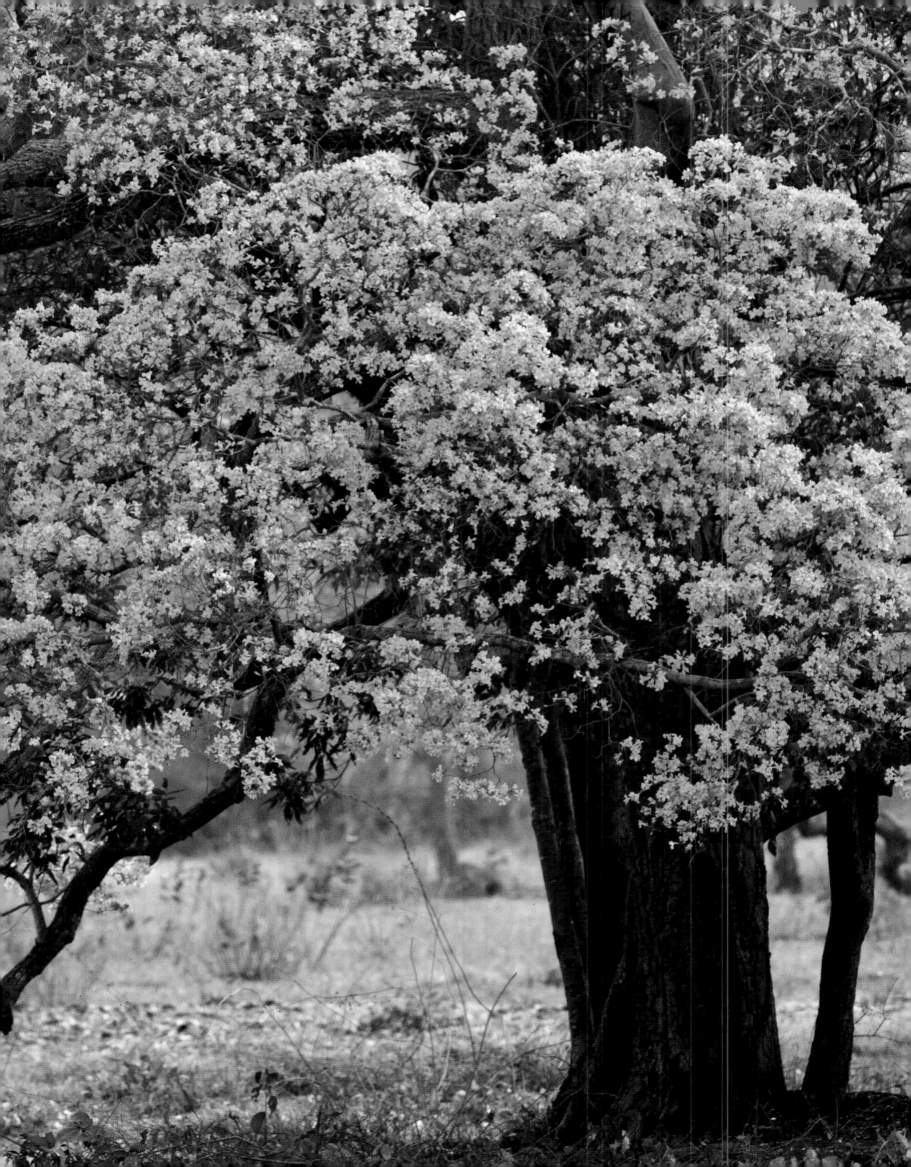

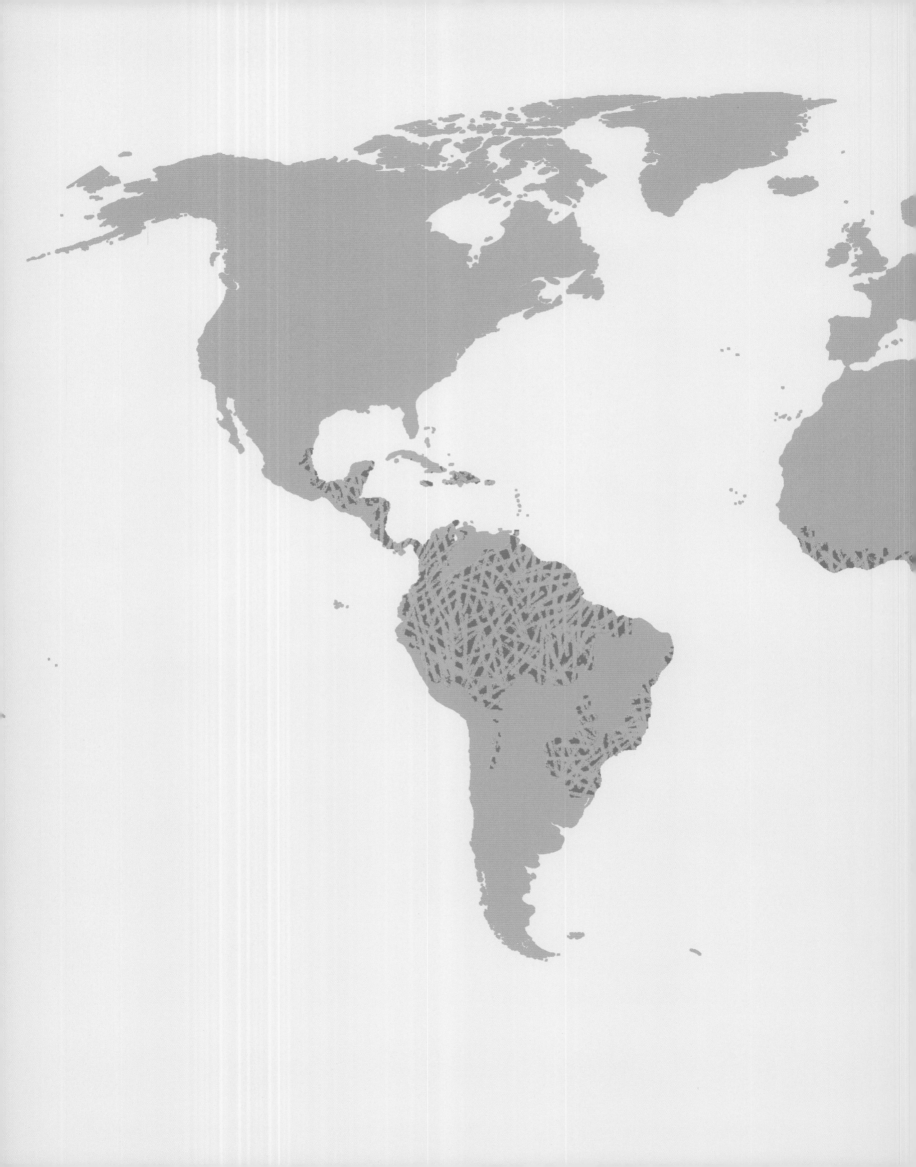

Tropical Rainforests

Forests of Diversity

The perenially warm, wet tropical forests cover only
a small percentage of the earth's land area but are habitat
for about half of all its animal and plant species.

Characteristics warm and wet throughout the year; slender, tall deciduous trees; multi-layered forest structure; extreme species richness

Distribution Central America, the Caribbean, and northern South America with the Amazon and Orinoco basins; equatorial western Africa (with Liberia and Côte d'Ivoire) and the Congo River basin; eastern Madagascar; southern India and Sri Lanka; continental Southeast Asia (including Thailand, Laos and Cambodia); Philippines, Malaysia, Indonesia, New Guinea; north-eastern Australia; South Sea islands

Tree species kapok (*Ceiba pentandra*), tonka (*Dypterix panamensis*), Para rubber tree (*Hevea brasiliensis*), Brazil-nut tree (*Bertholletia excelsa*), yellow meranti (*Shorea faguetiana*), tualang (*Koompasia excelsa*), strangler figs (*Ficus spp.*) (*Pterocarpus santalinus*), Baobab/Affenbrotbaum (*Adansonia spec.*), Marula (*Sclerocarya birrea*), Akazien (*Acacia senegal, A. raddiana*), Eukalyptus (*Eucalyptus tetrodonta, E. miniata*)

Animals leafcutter ant, poison dart frog, tapir, sloth, African forest elephant, okapi, chimpanzee, gorilla, orangutan, hornbill, bird of paradise

Status more than half already destroyed by humans; acutely endangered by logging, climate change, agriculture, and infrastructure projects

Special features many trees with buttress or stilt roots; dense vegetation with epiphytic plants—ones that grow on the surface of other plants—such as bromeliads and orchids

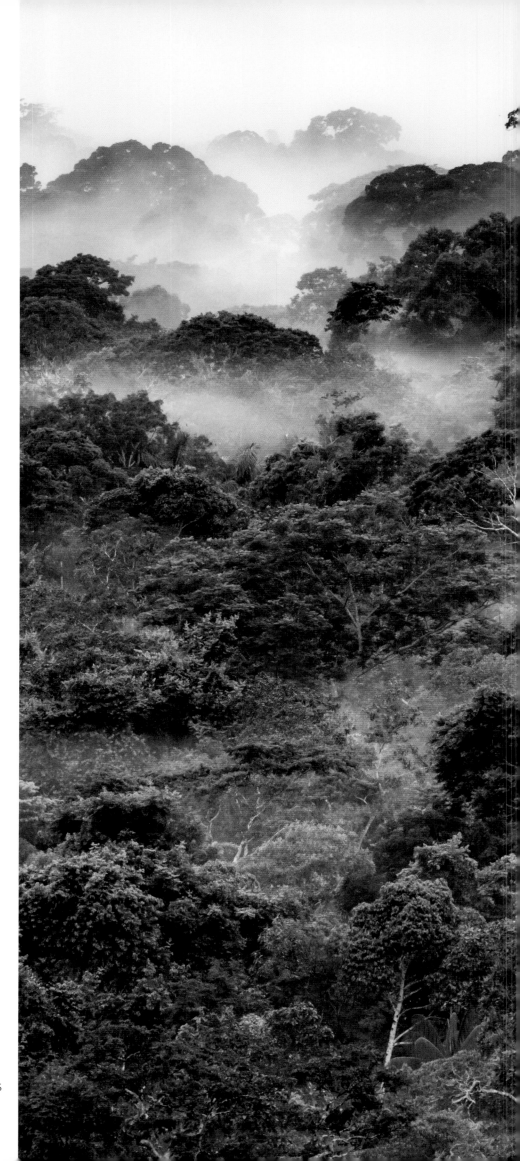

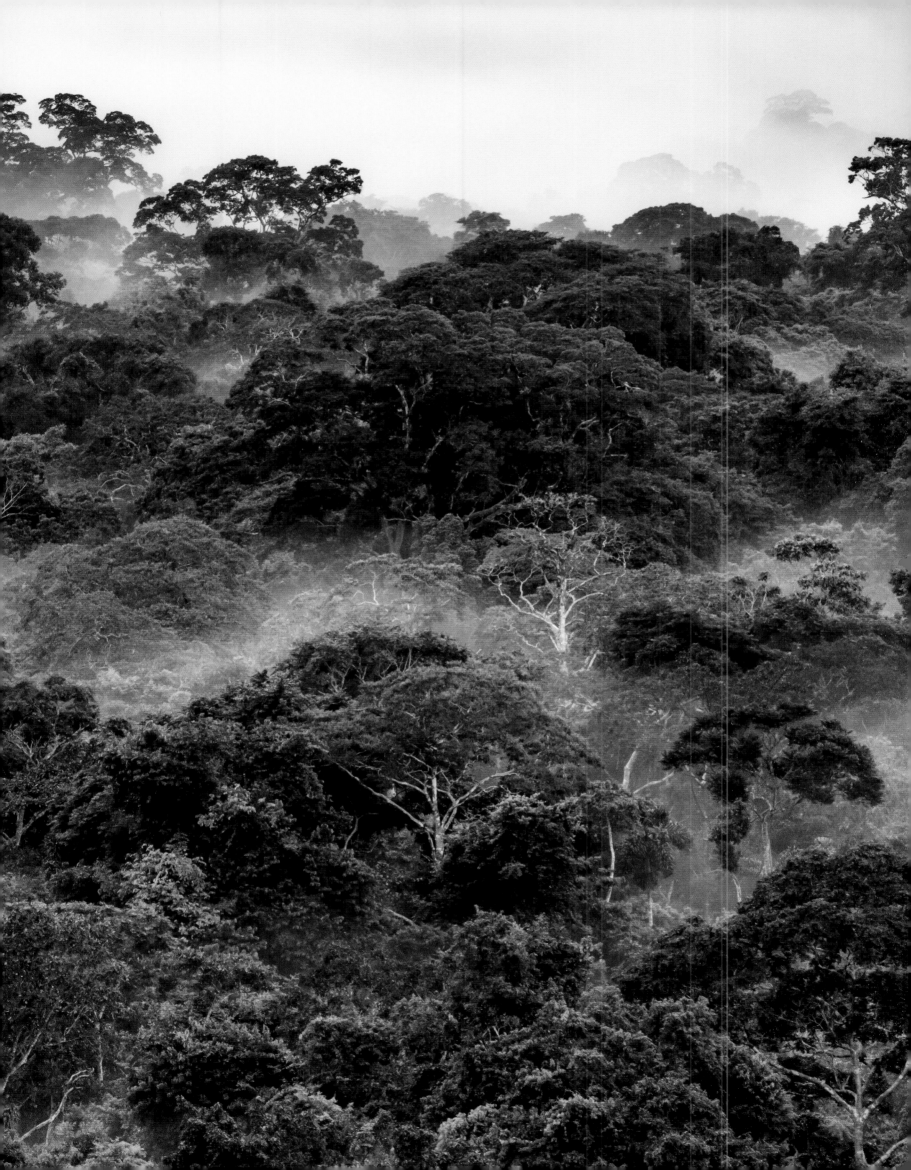

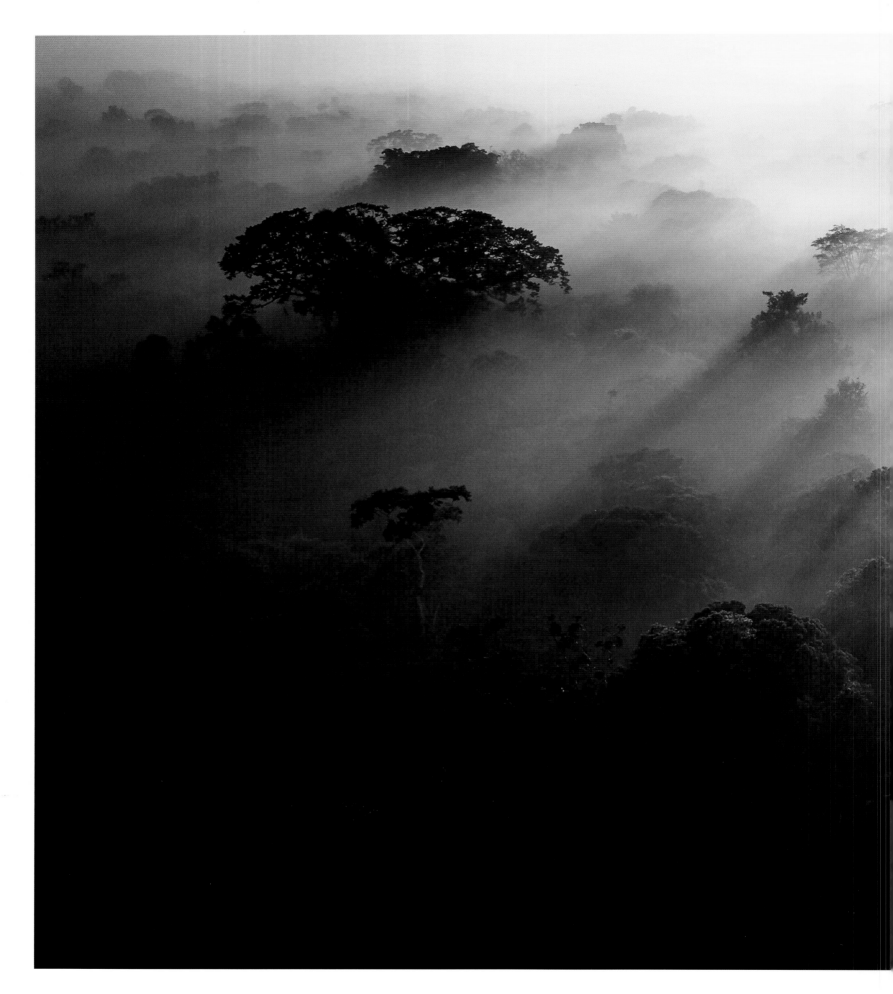

Rainforest at sunrise, Yasuní National Park, Ecuador: The low-angle sunlight exposes the staircase structure of the forest with its various canopy layers. The rising sun evaporates moisture out of the forest, giving rise to clouds and wafting fog. Thanks to their capacity to store enormous quantities of water and biomass (and thus, carbon), tropical rainforests are an important component of the global climate system.

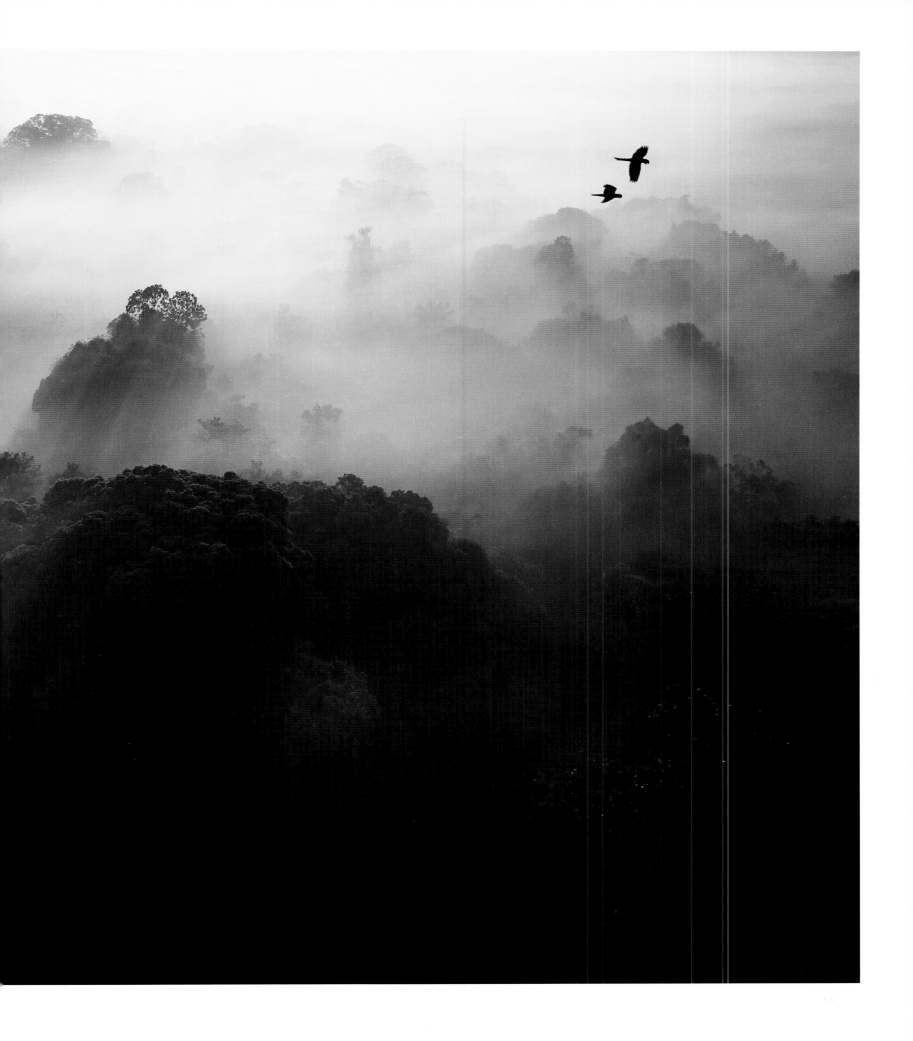

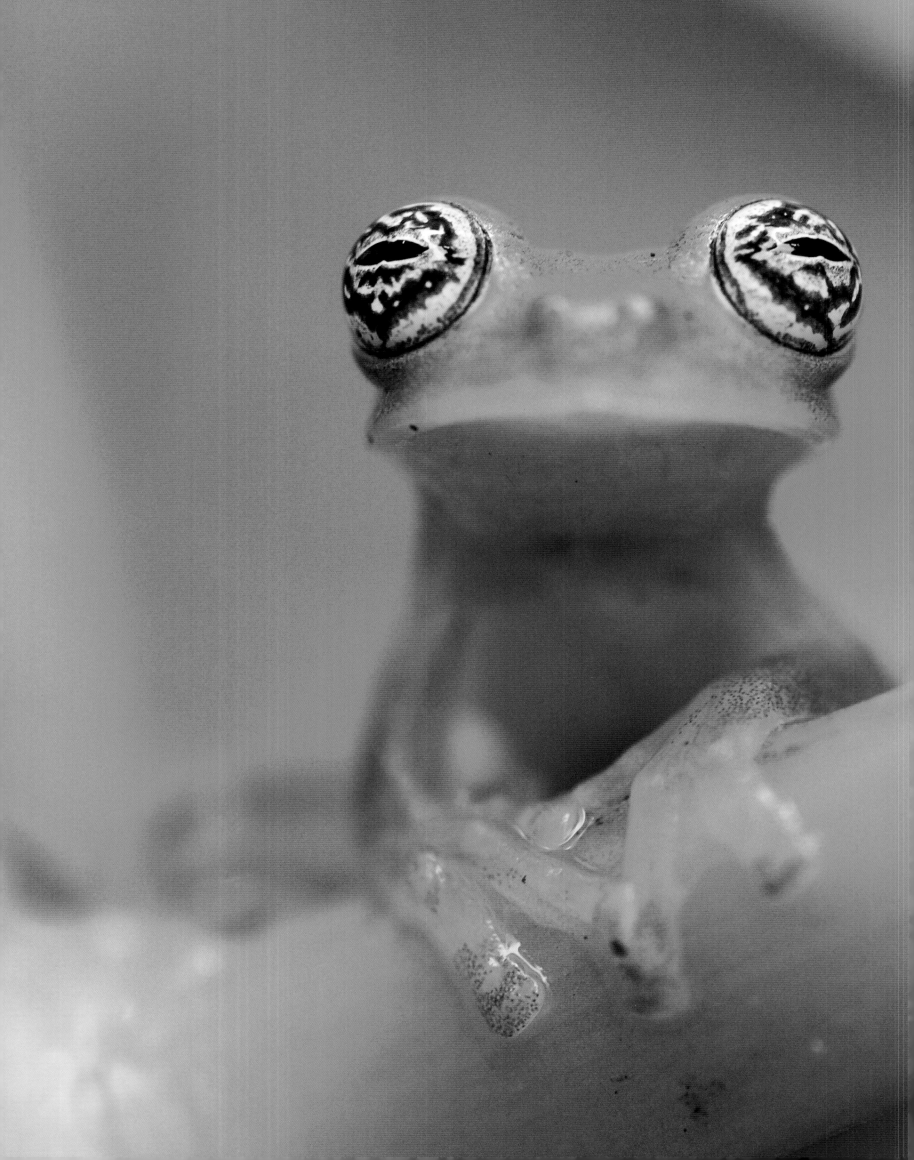

The **Limon giant glass frog** (*Centrolenella ilex*) inhabits the vegetation along water bodies in lowland rainforests of Central America. During the day, the pupils of its big eyes narrow to slits. It becomes active at night.

There are a great many species of amphibians in the tropical rainforests of South and Central America; but there are numerous, often endemic species in other tropical regions as well, such as in New Guinea, Sri Lanka, Southeast Asia, Madagascar, and central Africa. Amphibian populations around the world have been in decline now for a few decades—sometimes drastically—owing to many factors including destruction of habitat and the spread of fungal infections.

Tropical Rainforest: A Collective Notion

The term "tropical rainforest" covers various types of tropical forests in which conditions are warm and wet throughout the year. On average, annual precipitation ranges from 1,200–6,000 mm (47–236 in.). In some places, for example on windward-facing mountain slopes where clouds deposit all their moisture in the form of rain, average annual rainfall can be upwards of 10,000 mm (394 in.). By way of comparison, average annual precipitation in Germany is around 800 mm (31.5 in.).[1] These rains are not always evenly distributed throughout the year; many rainforests experience one or more dry seasons.[2]

Tropical rainforests occur in a wide band along the equator between the tropic of Cancer and the tropic of Capricorn. The duration of daylight in this zone varies only marginally, and the diurnal temperature range is greater than month-to-month temperature variation throughout the year, so it is an aseasonal climate. Before intensive human exploitation, tropical rainforest covered some sixteen million square kilometers (6.2 million sq. mi.), an area the size of Russia. Today, less than half of it remains undisturbed.[3] The largest extant, contiguous rainforests are located in Southeast Asia, in the Congo River basin of central Africa, and in the Amazon-Orinoco lowlands of South America.

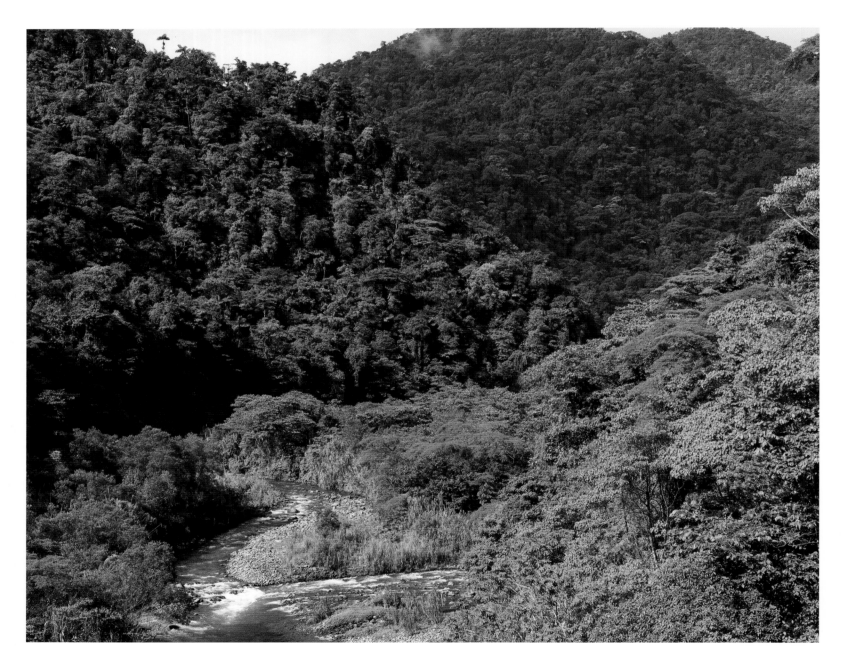

Above: **Rainforest on the Río Hondura,** elevation 480 meters (1575 feet) above sea level, Braulio Carrillo National Park, Costa Rica. // Right side: **Three Spix's night monkeys** (*Aotus vociferans*) peering out of a hollow tree trunk in Cuyabeno Wildlife Reserve in Ecuador. Weighing only about seven hundred grams (1.5 pounds), these animals live in small family units in the western Amazon Basin. They are nocturnal and feed on fruits, leaves, and insects.

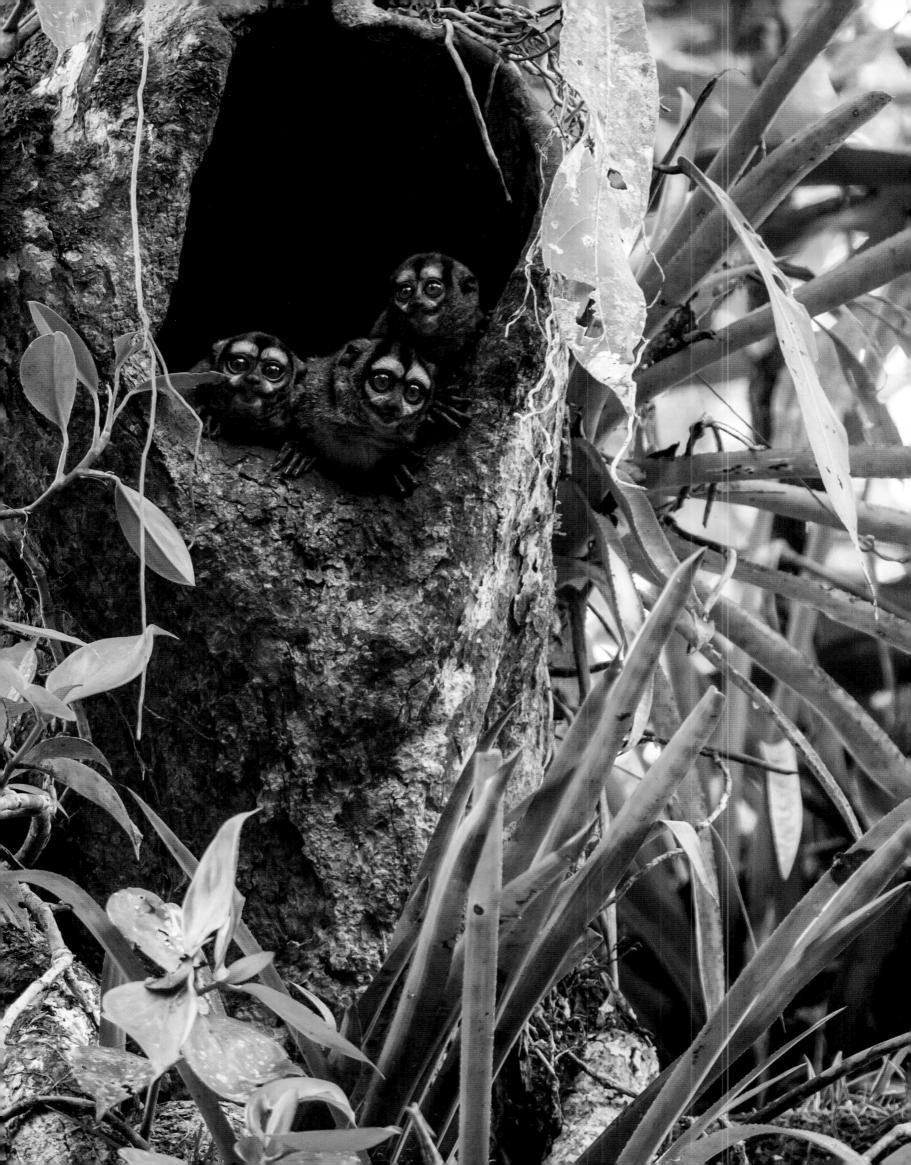

The **cannonball tree** (*Couroupita guianensis*) bears big, unmistakable blossoms and fruits on its trunk and branches. Botanists call this strategy of many rainforest trees—setting out flowers and fruits so as to be easily accessible to the forest animals below the dense canopy—"caulifory." The cannonball tree is in the monkey-pot family of trees (*Lecythidaceae*) which is especially well represented among the rainforest trees of Amazonia. The Brazil nut (*Bertholletia excelsa*) is a member of the same plant family.

Canopy habitat: Epiphytes—plants that live on the surface of other plants—and nests of the giant honey bee (*Apis dorsata*) in the crown of a tualang (*Koompassia excelsa*) in a rainforest on Borneo, Malaysia. In Asia, giant honey bees pollinate many rainforest plants, not to mention the flowers of the coffee shrub (*Coffea spp.*) cultivated on plantations.

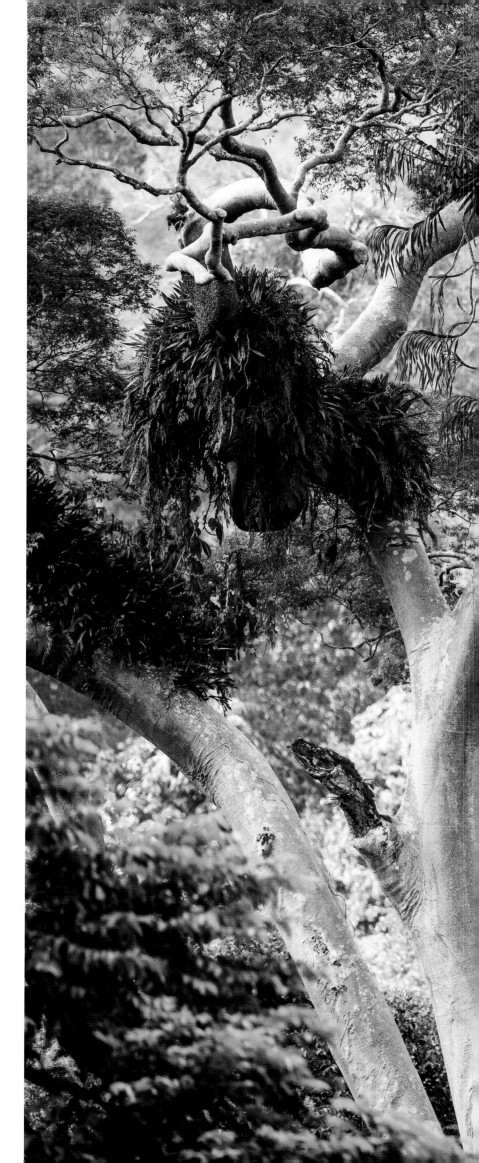

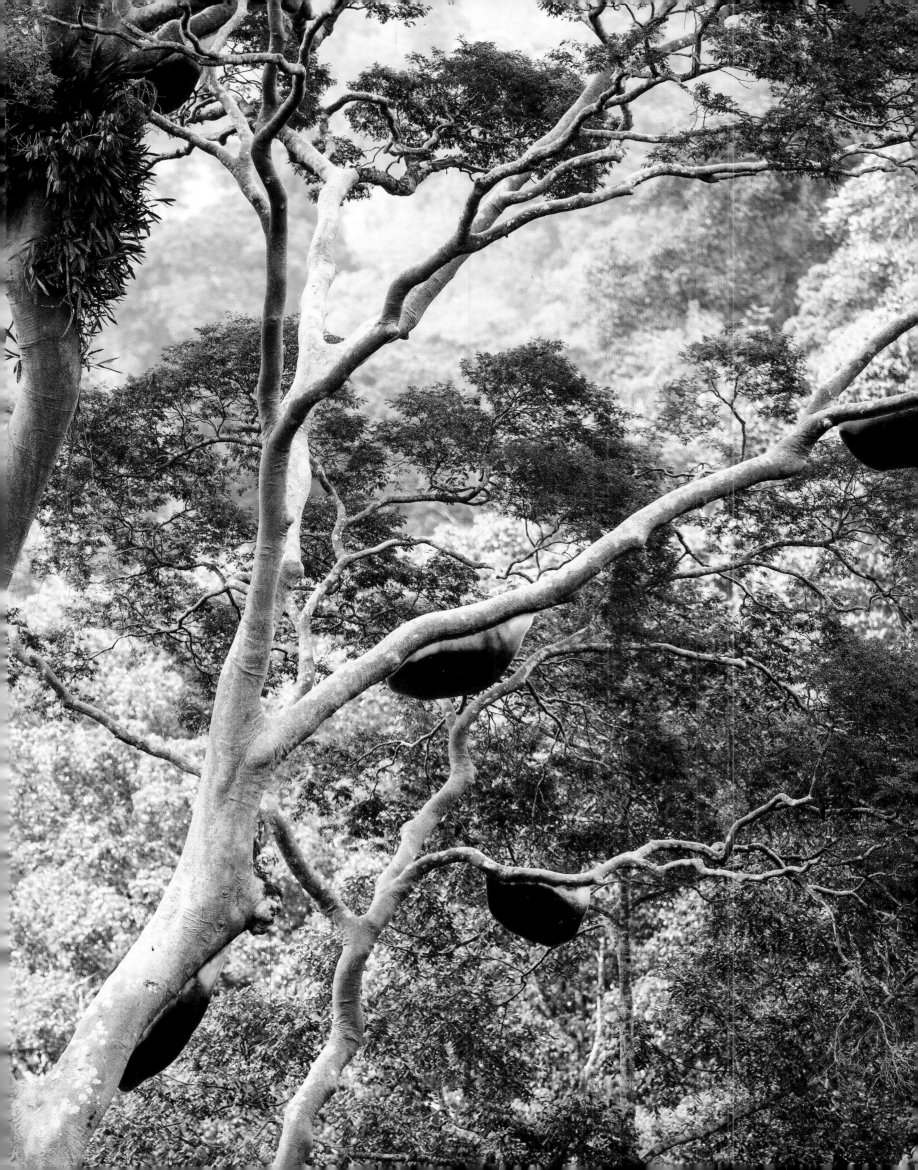

A Picture-Book Lowland Tropical Rainforest

What most people think of as typical is lowland rainforest. This type is common from coastal areas to elevations of around a thousand meters (3,280 feet), where wet conditions prevail year-round and average annual temperatures range from 22–28°C (71.6–82.4°F). Most tree species attain heights of no more than forty or fifty meters (131–164 feet) and form a closed, multi-tier canopy. Giant, lone trees, such as the kapok (*Ceiba pentandra*), grow even taller, up to sixty meters (197 feet) or more, and rise above the canopy as emergents. A nearly one-hundred-meter (328–foot) tall yellow meranti (*Shorea faguetiana*) in the Sabahan rainforest in the Malaysian sector of the island of Borneo is reckoned as one of the tallest tropical trees.[4] Many trees and plants have large, smooth leaves that taper to more-or-less-elongated apexes, called "drip-tips". Across these tips, rainwater can easily run off, avoiding moisture retention and thereby preventing algae and fungi from growing. In the lower layers of the forest, many trees are cauli- or ramiflorous—bearing fruit and flower directly on their stems and branches—which enables better access to fruits and nectar for bats, birds, and insects below the leaf-thicket of the overstory. Papaya and

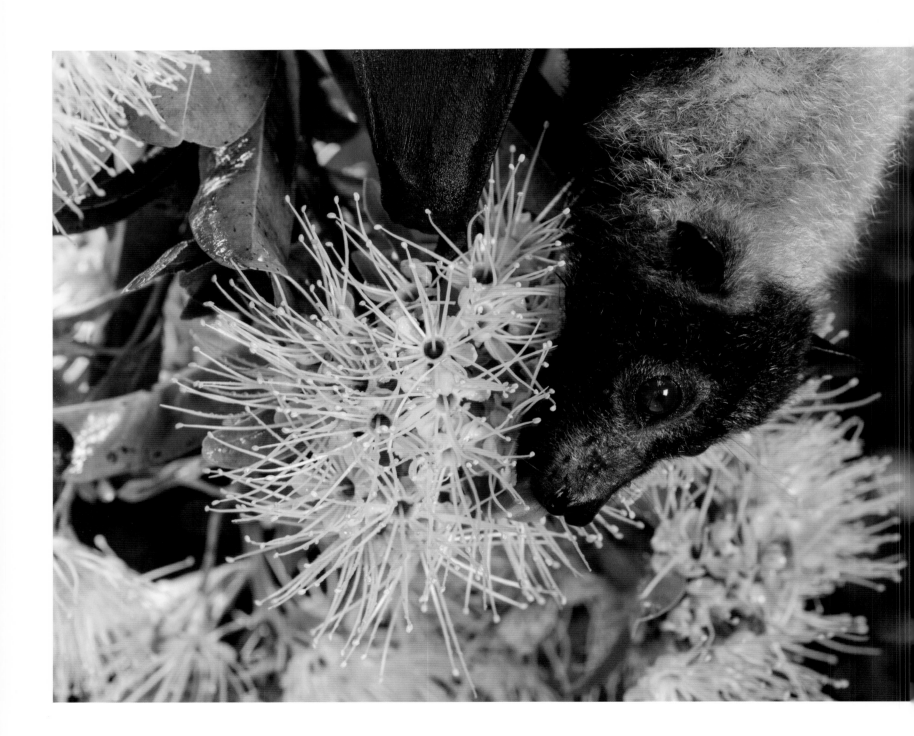

cacao trees are examples of this, as is the Brazilian grapetree (or *jaboticaba, Myrciaria cauliflora*), the trunk of which, when fruit-bearing, is plastered with tasty, darkly-colored cherries.

Most lowland rainforest trees and plants depend on animals to pollinate their flowers and disperse their seeds. Bats, birds, monkeys, squirrels, kinkajous, arboreal opossums, euglossine and orchid bees (*Euglossini, Eulaema*), bumble- and still more kinds of bees tackle the job of pollinating, and fruit-eating mammals that of dispersing, the seeds. For example, agoutis (a rodent species) crucially aid in dispersing Brazil-nuts by burying a portion of the seeds that fall from the tree. Larger mammals seldom appear in the rainforest because most of the food is located not down on the ground but rather up in the treetops, and is inaccessible to heavy, flightless animals. African forest elephants, tapirs and okapis (forest giraffes) survive by plying expansive home ranges and feeding on a large variety of plants.

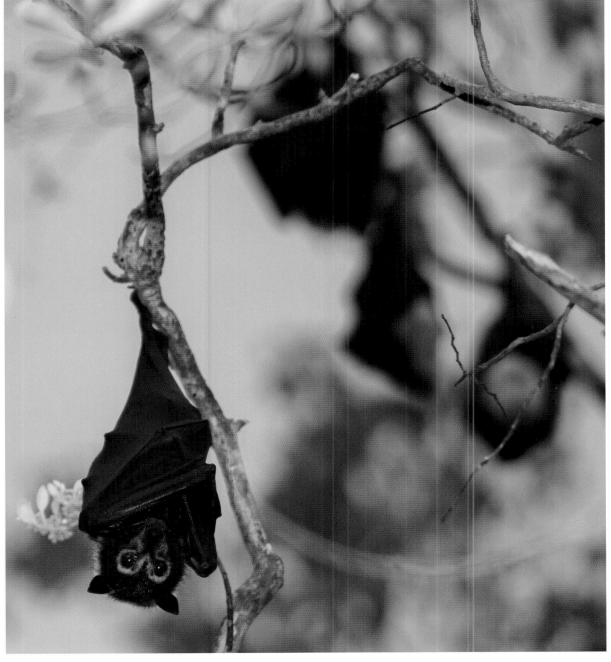

Left side: **A spectacled flying fox** (*Pteropus conspicillatus*) laps at nectar from the flowers of a golden penda tree (*Xanthostemon chrysanthus*), Atherton Tablelands, Queensland, Australia. Australia's tropical rainforests occur only in a narrow coastal strip in the northeastern part of the country and are now shrunken down to small pockets of retreat. // Right side: **Spectacled flying foxes** rest during the day in their roost trees. They become active at dusk, searching for fruit, nectar, and pollen. In the process, they provide valuable pollination and seed-spreading services for many trees of the rainforest.

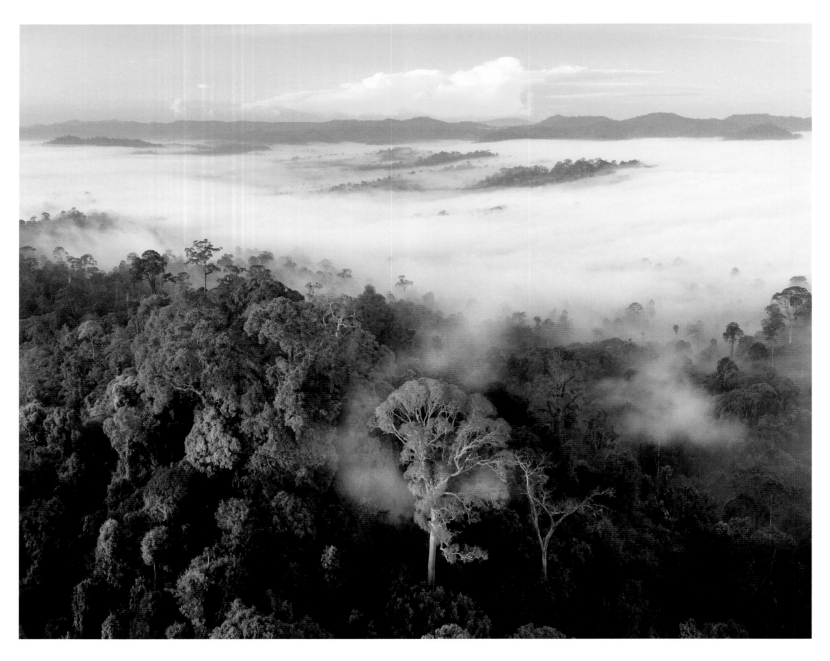

Above: **Fog and low-lying clouds** over lowland rainforest in the Danum Valley on Borneo. In the foreground, a large tualang (*Koompassia excelsa*) emerges out of the forest. // Right side: **A rhinoceros hornbill pair** (*Buceros rhinoceros*) flying over fog-bound rainforest in the Danum Valley on Borneo.

The Forest as Rainmaker

The tropical climate is dominated by intense sunlight and constant winds all year round. The winds drive clouds that form over the ocean ashore, where they dump their rain across the forest. The myriads of leaves in the crowns of the trees also constitute an enormous surface area for evaporation; around half the precipitation immediately turns back into vapor this way. Rising up from below, this moisture condenses on pollen grains, spores, bacteria, and other fine particles that have found their way into the atmosphere from the forest.[5] Fat thunderheads billow up during the day and unleash powerful afternoon and evening downpours. The rainforest itself thus produces a considerable portion of the rain that falls there.

Most lowland rainforests are transected by a network of countless meandering rivers fed by the runoff from extra-rainy mountains. The rivers are a dynamic force, carrying sediments and nutrients as well as creating openings in an otherwise dense forest. On floodplains, where the forest is periodically inundated for several months at a time or even year-round, swamp forests—such as the várzea and igapó forests in the Brazilian Amazon—have evolved a speciesrich underwater fauna. They are habitat for numerous frugivorous (fruit-eating) fish species, and for the Amazon river dolphin, which uses echolocation as it hunts for fish in the murky water among the trees and stilt roots. There is enormous biodiversity even underwater: The Amazon region alone is home to nine thousand different species of fish.

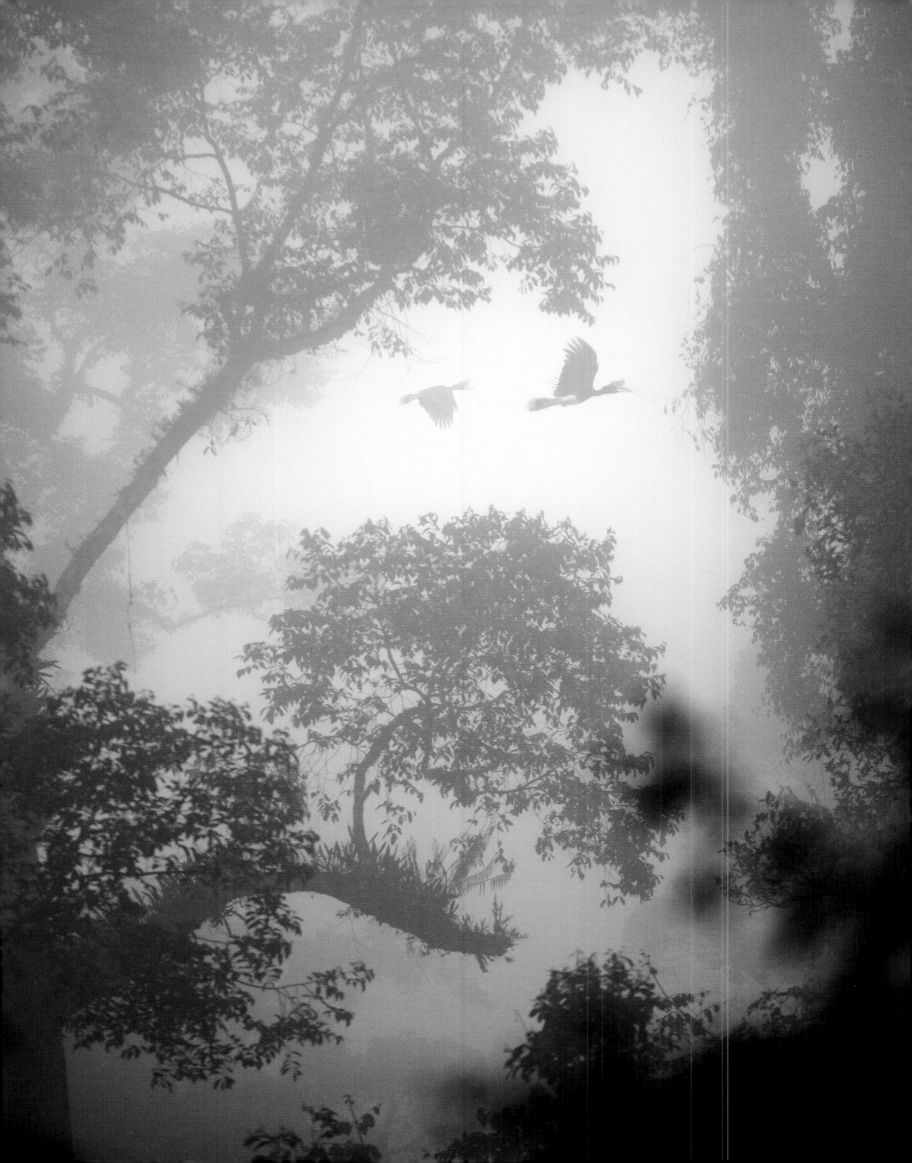

Even the **Amazon river dolphin** (*Inia geoffrensis*) is a forest-dweller, since it hunts for fish in the flooded forests of the Amazon Basin. Among the inundated tree-trunks, in water darkly stained by the leaves of rainforest plants, they are aided by their echolocation mechanism based on ultrasonic waves.

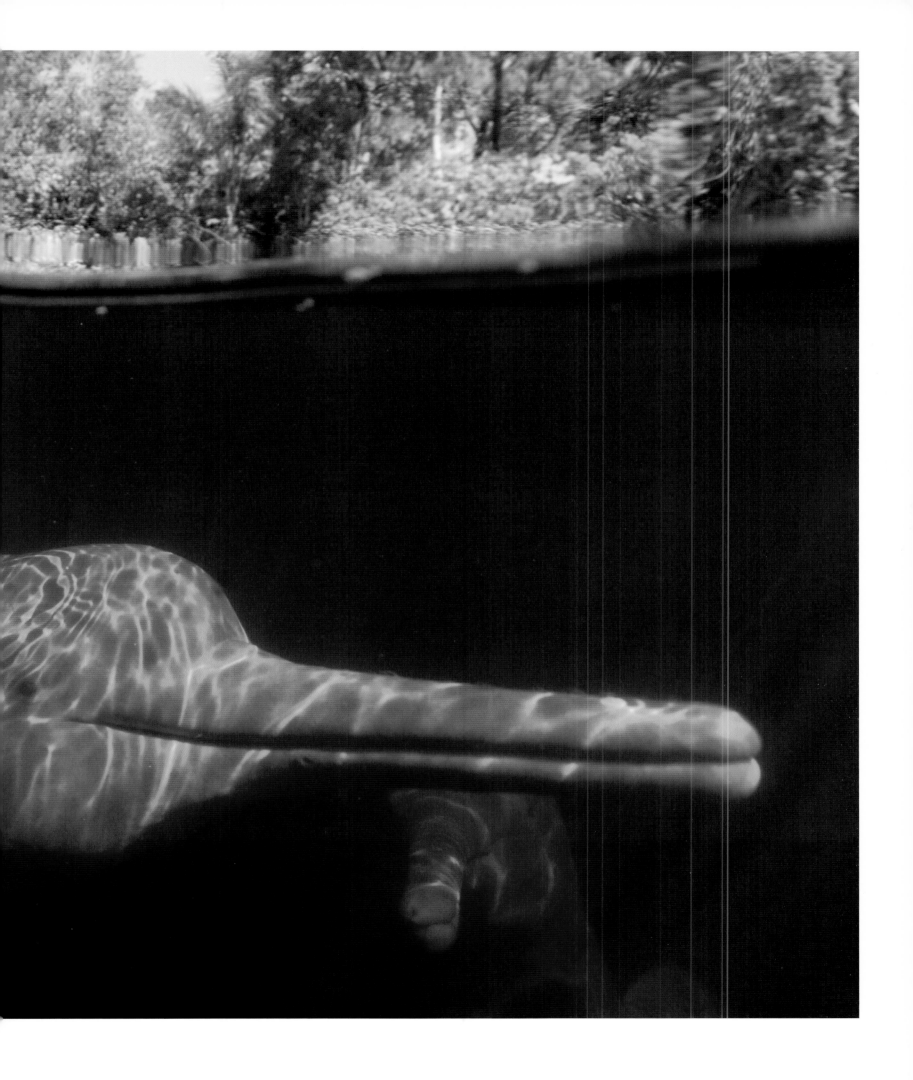

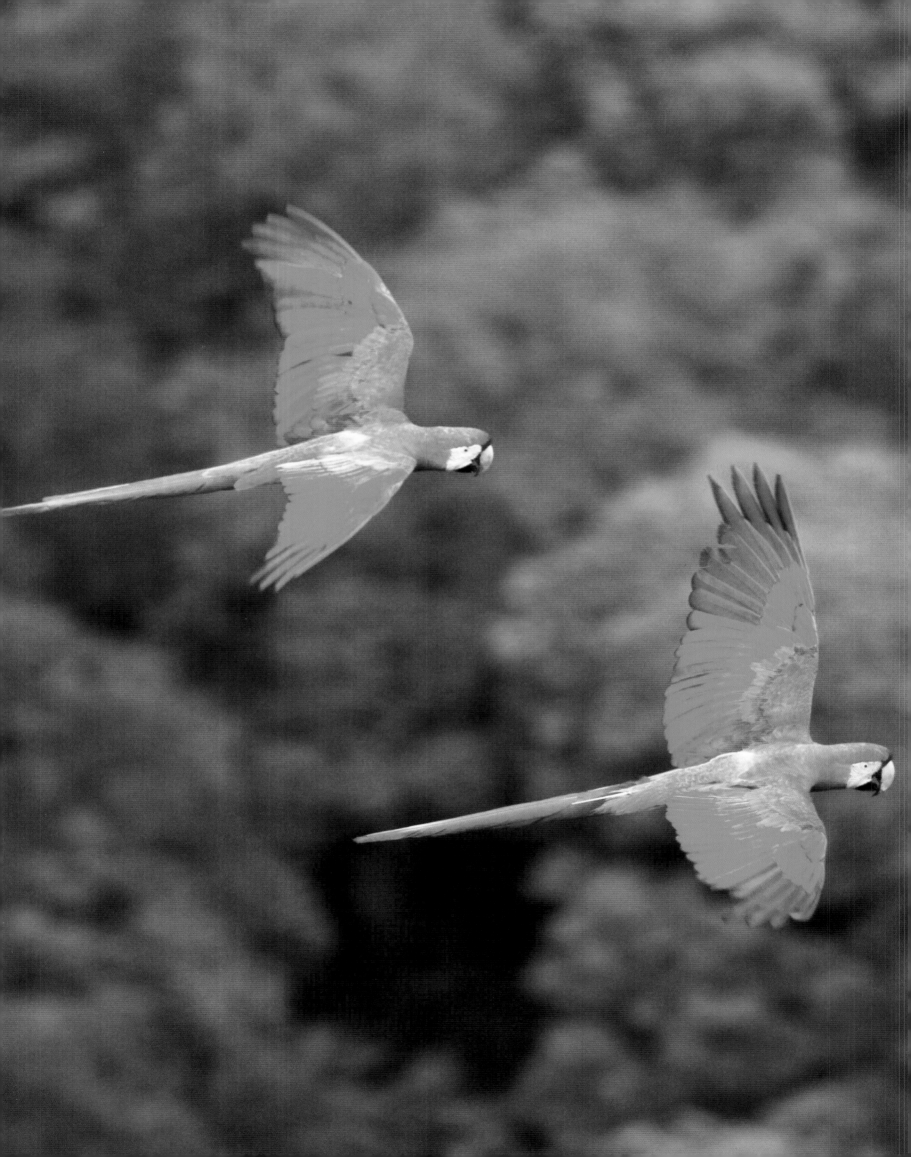

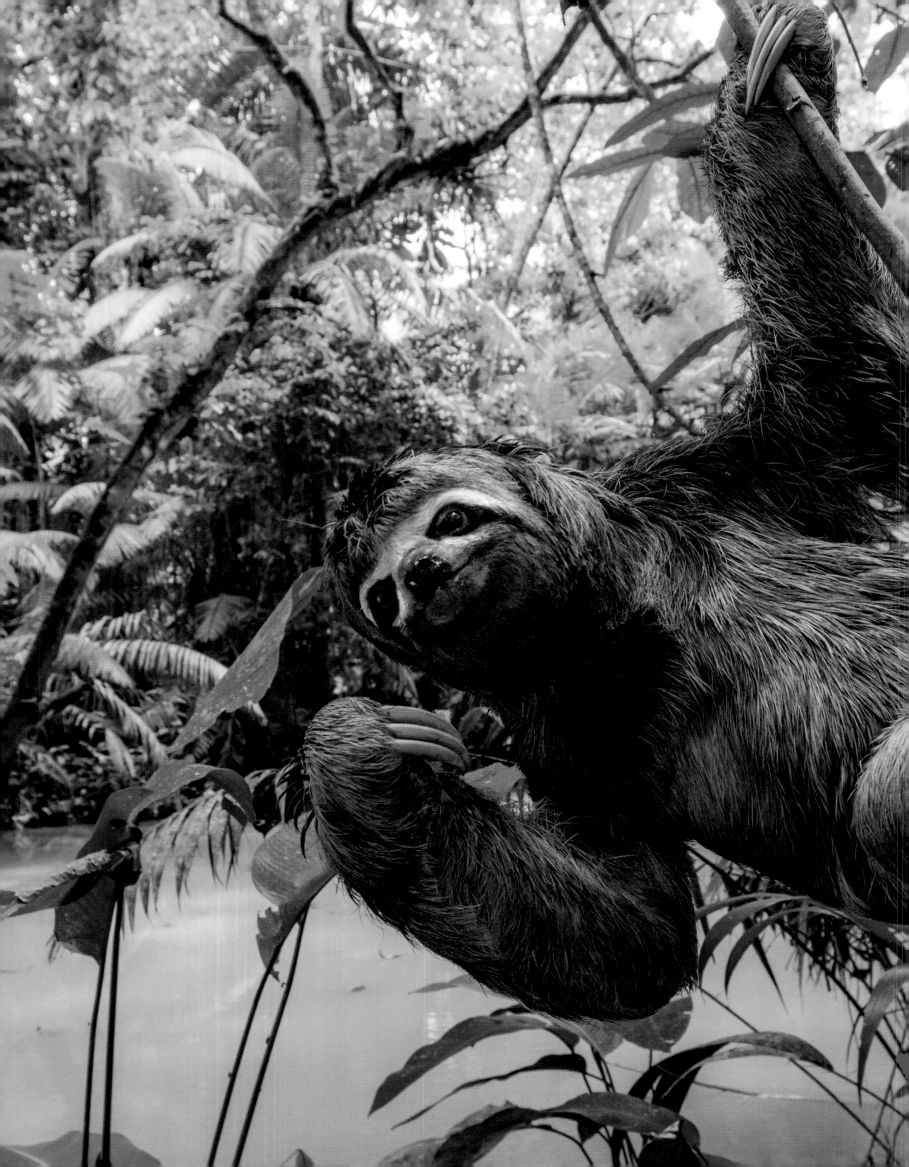

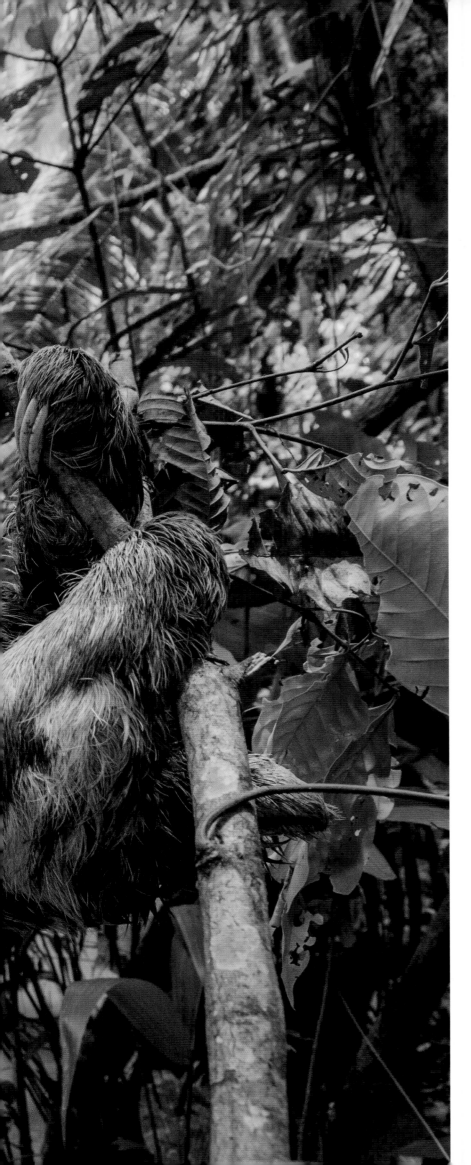

This brown-throated sloth (*Bradypus variegatus*) in Ecuador's Yasuní National Park is a species of three-toed sloth which, like all extant sloth species, are native to neotropical rainforests. Up until ten thousand years ago, ground-dwelling giant sloths weighing several tons populated large parts of the Americas. It is considered highly probable that humans hunted these animals to extinction.

Mountain Rainforests

In the cooler, higher-elevation mountain rain forests, where annual temperature averages range from 14 to 22°C (57–71.6°F), the trees no longer grow quite as tall; they reach heights of up to thirty-five meters (115 feet). On the other hand, there are more epiphytes—plants that grow on other plants, including bromeliads, ferns, mosses, lichens and orchids—and fewer lianas, which are climbers with woody tendrils. In cloud forests and montane rainforests at elevations between 1,500 and 3,000 meters (4,920–9,842 ft.), conditions are moist and cool all year; annual average temperatures range from 10–14°C (50–57.2°F). The trees that grow there are usually no taller than eighteen meters (59 feet), with smaller leaves and no buttress roots. The trees are profusely decked with epiphytes, but, at these elevations, there are no lianas.

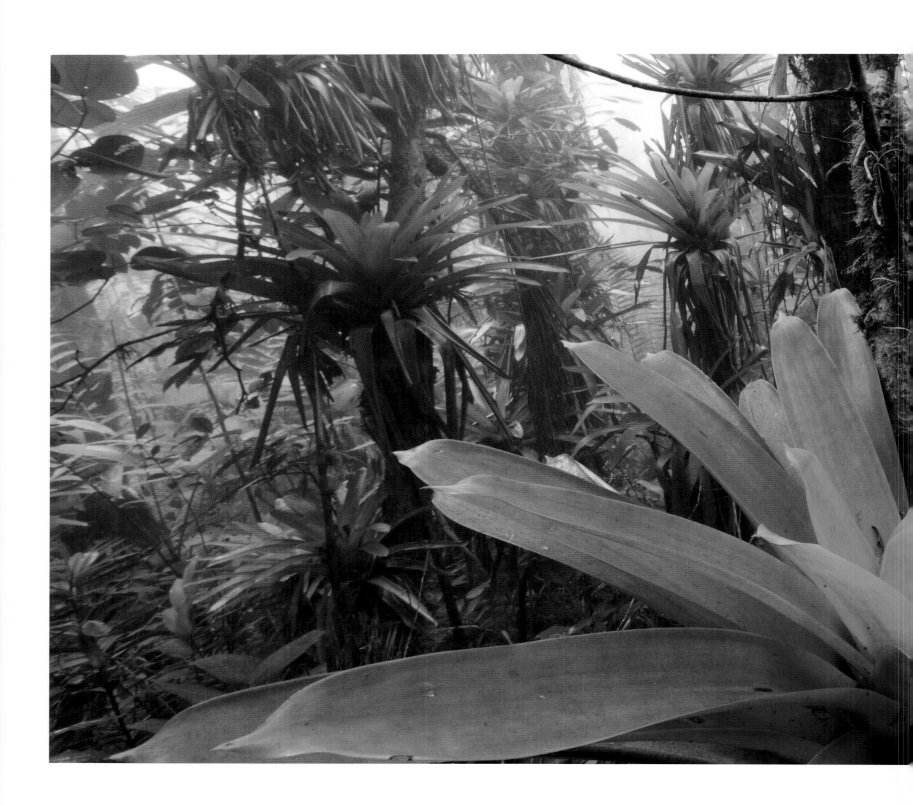

Tropical rainforests come in other forms: mangrove forests in brackish coastal waters; the peat swamp forests of equatorial Southeast Asia, such as on Sumatra and Borneo. In peat swamp forests, dead, grown-over peat mosses (*Sphagnum*) and other organic matter collect in bottom layers up to twenty meters (66 feet) thick. These wet, acidic soils host a specialized vegetation that spreads out like a mosaic: Stands of short, crippled-looking trees are interspersed with watercourses, pools and clearings upon which carnivorous pitcher plants thrive. The trees in the forests that edge the bogs, by contrast, may be as much as fifty meters (164 feet) tall.[6] These forests are threatened by logging, but also by drainage and arson; such was the case in 2015, a particularly dry year in which peat fires released large amounts of toxic smoke and carbon dioxide into the atmosphere.[7]

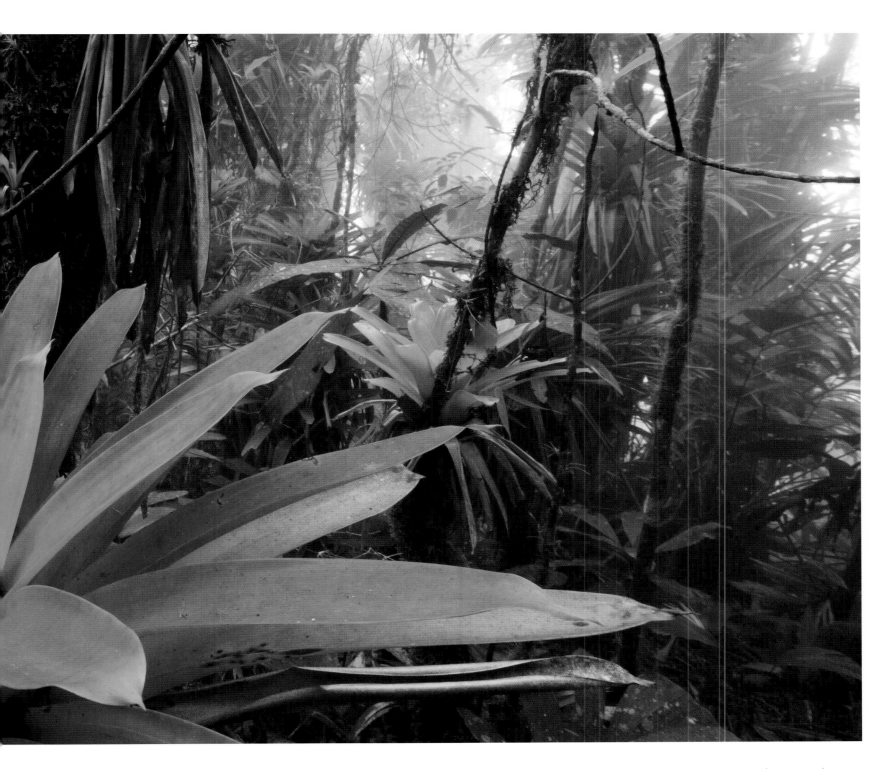

Bromeliads, also called pineapple plants, are epiphytes (plants that grow on other plants) that occur only in the neotropics—the tropical part of the Americas that encompasses northern South America, the Caribbean, Central America and the southernmost part of North America. Especially dense bromeliad growth is found in montane rainforests like this one, in the Sierra Nevada de Santa Marta, in northern Colombia.

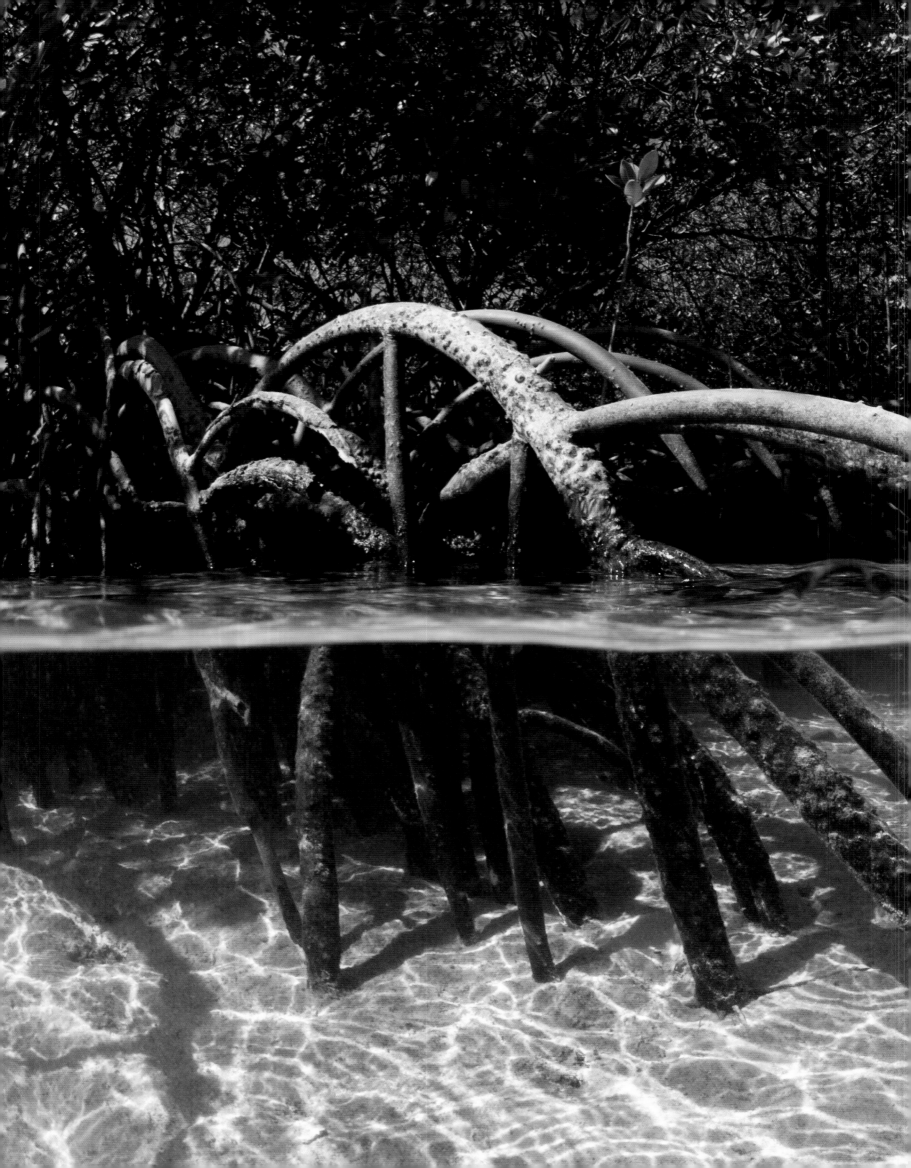

Mangroves: Amphibian Tropical Forests Between Land and Sea

Mangrove forests grow in the estuaries of rivers in the tropics as well as in the intertidal zone of shallow coastlines in both the tropics and subtropics, as for example in India and Bangladesh, Southeast Asia, and the Caribbean. Mangrove forests get inundated and exposed again with the rising and ebbing of the tide.[8] With their stilt- and respiratory roots, mangroves are optimally adapted to their amphibious habitat and can excrete excess salt via their leaves. For coastal areas, mangrove forests serve as effective protection against erosion, storm surges and coastal flooding, and they provide shelter and nourishment for many species of fish and birds. In the last thirty years, half of the world's mangrove forests have been lost[9] to expanding cities, ports and farmland as well as to industrialscale aquaculture of seafood species such as shrimp.[10] On the Indonesian island of Java, which has lost a whopping 70 percent of its mangroves, coastal residents are now promoting the regrowth of mangroves by erecting wooden barriers.[11] In many other regions as well—from Senegal, Mauritius[12] and Madagascar, to Bangladesh, Sri Lanka, and Indonesia, clear across to Ecuador,[13] Colombia[14] and Florida—mangroves are being replanted, individually and by hand, as people have come to recognize their unique importance for coastal ecosystems.

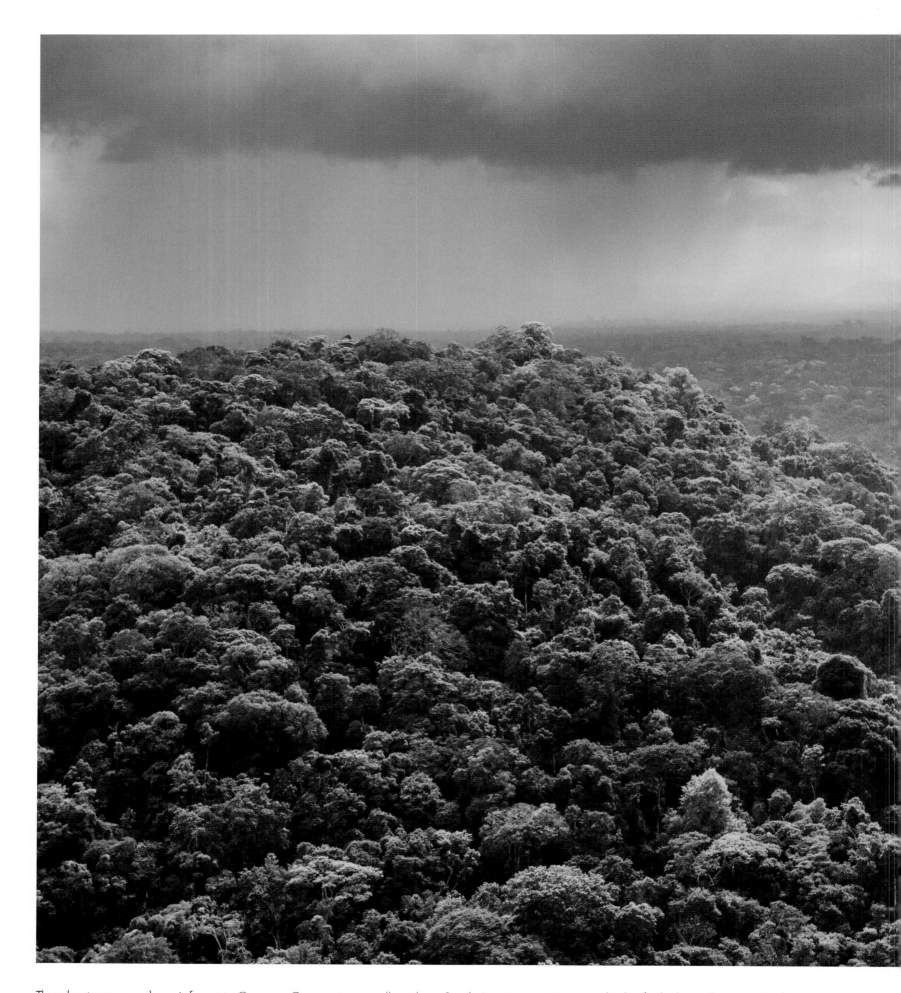

Thunderstorm over the rainforest in Guyana. Guyana is a small northern South American nation, two-thirds of which is still covered in forest. Due to the tropical climate and dense forests, most of its population of 750,000 lives near the coast. Guyana is dependent upon the help of rich nations to preserve its valuable old-growth forests.

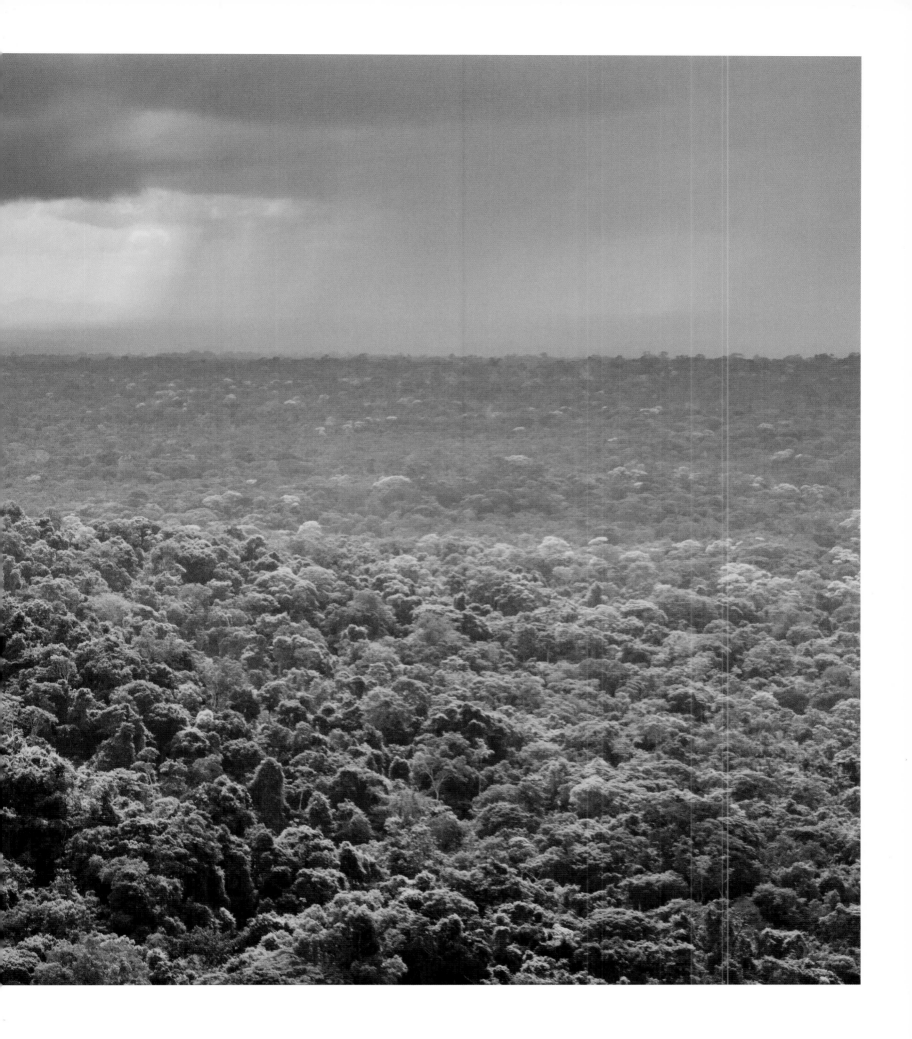

Recycling is Everything

The rainforest represents one great cycle of growth and decay; leaves, branches, whole trees, and animal carcasses decompose and are recycled quickly by fungi, millipedes, worms and other organisms in the warm, moist climate.[15] Whereas it takes anywhere from years to decades for a fallen tree to disintegrate in the temperate zone, it takes only a few months in a tropical rainforest. Thus, only a relatively small amount of material accumulates on the ground; the humus layer is thin. The abundant rainfall leaches nutrients from the upper layers down into the lower soil layers, which makes them poorly suited for agriculture.

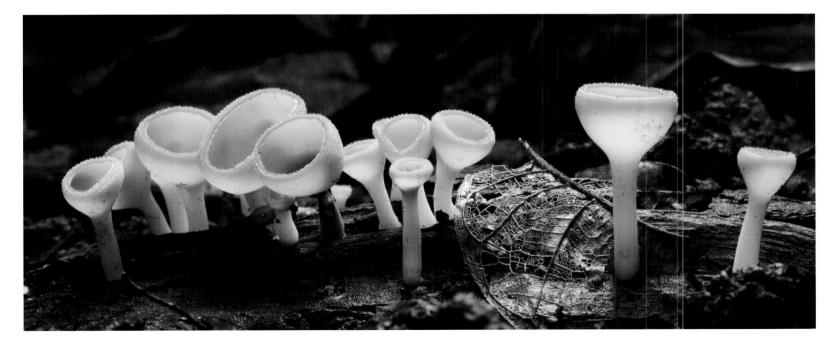

Left: **This orthopteran** n Costa Rica's Tortuguero National Park blends almost completely in with the tree trunk. Small creatures have many enemies in the forest, and good camouflage—perhaps as bark, a leaf, a branch, or even as bird droppings—is a time-tested survival strategy. Many insects ingest toxic compounds from the plants they feed on and build up reserves of them in their bodies in order to make themselves inedible. Others only act, by way of their shape or coloration, as though they were poisonous or defensively armed. // Top: **Once fallen onto the forest floor,** a leaf is quickly colonized by lichens and fungi. Sabah, Borneo, Malaysia. // Above: **Cup fungus mushrooms** (*Cookeina spec.*) growing on rotting wood in Corcovado National Park in southwestern Costa Rica. Researchers in Panama were able to identify 350 small funguses, some of them microscopic, on the leaves of just two tree species.

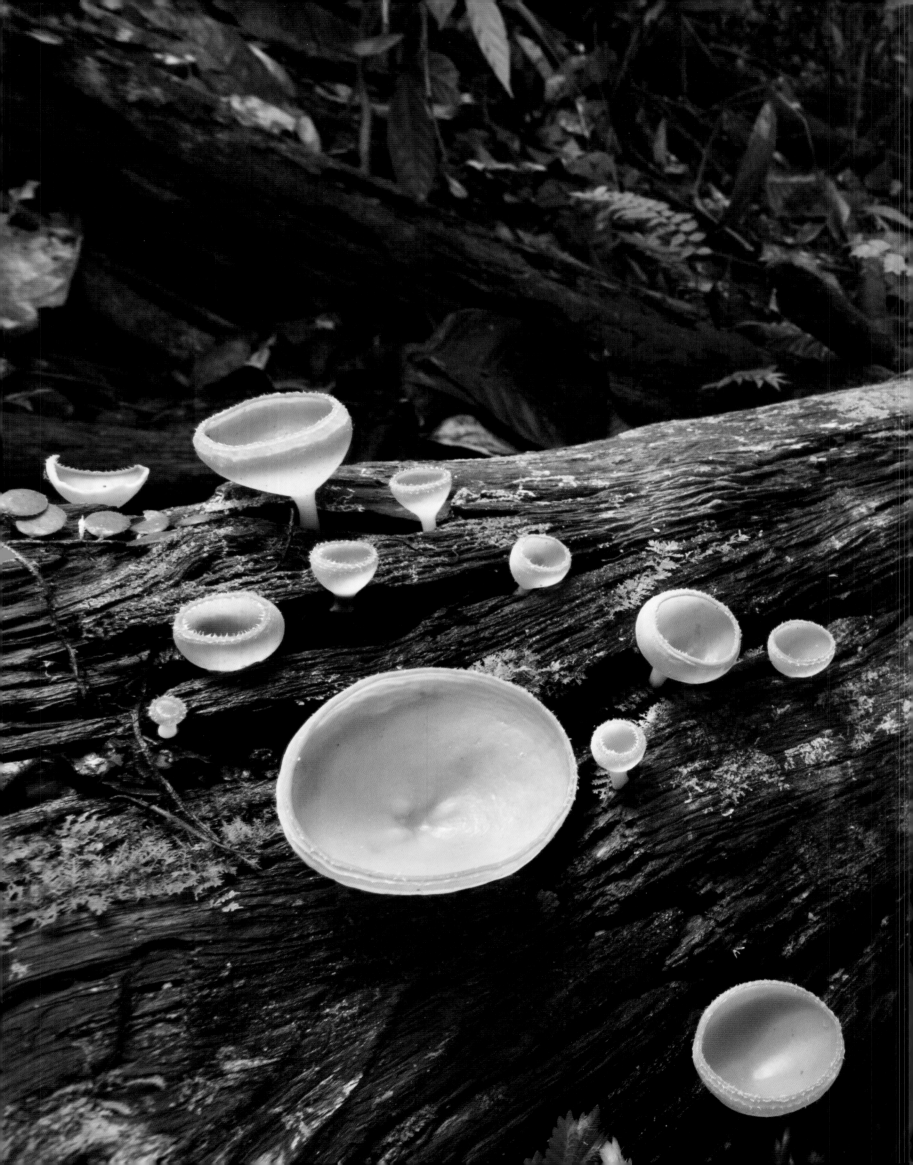

Fungi occupy a crucial ecological niche in every forest, for example as symbionts that help trees obtain nutrients, or as decomposers that break down leaves and deadwood like these cup fungi in the Danum Valley on Borneo. Funguses are a life form unto themselves, though probably more closely related to the animal than to the plant kingdom, since their cell walls contain chitin (like insect exoskeletons) and they store reserve energy in the form of glycogen or fat, similar to animals. These mysterious beings are represented in greater numbers in the rainforest than in any other habitat. Current estimates of worldwide fungus biodiversity range between 2.2 and 3.8 million species, of which only 150,000 have been described scientifically.

Race Toward the Light

What tropical rainforests lack on the ground, in terms of light and nutrients, is found in the forest overstory. The leaf canopy binds nitrogen and filters nutrients out of both air and rain. Accordingly, the lives of numerous species play out up high, unconnected with the ground.[16] Epiphytes, such as ferns, orchids, mosses, and bromeliads, disperse their seeds or spores into the upper layers of the forest with help from animals. Wherever more light filters through, climbing plants wind their way up the tree trunks. The climbers set roots in the ground and use the trees for support in reaching for the light and expanding their leaves in the tree–crowns. The climbers' woody tendrils, some as thick as your arm, twist and twine like corkscrews around tree stems, or dangle from branches.

The dark herbaceous layer, in the basement mainly of lowland rainforests, is also the nursery of the big trees: If one of the old, primeval-forest giants topples over, tree shoots kick off a competition to gain the light and reseal the gap in the canopy. This process also yields the lean, tall, unbranching growth to great heights, transitioning into a broad crown which is so typical of rainforest trees. In order for the shallow–rooting trees not to lose their footing, they rely on mighty, extensively elaborated buttress roots that sprawl across the forest floor in some places like a net. Since they need not guard against fire or frost, most of the trees have thin, smooth bark that makes life difficult for climbers and other vegetation.[17]

This mighty strangler fig (*Ficus spec.*) in the cloud forest of Monteverde, Costa Rica, has already accomplished its life's work. The fig first used its host–tree for support; then, it gradually overgrew the host; and then it finally dislodged its host from its position among the canopy. The fig's victim, now dead, is being recycled by rainforest organisms that decompose wood. What remains is the old fig's mesh-like, now-hollow trunk.

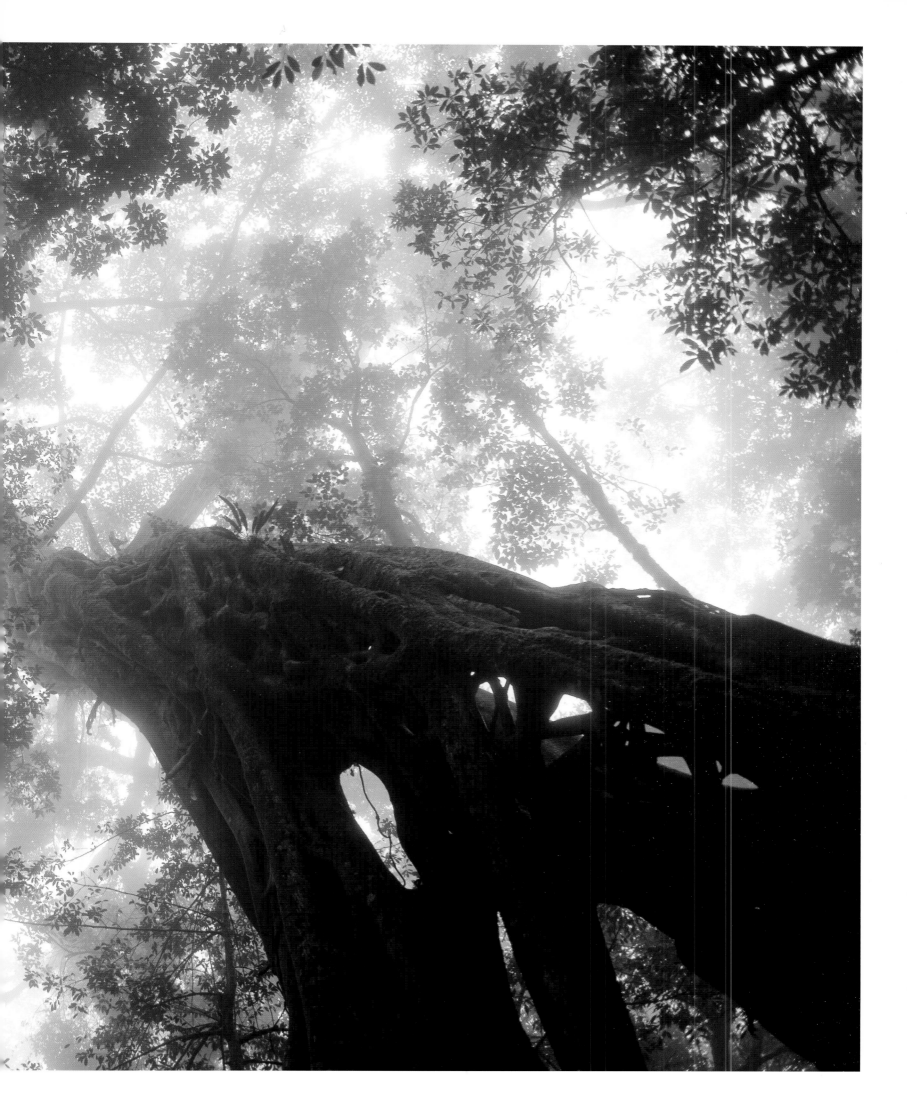

Biodiversity in the Superlative

Tropical rainforests contain around two-thirds of all known plant species in the world,[18] and the diversity of tree species increases enormously toward the equator: Some 85 percent or, in absolute terms, at least forty to fifty thousand of all the earth's tree species are at home in the tropics.[19] More than twenty thousand species grow in the Americas and in the Indo-Pacific region, whereas African rainforests, at five thousand, are less species-rich. By way of comparison: There are 124 tree species in all of central Europe, and less than a hundred in the boreal forests.[20] Unlike the trees of cooler climate zones, most tropical species have but a very limited distribution, not to mention a low-density growth pattern, with something like one specimen per hectare or even per square kilometer.[21] Of the sixteen thousand tree species found in the Amazon rainforest, only 227 are socalled "hyperdominant" species; these together account for half of the 390 billion trees in Amazonia. The rarest eleven thousand species combined make up just 0.12 percent of all individual trees—and, accordingly, are vulnerable with the destruction of the forest. Among the twenty most common trees in the Amazon rainforest are the Para rubber tree (*Hevea brasiliensis*), the mulberrytree relative Pseudolmedia laevis, and the wallaba (*Eperua falcata*) as well as various palms such as the walking palm (*Socratea exorrhiza*), so-called because of its stilt roots.[22]

The reason for the immense biological diversity of tropical rainforests is not thoroughly understood.[23] The decisive contributing factors, however, are steadily high temperatures, high humidity, and intense sunlight, which make for an enormous production of biomass that nourishes many herbivores, which in turn ensure the survival of numerous carnivores, parasites and pathogens. In addition, the climatic conditions in the tropics were stable over relatively long periods of time as well as across large, unbroken areas, which contributed to even the tiniest ecological niche having been able to develop, over time, its own, highly specialized species.

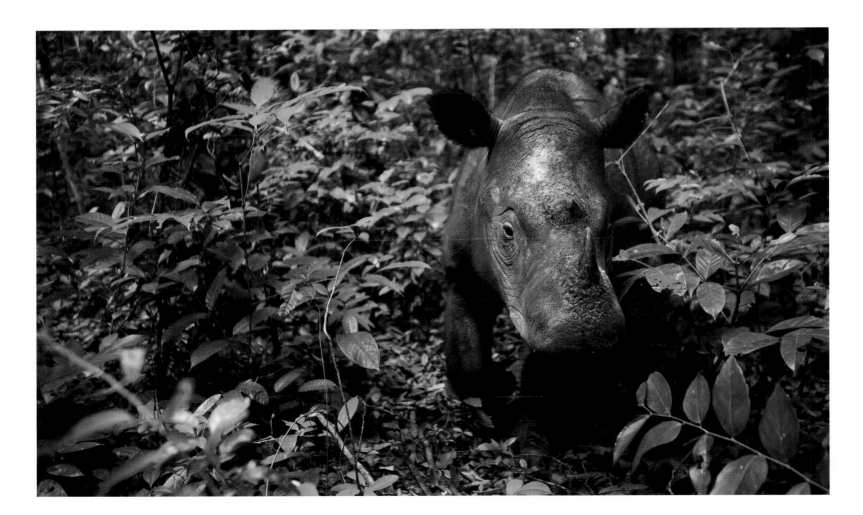

The Sumatran rhinoceros (*Dicerorhinus sumatrensis*) today inhabits only few small retreats on the Indonesian island of Sumatra. It is markedly smaller than its relatives in Africa and India and wears a relatively dense coat of hair. This picture was taken in Way Kambas National Park in southern Sumatra, where a rearing and reintroduction program is attempting to preserve this species.

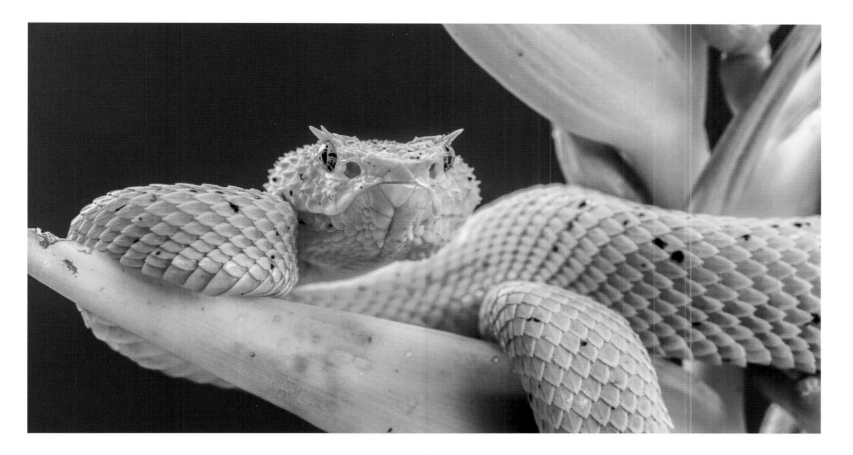

The eyelash viper (*Bothriechis schlegelii*) lies in wait for hummingbirds to come to a Heliconia flower (*Heliconia lankasteri*) for a sip of nectar. The small snake lies mostly well hidden in the vegetation and besides occurs in green- as well as in brown-shaded color varieties. Its bite is highly poisonous. La Selva, Costa Rica.

A **Stuhlmann's blue monkey** (*Cercopithecus mitis stuhlmanni*) in Kenya's Kakamega rainforest is munching on the seed pods of an African tulip tree (*Spathodea ambilatum*), also called a Nandi flame. Since 1900, the Kakamega Forest in western Kenya has shrunk to now less than a tenth of its former size.

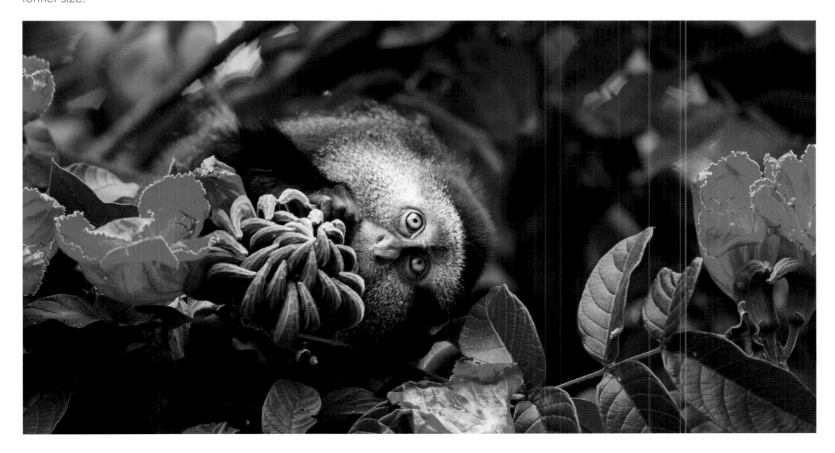

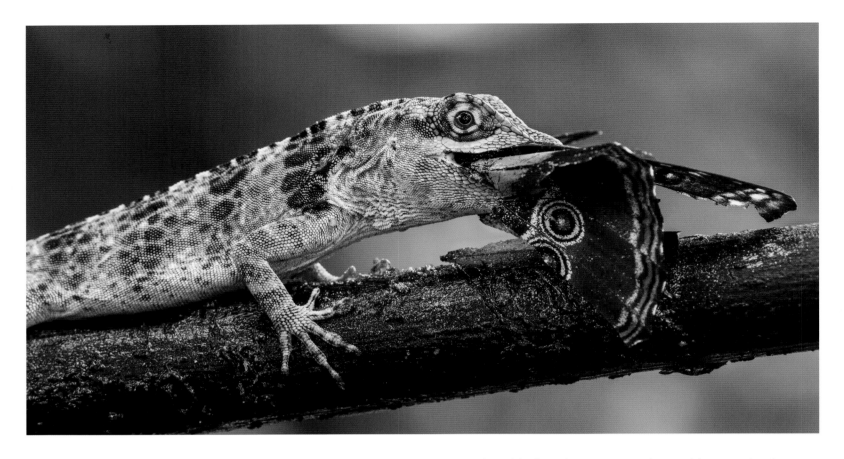

A Fraser's anole (*Anolis fraseri*) consuming a morpho butterfly. Anoles are a genus (*Anolis*) of reptiles common in the Caribbean and in the tropics of the Americas; they are related to iguanas. Valle del Cauca, southwestern Colombia.

An ocelot (*Leopardus pardalis*) during an inspection of its territory in northern Ecuador. Ocelots are solitary, nocturnal animals that stake out claims of several square kilometers of rainforest. Mashpi-Amagusa Rainforest Reserve, Ecuador.

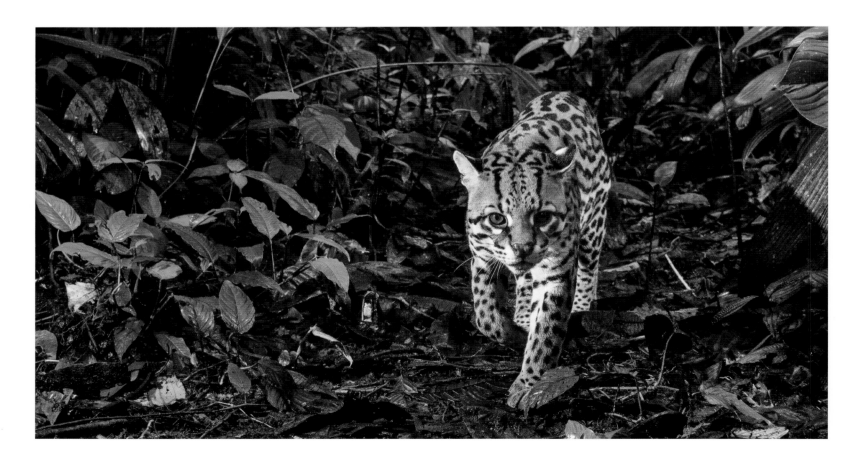

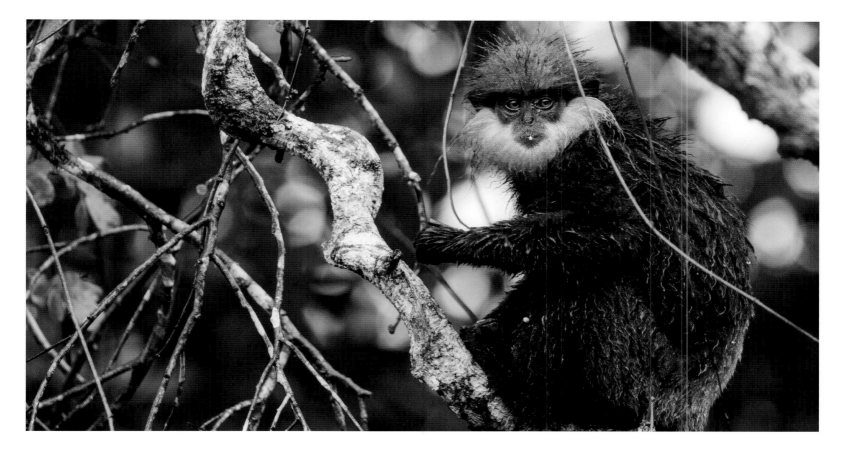

Wet monkey. The purple-face langur (*Trachypithecus vetulus*) lives exclusively in the tropical forests of Sri Lanka. This one here has descended upon a liana to eat after a rain shower. Sinharaja Forest Reserve in southern Sri Lanka.

The plate-billed mountain toucan (*Andigena laminirostris*) is a grandly colored bird that can grow up to 50 cm (20 in.) long. It lives in the cool montane rainforests of Ecuador and feeds mainly on fruits, especially from palms (as in this image) or cecropias (*Cecropia spp.*).

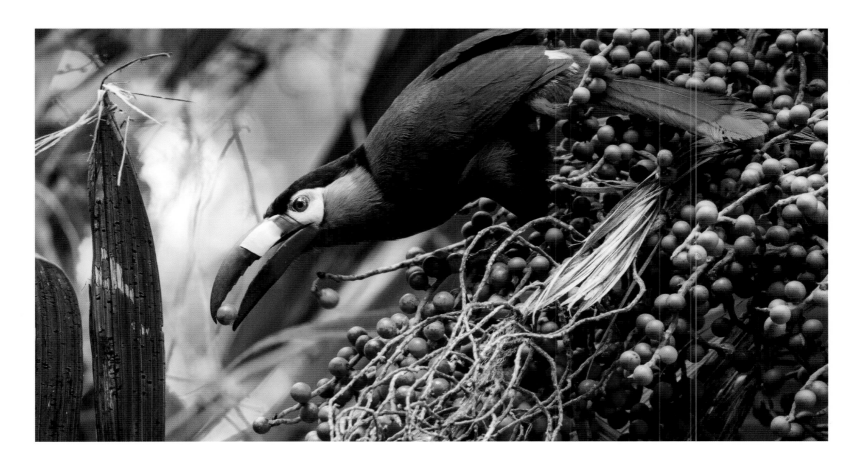

The Reign of the Small

By far the greatest diversity is found among the invertebrates, which also account for the greatest share of the biomass in tropical rainforests. There are ants, bees, wasps, worms, spiders, crickets, true bugs, isopods, grasshoppers, butterflies, snails and slugs, and homopterans (*cicadas*) as well as centipedes and millipedes among the invertebrates—not to mention the particularly species-rich group of the beetles. Mostly, the invertebrates live well-hidden in practically every nook of the forest—in the soil, leaf litter, deadwood and dead leaves, where they feed on leaves, fruits, wood, nectar, mushrooms, and other animals, or exist as parasites.

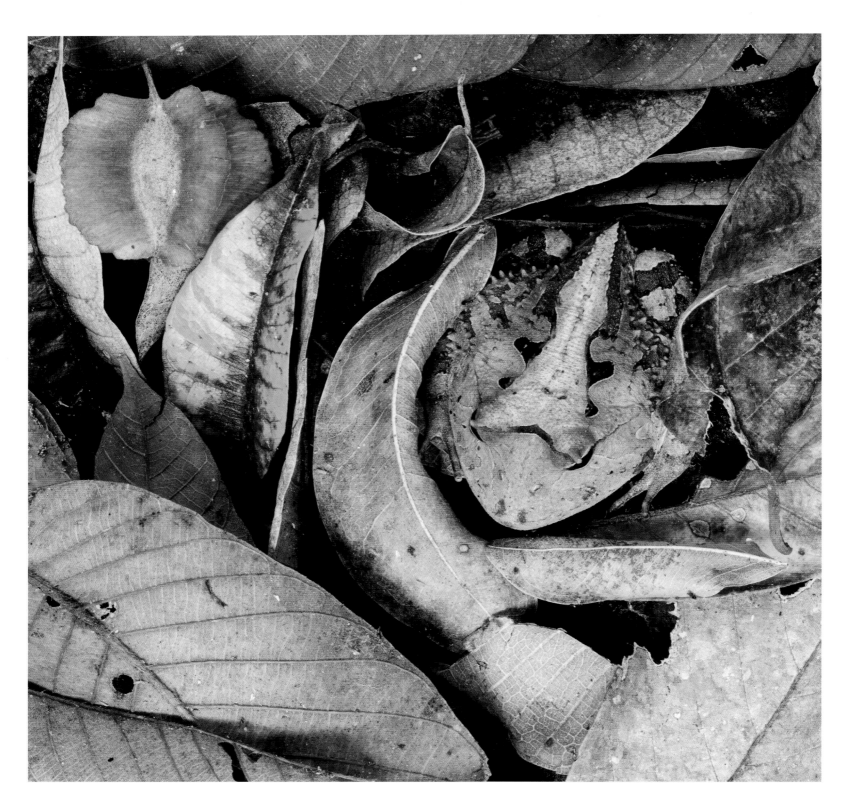

Lying in ambush. An Amazonian horned frog (*Ceratophrys cornuta*) waits, well camouflaged in the leaf litter on the ground, for passing prey. Lowland rainforest in the Manú biosphere reserve, Peru.

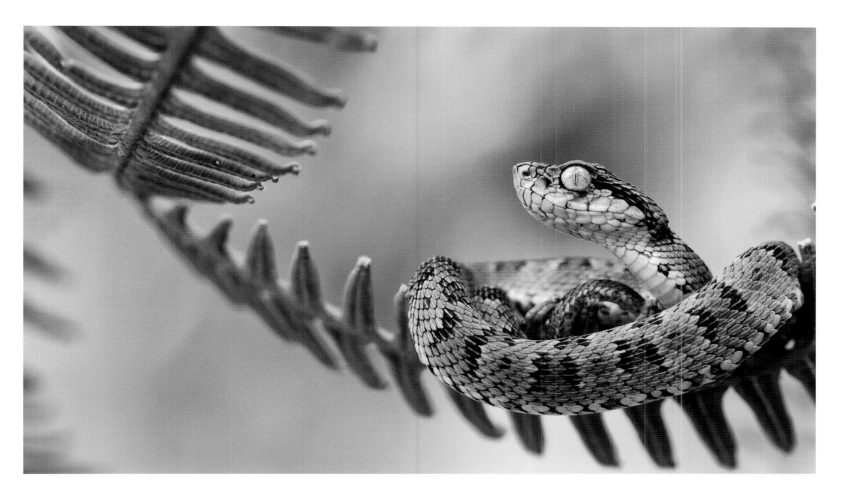

Snake on a swing. An Andean forest pit viper (*Bothriopsis pulchra*) has found a comfortable spot on a blade of fern. Sumaco Napo-Galeras National Park, Ecuador.

Marvelous spatuletail (*Loddigesia mirabilis*). The little hummingbird with the long tail-feathers only lives in a few montane rainforests in the north of Peru. Due to its limited range and dwindling habitat, it is acutely threatened with extinction.

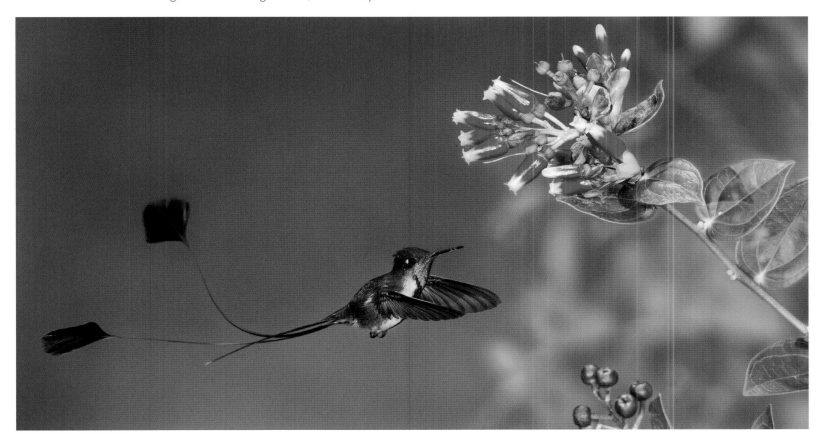

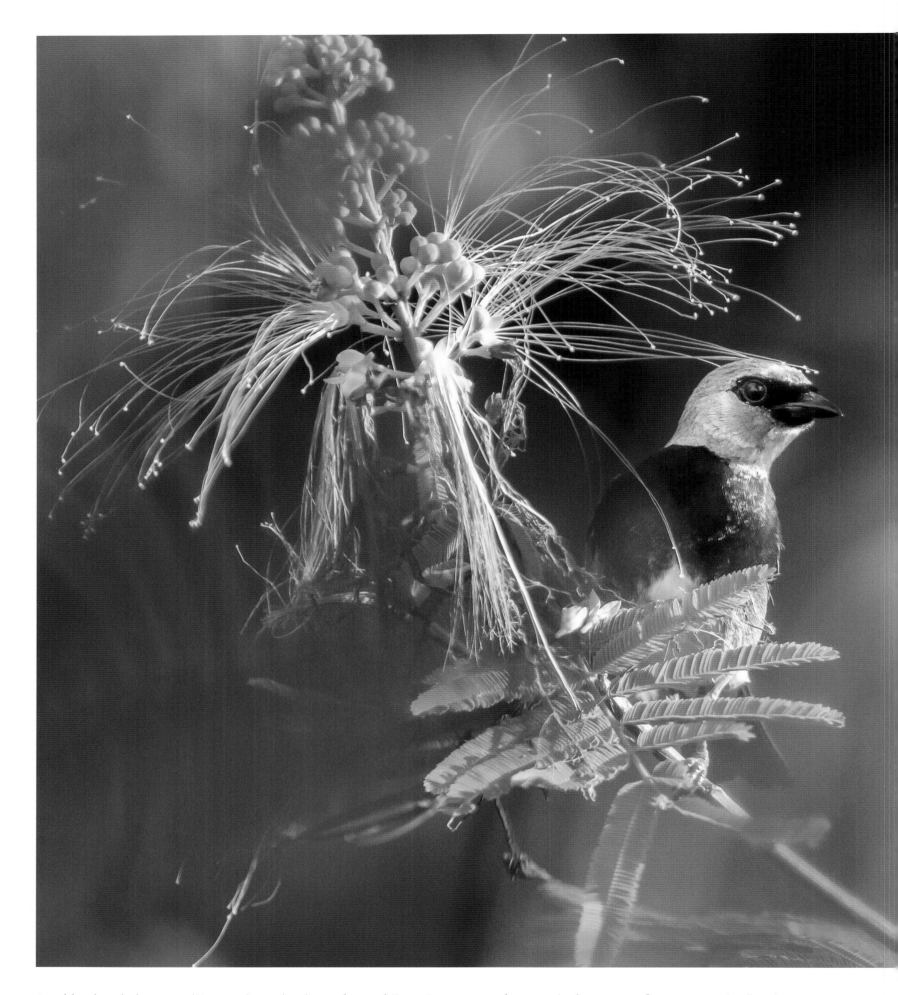

A **golden-hooded tanager** (*Tangara larvata*) in the rainforest of Costa Rica moves in for a snack of nectar at a flower on a red calliandra (*Calliandra calothyrsus*). The long, red filaments are the stamens on the blossoms of this mimosa; the nectar glands (nectaries) are located at the bottom of the filaments. Otherwise, these tanagers feed mainly on fruits and insects. Tanagers (*Thraupidae*) are one of the most magnificently colored and most species-rich bird families; they occur exclusively in the Americas, and there, foremost in tropical forests.

Ants: Marauding Hordes and Master Gardeners

Ants play a particularly important role in rainforest ecology. Of the fifteen thousand known ant species, many live in symbiosis with aphids, scale insects, leafhoppers, treehoppers, or caterpillars, feeding on these species' sugary secretions. In return, the ants—who know how to defend themselves—offer the other species protection from enemies. Similarly, some plants attract ants with extrafloral nectaries, or provide them with specially developed hollows in thorns, leaves, or stems, where they can stay in return for protection against browsers. There are even ants (*Myrmelachista schumanni*: lemon ants) that create gardens of their preferred nest tree (*Duroia hirsuta*: the lemon ant tree). They do this by injecting formic acid into leaves on the shoots of other trees near their nests, such that areas arise, in the middle of the otherwise species-rich Amazon rainforest, where practically no other trees grow.[24] Leafcutter ants (*Atta* and *Acromyrmex*), on the other hand, harvest large quantities of

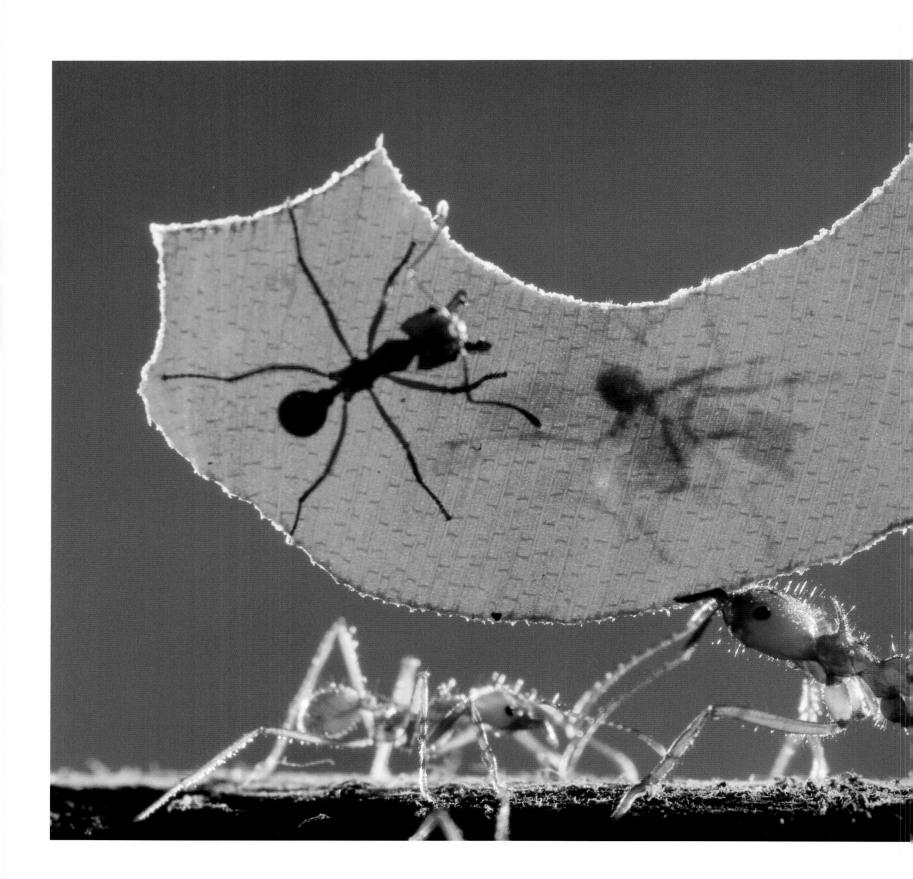

leaves and flowers, which they transport to their underground fungus gardens; their major food source is a white, fungal mat that grows upon cut-up vegetable matter. By this fungus-mediated pathway, the ants can consume a vegetarian diet despite all kinds of chemicals the plants defend themselves with. Army ants, on the other hand, are nomads with carnivorous lifestyles. In Africa (*Aenictus* and *Dorylus*) and Latin America (*Eciton*), they traverse the forest floor in giant hordes of up to several million individuals and, with their powerful biting apparatus, prey on any animal that does not flee fast enough. They are often shadowed by birds that snatch startled insects. But even ants have enemies: for example, the Asian crab spider (*Amyciaea forticeps*), which mimes, both in behavior and appearance, a writhing, injured weaver ant, thereby luring actual ants into its vicinity to pounce on.[25]

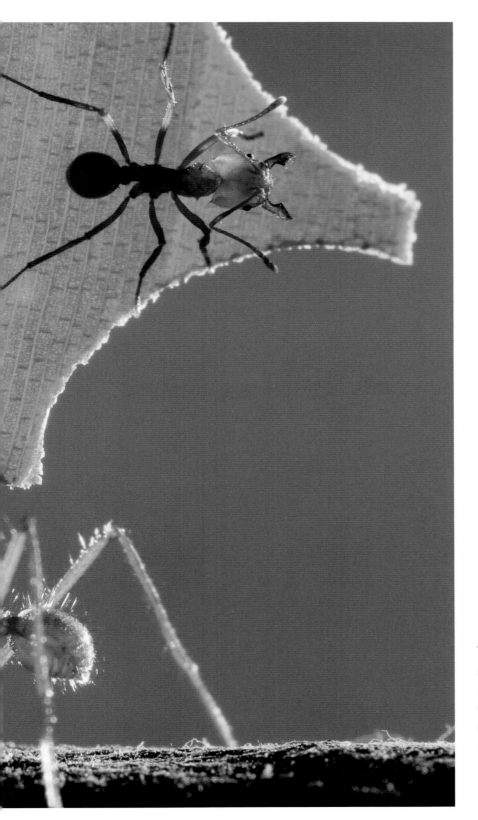

These leafcutter ants, of the genus *Atta*, call to mind the superhuman strength of a Superman or a Pippi Longstocking. With ease, leafcutter ants can hoist up several times their own body weight and defoliate whole trees in the shortest of whiles. Ants interact multifariously with other rainforest species, for example by harvesting leaves, dispersing seeds, protecting plants or animals from predators, or by themselves hunting other animals.

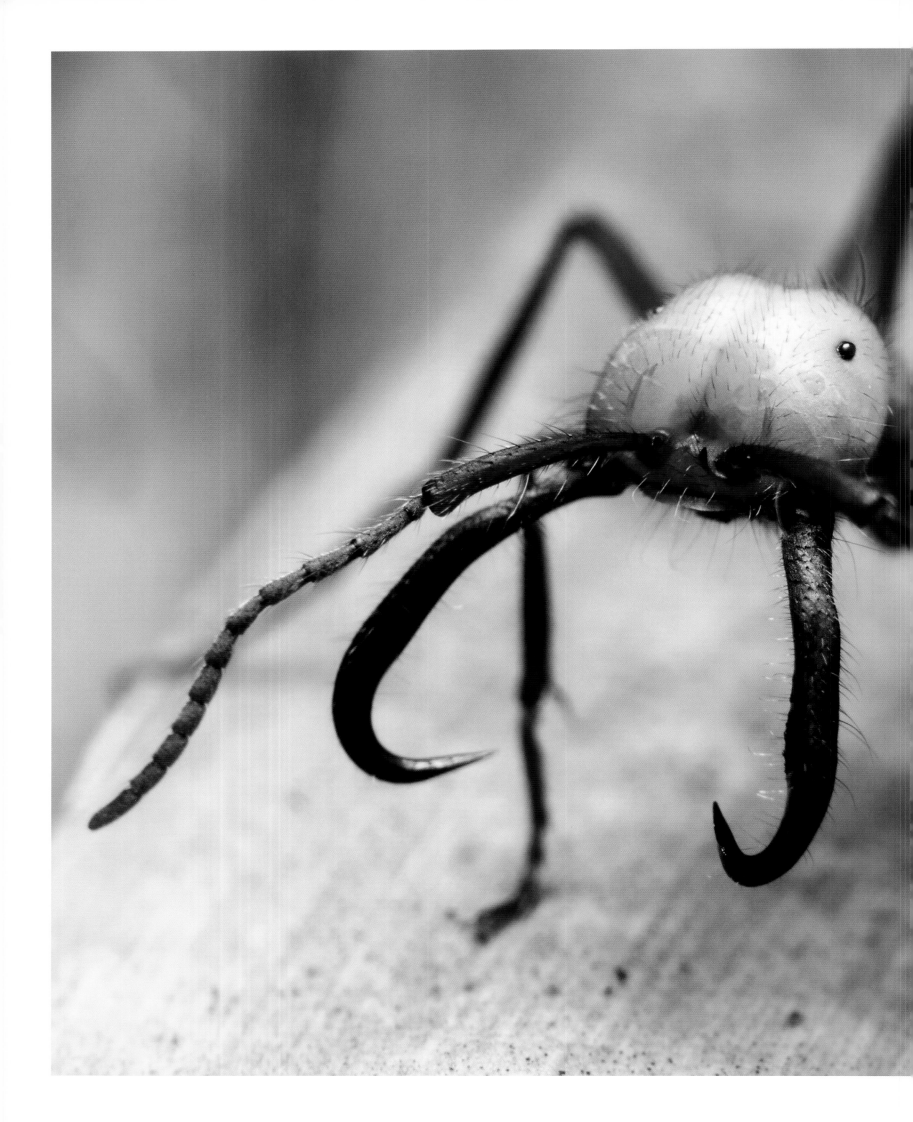

The great soldier ants of the nomadic South and Central American Eciton army ant (*Eciton burchellii*) have impressive mandibles. With these fearsome mouth parts, they ward away dangers from the worker ants of their colony while the workers scurry across the forest floor hunting for prey. Colonies of army ants and leafcutter ants can number into the millions of individuals; but there are also ants that live together in colonies as small as 150 individuals. All ant species are social, and the majority of them are found in tropical rainforests. Researchers have identified ninety-five different ant species on a single goupie tree (*Goupia glabra*) in central Amazonia. Weaver ants (*Oecophylla sp.*) are widespread in tropical Africa, Asia, and Australia; they live together in sometimes large colonies and make their complex nests out of leaves held together with threads of silk.

Rainforest and Humans

Humans have long inhabited the rainforest, a place of fascinating diversity and home to numerous herbal sources of food and medicine; demonstrable human habitation of the Amazon rainforest goes back at least eleven thousand years. Whereas shifting cultivation of small parcels by the nomadic indigenous peoples for millennia left hardly a scar, large-scale deforestation far exceeds the regenerative capacity of the rainforest. In contrast to the boreal forest, where major disturbances caused by storms, fire or insects are the rule, only very small clearings in tropical rainforests are created naturally, for example by landslides, falling trees, lightning strikes, leafcutter ants, bodies of water, or elephants and other animals. Such smaller gaps quickly close again. On the other hand, tropical cyclones cause larger devastation; so do humans. The resulting changes to soil and microclimate are so pronounced that the trees' seeds either no longer germinate at all, or else the seedlings rapidly desiccate. The result is the death of the forest.

The Forests of Diversity Are Disappearing

Tropical rainforests are not only a refuge of biodiversity but also store enormous quantities of carbon[26] and have a direct influence on local as well as global weather patterns. So far, mining, forestry, agriculture, urban expansion, and construction of dams and roads have reduced the rainforest-covered area down to half its original extent.[27] Since the turn of the millennium, about thirty thousand square kilometers (11,600 sq. mi.) of primary tropical forest has been lost annually, an area corresponding to the size of Belgium—and the trend in recent years, no less, is rising.[28] Some rainforest areas with high rates of endemic species have already been largely destroyed, for example the Atlantic Forest (or Mata Atlântica) along the east coast of Brazil as well as the rainforests of Madagascar, Sri Lanka, Ghana, Bangladesh, or the Philippines.[29] And, presumably, despite all efforts to protect them, even more forests in the tropics are bound to disappear or to become heavily fragmented or degraded into secondary forests with fewer species.

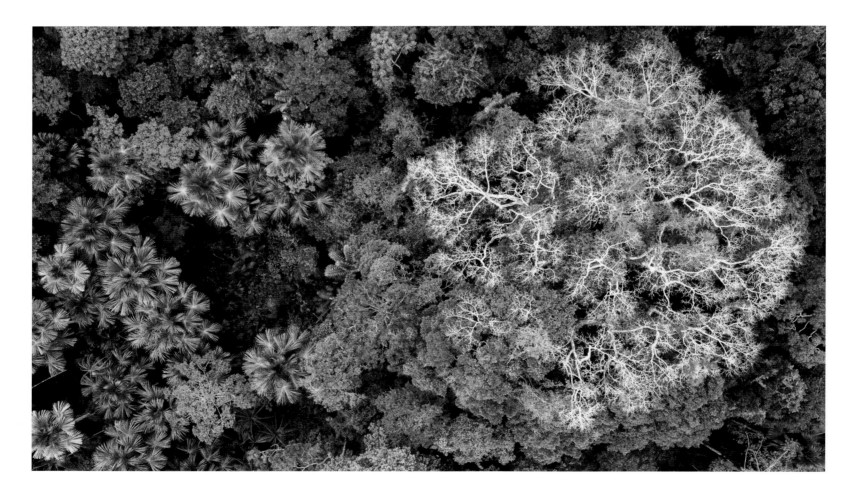

On this aerial image from Yasuní National Park in Ecuador, one can make out a cecropia (*Cecropia sp.*, top center), various palms, and the bare branches of a large kapok (*Ceiba pentandra*). Many of the giant trees that emerge above the rainforest canopy shed their foliage during the dry season. The diversity of tree species in tropical rainforests is very high, while the number of individual specimens of a given species in a given area is rather small.

To this, add the effects of climate change. Portions of the rainforests in the western Congo River basin are gradually turning into dry forests as a result of increasing dry spells. Increasing droughts and fires will likewise continue to strain tropical rainforests in many regions of the world. But on the other hand, the presence of indigenous groups, governmental authorities, and environmentally concerned tourists have in many places proven an effective deterrent against poachers, illegal loggers, and gold prospectors.[30] This, together with legal protections, sustainable use and environmental restoration, means there is a chance of preserving the treasures of tropical rainforests for future generations.

[1] https://www.umweltbundesamt.de/daten/
klima/trends-der-niederschlagshoehe
[2] Waide 2008
[3] Martin 2015
[4] https://www.nationalgeographic.com/
environment/2019/04/worlds-tallest-
tropical-tree-discovered-climbed-borneo/
[5] Pöhlker 2012
[6] Gazhoul 2010
[7] Höing, 2017
[8] Wittig 2012
[9] CIFOR Annual Report 2018
[10] Worthington 2018
[11] https://e360.yale.edu/features/
on-javas-coast-a-natural-approach-to-
holding-back-the-waters
[12] http://www.eli-africa.org/projects/
the-mangrove-project/
[13] http://cardnolatinamerica.com/en/
news/470-mangrove-reforestation-project
[14] https://www.fastcompany.com/
90236715/apple-is-investing-
in-a-huge-mangrove-forest-in-colombia

[15] Waide 2008
[16] Waide 2008
[17] https://www.audubonlifestyles.org/
tropical-rainforest-biome.html
[18] Waide 2008
[19] Leuschner 2014
[20] These numbers include both the various tropical
rainforest types as well as the dry forests.
[21] Slik 2015
[22] ter Steege 2013
[23] Butler 2019
[24] Frederickson 2005
[25] Ghazoul 2010
[26] Berenguer 2014
[27] Brancalion 2019
[28] https://blog.globalforestwatch.org/data-and-
research/world-lost-belgium-sized-area-of-
primary-rainforests-last-year
[29] Wilson 2002
[30] Martin 2015

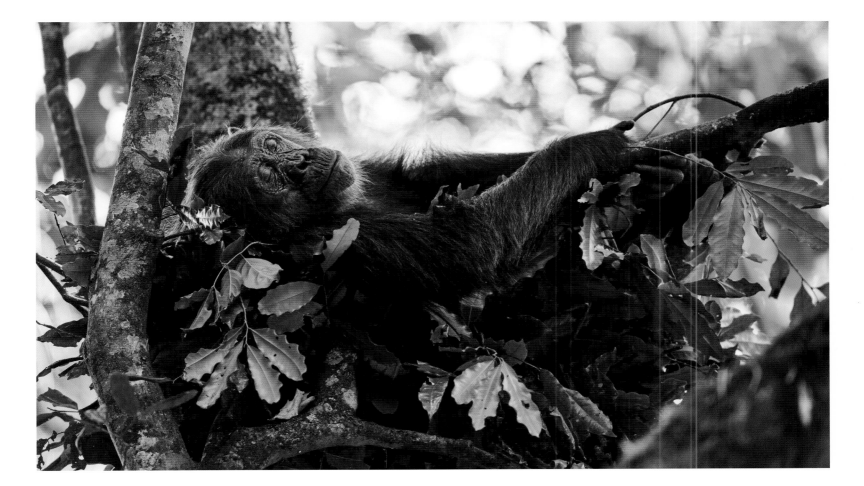

Chimpanzees build themselves nests in the crowns of trees where they can safely spend the night. This female eastern chimpanzee (*Pan troglodytes schweinfurthii*) is resting in her nest in Kibale National Park in Uganda. Scientists are finding more and more evidence that different chimpanzee populations have also developed different cultures, for example in their hunting techniques, or in the way they use tools.

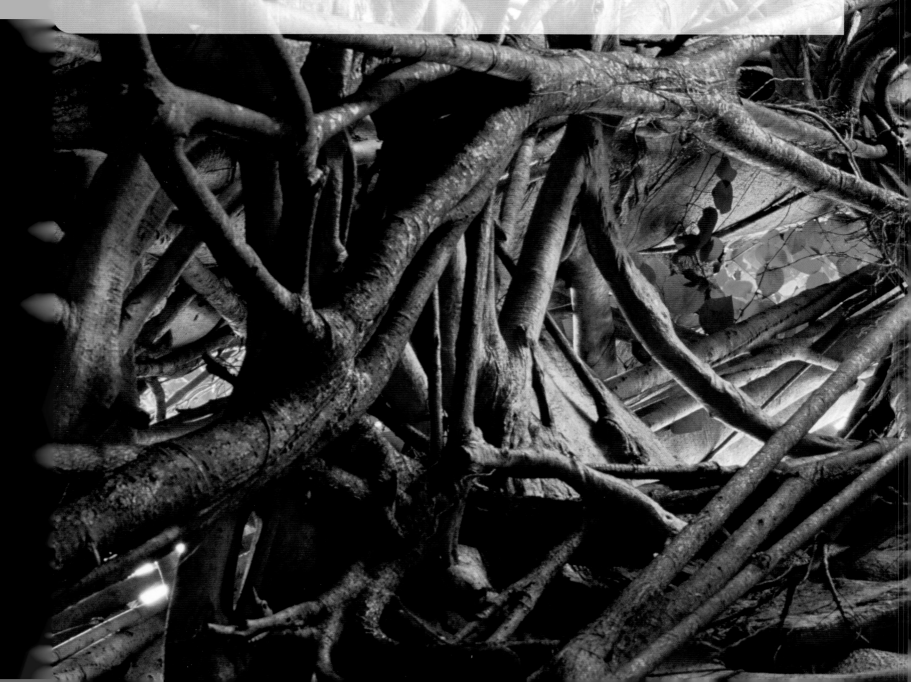

The Tree that Grows from Top to Bottom

Strangler figs (*Ficus spp.*), are widespread in the tropics worldwide and have developed a strategy all their own in the race for sunlight. Their sweet, plentiful fruits are highly favored by monkeys, birds and other animals. With the dung and droppings of these animals, the seeds are deposited in hollows and in the forks of branches high up in the trees, where they germinate. There, the young fig tree grows big leaves and sends long roots down the stem or free-floats them ground-ward. Once these roots reach the bottom, prop roots begin to form. As the years go by, the fig overgrows its hosttree like a net until the host is outranked and, ultimately, dies. Then the fig, now a magnificent giant tree in its own right, will have assumed its position in the canopy.

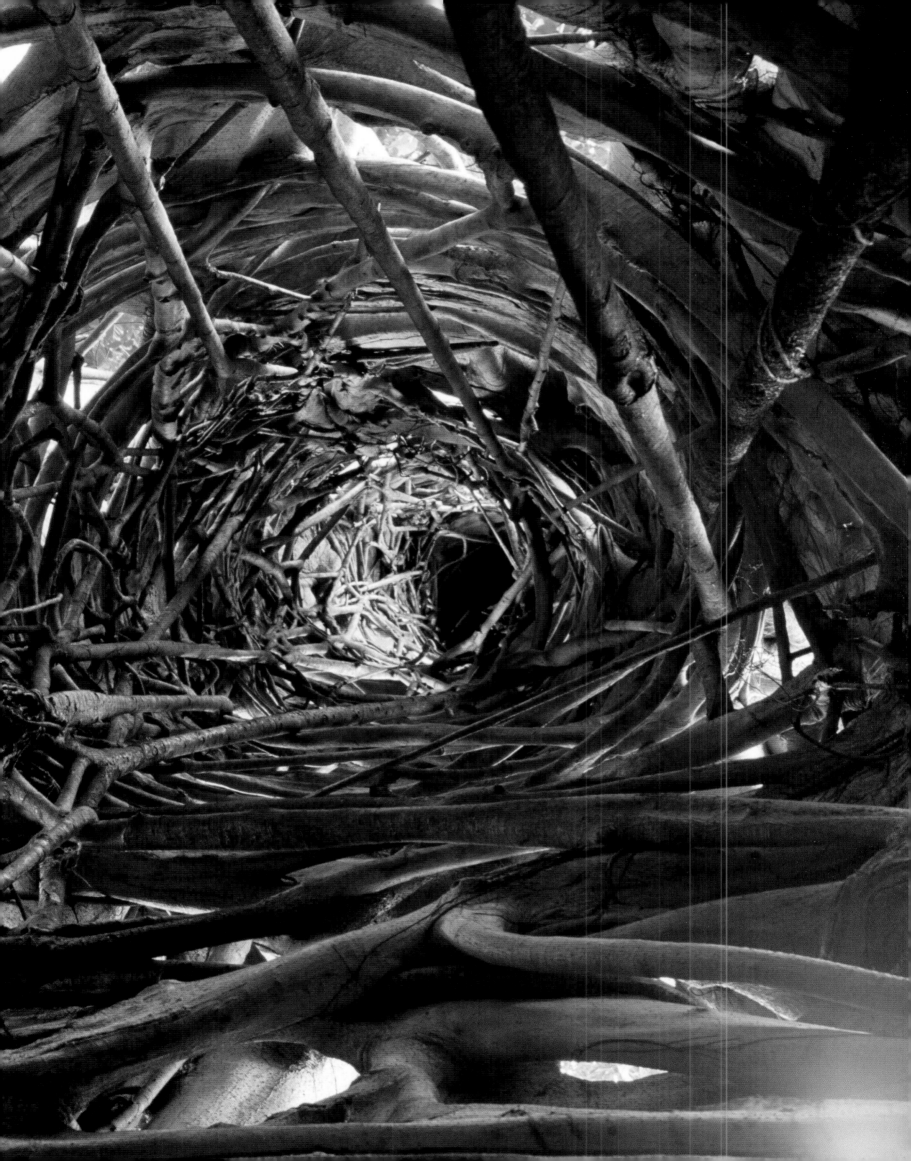

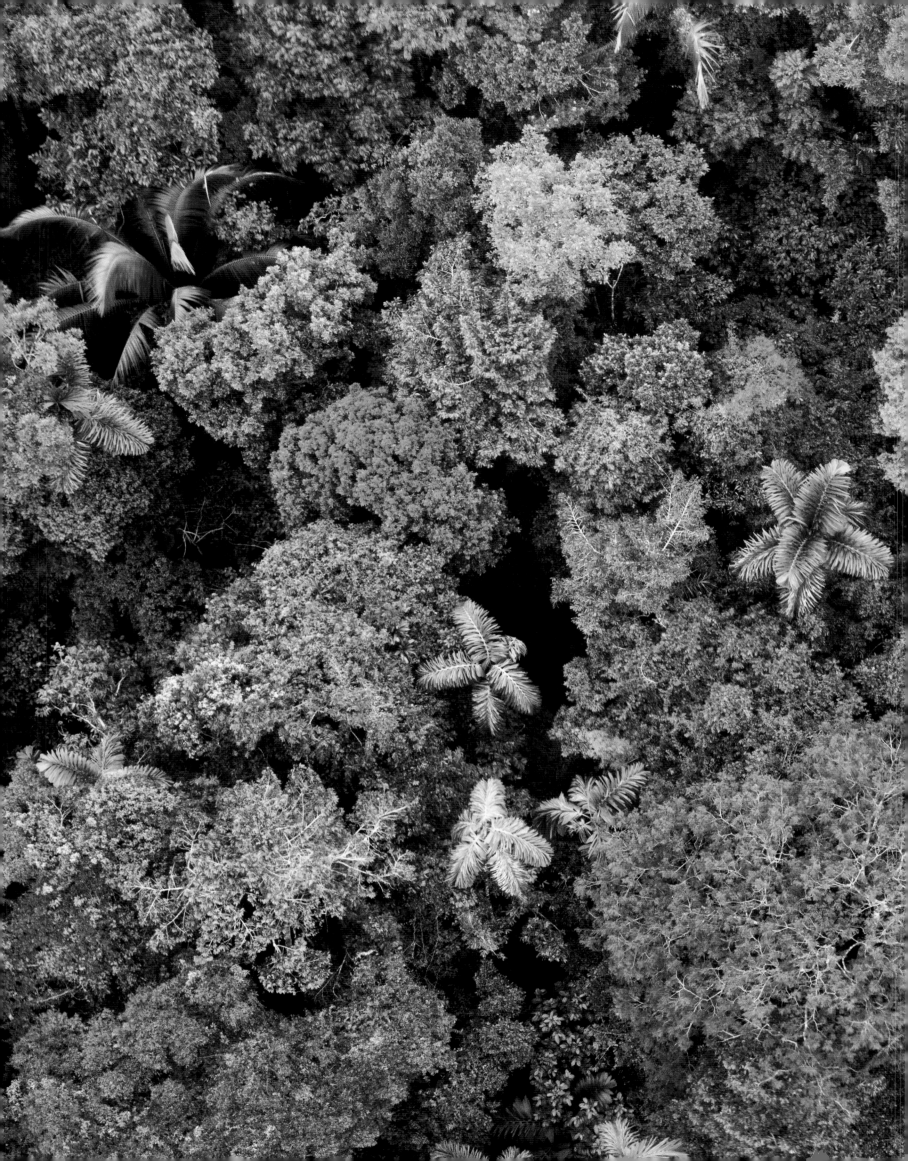

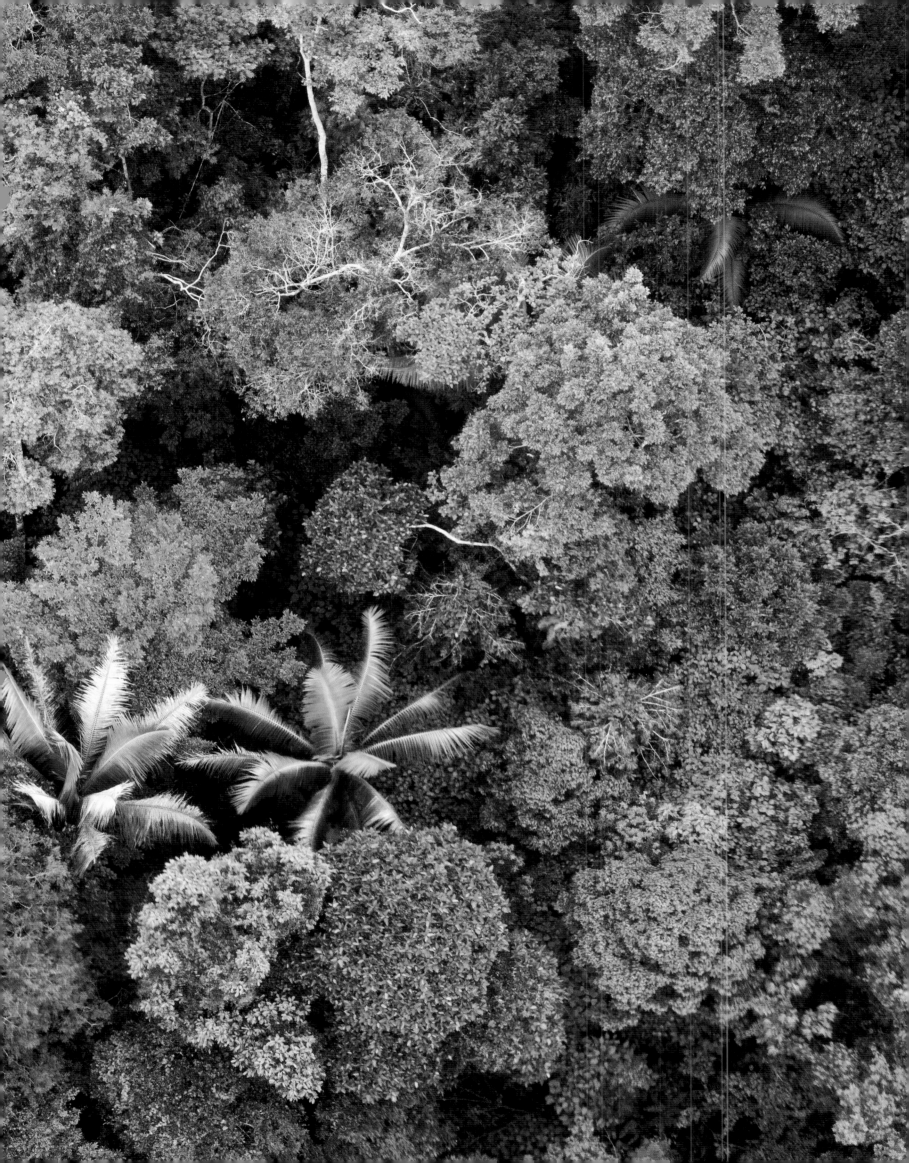

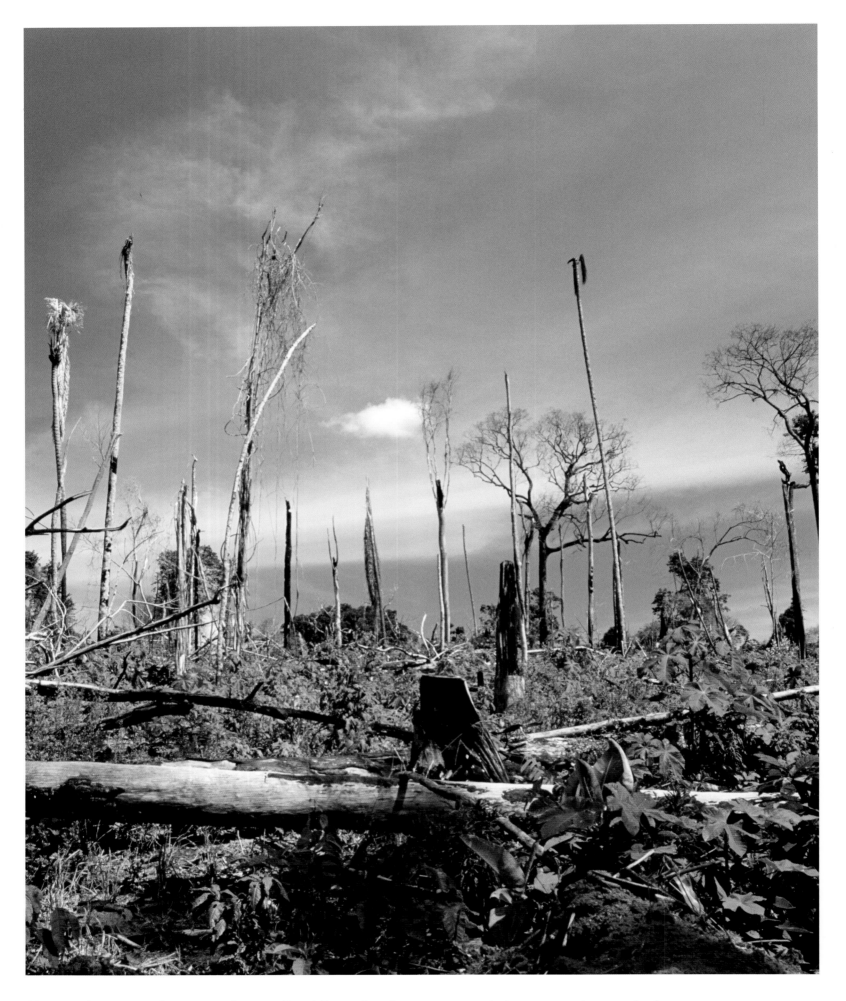

Clear-cut Amazon rainforest in northeastern Brazil. Tropical rainforests are particularly sensitive to large-scale clear-cutting.

Changing Forests

If one destroys the forests, as the European settlers everywhere in America do with careless haste, the springs dry up or at least markedly abate.

Alexander von Humboldt (1769–1859)

Lasting Damage From Civilization

With the spread of agriculture five to ten thousand years ago, more and more forests were transformed into fields, meadows, pastures, and settlements. The earth's forests provided material for shipbuilding and construction, firewood for heating and cooking, and charcoal for smelting metal and firing ceramics. The high demand for wood, even in antiquity, had led to extensive clear-cutting in some regions—for example, around the Mediterranean, where primeval oak forests were replaced by extensive shrub landscapes (macchias). In inaccessible tropical and boreal regions, the harm to forests was still quite circumscribed for a long time; but there as well, advances in tools and machinery permitted people to penetrate ever farther into the woods. For the last three hundred years, the pace of exploitation by industrial agriculture and forestry has only increased; and more recently, global warming, extreme weather, and forest fires have been affecting forests with increasing severity. So far, the result has been a loss of about half of the world's forests; between the years 2000 and 2012 alone, the world lost nearly 2.3 million square kilometers of forest.[1] While it is true that around 800,000 square kilometers of forest grew back over the same period, new growth and plantations only partially balance out the loss of species-rich, old-growth forests. In any case, forest monitoring data do show that the pace of deforestation has slowed noticeably over the last two decades, and that the percentage of forests under sustainable management, especially in the temperate and boreal zones, is on the rise.[2]

Forests Stabilize the Climate

Forests have an enormous influence on heat distribution, in cloud formation, and in the global carbon and hydrologic cycles,[3] and are therefore second only to the oceans as the most important component of the global climate system. Forests engage in a constant exchange with the atmosphere, from which they take up the carbon dioxide to construct stems, branches, roots and leaves. Accounting for the forest floor and soil, forests contain more carbon than the entire atmosphere.[4] Tropical forests store half (55 percent), boreal forests one-third (32 percent), and temperate-latitude forests roughly one-tenth (14 percent) of all the carbon tied up in forests.[5] Forests cool their surroundings as they produce water vapor through photosynthesis; and this, together with the shade they give, make the canopy work like a natural air conditioning system. Yet forests are no panacea for the climate crisis; for not even they are capable of absorbing all anthropogenic greenhouse gas emissions. Sometimes, forests even have a disadvantageous effect on the climate system—for example, where dark, forested areas result in greater absorption of solar energy,[6] or when forest fires release large quantities of carbon dioxide in a single pulse.[7]

The Climate Shapes the Forest

Climate change is causing shifts in the composition and distribution of forests. Forest types adapted to cooler, more humid conditions "migrate" uphill or toward the poles. Where there is no room to migrate, species that cannot adapt quickly enough to the changes, or that are not mobile enough to seek out new habitats, die out. Especially in tropical forests, many plants and animals have very specific, geographically limited adaptations to the microclimate of their traditional habitats. If temperatures and precipitation patterns change beyond a certain threshold, there is hardly an alternative; and the same is true of forests on mountains or islands.

Forests are also being affected by a worldwide surge in extreme weather, like droughts or torrential rainfall, as a result of climate change. Researchers in Costa Rica have reported that seasonal precipitation in the Guanacaste dry forest has become increasingly irregular in recent decades.[8] The monsoon rains of Asia have also declined over the past eighty years—due to air pollution as well as climate change—leading to more frequent, more severe regional droughts and dry spells.[9] The clearing of woodlands exacerbates the situation because it eliminates the ability of the forest to even out the extremes. The less forest remains in a given area, the slower and more arduous it becomes to repair this woodland air-conditioning system. Soils become saline or erode away; groundwater recedes; and the local climate changes, such that the conditions become less and less favorable for new forests. This applies especially to tropical rainforests, where tree seeds need the shade of the lower forest layers to germinate and where, without the protection of the forest, the thin humus layer quickly washes away. By contrast, forests in the temperate latitudes have nutrient-rich soil even in lower soil horizons, and so—through natural succession from the first pioneer tree to closed, mixed forest—reforestation can usually proceed relatively quickly, at least given an adequate water supply.

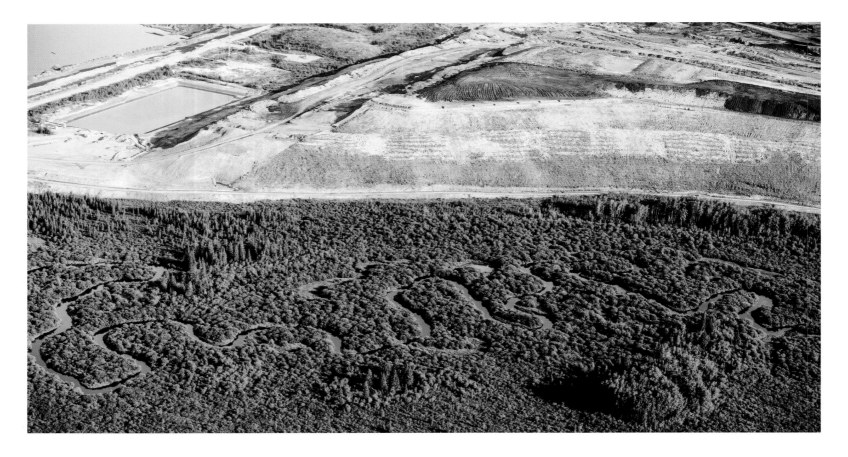

Forests endow us long-term with various ecological services: They retain precipitation and turn it into potable water; they protect us from soil erosion, high winds, floods, landslides and avalanches; they provide us with wood, foodstuffs and medicines; they cool us during the summer, and their wood warms us during the winter; they shelter untold living things; and we find in them tranquility and recreation. To put it succinctly: They are an indispensable font of essential resources in many regions, and are the foundation of our economy. Yet we nevertheless often deal with them ruthlessly and sacrifice centuries-old forests for short-term gains. This image shows an area to the north of Fort McMurray, Canada, where tar sands are being mined for oil extraction and the boreal forest must yield to mining zones and tailing heaps.

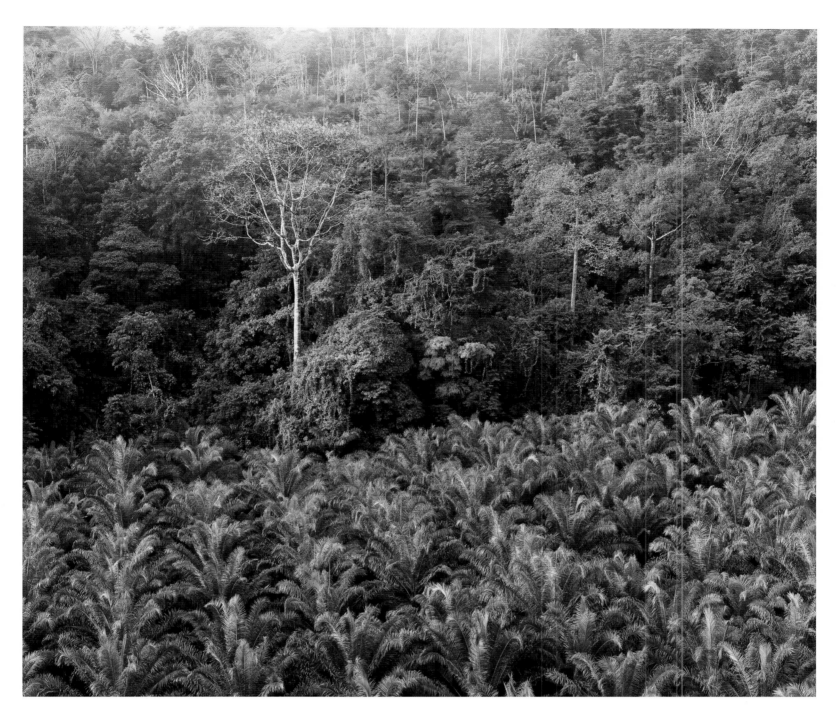

Oil palm plantation, at the edge of the rainforest, Osa Peninsula, Costa Rica. Diverse old-growth forests with complex ecological webs are being replaced all over the world by agricultural land, monoculture timber plantations or by impoverished forest replantings.

The Forest Is Drying Out

Brazil has lost 800,000 of the four million square kilometers of Amazon rainforest it possessed in the 1970s[10]—an area the size of Turkey. Over the same time period, average temperatures in the Amazon Basin rose by 0.6 °C. In the southern and southeastern Amazon region, there have been several unusual droughts in the last two decades, and the length of the dry season is at least sixteen days longer than it was in 1979.[11] Scientists fear that the progressive transformation of rainforest into cattle pastures and soybean fields could soon reach a point at which the ecosystem will be irreparably damaged[12]—especially since the forest itself plays a considerable part in generating its own rain. If no rain falls, the changed environmental conditions mean that even non-deforested areas will eventually turn into dry forests and steppes. With that, not only would thousands of rainforest plant and animal species die out, but it would also release many billions of tons of carbon into the atmosphere. Deforestation and climate change thus interact to dreadful effect, because they disrupt the local water balance, leading to an increase in both surface and atmospheric temperature.

The Forest in Flames

At the edge of the Arctic tundra, rising temperatures are allowing boreal forests to expand northwards; but increasing drought and higher temperatures also mean more wildfires and more insect outbreaks. As a result, huge areas of boreal forest in Canada, Alaska and Siberia are burning more and more frequently, releasing tons of carbon dioxide and sending massive wind-blown smoke plumes far out across the Arctic ice. The ice, blackened by the soot, reflects less solar energy and melts more quickly as a result. The ground beneath up to 80 percent of boreal forests is frozen. Where this permafrost soil thaws out, the trees lose their footing, and the forests convert to swamps.[13]

Intense forest fires occur not only in the far north, but so too, with increasing frequency, in every other climate zone—even in moist tropics like Amazonia or Indonesia. Scientists are in agreement that major forest fires, while a part of the natural ecosystem, are becoming both more intense and more frequent in boreal as well as Mediterranean forests due to human activity.

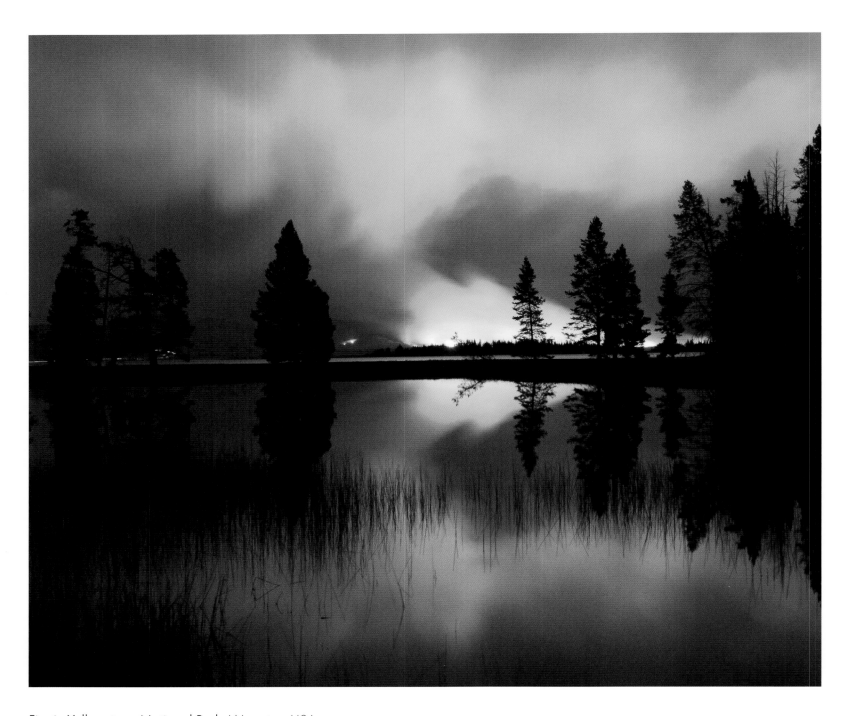

Fire in Yellowstone National Park, Wyoming, USA.

The Will to Change

As it stands, forests are under enormous pressure; but globally, awareness of the problems, and the will to change, have probably never run so high. In order to preserve forests—as one of our most important natural resources, for the benefit of all, including for future generations—we must promote reforestation, better protect remaining woodlands, and develop sustainable uses for forest resources.

Many important animal species for the forest ecosystem—the predators, and the birds and mammals that disperse seeds—need large, unbroken tracts of forest. If the forest falls below a certain minimum size, these animals cannot survive; the forest becomes impoverished in a way that robs it of its capacity to provide many important services, even to humans. Large protected areas, with undisturbed cores and wildlife corridors connecting remaining stands of forest, are therefore important building blocks toward protecting forests. But conservation areas alone will not suffice, because usually only a small percentage of a given forest will in fact be strictly protected. This is where sustainable use comes into play. Sustainable use provides a middle road between destruction and strict conservation, and there are many promising approaches on how to do it.

Beech seedlings, on the forest floor, Abruzzo, Italy.

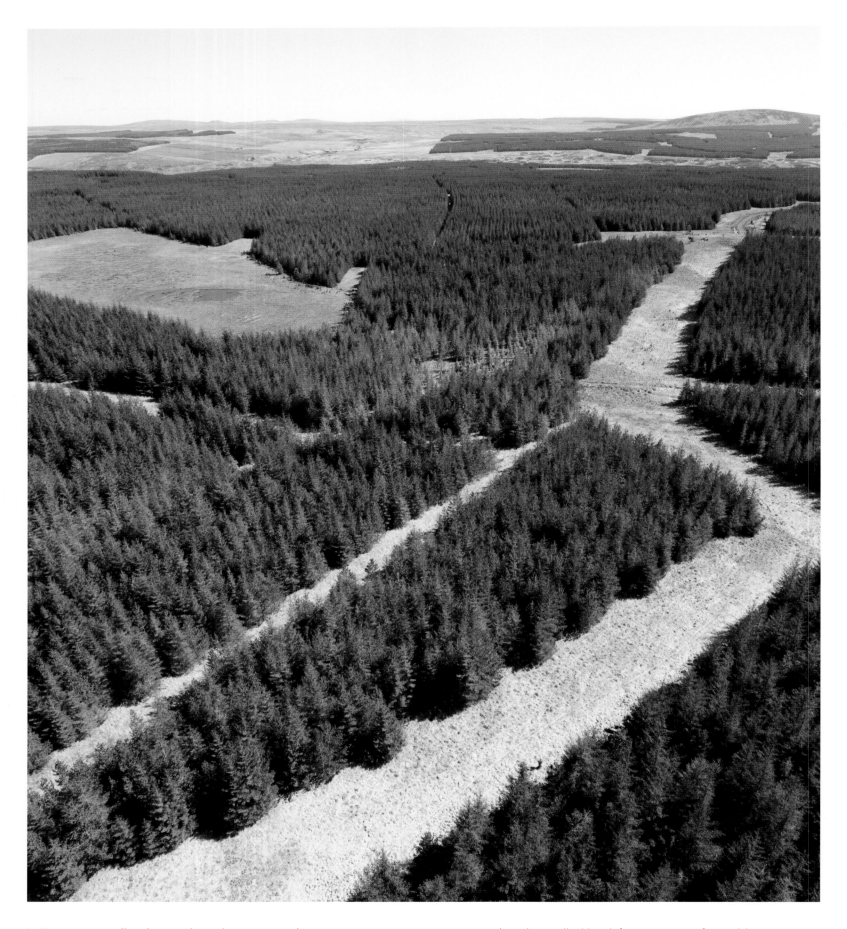

In Europe, woodland areas have been expanding again in recent years as agriculture has pulled back from certain unfavorable areas. But timberland tree cultivations, such as this spruce plantation in a moorland area in Scotland, are reckoned as part of this increase. On the other hand, old-growth forests are still being cut even in Europe, among them virgin beech forests in the Carpathians and needle-leaved boreal forests across Fennoscandia. Moreover, the plus in wooded area comes, at least in part, at the cost of deforestation in other parts of the world, because Europe imports large quantities of wood and animal fodder.

Low-Intensity Economic Uses

Because valuable tropical timber trees in a rainforest often grow with large gaps between one tree and the next, responsible timber companies fell only large, individual trees. The density of such species in the Amazon and Congo River basins is usually one or two—but in Southeast Asia up to ten—trees per hectare.[14] If the logging trails are sealed off once the timber has been harvested, they quickly become overgrown with vegetation again, which also prevents the forest from being plundered by poachers and the network of roads from expanding.[15] Such carefully managed rainforests still retain two-thirds of the carbon originally bound up in them, and the forest's water balance remains largely undisturbed.[16]

Sustainable agricultural and logging systems are informed by the multi-tiered ecological structure of forests. Examples are silvopasture, in which livestock find their fodder in the woods; or agroforestry systems, in which crops, such as coffee or cocoa, grow beneath shade trees. A similar approach is "rainforestation farming" in the Philippines, which is the planting of deforested areas with all kinds of tropical crops—like coconut trees, bananas, ginger, cardamom, and ornamentals—alongside valuable tropical timber species. Such tree-farms supply the local population with food crops, stabilize the soil, and at the same time offer a long-term economic perspective. In the tropics in particular, where most crops are now grown in monocultures, such diverse plantations have a great deal of potential.[17]

Since trees and other forest plants absorb carbon dioxide from the atmosphere as they grow and store it in their tissues, many scientists believe that resuscitating forests is one of the most effective ways of counteracting the increased concentration of carbon dioxide in the atmosphere. Researchers have calculated that around eighteen million square kilometers of degraded, grass-covered, or sparsely vegetated areas would lend themselves to reforestation[18]—an area almost twice the size of Europe. Researchers have identified by far the greatest potential for this in just six countries, namely: Brazil, China, Russia, Canada, Australia, and the United States.

Diverse Forests Are Stable Forests

The ecosystem services forests provide—upon which hundreds of millions of people rely day in and day out, especially in tropical regions—are directly related to the biological and structural diversity of the forests, and to their ecological complexity. Water storage, erosion control, resilience in extreme weather, the many edible and medicinal plants—all of it rises and falls with the biodiversity of the forest. It may well be that timber plantations provide some of these ecosystem services, such as ready timber, water retention, and erosion control; but plantations are no substitute for forests.

The good news, in light of the ongoing disappearance of species-rich, naturally structured forests, is that where populations of original forest species are still in place, forests can regenerate, and species-rich secondary forests can grow in. The bad news: Growth and regeneration take many decades to centuries, and locally extinct species usually do not recolonize the forest on their own. Natural forest regeneration can be accelerated but may involve significant effort in some circumstances; see the box, "So Many Trees Don't Make A Forest."

The next few years and decades will determine the future of many forests. Will they be further degraded, fragmented, or even completely destroyed? Or will we succeed in putting an end to over-exploitation, use forests sustainably, and perhaps even build them up again?

[1] Hansen 2013
[2] bpb/FAO 2017
[3] Ellison 2017
[4] Pan 2013
[5] Pan 2011
[6] Bonan 2018
[7] Haskell 2017
[8] https://www.gdfcf.org/dry-forest
[9] Liu 2019
[10] The Economist 2019
[11] Nobre 2016
[12] Sampaio 2007
[13] Carpino 2018
[14] Lewis 2015
[15] Kleinschroth 2019
[16] Lewis 2015
[17] Liu 2018
[18] Bastin 2019
[19] http://www.biovision.ch/projekte/aethiopien/
[20] www.pulitzercenter.org/reporting/tree-planting-programs-can-do-more-harm-good
[21] Hua 2018
[22] Cooper 2018

So Many Trees Don't Make A Forest

In August 2019, the African nation of Ethiopia made headlines when the government and the people set a goal for themselves of acting in common to plant four billion trees in the span of a few months. On a single day at the start of the campaign, over 350 million seedlings were planted nationwide. Ethiopia's forests, which covered 40 percent of the country as recently as a hundred years ago, had shrunk down to scraggly remnants through overuse; and so the need to take action was pressing.[19] However, reforestation requires a lot of endurance, because the shoots need to be tended and protected for years so that they actually grow into trees. And it requires a guarantee that the emerging forests not be cleared again already a few years later.

Sometimes, planting forests can do even more harm than good. Beginning in the mid-20th century, broad swaths of bogland in the boreal forest of Alberta, Canada, were drained in order to plant native black spruce. By the 1980s, the program had resulted in robust forests; but the native, wet peat mosses were replaced beneath the spruce trees by drier moss species that burn like tinder in years with low humidity. This led, for example in April 2016, to the devastating Fort McMurray wildfire, which incinerated over six thousand square kilometers of forest.[20] The risk of forest fire

is also higher in yellow pine plantations in the western United States, or in the pine and eucalyptus woodlands of Europe and South Africa; and climate change is raising the stakes. Beginning at the turn of the millennium, state-sponsored tree plantations were installed on arable as well as fallow fields in order to combat soil erosion across large parts of southwestern China. Indeed, the forested surface across the region rose by a third. Scientists, however, have criticized that the forests are more like plantations, because, in most cases, instead of native tree species, monocultures of bamboo, eucalyptus, or Japanese cedar (*Cryptomeria japonica*) were planted. In some instances, native forests were even replaced by these woodland plantations.[21] Thus, on occasion, it is better to rely on the regenerative power of locally adapted forests, as successful reforestation projects in the southern Sahel region of Africa have demonstrated. Farmer managed natural regeneration (FMNR) is an approach by which farmers in deforested areas can green up whole tracts of land in a few years simply by tending to and protecting the roots and tree stumps that are already in the soil.[22] And one thing is clear: No matter how it is accomplished, restoring forests is far more difficult than preserving existing ones.

About the Author

Gunther Willinger is a biologist, science journalist, and photographer. His core subject is the relationship between man and nature: from our yearning for wilderness to the development of agriculture and forestry. Forests fascinate him with their beauty and the unbelievable abundance of interconnected life forms. In addition to the forest landscapes of his European home, he knows the forests of Costa Rica, California, and South Africa from longer stays abroad. He lives with his wife and two sons in Tübingen, Germany.

www.guntherwillinger.de

Nature Picture Library is one of the world's finest sources of wildlife and nature photos and footage, representing more than 500 leading photographers with worldwide coverage. They support and promote truthful, ethical nature photography and regularly donate to a number of conservation charities in order to support their vital work. For more information, visit **www.naturepl.com**

BIBLIOGRAPHY

The Fascination of the Forest

Bijl, P. K., et al. (2010). Transient Middle Eocene Atmospheric CO2 and Temperature Variations. Science, 330(6005), 819–821. doi:10.1126/science.1193654

Chazdon, R. L., et al. (2016). When is a forest a forest? Forest concepts and definitions in the era of forest and landscape restoration. Ambio, 45(5), 538–550. doi:10.1007/s13280-016-0772-y

Eichler, H. (1999). Gesichter der Erde – Weltvademecum, Touristbuch Hannover

Fahey, T.J. (2013). Forest Ecology. Encyclopedia of Biodiversity, 528–536. doi:10.1016/b978-0-12-384719-5.00058-

Food Agric. Organ. (FAO) (2010). Global forest resources assessment 2010. For. pap. 163, FAO, Rome

Food Agric. Organ. (FAO) (2016). FRA 2015 Process Document, Forest Resources Assessment Working Paper 186, http://www.fao.org/forest-resources-assessment/documents/en/

Grebner, D. L. et al. (2013). Forest Regions of the World. Introduction to Forestry and Natural Resources, 21–76. doi:10.1016/b978-0-12-386901-2.00002

Hansen, M.C. (2010). Quantification of global gross forest cover loss, Proc Natl Acad Sci U S A; 107(19): 8650–8655. doi: 10.1073/pnas.0912668107

Haskell, D.G. (2015). Das verborgene Leben des Waldes, Kunstmann, München.

Jaun, A. & Joss, S. (2011) Im Wald, Haupt Verlag.

Keil, P. et al. (2019). Global patterns and drivers of tree diversity integrated across a continuum of spatial grains; Nature Ecology & Evolution, Volume 3, pages 390–399, doi:10.1038/s41559-019-0799-0

Leuschner, C. et al. (2014). Tropische Regenwälder und temperate Laubwälder – Ein struktureller und funktionaler Vergleich Ber. d. Reinh.-Tüxen-Ges. 26, 119-135. Hannover 2014

Olson, D. M., et al. (2001). Terrestrial ecoregions of the world: a new map of life on Earth. Bioscience 51(11):933-938.

Pan, Y. et al. (2013). The Structure, Distribution, and Biomass of the World's Forests, Annual Review of Ecology, Evolution, and Systematics 44:593–622, doi: 10.1146/annurev-ecolsys-110512-135914

Potapov P, et al. (2017). The last frontiers of wilderness: Tracking loss of intact forest landscapes from 2000 to 2013. Science Advances 3:1-13.

Qian, H. et al. (2019). Global and regional tree species diversity, Journal of Plant Ecology, Volume 12, Issue 2, April 2019, Pages 210–215, https://doi.org/10.1093/jpe/rty013

Whittaker, R.H. (1975). Communities and Ecosystems, 2nd edn. New York: Macmillan.

Winter, L. et al. (2017) Analysing the Impacts of Various Environmental Parameters on the Biodiversity Status of Major Habitats, Sustainability, 9(10), 1775; https://doi.org/10.3390/su9101775

Boreal Forests

Boreal Songbird Initiative, Webseite: https://www.borealbirds.org/threats-boreal-birds, abgerufen am 7.8.2019

DeAngelis, D.L. (2019). The Boreal Forest Ecosystem, Encyclopedia of Ecology (Second Edition), Vol2, 479 – 483. Update of D.L. DeAngelis, Boreal Forest, In Encyclopedia of Ecology, Academic Press, Oxford, 2008, pp. 493–495. doi:10.1016/B978-0-12-409548-9.00723-5

FAO. 2018. The State of the World's Forests 2018 - Forest pathways to sustainable development. Rome.

Gauthier, S. et al. (2015). Boreal forest health and global change, Science 349, 819; DOI: 10.1126/science.aaa9092

Gower, S. T. et al. (1990). Larches: Deciduous Conifers in an Evergreen World. BioScience, 40(11), 818–826. doi:10.2307/1311484

Schmitz, O.J. et al. (2014). Animating the Carbon Cycle Ecosystems 17: 344–359, doi: 10.1007/s10021-013-9715-7

Schmitz, O. J. et al. (2018). Animals and the zoogeochemistry of the carbon cycle. Science Vol. 362, Issue 6419, DOI: 10.1126/science.aar3213

Svensson, J. et al. (2018). Landscape trajectory of natural boreal forest loss as an impediment to green infrastructure. Conservation Biology. doi:10.1111/cobi.13148

Forests of the Temperate Zone

Currie, W. S. et al. (2008). Temprate Forest. Encyclopedia of Ecology, 3494–3503. doi:10.1016/b978-008045405-4.00704-7

Fischer, A. et al. (2013). Disturbances in deciduous temperate forest ecosystems of the northern hemisphere: their effects on both recent and future forest development, Biodivers Conserv (2013) 22:1863–1893. doi 10.1007/s10531-013-0525-1

Gilliam, F.S. (2016). Forest ecosystems of temperate climatic regions: from ancient use to climate change, New Phytologist (2016) 212: 871–887 doi: 10.1111/nph.14255

Jacobson, A.P. et al. (2016). Leopard (Panthera pardus) status, distribution, and the research efforts across its range. PeerJ 4:e1974 https://doi.org/10.7717/peerj.1974

Kohnle, U. (2009). Küstenregenwälder im Nordwesten Amerikas. AFZ-DerWald, 64. Jahrg., 19, 1033.

Kuhlmann, W. et al. (2018). Are Forests the New Coal? A Global Threat Map of Biomass Energy Development, Environmental Paper Network, Briefing

Leuschner, C. et al. (2014). Tropische Regenwälder und temperate Laubwälder – Ein struktureller und funktionaler Vergleich Ber. d. Reinh.-Tüxen-Ges. 26, 119-135. Hannover 2014

Prăvălie, R. (2018). Major perturbations in the Earth's forest ecosystems. Possible implications for global warming. Earth-Science Reviews, 185, 544–571. doi:10.1016/j.earscirev.2018.06.010

Mediterranean Sclerophyll Forests

Ashton, P. S. (2003). Floristic zonation of tree communities on wet tropical mountains revisited. Perspectives in Plant Ecology, Evolution and Systematics, 6(1-2), 87–104. doi:10.1078/1433-8319-00044

Baker, K.H. et al. (2017). Strong population structure in a species manipulated by humans since the Neolithic: the European fallow deer (Dama dama dama), Heredity volume 119, pages 16–26

Catalano, L. (2007). Naturreiseführer Toskana mit Umbrien, Tecklenborg Verlag, Steinfurt

de Rigo, D. et al. (2016). Quercus ilex in Europe: distribution, habitat, usage and threats. In: San-Miguel-Ayanz, J., de Rigo, D., Caudullo, G., Houston

Durrant, T., Mauri, A. (Eds.), European Atlas of Forest Tree Species. Publ. Off. EU, Luxembourg, pp. e014bcd+, https://forest.jrc.ec.europa.eu/en/european-atlas/

FAO and Plan Bleu (2018). State of Mediterranean Forests 2018. Food and Agriculture Organization of the United Nations, Rome and Plan Bleu, Marseille.

Keeley, J. E. (2008). Chaparral. Encyclopedia of Ecology, 551–557. doi:10.1016/b978-008045405-4.00321-9

Médail, F. (2008). Mediterranean. Encyclopedia of Ecology, 2296–2308. doi:10.1016/b978-008045405-4.00348-7

Rundel, P. W. et al. (2013). Mediterranean-Climate Ecosystems. Encyclopedia of Biodiversity, 212–222. doi:10.1016/b978-0-12-384719-5.00245

Schönfelder, I. und P. (1999). Die Kosmos-Mittelmeerflora, Kosmos Stuttgart

Sheffer, E. (2012). A review of the development of Mediterranean pine-oak ecosystems after land abandonment and afforestation: are they novel ecosystems? Annals of Forest Science, Springer Verlag/EDP Sciences, 2012, 69 (4), pp.429-443. DOI 10.1007/s13595-011-0181-0

Tagawa, H. (1997). World-wide Distribution of Evergreen Lucidophyll Oak-laurel Forests, TROPICS Vol. 6 (a): 295-316

Tropical Dry Forests

Bastin, J.-F. et al. (2017). The extent of forest in dryland biomes. Science, 356(6338), 635–638. doi:10.1126/science.aam6527

Bittner, A. (Hrsg.) (1992). Madagaskar. Mensch und Natur im Konflikt. Springer Basel AG. DOI 10.1007/978-3-0348-6407-7

Blackie et al. (2014). Tropical Dry Forests: The State of Global Knowledge and Recommendations for Future Research. CIFOR discussion paper. Bogor, Indonesia: Center for International Forestry Research, https://www.cifor.org/library/4408/

CIFOR 2014, Tropical Dry Forests: Under threat and under researched, CIFOR Fact Sheet, https://www.cifor.org/library/4875/

Dexter, K.G. (2018). Inserting Tropical Dry Forests Into the Discussion on Biome Transitions in the Tropics, Front. Ecol. Evol., 24 July 2018 | https://doi.org/10.3389/fevo.2018.00104

Frankie, G. W., et al. (1974). Comparative Phenological Studies of Trees in Tropical Wet and Dry Forests in the Lowlands of Costa Rica. The Journal of Ecology, 62(3), 881. doi:10.2307/2258961

Gillespie, T.W. (2000). Diversity, composition, and structure of tropical dry forests in Central America, Plant Ecology 147: 37–47, doi: 10.1023/A:1009848525399

Gopalakrishna, S.P. et al. (2015). Tree diversity in the tropical dry forest of Bannerghatta National Park in Eastern Ghats, Southern India, European Journal of Ecology, EJE 2015, 1(2): 12-27, doi: 10.1515/eje-2015-0013

Hernández-Jaramillo, A. et al. (2018). Bosque seco tropical: guía de especies. Bogotá: Programa de las Naciones Unidas para el Desarrollo, Fondo Mundial para el Medio Ambiente, Instituto de Investigación de Recursos Biológicos Alexander von Humboldt, Ministerio de Ambiente y Desarrollo Sostenible. 212 pp. http://humboldt.org.co/es/component/k2/item/1355-bosque-seco-tropical-guia-de-especies

Hutley, L. B. et al. (2008). Savanna. Encyclopedia of Ecology, 3143–3154. doi:10.1016/b978-008045405-4.00358-x

Janzen, D.H. (1988). Tropical Dry Forests: The Most Endangered Major Tropical Ecosystem, in „Biodiversity", E. O. Wilson, F. M. Peter, Eds. (National Academies Press), pp. 130–137. https://www.ncbi.nlm.nih.gov/books/NBK219281/

Lasco, R. et al. (2008). Climate Change and Forest Ecosystems in the Philippines: Vulnerability, Adaptation and Mitigation. Journal of Environmental Science and Management. 11.

Lauerer, M. et al. (2008). Wald mit zwei Gesichtern: Pazifischer Trockenwald in Nordwest-Peru. Der Palmengarten. 38-46.

Leigh, E.G. (2008). Tropical Seasonal Forest. Encyclopedia of Ecology, 3629–3632. doi:10.1016/b978-008045405-4.00336-0

Miles, L. et al. (2006). A global overview of the conservation status of tropical dry forests. Journal of Biogeography, 33(3), 491–505. doi:10.1111/j.1365-2699.2005.01424.x

Murphy, P. et al. (1986). Ecology of Tropical Dry Forest. Annual Review of Ecology and Systematics, 17, 67-88. Retrieved from http://www.jstor.org/stable/2096989

National Research Council (2008). Lost Crops of Africa. Volume III: Fruits, Washington, D.C.: The National Academies Press. http://www.nap.edu/catalog/11879.html

Patrut A. et al. (2015). African Baobabs with False Inner Cavities: The Radiocarbon Investigation of the Lebombo Eco Trail Baobab. PLoS ONE 10(1): e0117193. doi:10.1371/journal. pone.0117193

Pizano, C & García, H (Editores) (2014). El bosque seco tropical en Colombia. Instituto de Investigación de Recursos Biológicos Alexander von Humboldt (IavH). Bogotá D.C., Colombia. http://www.humboldt.org.co/es/component/k2/item/529-el-bosque-seco-tropical-en-colombia

Portillo-Quintero, C. A. et al. (2010). Extent and conservation of tropical dry forests in the Americas. Biological Conservation, 143(1), 144–155. doi:10.1016/j.biocon.2009.09.020

Starr, M. et al. (2015). Water balance of the Sudanese savannah woodland region, Hydrological Sciences Journal, 60:4, 706-722, DOI: 10.1080/02626667.2014.914214

Sunderland, T., et al. (2015). Global dry forests: a prologue. International Forestry Review, 17(2), 1–9. doi:10.1505/146554815815834813

Waeber, P. O. et al. (2015). Dry forests in Madagascar: neglected and under pressure. International Forestry Review, 17(2), 127–148. doi:10.1505/146554815815834822

Wohlfart, C., et al. (2014). Mapping Threatened Dry Deciduous Dipterocarp Forest in South-East Asia for Conservation Management. Tropical Conservation Science, 597–613. https://doi.org/10.1177/194008291400700402

Tropical Rainforests

Armstrong, A. H. (2017). Tropical Rainforest Eco-systems. International Encyclopedia of Geography: People, the Earth, Environment and Technology, 1–16. doi:10.1002/9781118786352.wbieg0644

Berenguer, E. et al. (2014). A large scale field assessment of carbon stocks in human modified tropical forests, Global Change Ecology, Vol.20 (12), 3713-3726

Brancalion, P.H.S. et al. (2019). Global restoration opportunities in tropical rainforest landscapes. Sci Adv 5 (7), eaav3223. DOI: 10.1126/sciadv.aav3223

Butler, R.A. (2019). Why are rainforests so diverse? Mongabay Website, https://rainforests.mongabay.com/03-diversity-of-rainforests.html, abgerufen am 1.8.2019

Frederickson, M. E. et al. (2005). "Devil"s gardens' bedevilled by ants. Nature, 437(7058), 495–496. doi:10.1038/437495a

Ghazoul, J. et al. (2010). Tropical Rain Forest. Ecology, Diversity, and Conservation. Oxford University Press.

Höing, A. (2017). Waldbrände in Indonesien – Ein kurzer Überblick über eines komplexes Thema, süd-ostasien 4/2017

Leuschner, C. et al. (2014). Tropische Regenwälder und temperate Laubwälder – Ein struktureller und funktionaler Vergleich Ber. d. Reinh.-Tüxen-Ges. 26, 119-135. Hannover 2014

Martin, C. (2015). Endspiel – Wie wir das Schicksal der tropischen Regenwälder noch wenden können, oekom Verlag, München.

McFarland, B. J. (2018). Tropical Rainforest Eco-logy. In: Conservation of Tropical Rainforests, 59–72. Palgrave Studies in Environmental Policy and Regulation. Palgrave Macmillan, Cham. doi:10.1007/978-3-319-63236-0_3

Pöhlker, C. et al. (2012) Biogenic Potassium Salt Particles as Seeds for Secondary Organic Aerosol in the Amazon,Science 337, 1075 (2012); DOI: 10.1126/science.1223264

Schmitt M. et al. (2016). Aluminium Accumulation and Intra-Tree Distribution Patterns in Three Arbor aluminosa (Symplocos) Species from Central Sula-wesi. PLoS ONE 11(2): e0149078. doi:10.1371/journal.pone.0149078

Slik, F. et al. (2015). An estimate of the number of tropical tree species. Proceedings of the National Academy of Sciences. 112 (24): 7472.

ter Steege, H., et al. (2013). Hyperdominance in the Amazonian Tree Flora. Science, 342(6156), 1243092–1243092. doi:10.1126/science.1243092

Twilley, R. R. (2008). Mangrove Wetlands. Encyc-lopedia of Ecology, 2198–2208. doi:10.1016/b978-008045405-4.00346-3

Waide, R. B. (2008). Tropical Rainforest. Encyc-lopedia of Ecology, 3625–3629. doi:10.1016/b978-008045405-4.00333-5

Willis, K. J. (ed.) (2018). State of the World's Fungi 2018. Report. Royal Botanic Gardens, Kew.

Wittig, R. (2012). Geobotanik, UTB Band Nr. 3753, Haupt Verlag, Bern

Wilson, E.O. (2002). Die Zukunft des Lebens. Siedler, Berlin.

Worthington, T. et al. (2018). Mangrove Restoration Potential: A global map highlighting a critical oppor-tunity. https://doi.org/10.17863/CAM.39153

Yale University, Global Forest Atlas, https://global-forestatlas.yale.edu/climate-change/climate-chan-ge-and-tropical-forests, abgerufen am 1.8.2019

Zuchowski, W. (2007). Tropical Plants of Costa Rica, Zona Tropical Publications, San José, Costa Rica; ISBN 978-0-8014-7374-6

Changing Forests

Bastin J.F. et al. (2019). The global tree restoration potential, Science, 5 July 2019, doi: 10.1126/science.aax0848

Bonan, G. B. et al. (2018). Climate, ecosystems, and planetary futures: The challenge to predict life in Earth system models, Science 359, eaam8328. doi: 10.1126/science.aam8328

Bundeszentrale für politische Bildung mit Daten der FAO (2017) Jährliche Änderung des Waldbestandes, http://www.bpb.de/nachschlagen/zahlen-und-fak-ten/globalisierung/52727/waldbestaende, abgeru-fen am 1.8.2019

Carpino, O.A. et al. (2018). Climate change and permafrost thaw-induced boreal forest loss in north-western Canada, Environmental Research Letters, 13 084018

Cooper, R. (2018). Natural Resources Management Strategies in the Sahel. K4D Helpdesk Report. Brigh-ton, UK: Institute of Development Studies.

Ellis, E. C., et al. (2013). Used planet: A global history. Proceedings of the National Academy of Sciences, 110(20), 7978–7985. doi:10.1073/pnas.1217241110

Ellison, D et al. (2017). Trees, forests and water: Cool insights for a hot world. Global Environ-mental Change, 43, 51–61. doi:10.1016/j.gloenvcha.2017.01.002

Hansen, M.C. et al. (2013). High-Resolution Global Maps of 21st-Century Forest Cover Change, Science Vol. 342, Issue 6160, pp. 850-853, doi: 10.1126/science.1244693

Haskell, D.G. (2017). Der Gesang der Bäume, Kunst-mann, München.

Hua, F. et al. (2018). Tree plantations displacing native forests: The nature and drivers of apparent forest recovery on former croplands in Southwestern China from 2000 to 2015. Biological Conserva-tion, 222, 113-124.

Jones, K. R., et al. (2018). One-third of global protec-ted land is under intense human pressure. Science, 360(6390), 788–791. doi:10.1126/science.aap9565

Keenan, T.F. et al. (2018). The Terrestrial Carbon Sink, Annual Review of Environment and Resources 2018 43:1, 219-243. https://doi.org/10.1146/annurev- environ- 102017- 030204

Kleinschroth, F. et al. (2019): Road expansion and persistence in forests of the Congo Basin. Nature Sustainability, vol 2, 628–634 doi: 10.1038/s41893-019-0310-6

Lewis, S. L. et al. (2015). Increasing human domi-nance of tropical forests. Science, 349(6250), 827–832. doi:10.1126/science.aaa9932

Liu, C. L. C. et al. (2018). Mixed-species versus monocultures in plantation forestry: Development, benefits, ecosystem services and perspectives for the future. Global Ecology and Conservation, 15, e00419. doi:10.1016/j.gecco.2018.e00419

Liu, Y. et al. (2019). Anthropogenic aerosols cause recent pronounced weakening of Asian Summer Monsoon relative to last four centu-ries. Geophysical Research Letters, https://doi.org/10.1029/2019GL082497

Nobre, C.A. et al. (2016). Land-use and climate change risks in the Amazon and the need of a novel sustainable development paradigm. PNAS 113 (39) 10759-10768; https://doi.org/10.1073/pnas.1605516113

Pan Y. et al. (2011). A large and persistent carbon sink in the world's forests. Science 333(6045):988–93. doi: 10.1126/science.1201609

Pan, Y. et al. (2013). The Structure, Distribution, and Biomass of the World's Forests, Annual Review of Ecology, Evolution, and Systematics 44:593–622, doi: 10.1146/annurev-ecolsys-110512-135914

Prăvălie, R. (2018). Major perturbations in the Earth's forest ecosystems. Possible implications for global warming. Earth-Science Reviews, 185, 544–571. doi:10.1016/j.earscirev.2018.06.010

Sampaio, G. et al. (2007). Regional climate change over eastern Amazonia caused by pasture and soybean cropland expansion, Geophysical Research Letters, Vol. 34, L17709, doi:10.1029/2007GL030612, 2007

Smith, F. A., et al. (2018). Body size downgrading of mammals over the late Quaternary. Science, 360(6386), 310–313. doi:10.1126/science.aao5987

The Economist (2019). On the brink: The Amazon is approaching an irreversible tipping point, https://www.economist.com/briefing/2019/08/01/the-ama-zon-is-approaching-an-irreversible-tipping-point, abgerufen am 1.8.2019

Yosef, G. et al. (2018). Large-scale semi-arid affo-restation can enhance precipitation and carbon sequestration potential. Scientific Reports, 8 (996), 2045-2322, doi10.1038/s41598-018-19265-6

Imprint

© 2019 teNeues Media GmbH & Co. KG, Kempen

Texts © Gunther Willinger
Picture Editing by Gunther Willinger
Foreword by Prof. Dr. Jürgen Bauhus
Translations by John A. Foulks
Copyediting by Amanda Ennis, Shearwater Language Services
Design by Jens Grundei, teNeues Media
Final Artwork & Icons by Anika Lethen
Maps by Susanne Kuhlendahl

Editorial coordination by Stephanie Rebel, teNeues Media
Production by Nele Jansen, teNeues Media
Color separation by Jens Grundei, teNeues Media

ISBN 978-3-96171-218-2

Library of Congress Number: 2019945166

Printed in the Czech Republic by Tesinska Tiskarna AG

Bibliographic information published by the Deutsche Nationalbibliothek
The Deutsche Nationalbibliothek lists this publication in the Deutsche
Nationalbibliografie; detailed bibliographic data are available on the
Internet at http://dnb.dnb.de.

Published by teNeues Publishing Group

teNeues Media GmbH & Co. KG
Am Selder 37, 47906 Kempen, Germany
Phone: +49-(0)2152-916-0
Fax: +49-(0)2152-916-111
e-mail: books@teneues.com

Press department: Andrea Rehn
Phone: +49-(0)2152-916-202
e-mail: arehn@teneues.com

teNeues Media GmbH & Co. KG
Munich Office
Pilotystraße 4, 80538 Munich, Germany
Phone: +49-(0)89-443-8889-62
e-mail: bkellner@teneues.com

teNeues Media GmbH & Co. KG
Berlin Office
Mommsenstraße 43, 10629 Berlin, Germany
Phone: +49 (0)152-0851-1064
e-mail: ajasper@teneues.com

teNeues Publishing Company
350 7th Avenue, Suite 301, New York, NY 10001, USA
Phone: +1-212-627-9090
Fax: +1-212-627-9511

teNeues Publishing UK Ltd.
12 Ferndene Road, London SE24 0AQ, UK
Phone: +44-(0)20-3542-8997

teNeues France S.A.R.L.
39, rue des Billets, 18250 Henrichemont, France
Phone: +33-(0)2-4826-9348
Fax: +33-(0)1-7072-3482

www.teneues.com

teNeues Publishing Group
Kempen
Berlin
London
Munich
New York
Paris

teNeues